AFTER *PARIS*, NOW *NEW YORK*. I WOULD LIKE TO THANK
JEAN-MICHEL BERTS FOR HIS FRIENDSHIP AND HIS INSPIRATION,
SCOTT KELBY FOR ALWAYS BEING THERE FOR ME WHEN I NEEDED IT THE MOST,
MY WIFE KAREN AND DAUGHTER MARINE
WHO HELPED ME PUT THIS BOOK TOGETHER.

NEW YORK

SERGE RAMELLI

teNeues

YellowKorner
éditions

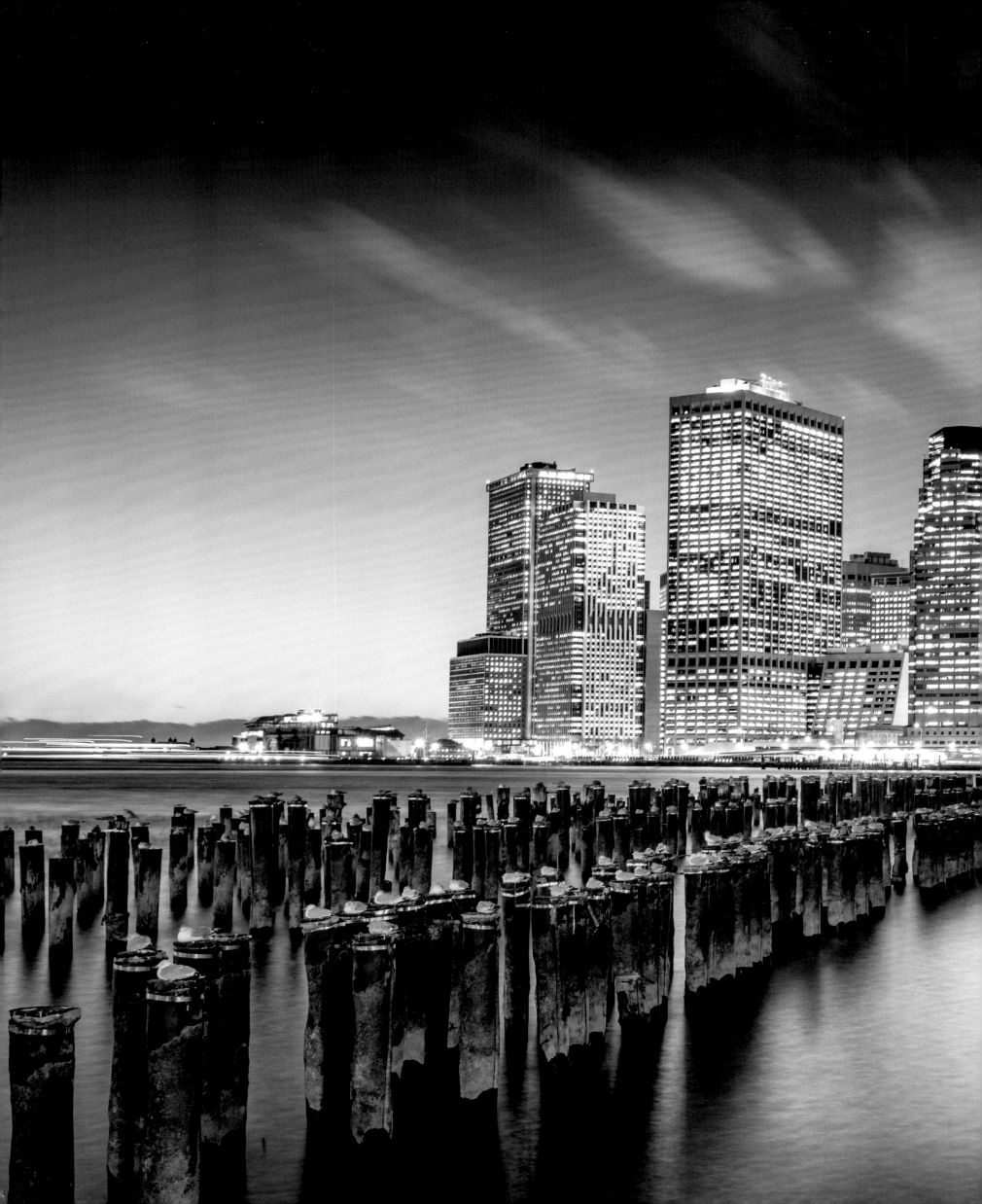

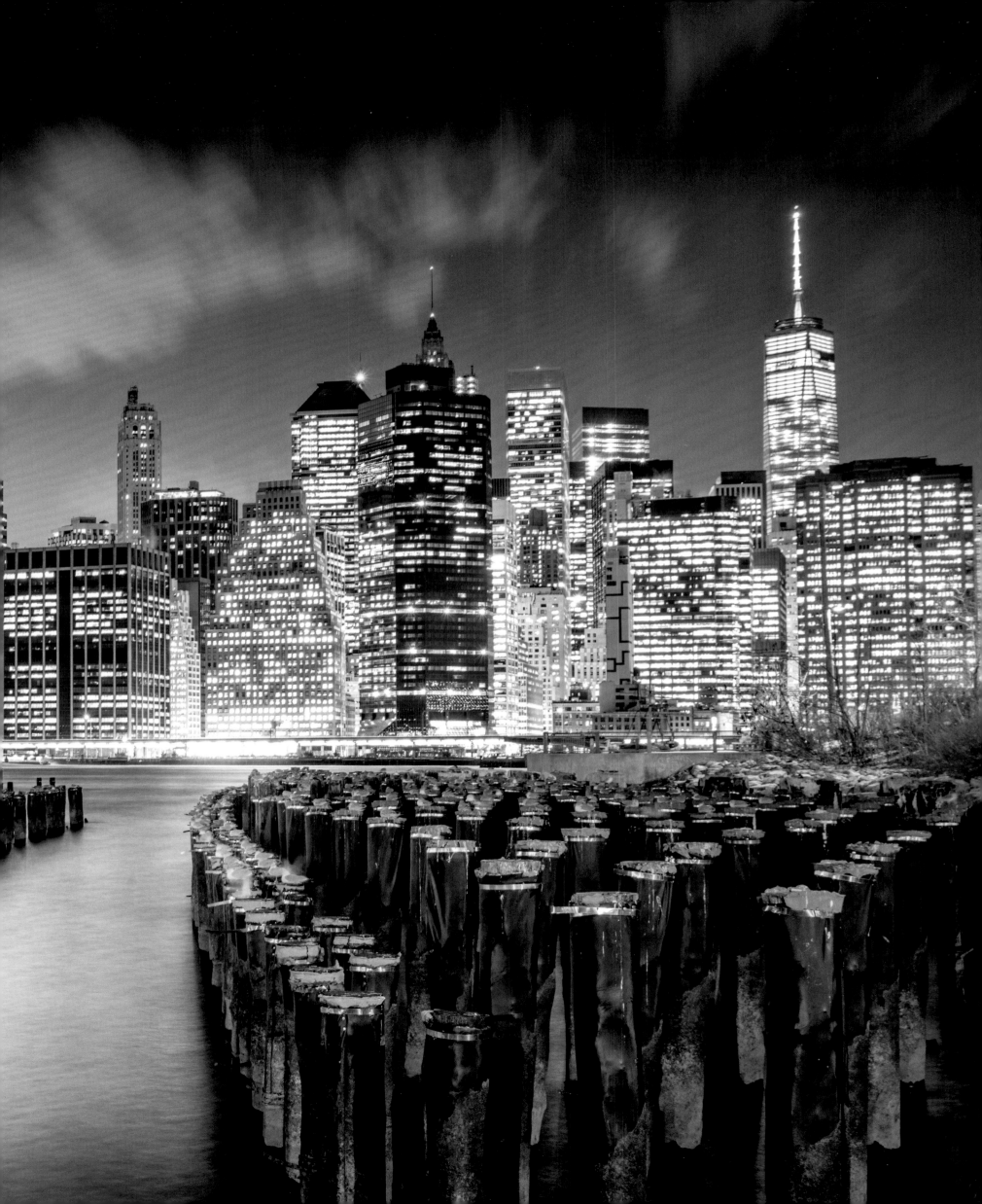

INTRODUCTION

After Paris, New York was Serge Ramelli's choice of second instalment for his photo-graphic diptych of contemporary cityscapes, and it's certainly no coincidence that the photographer selected this super-sized city as the subject of his second book. How could he fail—he, the self-taught photographer—to pay homage to this, the city of the willing, the *self-made men*, and the resourceful? And how could this great lover of cinema have chosen any other backdrop or any other film location than that of the Big Apple, made immortal by more than a century of legendary cinematography? Because Serge Ramelli is one of those seasoned dreamers who found, just as his life in sales seemed to be all worked out, that discovery and great change were in store, first as he returned to his initial love—imagery—which he began exploring in Paris, and then as he made the mythical Atlantic crossing to choose the other side of the pond over *Old Europe*. When the *novice photographer* decided to settle permanently in the United States it was primarily with the aim of putting his skills into practice at an even more refined level—skills he had acquired through reading, photographic research on location and experimentation with digital tools. It was also to share his profound knowledge in the field of photo-editing and, more generally, production work with a wider audience via the medium of his tutorials and technical writings on photography. But above all, he came to settle in the USA in the hope of diversifying the ways his passion for pictures could be put into practice by founding his own production company and creating a number of film projects of his own design[1]. In America, Serge Ramelli has found a landscape that fits. From Los Angeles to New York via Vegas, always on the hunt for a picture, he makes his way on wheels and on foot along the long avenues, some lined with coconut trees like Ocean Avenue in Santa Monica, some with casinos such as the Las Vegas Strip, and some with theatres as along Broadway. Such exploits put Ramelli almost on a par with the prospectors who helped to forge the great American dream, such as those depicted in Charlie Chaplin's *The Gold Rush*, Paul Thomas Anderson's *There Will Be Blood* or, in a more modern context, Martin Scorsese's *The Wolf of Wall Street*. An eager lover of dramatic imagery, Serge Ramelli is constantly on the lookout for spectacular lighting, whether natural or artificial, and with its gigantic advertising and garish boards New York is an almost perfect city for such a hunt. Just like his Parisian imagery, his New York works are not confined by documentary dimensions. Human figures, although present, blend into the overriding pattern that absorbs the city, as can be seen among the heights and commercialist pomposity of Times Square, between the leafy greenery and neo-gothic buildings of Central Park, and in the mists, somewhat uninviting, that hang over the bridges spanning the East and Hudson rivers. Such compositions hint that the photographer might just be more interested in the general decorum of the city than in the sidewalk-users themselves, who come and go after all. While the choice of black and white may have its roots in the wintery conditions at play, it is likewise the cause of the intentional historicization of the imagery and its anchoring in a tradition of representation. In contrast, the most modern images of the city—the aerial night views—make up the overwhelming majority of the photographer's 'color' oeuvre. Yet in both cases his camera angles widen until reaching the proportions

[1] The most recent is called *The Parisian* and tells of a love story, nothing short of ubiquitous, between a man and a woman mid-way between Paris and LA.

of a panorama, a format almost always attributed to New York. Despite being in the city, subjects are photographed at a distance in tribute to a more sightseeing style of imagery which guarantees a whole host of cultural references in every snapshot. In this respect, Ramelli's photographs share many perspectives with the work of Berenice Abbott. New York forces the photographer to confront the challenge of height, incurring a large amount of post-production work: How can the vertigo of the skyscraper be truly captured? How can the distorting perspectives of the city be brought into frame? Ramelli's New York is not so much the 21st century city but that of the immigrant arriving to Ellis Island toward the beginning of the 1900s, awed by the first skyscrapers freshly risen from the ground. Ramelli's New York imagery can be traced back, indirectly, to the *Commissioners' Plan* of 1811 which was devised by John Randel[2] to organize the city into parallel and perpendicular blocks. In his New York compositions, Ramelli attempts to bring out the city's landscape and give it a natural feel almost akin to the peaks and crags of a mountain range. Looking south from the legendary Empire State Building, a twilight view of Lower Manhattan rolls out dominated by the One World Trade Center. In this host of skyscrapers it is impossible not to see something of a new Matterhorn, Dent Blanche or Crazy Peak crafted by the hand of man[3]. Using his successful 'capturing' techniques, Ramelli presents the frozen Jacqueline Kennedy Onassis Reservoir in Central Park as an unspoiled mountain lake, and accentuates the natural dimension of a view of the Hudson River immaculately dressed in glints of light. In some ways, the photographer gives the city the look of nature untouched, reinstating its historical title of a New World settlement for those English colonies, full of both such precarity and promise, who laid down roots on the Eastern side of what was to become the United States: Such images are reminiscent of the Chesapeake Bay where the first settlers drew up at the start of the 17th century led by Captain John Smith. And this explains why the myth of fertile, nutritive America is written all across Ramelli's New York photography: Here is a land ready to welcome anyone prepared to fight and prosper. Yet behind the gargantuan gluttony of American ambition lies the desire for social assimilation, synthesized into the ideology of the 'melting pot'[4]. Each community in Manhattan finds its neighborhood and overlays its own rhythm, color and tonality, and it is to this wonderful crucible that the photographer pays tribute as he points his camera at two shops, one French, the other Irish, in the Financial District. This image is a direct translation of Ramelli's humorous outlook on the city: The French bakery is aptly named *Financier*[5] while the Irish pub, *Ulysses'*, is itself a triple-play on the main character of the *Odyssey*, making reference simultaneously to the first waves of immigration to the United States, to Homer's epic poem and inevitably to James Joyce's novel.

For Ramelli, the showman-like dimension of the imagery is not so much rooted in its monumentality but in its devotion to the American love of 'showbiz', the culture constructed from percussive visuals and exuberance. This brings us to the photograph of Times Square where we see illuminations of all kinds in their familiar arrangement, an almost naked cowboy guitarist among them in the foreground. Ramelli uses his photographic artistry in this way to deconstruct the various faces of American drama and soap opera, his photographer's eye having been trained first and foremost on Hollywood imagery[6]. A film producer himself, Ramelli does indeed lay out his photographs almost like film posters, images taking on the 'communicational role' of the billboard, vehicles filled with symbols, references and 'explicit content'. The metal fire escape, made law in 1840 and visibly ornamenting historic apartment blocks all around the city, is one such meaningful element. Serge Ramelli takes pleasure in such iron ornamentation, as the archetype of progress and reason in the American way, when he photographs a shop façade on Broome Street just down from Broadway. With its zig-zags of metal, the pictured stairway is forged almost in the form of a thunderbolt and echoes the poster for the musical *West Side Story*, Ramelli honoring the famous *I like to be in America* sung by the characters. In these snapshots the photographer immortalizes the illusory blaze of a lifestyle founded on credit, a 'small fee' and a 'washing machine', a lifestyle most clearly seen in the images of Brooklyn that are crafted by the photographer almost like odes to Sergio Leone's urban western *Once Upon a Time in America*. The photograph of Manhattan Bridge in Dumbo[7] is a case in point with its red-brick buildings calling and answering in perfect symmetry, buildings between which the puny little hoodlum Noodles, from Leone's film, first exercised the basics of being a future boss of New York. But it is perhaps in the images of the Statue of Liberty, the Flatiron Building and Central Park that the photographer's love of cinematography is best expressed. Under his watchful eye, these unsurpassable monuments of American cinema become motifs in the truest form: An exploit managing to combine, in each image, the vast spectrum of Hollywood creation running from *Godzilla* (1998) to Hitchcock's *Saboteur* (1942), from *Planet of the Apes* (1968) to *Serendipity* (2001).

Harold Hinsinger

[2] This city plan gave Manhattan Island the appearance of a chessboard outlining 'blocks' of streets crossing at right angles, beginning at 14th Street.
[3] The Matterhorn and Dent Blanche are both summits in the Alps; Crazy Peak is in the American Rocky Mountains.
[4] The concept of the 'melting pot' requests that each immigrant arriving on American soil 'melts' the culture of their own country into that of the host country, the basis of which is the *United States Bill of Rights*.
[5] A *financier* is a French patisserie made with powdered almonds, formerly known as a *visitandine*.
[6] Films such as *Gone with the Wind*, *Gladiator* or *Gangs of New York*. While Ramelli is also inspired by the films of Luc Besson, it's certainly because he might be the most 'Hollywood' of the French directors.
[7] DUMBO is the acronym standing for *District Under the Manhattan Bridge Overpass*.

EINLEITUNG

Serge Ramelli hat nach Paris nun New York ins Auge gefasst und so ein fotografisches Diptychon über zeitgenössische Metropolen geschaffen. Und es ist sicher kein Zufall, dass er seinen zweiten Bildband dieser einzigartigen Stadt widmet. Wie könnte er, der Autodidakt, die Stadt der *Self-made-men* und der Kreativität auf andere Art ehren als mit seinen Bildern? Wie könnte er, der große Experte des Kinos, sich einen anderen Rahmen, ein anderes Szenenbild aussuchen, als das des Big Apple, welches seit Jahrzehnten Bestandteil legendärer Filme ist? Serge Ramelli weiß zu träumen, er kennt sich aus mit dem Abenteuer, dem ganz Neuen, obgleich sein Leben als kaufmännischer Angestellter vorgezeichnet schien. Noch zu seiner Pariser Zeit widmete er sich seiner ursprünglichen Leidenschaft, dem Bild, und vollführte dann die mythische Überquerung des Atlantiks, wählte die Neue Welt anstelle des Alten Europa. Als sich der Neo-Fotograf endgültig in den USA niederlässt, tut er dies vor allem, um sein Wissen in die Praxis umzusetzen – Wissen, das er sich durch Lektüre, durch fotografische Erkundungen „in situ" und mittels digitaler Experimente angeeignet hat. Zugleich möchte er möglichst vielen Menschen über Tutorials seine außergewöhnlichen Kenntnisse in der Bildherstellung und vor allem der Bildbearbeitung nahebringen. Doch vor allem kam er mit der Hoffnung in die USA, herauszufinden, wie er seine Leidenschaft für Bilder in bewegte Bilder umwandeln kann. Dafür hat er eine Produktionsfirma gegründet und verwirklicht nun Filmprojekte in seinem ganz eigenen künstlerischen Stil[1].

In den USA findet Serge Ramelli eine Landschaft nach seinem Maßstab vor. Von Los Angeles über Las Vegas nach New York fährt und flaniert er – immer auf der Jagd nach einem Bild – über die breiten Avenues, gesäumt von Palmen an der Ocean Avenue, von Casinos am Strip, von Theatern am Broadway. Der Fotograf reiht sich in die lange Tradition der Goldgräber und Glücksritter ein, die den amerikanischen Traum geprägt haben – genau wie in Chaplins *Goldrausch*, in Paul Thomas Andersons *There Will Be Blood* oder in Scorseses *The Wolf of Wall Street*. Als eifriger Liebhaber einer dramatischen Bildersprache durchstreift Serge Ramelli mit umgehängter Kamera die Städte, lauert dem passenden natürlichen Licht oder der richtigen Beleuchtung auf. Und New York ist mit seiner auffälligen Reklame und den blinkenden Leuchtschriften wahrscheinlich die geeignetste Stadt für seine Jagd. Doch genau wie in seinen Paris-Bildern erteilt Ramelli in seinen New York-Bildern der traditionell dokumentarischen *Street Photography* eine Absage. Menschliche Figuren sind zwar präsent, verlieren sich aber im übergreifenden, alles beanspruchenden Motiv der Stadt: In der Hervorhebung der großflächigen Werbung am Times Square, in der dichten, neogotischen Belaubung des Central Park und im unbehaglichen Nebel am Ufer der Brücken, die den East River und den Hudson River überspannen. Der Fotograf interessiert sich offenbar eher für das Dekorum der Stadt als für die wechselnden Benutzer ihrer Gehsteige. Für die starke Historisierung des Bildes, für seine Verankerung in einer Darstellungstradition, ist auch die Wahl des Schwarz-Weiß verantwortlich. So ist es kein Zufall, dass im Gegenzug die modernsten Aufnahmen der Stadt – nächtliche Luftbilder – die große Mehrheit des „farbigen" Bilderkorpus bilden. In manchen Fällen erweitert sich der Aufnahmewinkel bis hin zum Panorama, dem New York quasi standardmäßig zugeteilten Format. Die Bewohner der Stadt sind aus der Distanz

[1] Die aktuellste Produktion ist *The Parisian*, eine allgegenwärtige Liebesgeschichte zwischen einem Mann und einer Frau irgendwo zwischen Paris und LA.

abgebildet und ordnen sich der Bildwelt des Sightseeing unter, die der Darstellung eine Fülle kultureller Bezüge beschert. In dieser Hinsicht teilen Serge Ramellis Fotografien Aspekte mit den Arbeiten von Berenice Abbott. New York zwingt den Fotografen sich der Herausforderung der Höhe und einer Menge Bildnachbearbeitung zu stellen: Wie kann die schwindelerregende Höhe des Wolkenkratzers eingefangen werden? Wie können die verzerrenden Perspektiven in ein Format gebracht werden? Beim Betrachten der Aufnahmen hat man leicht den Eindruck, der Bildwelt des Amerikanischen Traums Ende des 19. Jahrhunderts gegenüberzustehen. Denn Ramellis New York ist nicht so sehr das des 21. Jahrhunderts, sondern vielmehr das des frühen Einwanderers, der das Land der unbegrenzten Möglichkeiten über Ellis Island betritt und die ersten Wolkenkratzer bestaunt. Ramellis New York-Bilder verweisen indirekt auf den 1811 von John Randel erdachten *Commissioners' Plan*[2], der Städte anhand von Parallelen und rechten Winkeln in Blöcke unterteilte. In seinen New Yorker Kompositionen versucht Ramelli, die Landschaft der Stadt wieder aufleben zu lassen, um dem urbanen Panorama eine ähnliche Prägnanz zu verleihen wie Berggipfeln und Felsformationen. Vom legendären Empire State Building im Süden entfaltet sich der in Dämmerlicht getauchte Blick auf das vom One World Trade Center dominierte Lower Manhattan. Und tatsächlich erkennt man in dieser Wolkenkratzerkette leicht das neue Matterhorn, die Dent Blanche oder den Crazy Peak[3]. Ramelli beherrscht die entsprechende Darstellungsweise, und so verleiht er dem vereisten Jaqueline Kennedy Onassis Reservoir im Central Park die Erscheinung eines klaren Bergsees. Der Fotograf setzt den Akzent auf das Natürliche, indem er einen Hudson River zeigt, der durch Lichtreflexe wie makellos wirkt. Auf gewisse Weise gibt der Fotograf der Stadt ihre Unschuld zurück und verwandelt sie wieder in ein historisches Settlement der Neuen Welt, zur gefahr- und verheißungsvollen britischen Kolonie, in der der Grundstein für die heutigen Vereinigten Staaten gelegt wurde. In den Bildern steckt ein wenig Chesapeake Bay – die Bucht, in der zu Beginn des 17. Jahrhunderts die ersten, von Captain John Smith angeführten Kolonisten landeten. So lässt sich aus Serge Ramellis New York-Fotos der Mythos der „Nährmutter Amerika" herauslesen – das Land, das alle mit offenen Armen empfängt, die sich beweisen und reich werden wollen. Hinter der Gefräßigkeit des amerikanischen Erfolgsstrebens gibt es auch den Willen zur gesellschaftlichen Assimilation, zusammengefasst in der Idee des „Melting Pot"[4]. In Manhattan findet jede Gruppe ihr Viertel und prägt dessen Rhythmus, Farbe und Klang. Und diesen Schmelztiegel würdigt der Fotograf, indem er seine Kamera auf zwei Ladengeschäfte – ein französisches und ein irisches – im Financial District richtet. Das Bild verrät den amüsierten Blick, den Ramelli auf die Stadt wirft: Die Patisserie heißt zum Viertel passend *Financier*[5], und der irische Pub *Ulysses* spielt auf die *Odyssee* der ersten Einwanderer, auf Homers Epos und natürlich auf den Roman von James Joyce an. Bei Ramelli steckt das Spektakuläre der Darstellung nicht in ihrer Monumentalität, sondern in ihrer Verpflichtung zum amerikanischen Entertainment, an diese Kultur des visuellen Schockeffekts und des Überschwangs. Das zeigt sich auch in seiner Aufnahme vom Times Square, wo die bekannte Partitur der Lichter gespielt wird, mit halb nacktem, Gitarre spielenden Cowboy im Vordergrund. Ramelli dekliniert in seinen Fotografien zahlreiche Facetten des amerikanischen Schauspiels und der Soap Opera. Es ist die Bilderwelt Hollywoods, die das Auge des Fotografen geschult hat[6]. Als Filmproduzent begreift Ramelli seine Fotografien auch als Filmplakate. In diesem Kontext erhalten seine Bilder einen kommunikativen Fokus, sind Ausdrucksmittel, die voller Zeichen, Anspielungen und „explicit content" stecken. Zu diesen bedeutungsgeladenen Elementen gehört die Feuerleiter, die seit dem 1840 eingeführten Gesetz sämtliche historische Gebäude der Stadt schmückt. Serge Ramelli erfreut sich an dieser eisernen Verzierung, dem Archetyp des Fortschritts und der amerikanischen Rationalisierung, und fotografiert die Fassade eines Ladengeschäfts an der Broome Street, nicht weit entfernt vom Broadway. Die Zickzacklinie des Metalls, die wie ein Blitz geschmiedete Treppe… ja, genau: Wir stehen vor dem Plakat für das Musical *West Side Story,* und Ramelli feiert das berühmte von Immigranten gesungene *I like to be in America.* In diesem Bild verewigt der Fotograf den illusorischen Glanz eines Lebens auf Pump, mit „small fee" und „washing machine". Dies wird besonders in den Brooklyn-Bildern des Künstlers deutlich, die als Ode auf den urbanen Western *Es war einmal in Amerika* von Sergio Leone konzipiert sind. Dies beweist die im Dumbo[7] aufgenommene Manhattan Bridge mit den roten Backsteinbauten, die sich in perfekter Symmetrie spiegeln: Genau zwischen diesen Häusern macht der schmächtige kleine Ganove Noodles in Leones Film seine ersten Fingerübungen als zukünftiger Gangsterboss. Letztendlich zeigt sich aber wahrscheinlich am ehesten in den Bildern der Freiheitsstatue, des Flatiron Building und des Central Parks die Liebe des Fotografen für die „siebte Kunst", die Cinematografie. Unter seiner Regie werden diese unübertroffenen Denkmäler des amerikanischen Kinos Bildmotive im eigentlichen Sinn und es gelingt ihm die Meisterleistung, das breite Spektrum der Hollywoodproduktion aufzurufen, von *Godzilla* (1998) bis zu Hitchcocks *Saboteure* (1942), über *Planet der Affen* (1968) zu *Weil es Dich gibt* (2001).

Harold Hinsinger

[2] Dieser Stadtplan gab Manhattan das Aussehen eines Schachbretts. Ab der 14ten Straße gibt es die Gliederung in sogenannte „Blocks", deren Straßen sich im rechten Winkel schneiden.
[3] Matterhorn und Dent Blanche sind Berggipfel in den Alpen, der Crazy Peak gehört zu einer Gebirgskette in den nördlichen Rocky Mountains.
[4] Das Konzept des „Melting Pot" (Schmelztiegel) besagt, dass jeder Einwanderer, der amerikanischen Boden betritt, die Kultur seiner Heimat mit der Amerikas verschmelzen lässt. Dies gilt als Grundlage der amerikanischen *Bill of Rights*.
[5] Ein „Financier" ist übersetzt ein französisches Mandelbiskuit.
[6] Filme wie *Vom Winde verweht*, *Gladiator* oder *Gangs of New York* oder auch die Werke Luc Bessons inspirieren den Fotografen, zweifellos weil es sich bei ihm um den wohl Hollywood-affinsten Regisseur Frankreichs handelt.
[7] *District Under the Manhattan Bridge Overpass*, ein unterhalb der Manhattan Bridge gelegenes Viertel von Manhattan.

I N T R O D U C T I O N

Après Paris, Serge Ramelli a choisi New York pour clôturer son diptyque photographique sur la métropole contemporaine. Et ce n'est certainement pas un hasard si le photographe a décidé de consacrer son deuxième livre à cette ville démesurée. Pouvait-il faire autrement, lui, le photographe autodidacte, que de rendre hommage à la ville des volontaires, des *self-made-men* et de la débrouille ? Pouvait-il, ce grand amateur de cinéma, choisir un autre cadre de tournage que la Grosse Pomme, immortalisée par plus d'un siècle de films légendaires ? Car Serge Ramelli, dont la vie de commercial semblait toute tracée, est l'un de ces rêveurs chevronnés qui ont fait l'expérience de la découverte et du grand changement : le revirement vers sa passion première, l'image, qu'il travaille d'abord à Paris, puis la mythique traversée de l'Atlantique, le choix de « l'autre côté » plutôt que de la Vieille Europe. Si le « tout nouveau photographe » décide de s'installer définitivement aux États-Unis, c'est avant tout pour mettre en pratique – à une échelle supérieure – un savoir acquis à force de lectures, de recherches photographiques réalisées *in situ* et d'expérimentations numériques. C'est également pour faire partager au plus grand nombre, au moyen de tutoriels et d'ouvrages techniques sur la photographie, sa profonde connaissance de la retouche et, plus généralement, du travail de production. Mais surtout, s'il s'installe aux États-Unis, c'est pour diversifier sa façon de mettre en pratique sa passion de l'image, en créant sa propre société de production et en imaginant de nombreux projets cinématographiques[1].

En Amérique, Serge Ramelli trouve un paysage à sa mesure. De Los Angeles à New York en passant par Las Vegas, toujours à la recherche d'images, il roule et déambule sur les longues avenues, qu'elles soient bordées de cocotiers, comme l'Ocean Avenue de Santa Monica, de casinos, tel le Las Vegas Strip, ou de théâtres, à Broadway par exemple. Par cette démarche, Ramelli est proche des prospecteurs qui ont contribué à forger le mythe américain, qu'il s'agisse de ceux de *La Ruée vers l'or* de Charlie Chaplin, de ceux de *There Will Be Blood*, de Paul Thomas Anderson, ou encore de ceux, plus contemporains, du *Loup de Wall Street,* de Martin Scorsese. Avide d'images dramatiques, Serge Ramelli est à l'affût d'éclairages spectaculaires, tant naturels qu'artificiels. Et New York est une ville ô combien propice pour ce genre de chasse, avec son ogresse publicité et ses enseignes criardes ! Comme ses images parisiennes, les images new-yorkaises de Ramelli n'ont aucune dimension documentaire. La figure humaine, bien que présente, se fond dans le motif général et absorbant de la ville, dans l'élévation et la grandiloquence publicitaire de Times Square, dans le feuillage touffu et les immeubles néogothiques de Central Park, dans la brume peu engageante enfin, qui estompe les ponts enjambant l'East River et l'Hudson River. Ici, le photographe semble s'intéresser davantage au décor de la ville qu'aux hommes et aux femmes qui arpentent ses trottoirs. Si le choix du noir et blanc est lié aux conditions climatiques hivernales, il entraîne également une historicisation forcée de l'image, un ancrage dans une tradition de la représentation. À l'inverse, les images les plus contemporaines de la ville – les vues aériennes de nuit – constituent l'écrasante majorité du corpus «couleur» du photographe. Dans un cas comme dans l'autre pourtant,

[1] Le dernier en date, *The Parisian*, relate une histoire d'amour entre un homme et une femme pour le moins ubiquiste, à mi-chemin entre Los Angeles et Paris.

les angles de prise de vue s'élargissent jusqu'à coïncider avec le panorama, format quasi indissociable de la ville de New York. Bien que citadins, les sujets sont photographiés à distance et payent leur tribut à l'imagerie du *sightseeing*, qui garantit au cliché un fourmillement de références culturelles. Les photographies de Serge Ramelli partagent en cela quelques perspectives avec celles de Berenice Abbott. À New York, le photographe fait face au défi de la hauteur, ce qui suppose un très important travail de postproduction ; comment saisir le vertige des gratte-ciel ? Comment faire entrer dans le cadre les perspectives déformées de la ville ? Le New York de Ramelli n'est pas tant celui du XXIe siècle que celui de l'immigrant arrivant à Ellis Island au tournant des années 1900, impressionné par les premiers gratte-ciel tout juste sortis de terre. Les images new-yorkaises de Ramelli renvoient indirectement au Commissioners' Plan de 1811, imaginé par John Randel[2] en vue d'organiser la ville en blocs, tout en parallèles et en perpendiculaires. Dans ses compositions new-yorkaises, Ramelli tente de faire ressortir le paysage de la ville, pour donner à celui-ci le naturel des pics et des aiguilles montagnards. Depuis le légendaire Empire State Building, en direction du sud, s'étale une vue crépusculaire du Lower Manhattan que domine le One World Trade Center. Comment ne pas voir dans cette foule de gratte-ciel de nouveaux Cervin, dent Blanche ou Crazy Peak[3] édifiés de main d'homme ? Grâce à une science de la captation adéquate, Ramelli donne au Jacqueline Kennedy Onassis Reservoir gelé de Central Park l'allure d'un lac de montagne encore préservé. Le photographe accentue le naturel de la vue en saisissant l'Hudson River rendue immaculée par les reflets de lumière. D'une certaine façon, le photographe donne à la ville un aspect de nature inviolée, lui rendant son titre historique de *settlement* du Nouveau Monde, ces colonies anglaises à la fois précaires et prometteuses qui s'installèrent sur la façade est des futurs États-Unis. Il y a dans ces images un peu de la baie de Chesapeake, où accostèrent les premiers colons menés par le capitaine John Smith, au tout début du XVIIe siècle. Voilà pourquoi, dans la photographie new-yorkaise de Serge Ramelli, se lit en filigrane le mythe de l'Amérique nourricière, terre d'accueil pour qui veut se battre et prospérer. Mais derrière la gloutonnerie gargantuesque de l'ambition américaine figure cette volonté d'assimilation sociale, synthétisée par l'idéologie du *melting-pot*[4]. Dans Manhattan, chaque communauté trouve son quartier et y imprime un rythme, une couleur, une tonalité. C'est ce formidable creuset auquel le photographe rend hommage lorsqu'il braque son appareil sur deux commerces, l'un français, l'autre irlandais, dans le Financial District. L'image montre le regard amusé que Ramelli porte sur la ville : la pâtisserie est justement nommée *Financier*[5] ; le nom du pub irlandais – le *Ulysses'* – est quant à lui un triple jeu autour du personnage central de l'*Odyssée*, renvoyant tout à la fois aux premières vagues d'immigration aux États-Unis, au poème épique d'Homère et, inévitablement, au roman de James Joyce. Chez Ramelli, la dimension spectaculaire de l'image ne réside pas tant dans sa monumentalité que dans son allégeance à l'attraction américaine pour le spectacle, à cette culture faite de percussion visuelle et d'exubérance. On pense ici à cette photographie de *Times Square* où se joue la partition habituelle des illuminés en tout genre, tel le cow-boy guitariste quasiment dénudé du premier plan. Ramelli décline ainsi dans son art de la photographie les multiples facettes du drame et du *soap opera* à l'américaine. C'est l'imagerie hollywoodienne qui, en premier lieu, a éduqué l'œil du photographe[6]. Producteur de cinéma, Ramelli conçoit d'ailleurs ses photographies comme des affiches de films. En ce sens, ses images acquièrent la « part communicationnelle » du poster, véhicule rempli de signes, de références, de « contenu explicite ». L'escalier de secours métallique, imposé par une loi de 1840 et qui orne les immeubles historiques de la ville, est l'un de ces éléments signifiants. Serge Ramelli se régale de cette modénature de fer, archétype du progrès et de la rationalisation à l'américaine, lorsqu'il prend en photographie la façade d'une boutique sur Broome Street, non loin de Broadway. Zigzag de métal, l'escalier représenté, forgé à la manière d'un éclair, rappelle l'affiche de la comédie musicale *West Side Story*. Ramelli célèbre ici le fameux « *I like to be in America*[7] » chanté par les comédiens. Dans cette image, le photographe immortalise le flamboiement illusoire d'un mode de vie basé sur le crédit, les « petits prix » et la « machine à laver ». Cela est particulièrement visible dans les images de Brooklyn conçues par le photographe comme des odes au western urbain de Sergio Leone, *Il était une fois en Amérique*. Pour preuve, cette photographie du Manhattan Bridge prise dans le DUMBO[8], avec les immeubles de briquettes rouges se répondant dans une parfaite symétrie, entre lesquels Noodles, la petite frappe malingre du film de Leone, fait ses premières gammes de futur *boss* de New York. Mais c'est peut-être dans les images de la statue de la Liberté, du Flatiron Building et de Central Park que se lit le mieux l'amour que porte le photographe au septième art. Sous sa houlette, ces monuments incontournables du cinéma américain deviennent de véritables *motifs*. Une prouesse qui réunit en chacune des images le large spectre de la production hollywoodienne, de *Godzilla* (1998) à *Cinquième Colonne* (1942) en passant par *La Planète des singes* (1968) et *Un amour à New York* (2001).

Harold Hinsinger

[2] Ce plan cadastral imposa à l'île de Manhattan, à partir de la 13e rue, la règle du plan en échiquier, délimitant ainsi des « blocs » de rues se croisant à angle droit.
[3] Le Cervin et la dent Blanche sont deux sommets des Alpes ; le Crazy Peak se situe dans la chaîne des Rocheuses, aux États-Unis.
[4] Équivalent du creuset français, l'idéologie du *melting-pot* veut que tout immigré arrivant sur le sol des États-Unis « fonde » sa culture d'origine dans celle de son pays d'accueil, avec pour référent la Déclaration des droits américaine, la United States Bill of Rights.
[5] Le financier est une pâtisserie française à base de poudre d'amandes, autrefois connue sous le nom de visitandine.
[6] Des films tels qu'*Autant en emporte le vent*, *Gladiator* ou *Gangs of New York*. Si Serge Ramelli s'inspire également des films de Luc Besson, c'est certainement parce qu'il s'agit peut-être du plus hollywoodien des réalisateurs français.
[7] « J'adore vivre en Amérique. »
[8] DUMBO est l'acronyme de Down Under the Manhattan Bridge Overpass, un quartier de Brooklyn situé sous le pont de Manhattan.

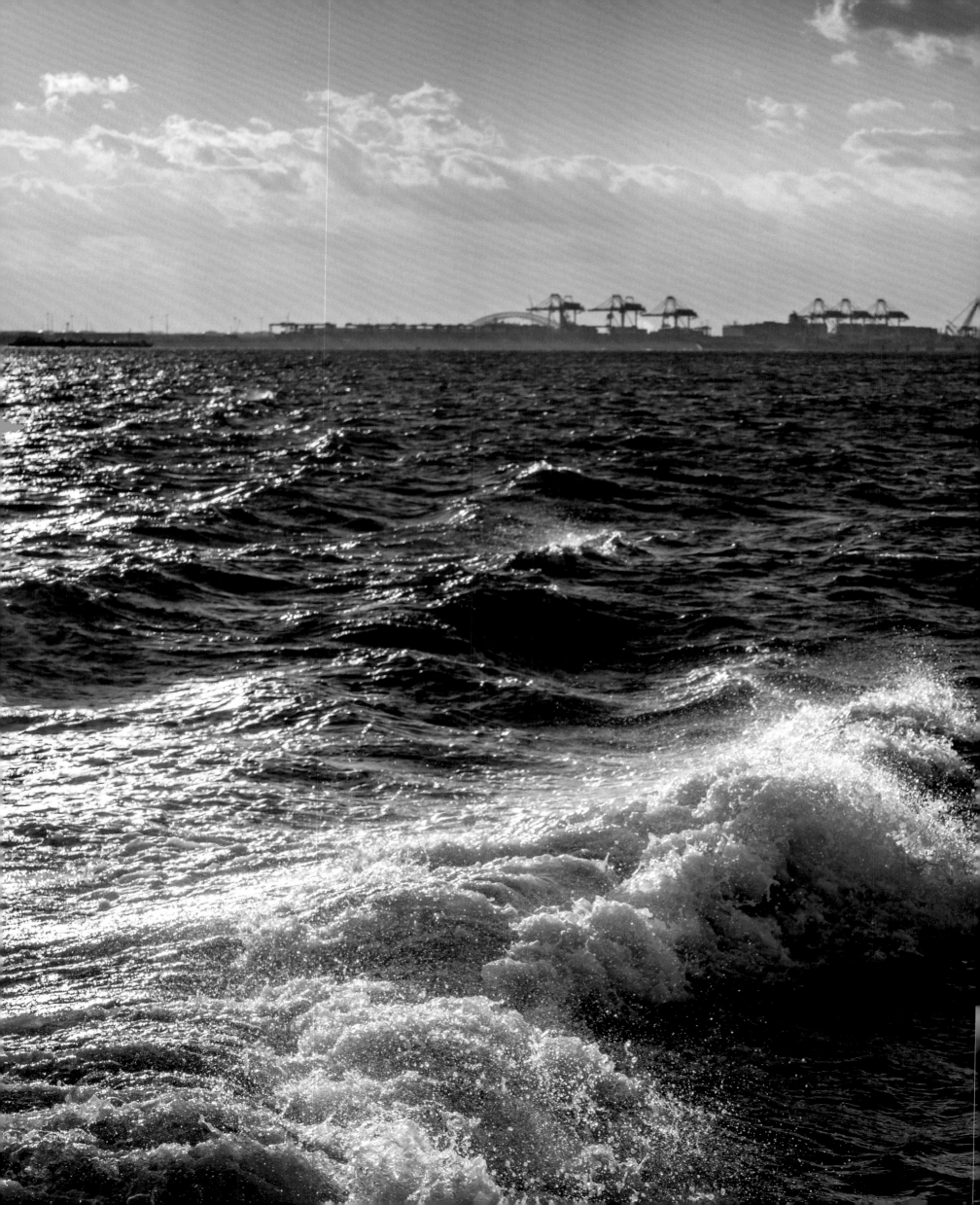

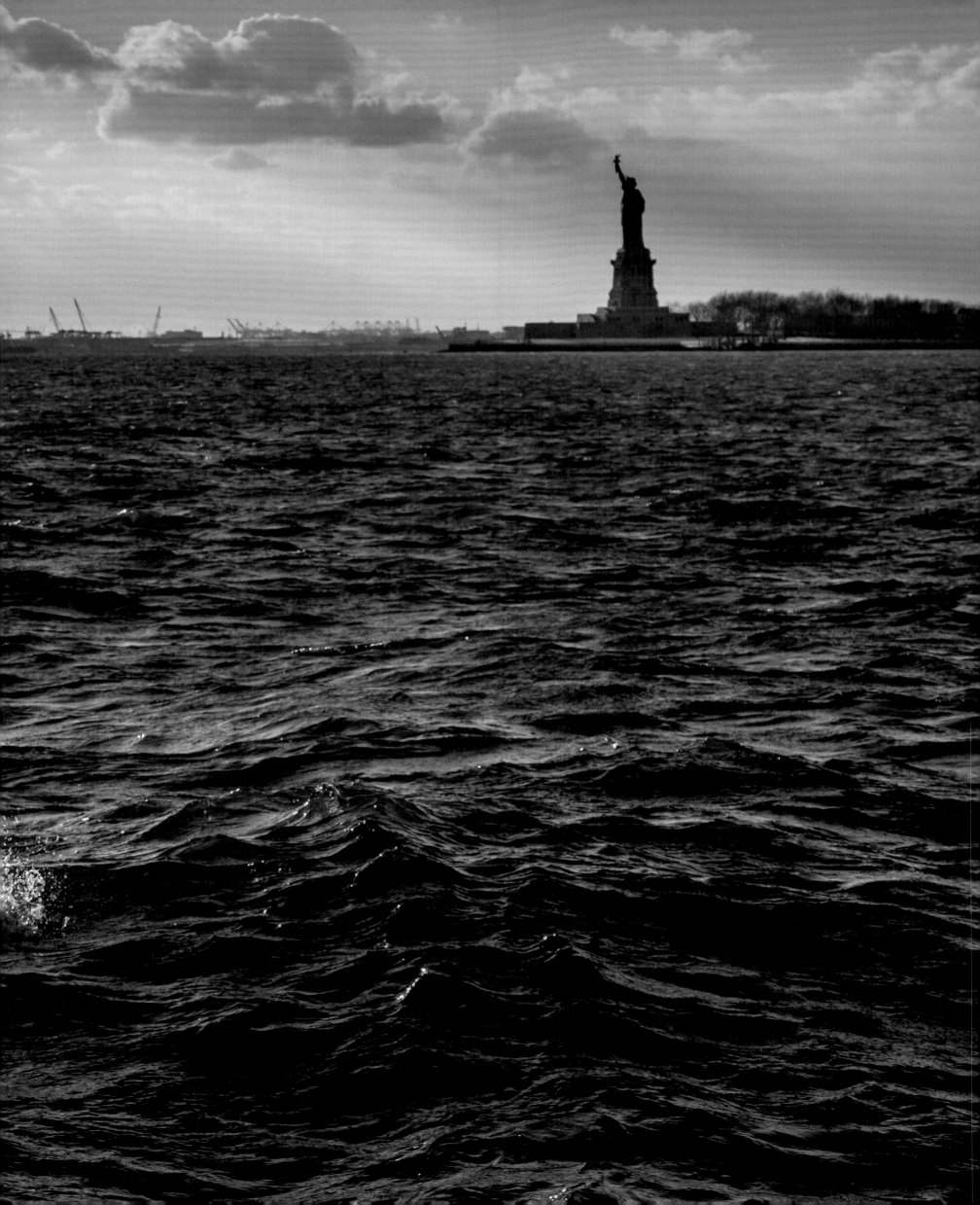

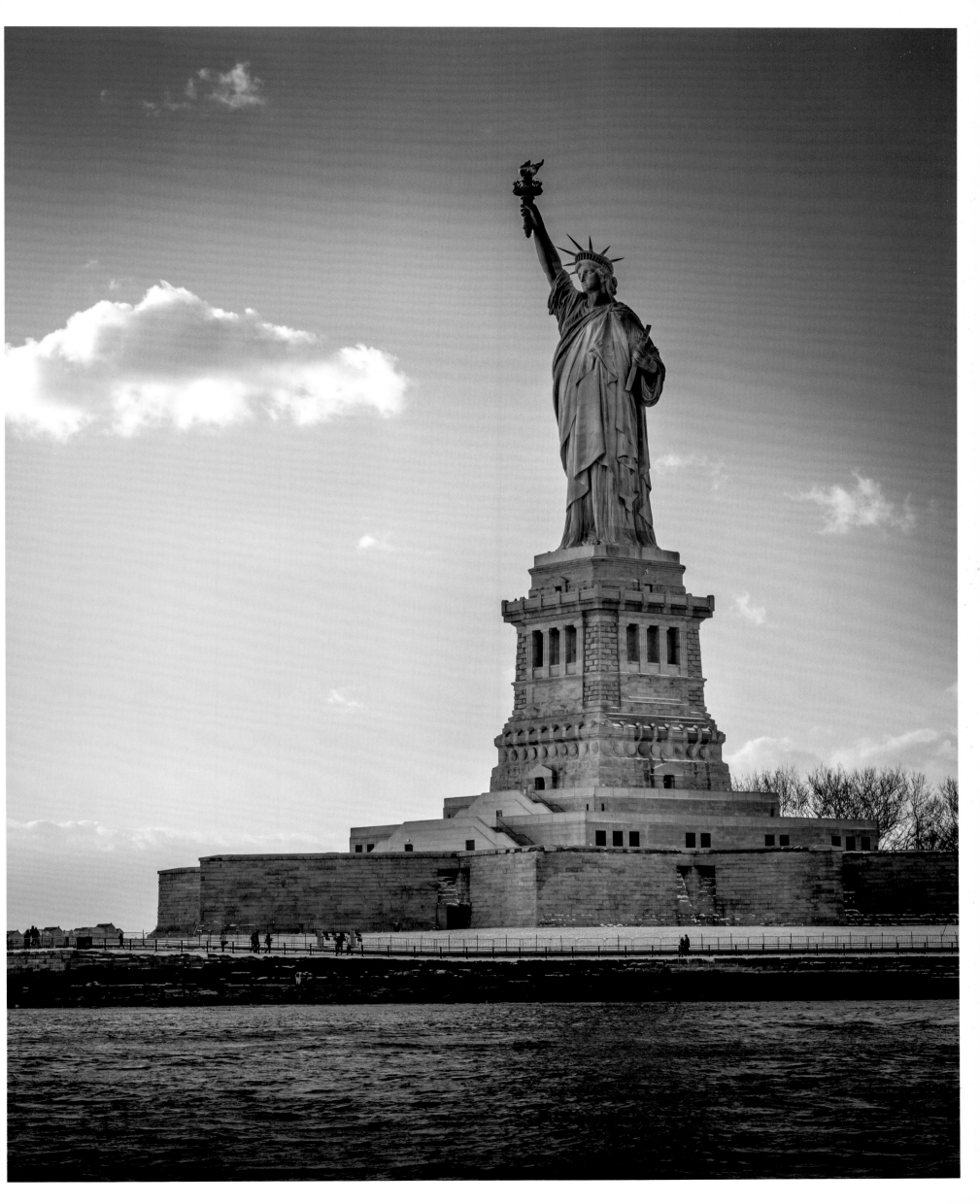

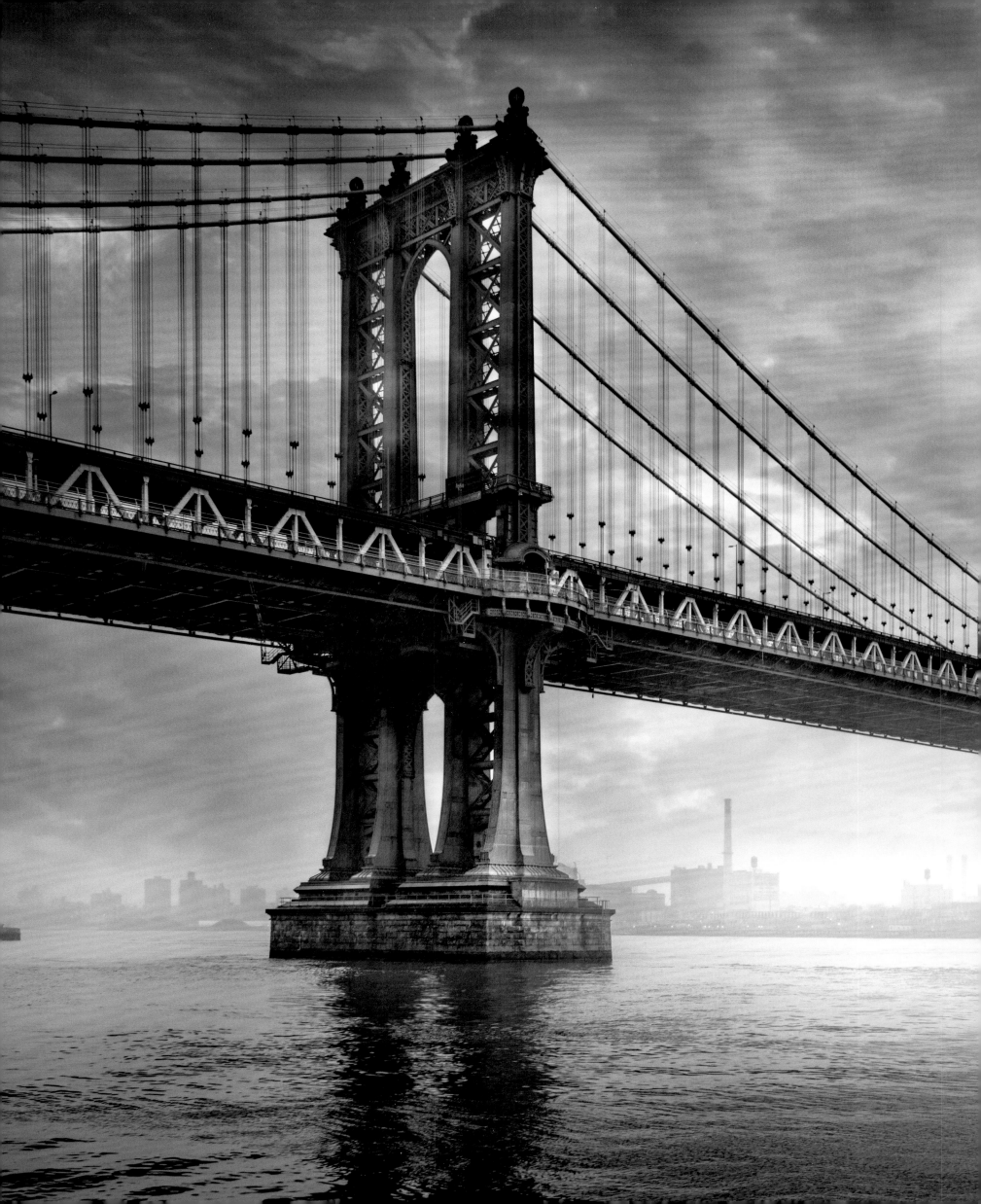

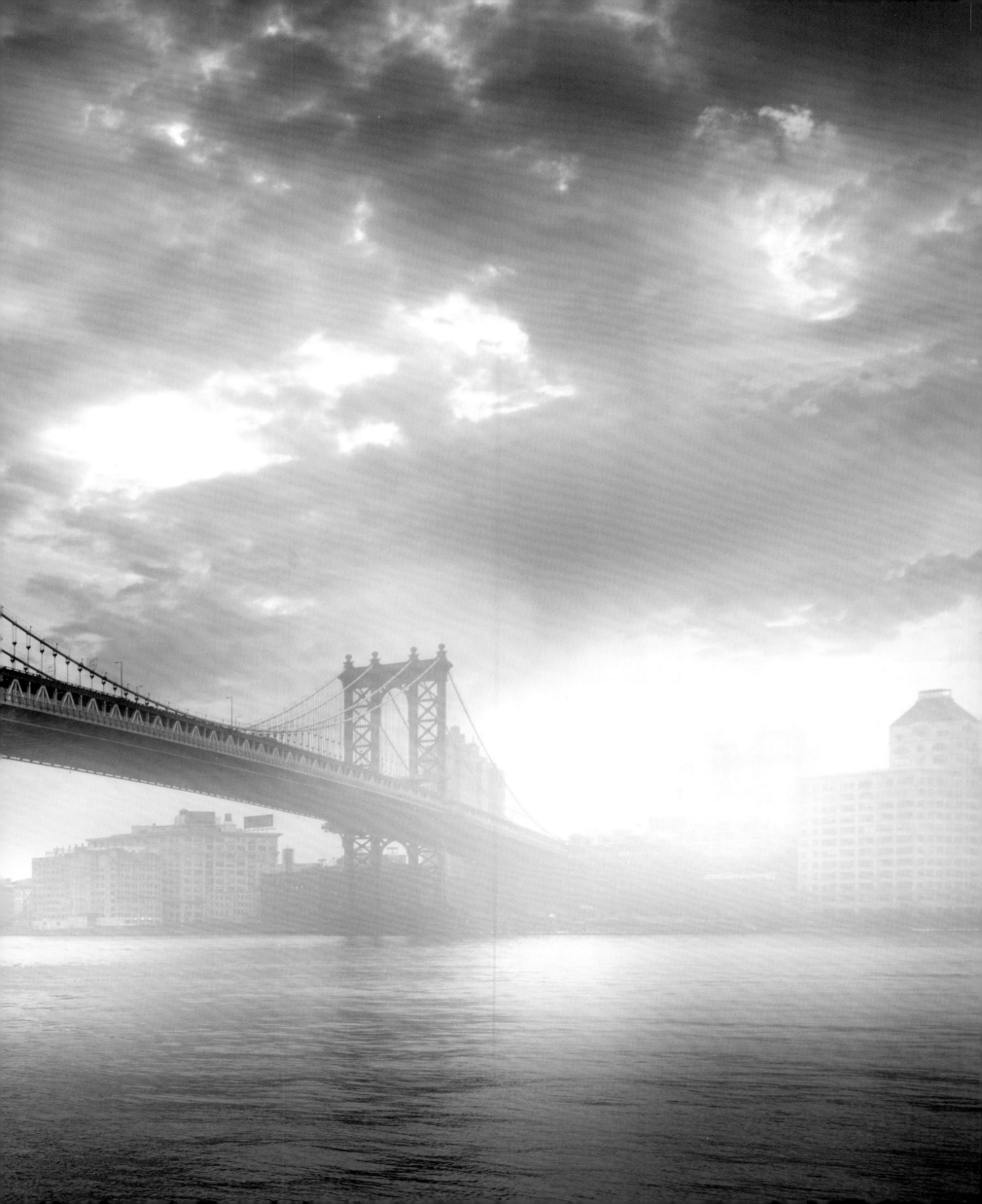

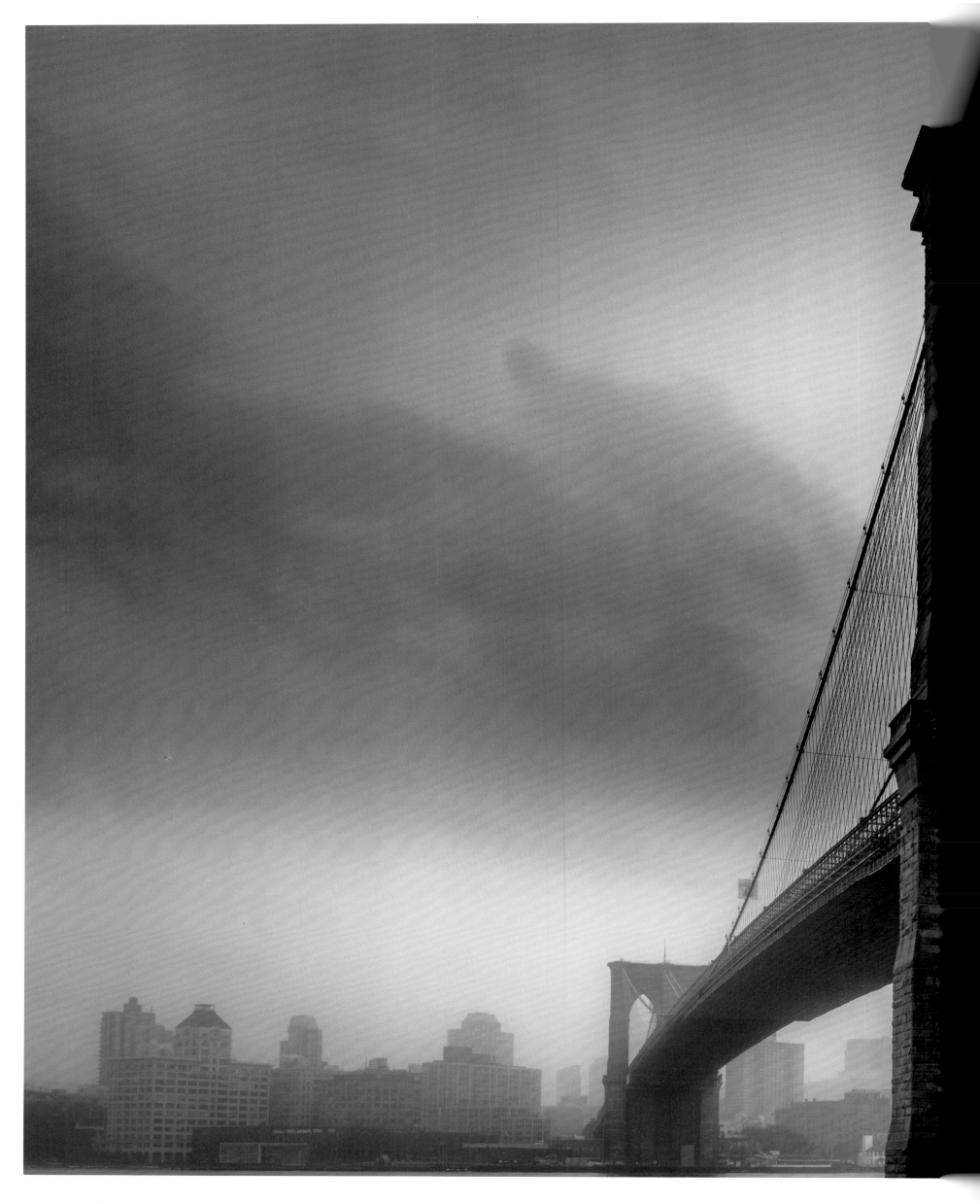

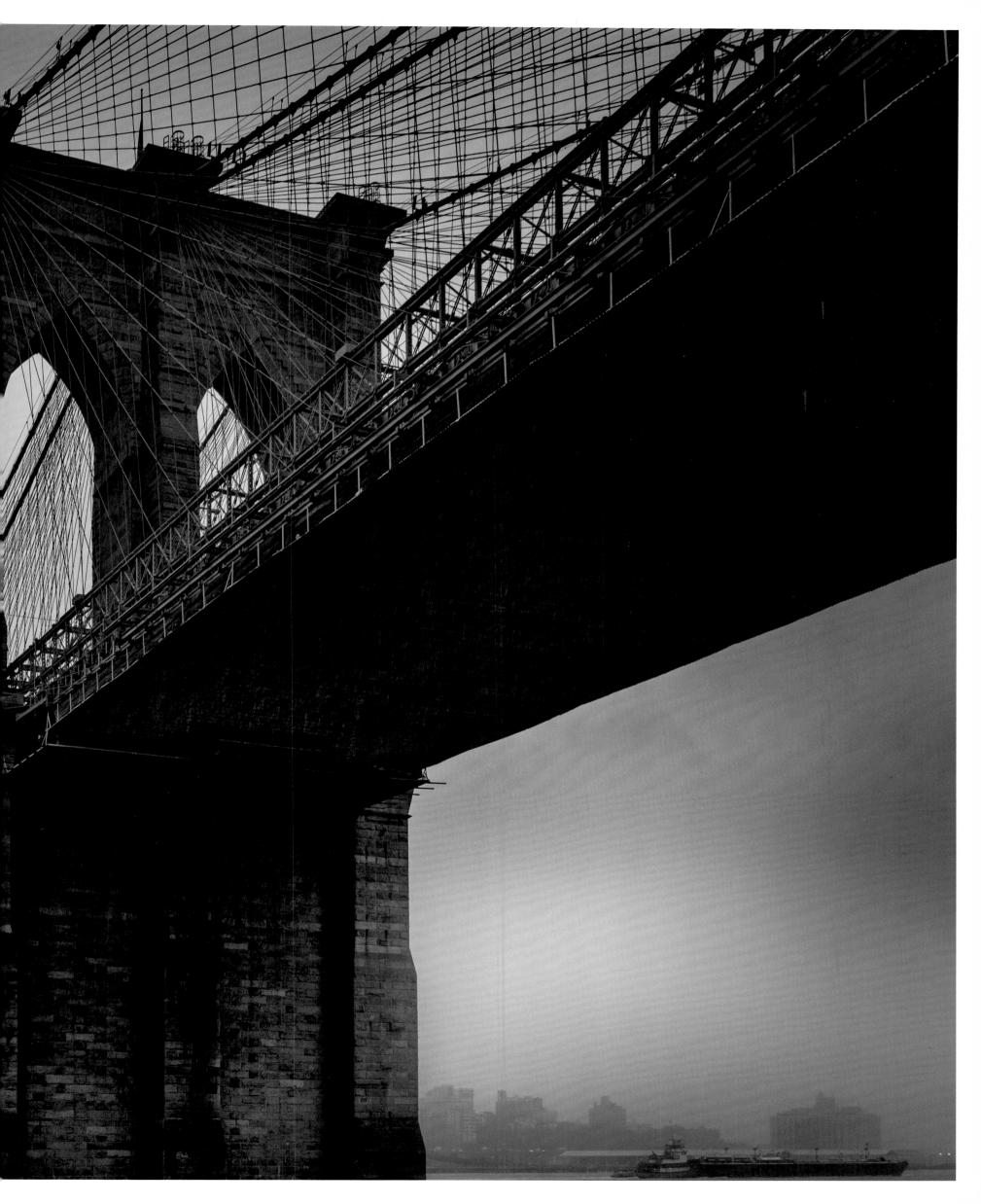

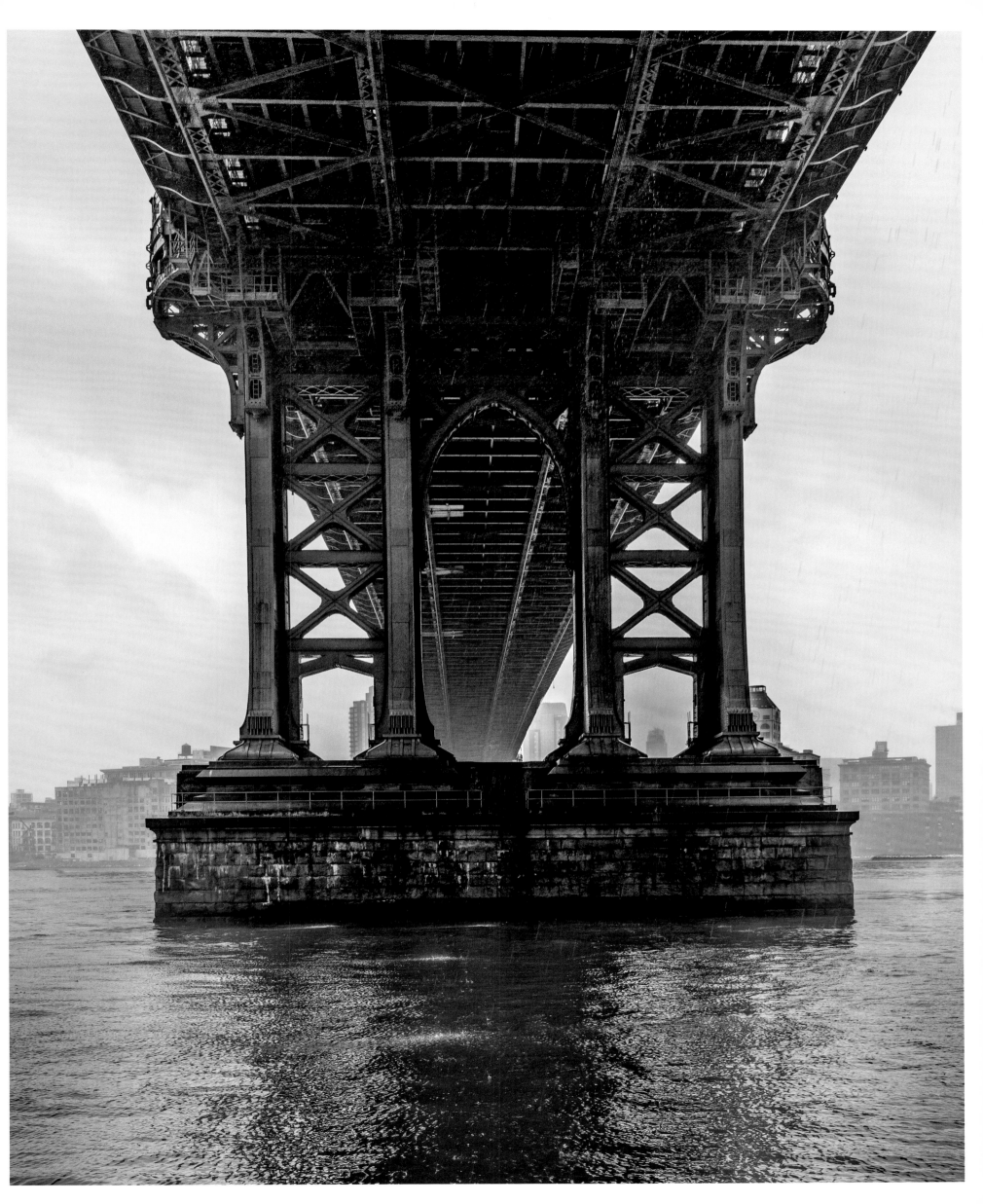

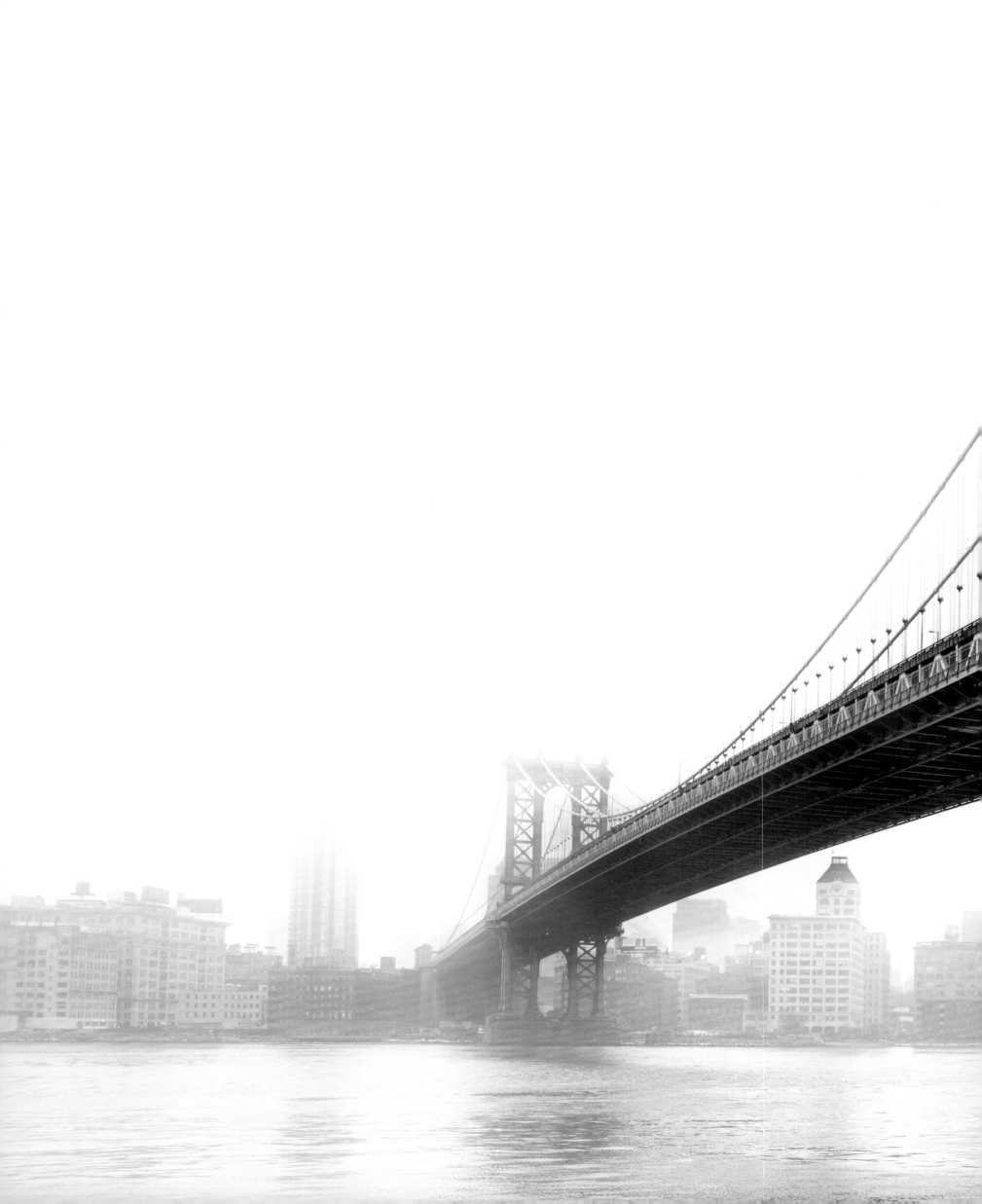

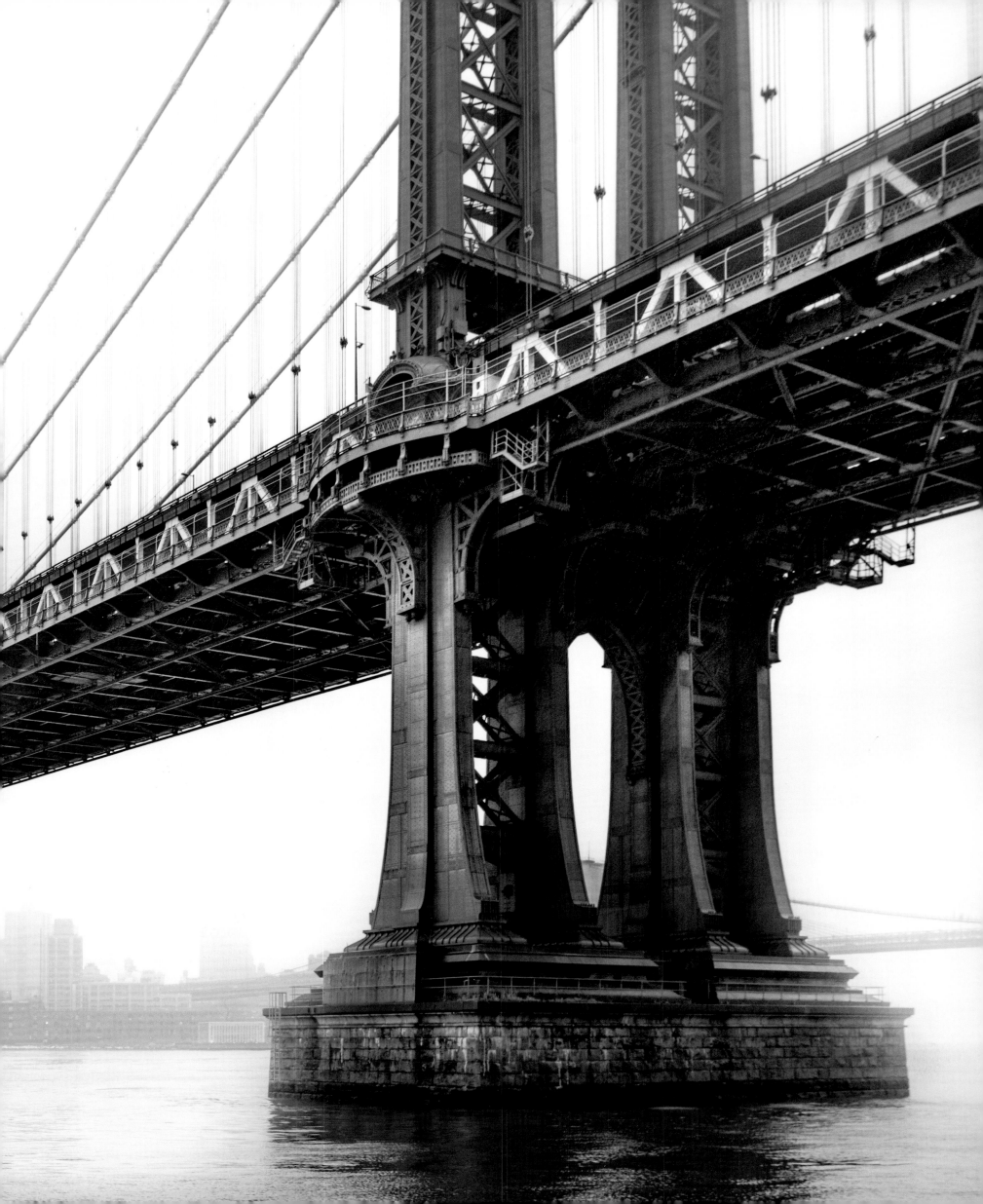

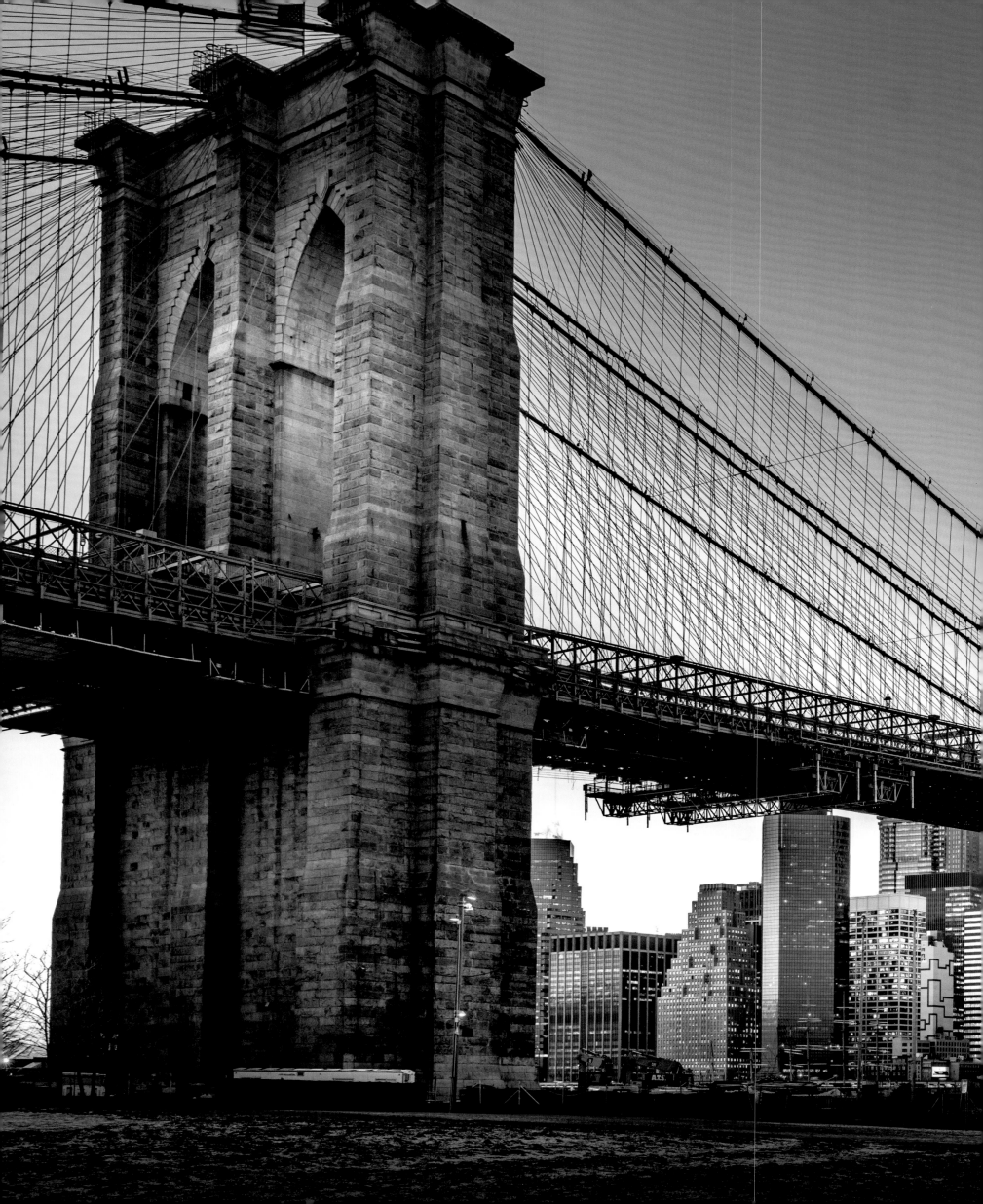

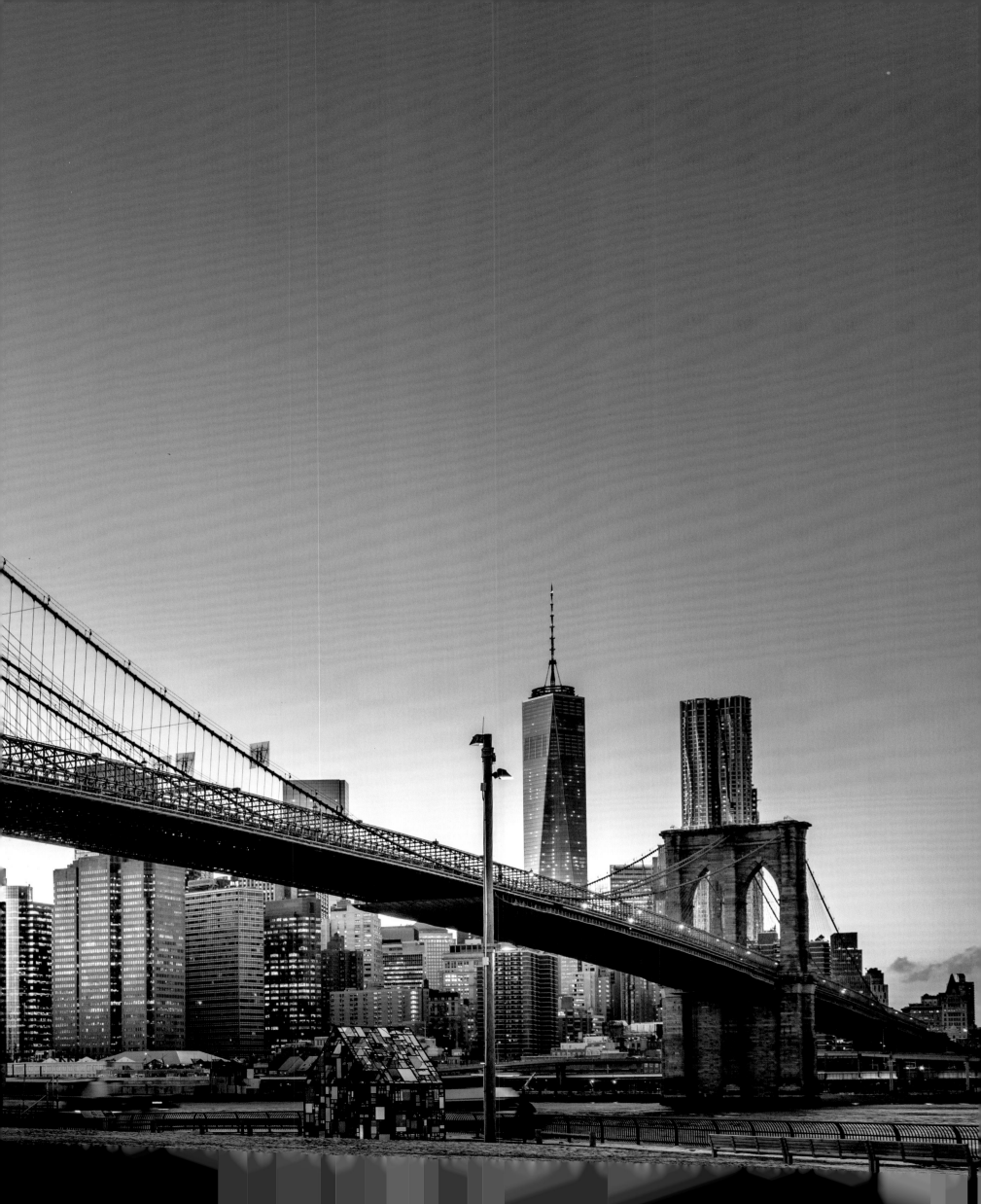

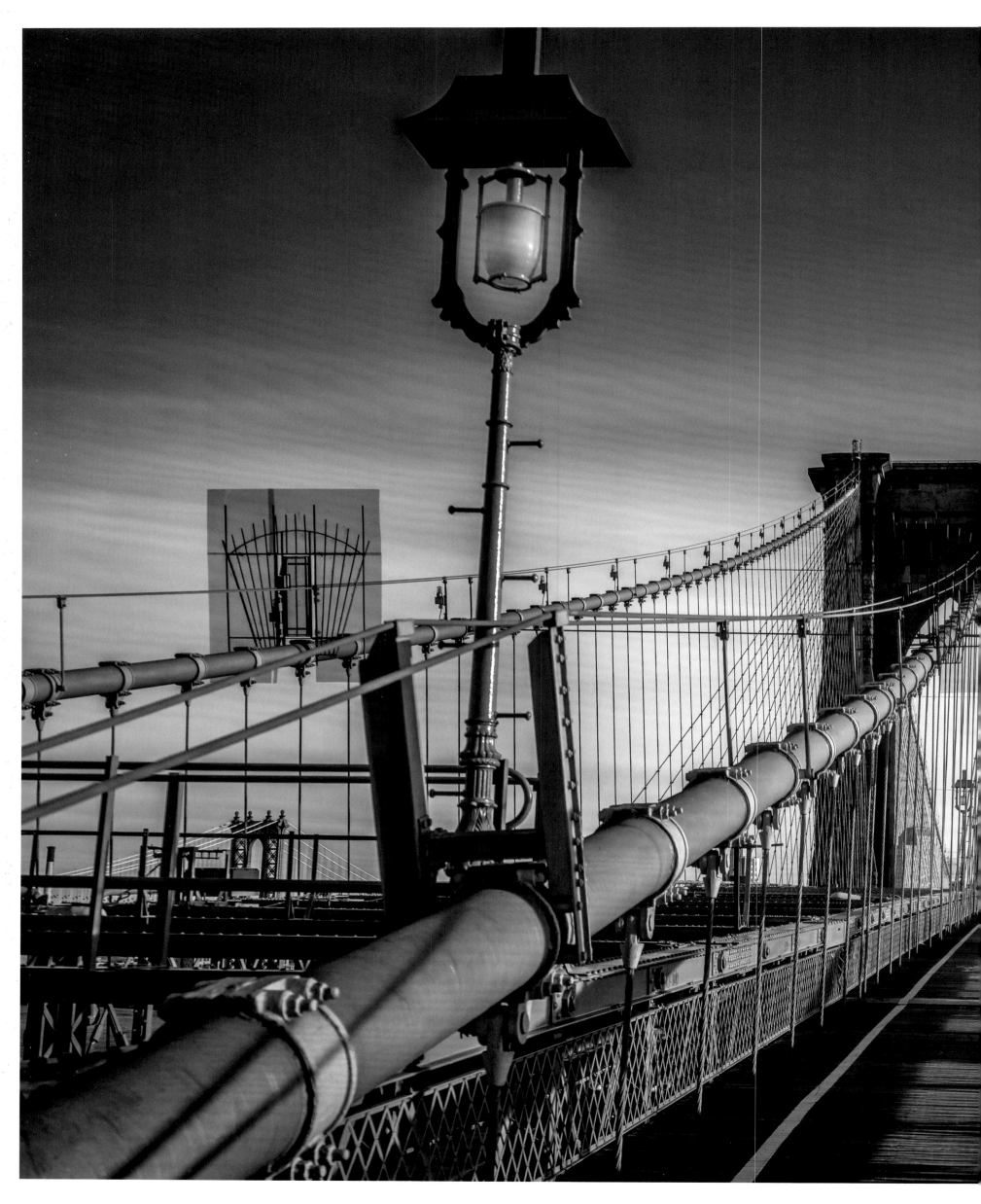

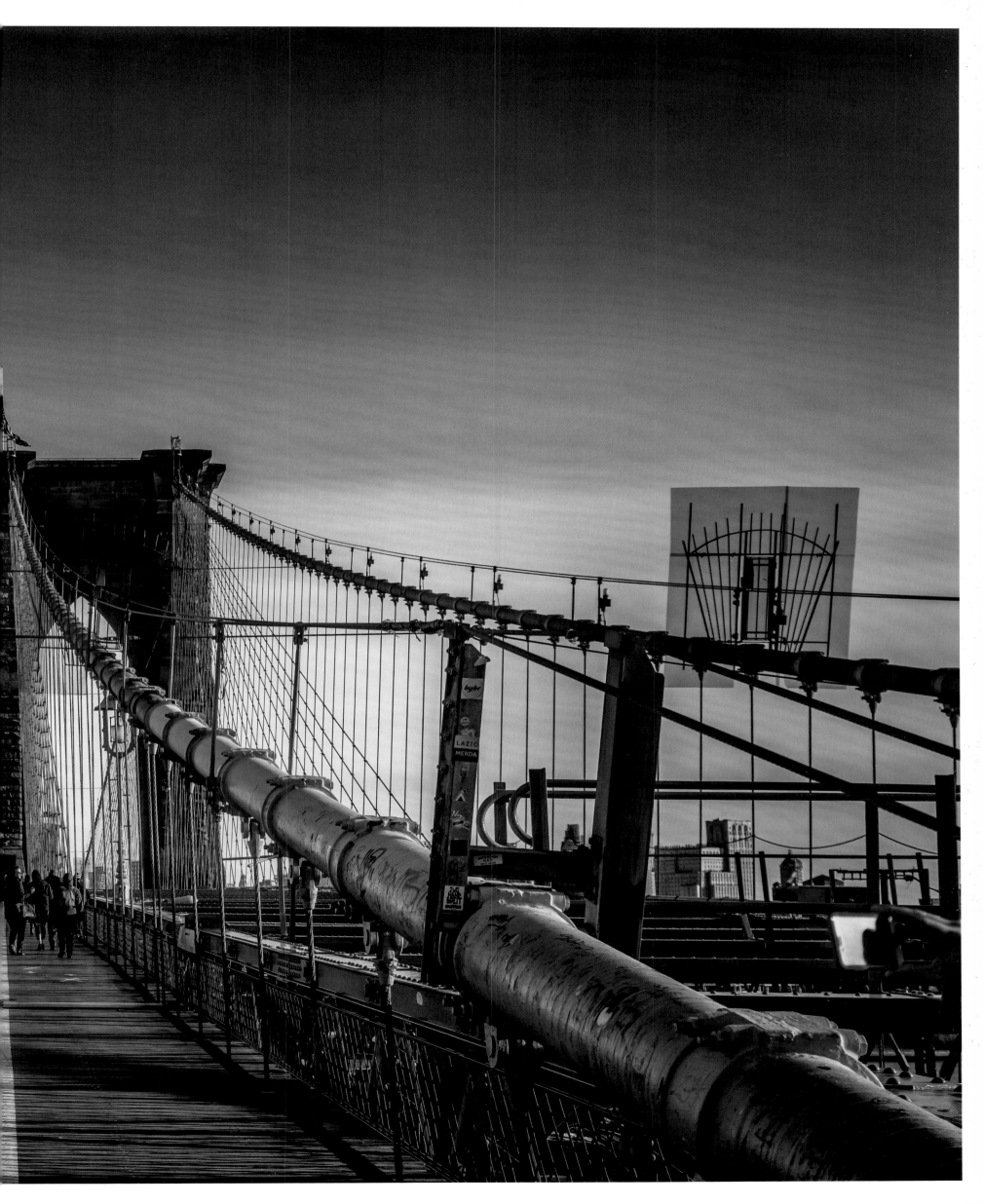

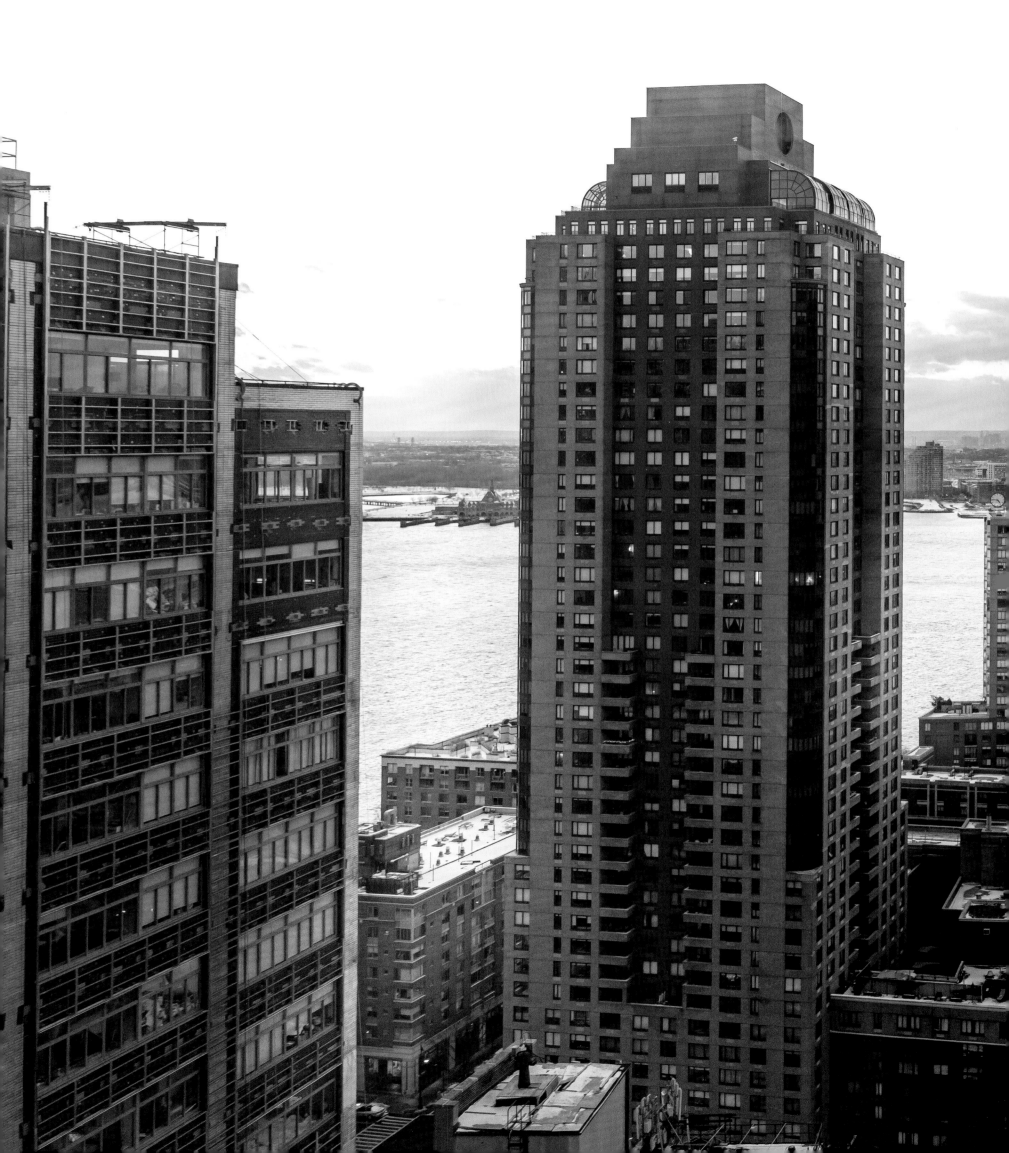

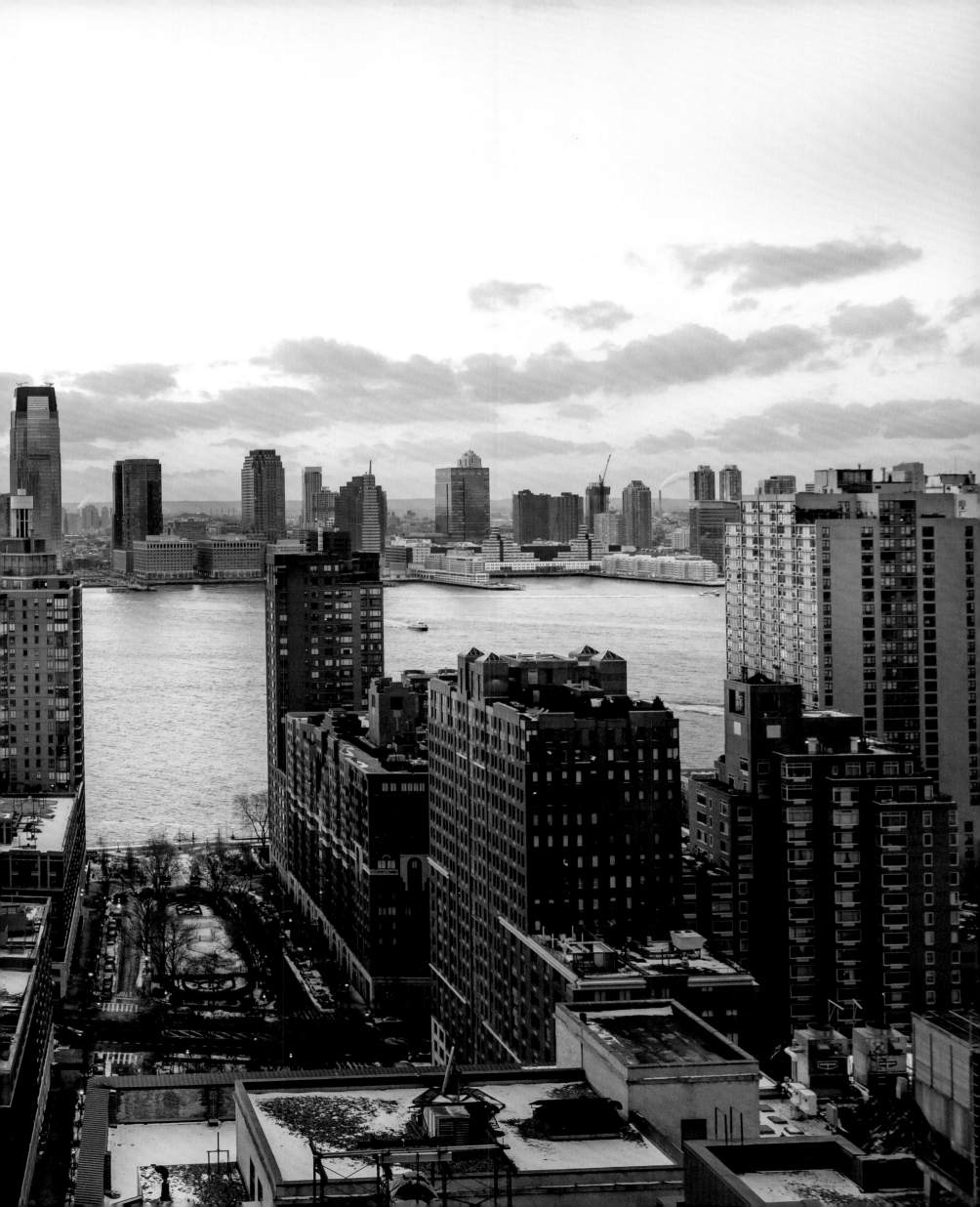

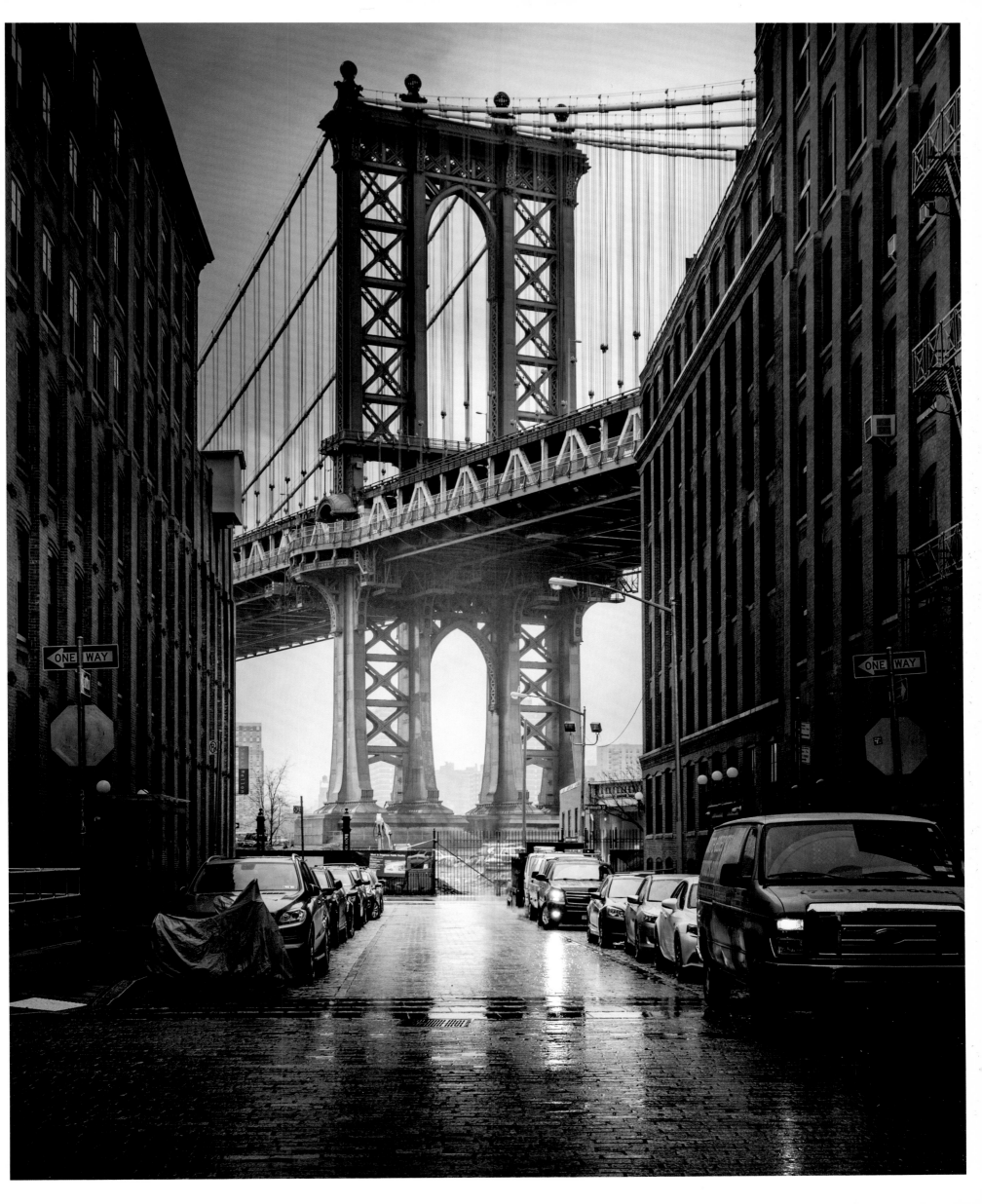

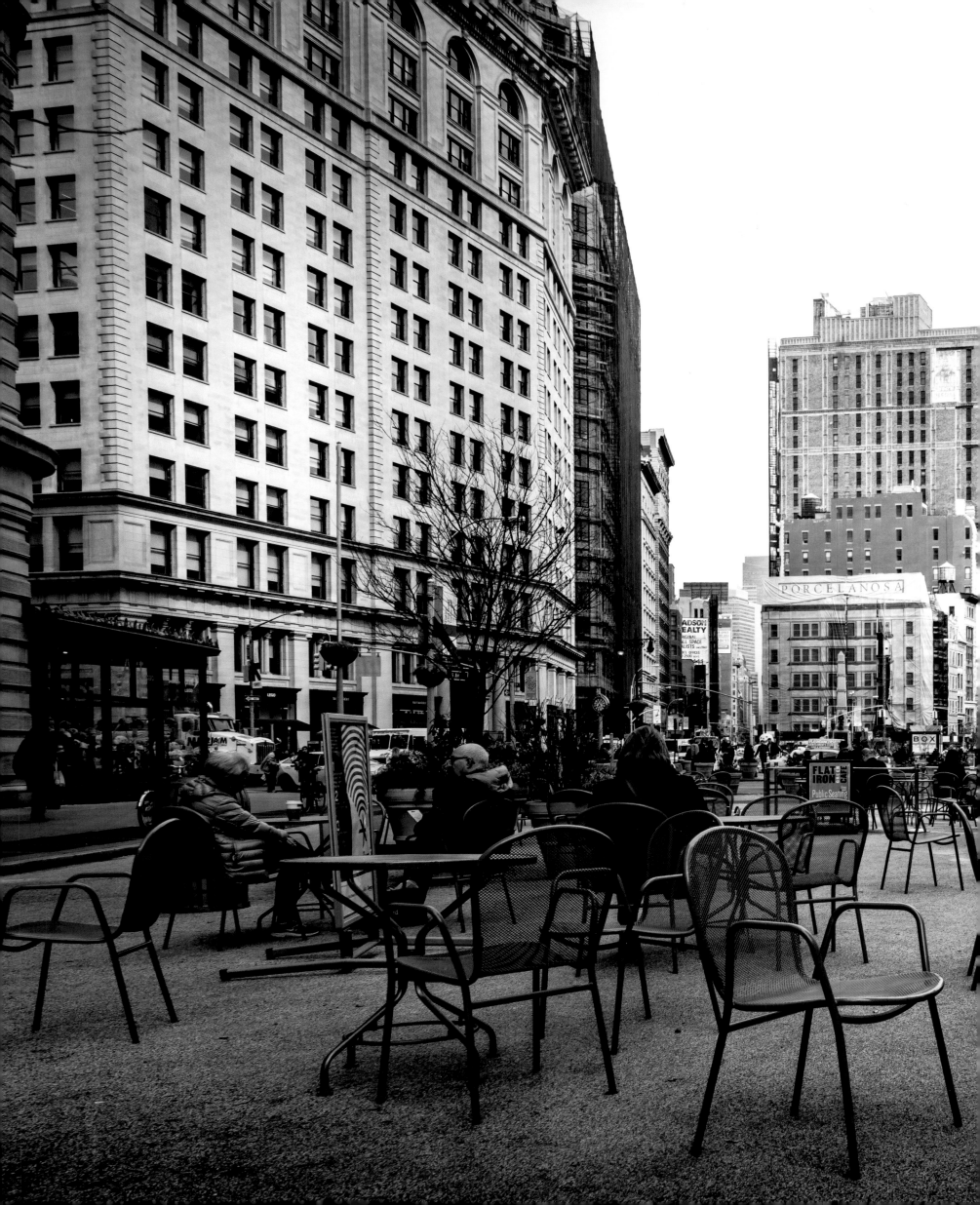

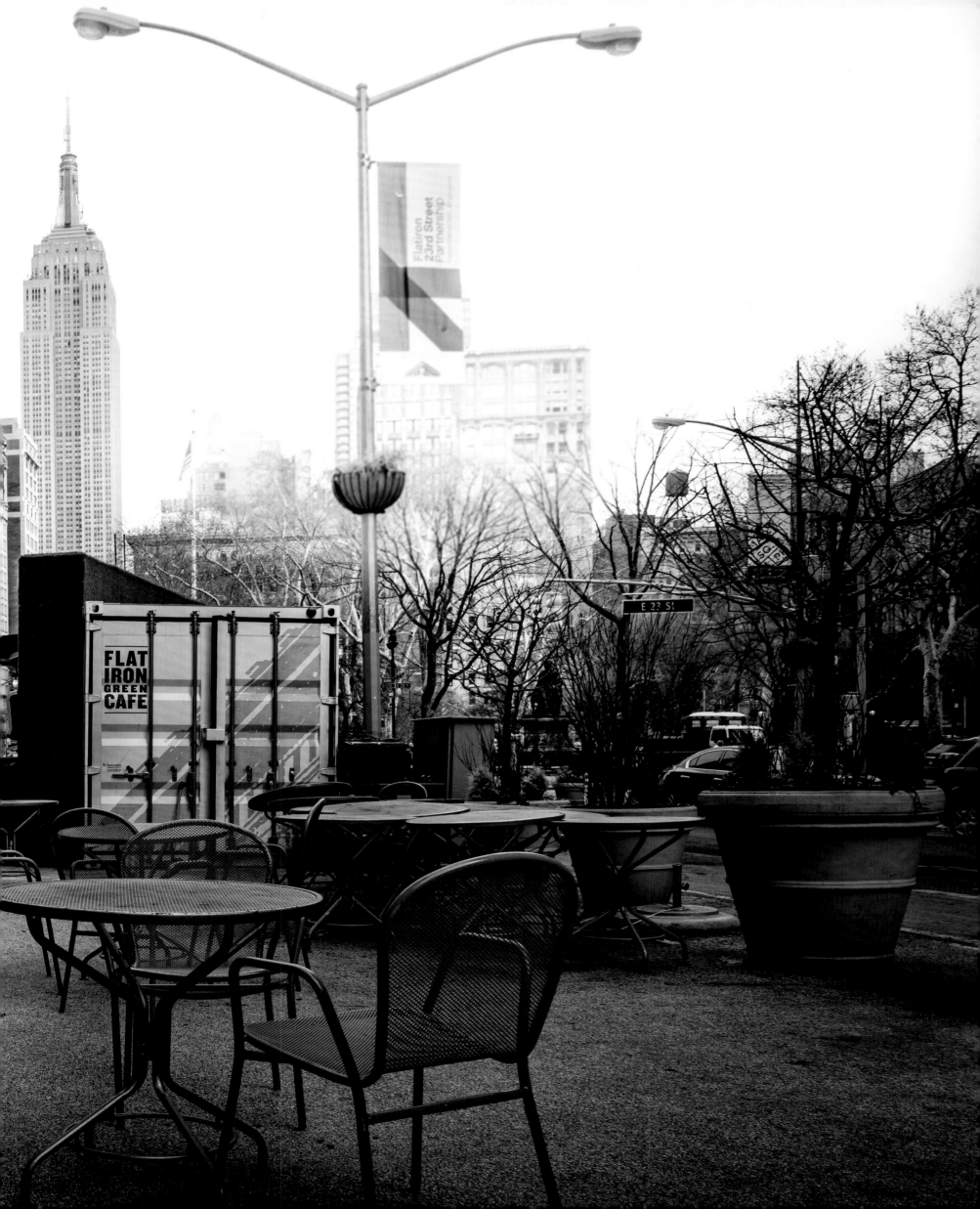

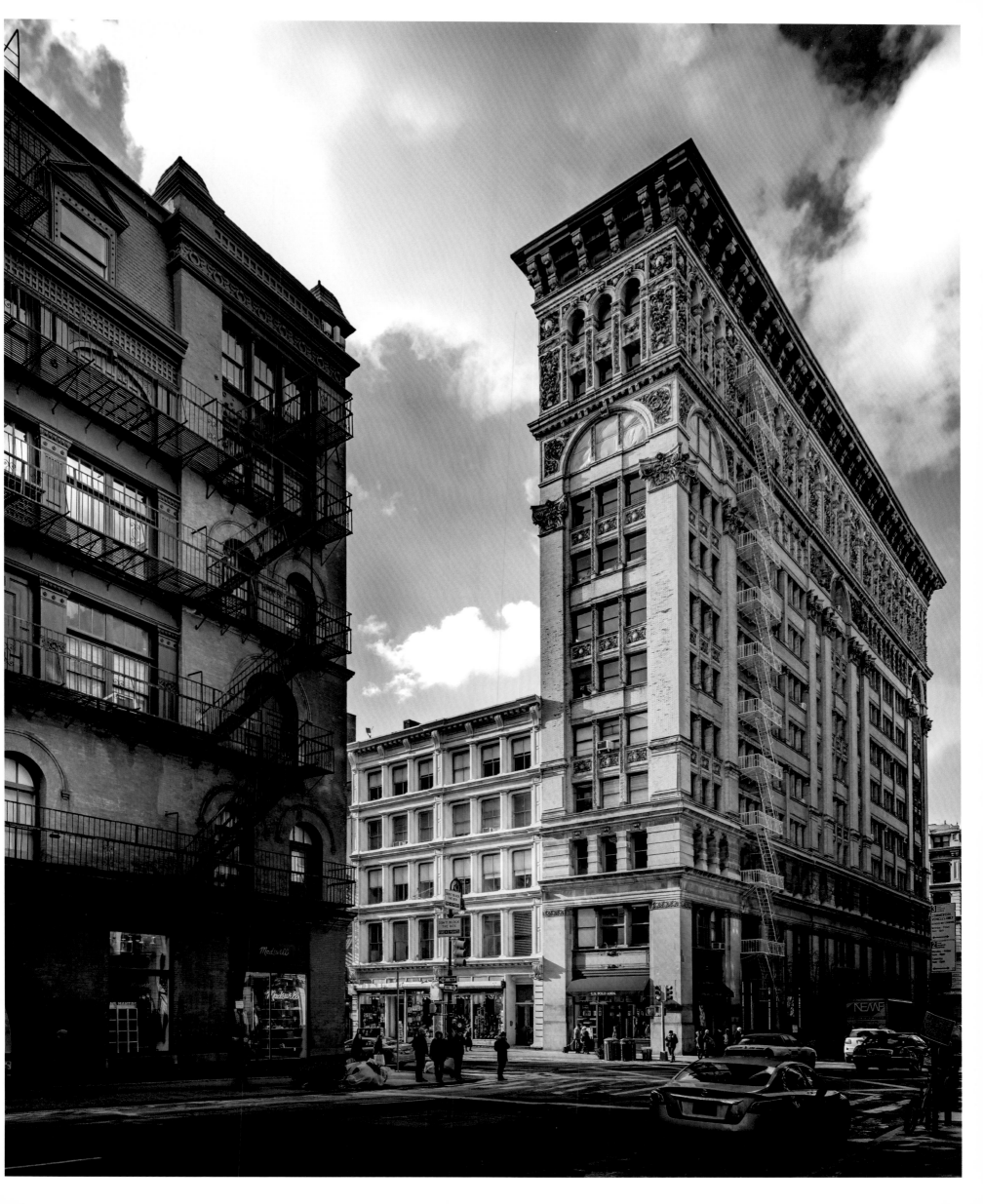

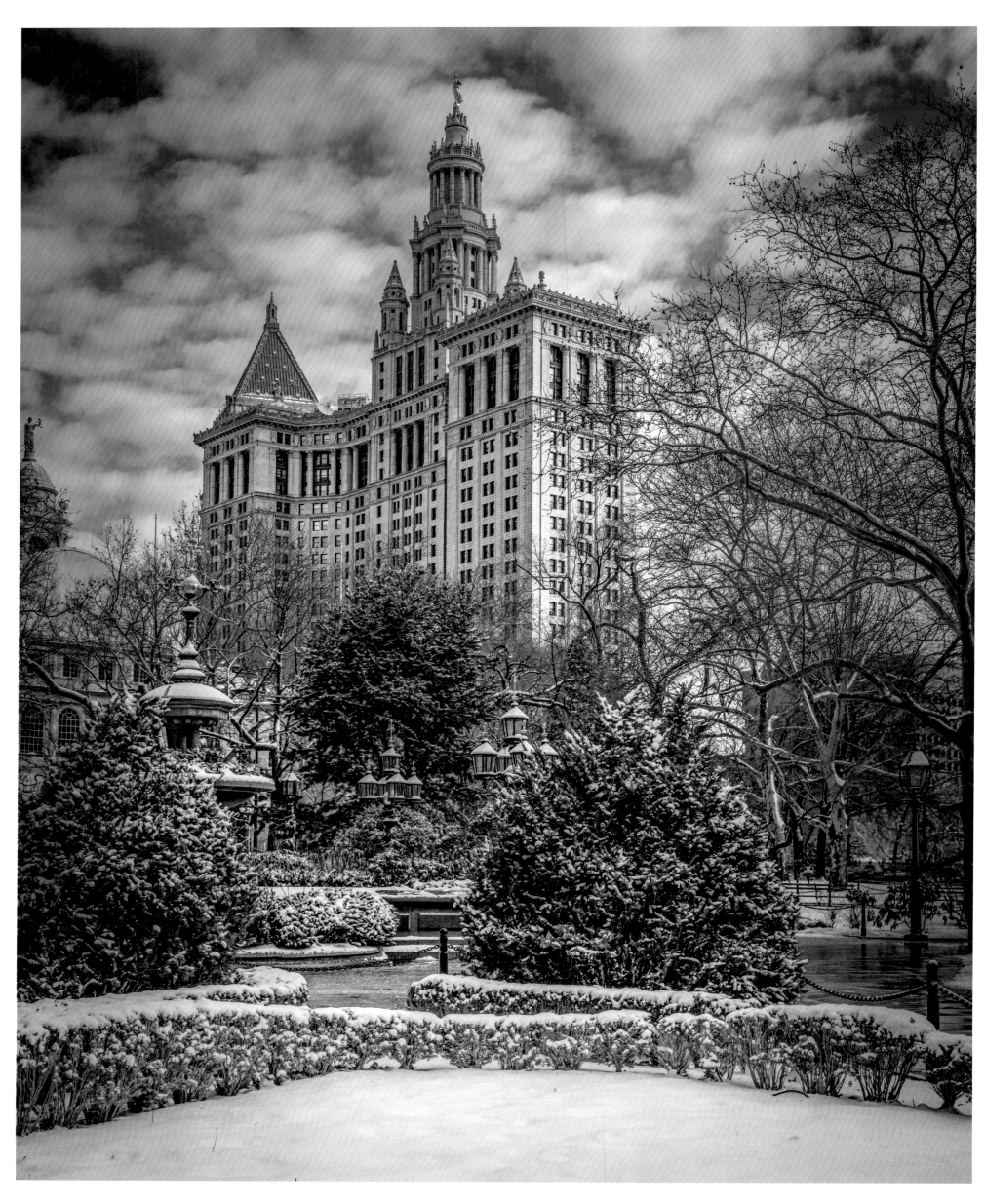

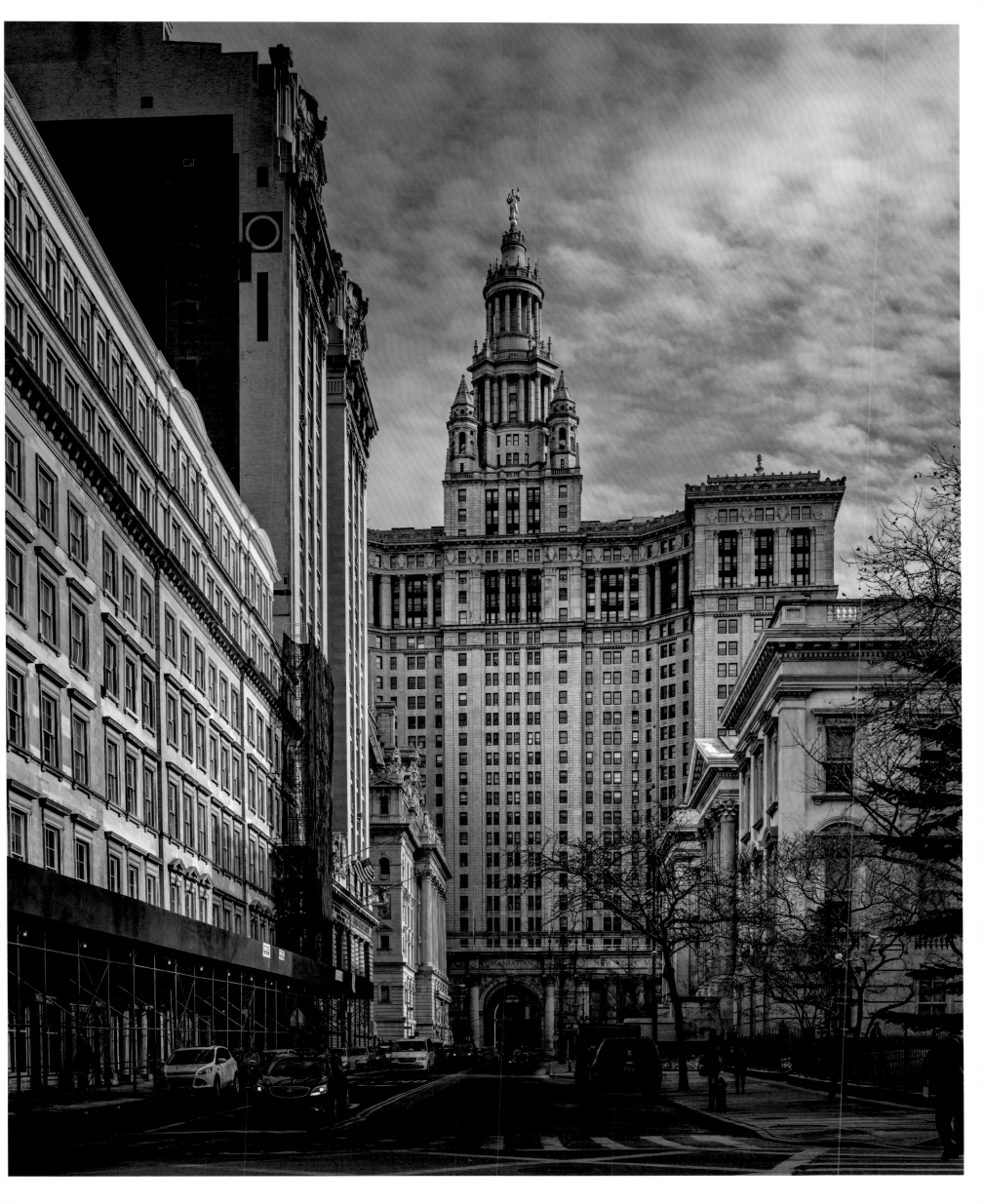

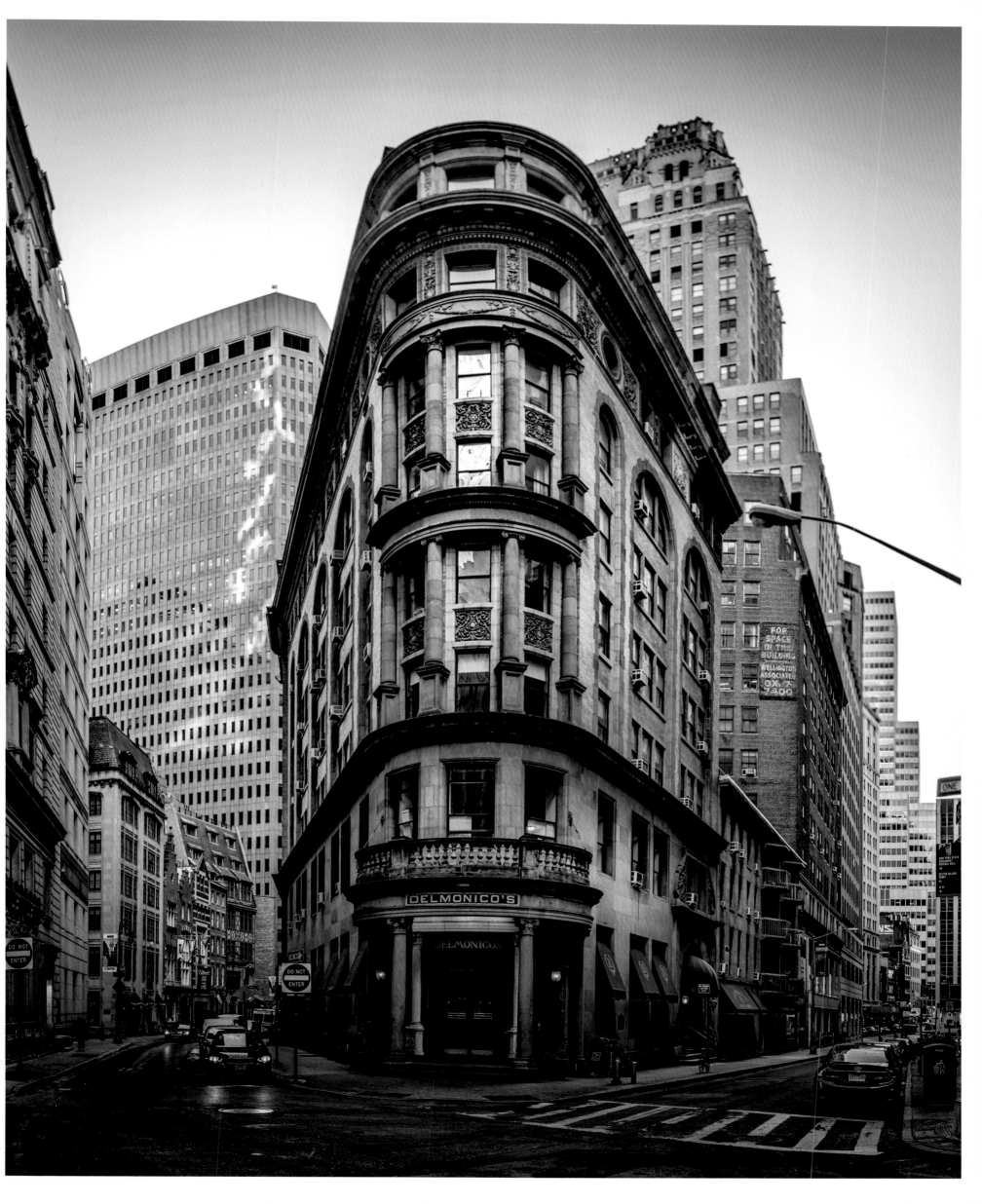

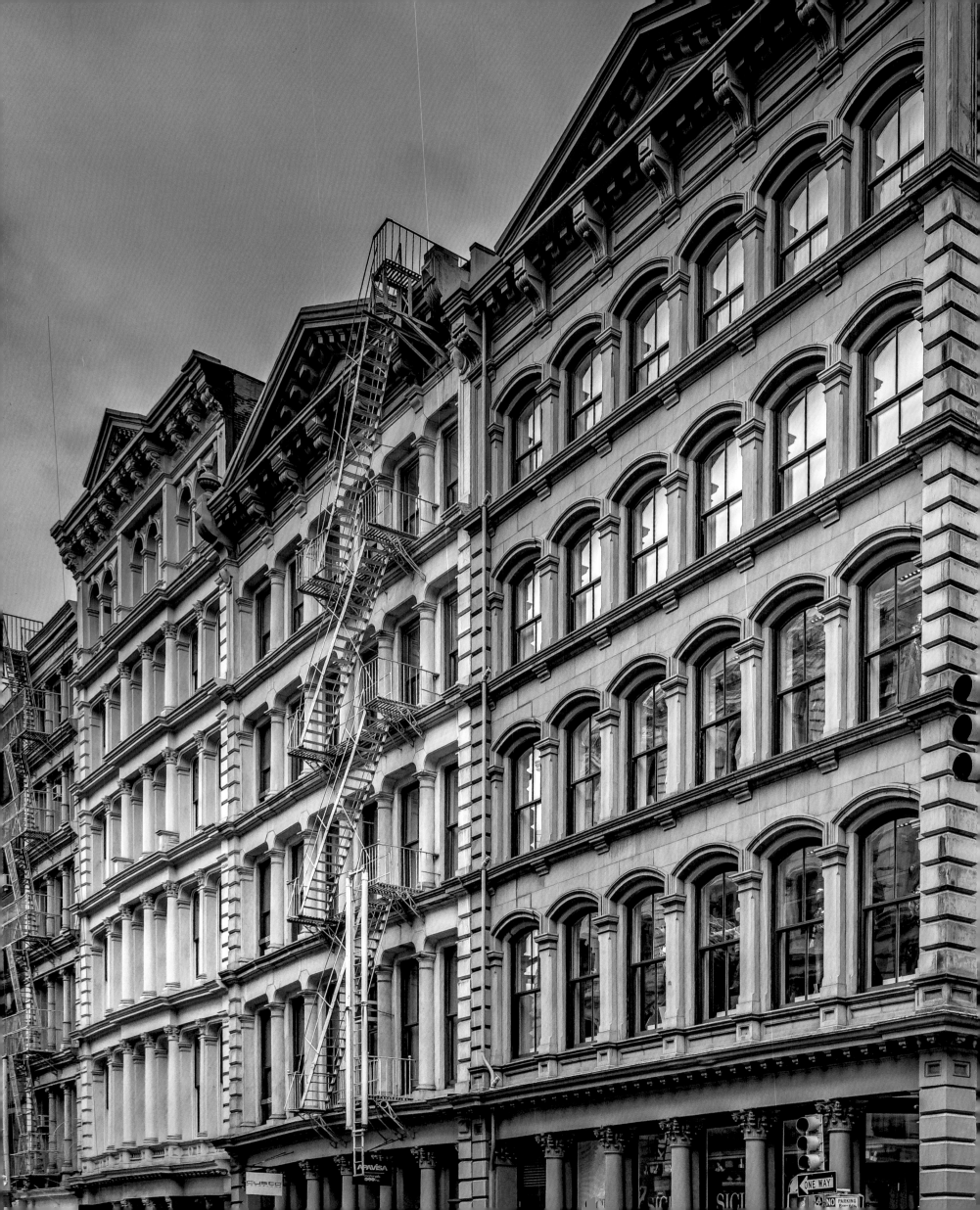

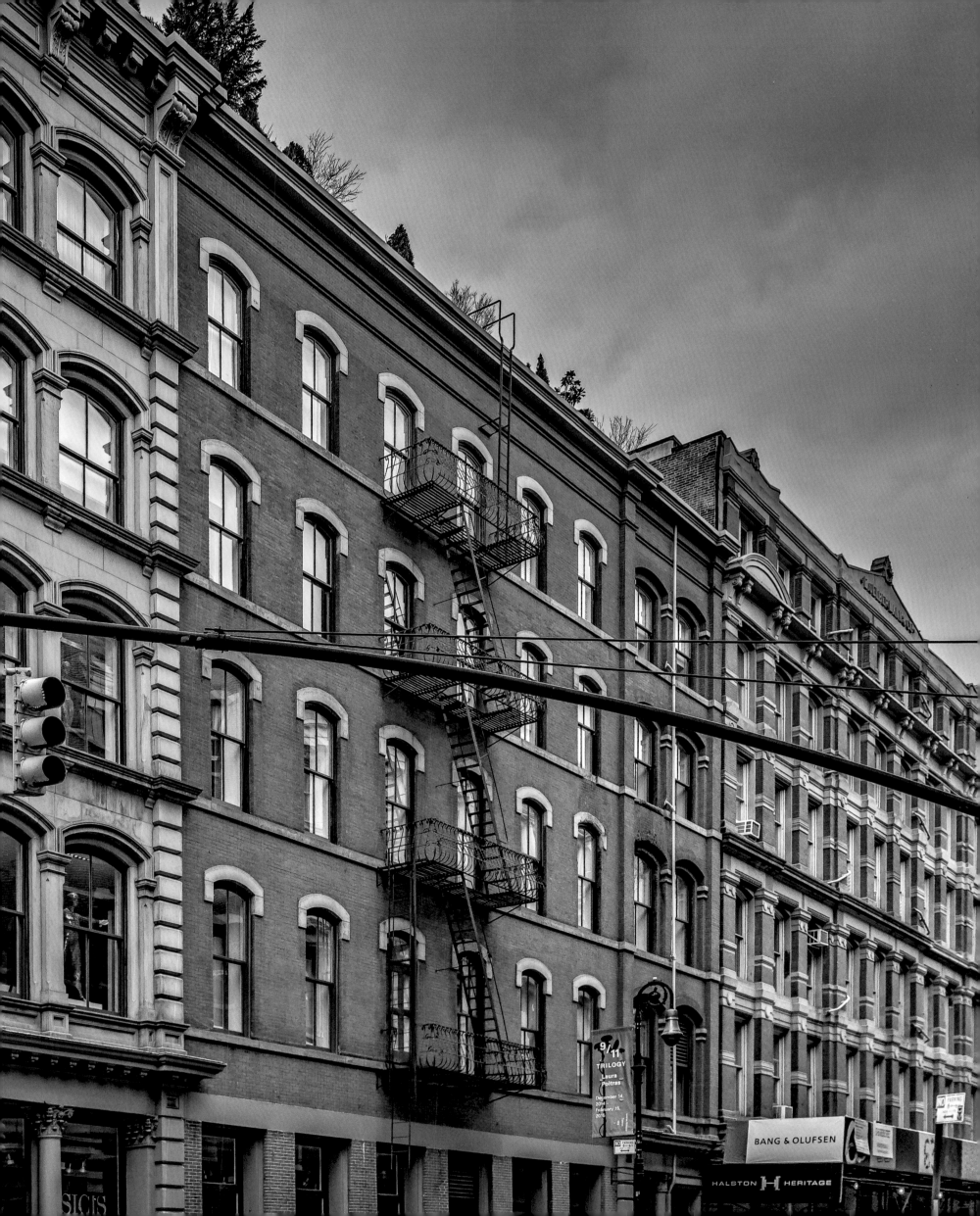

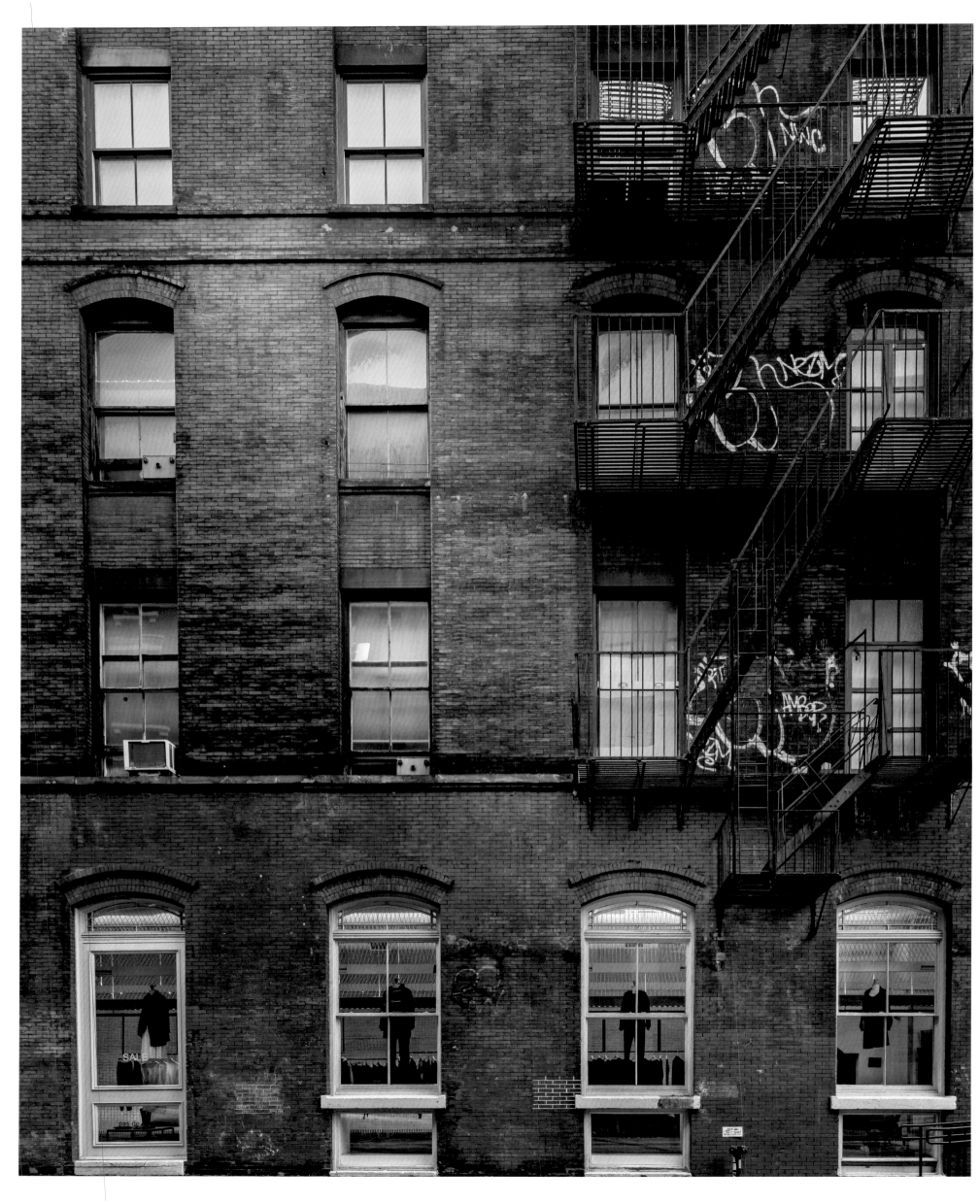

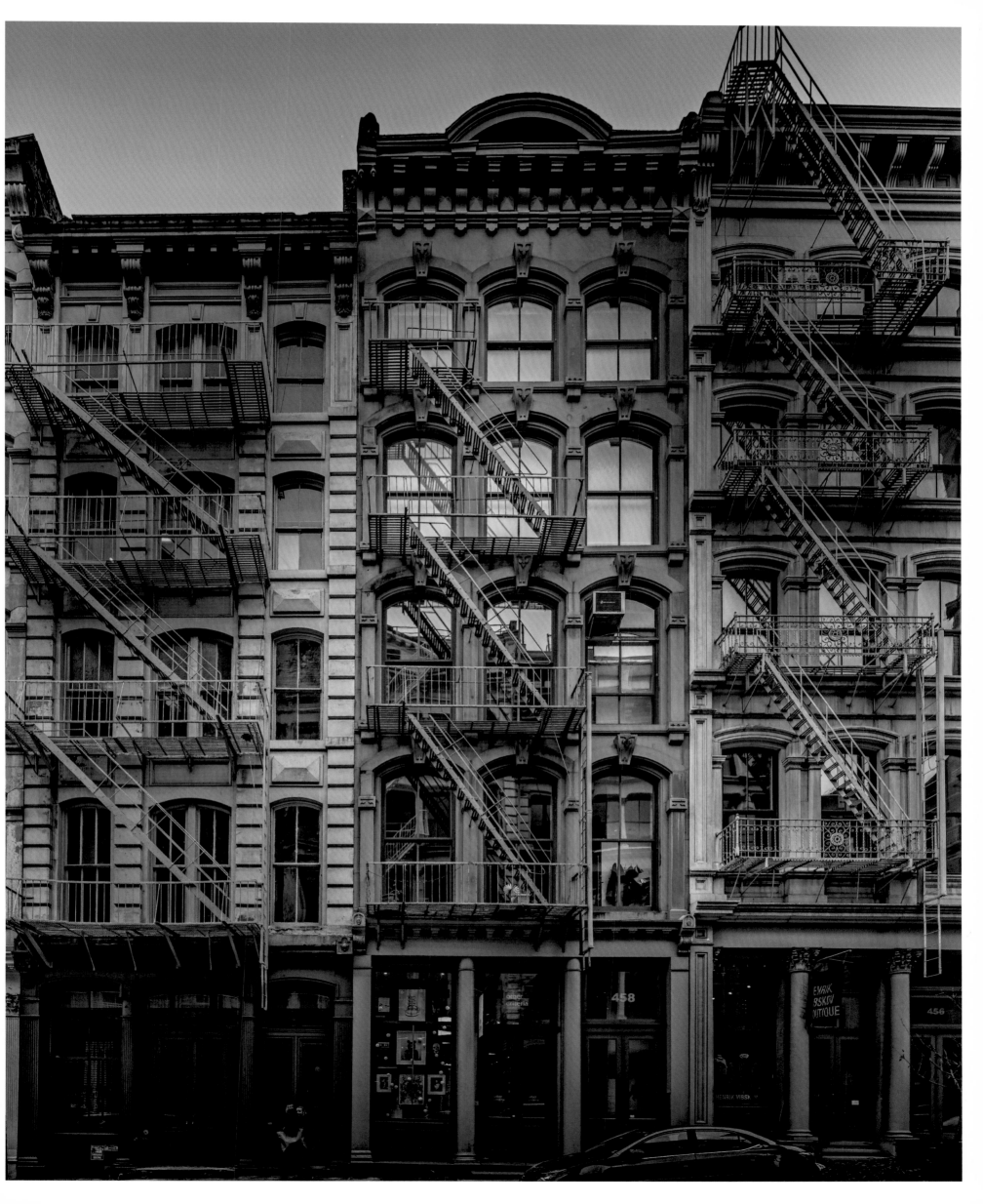

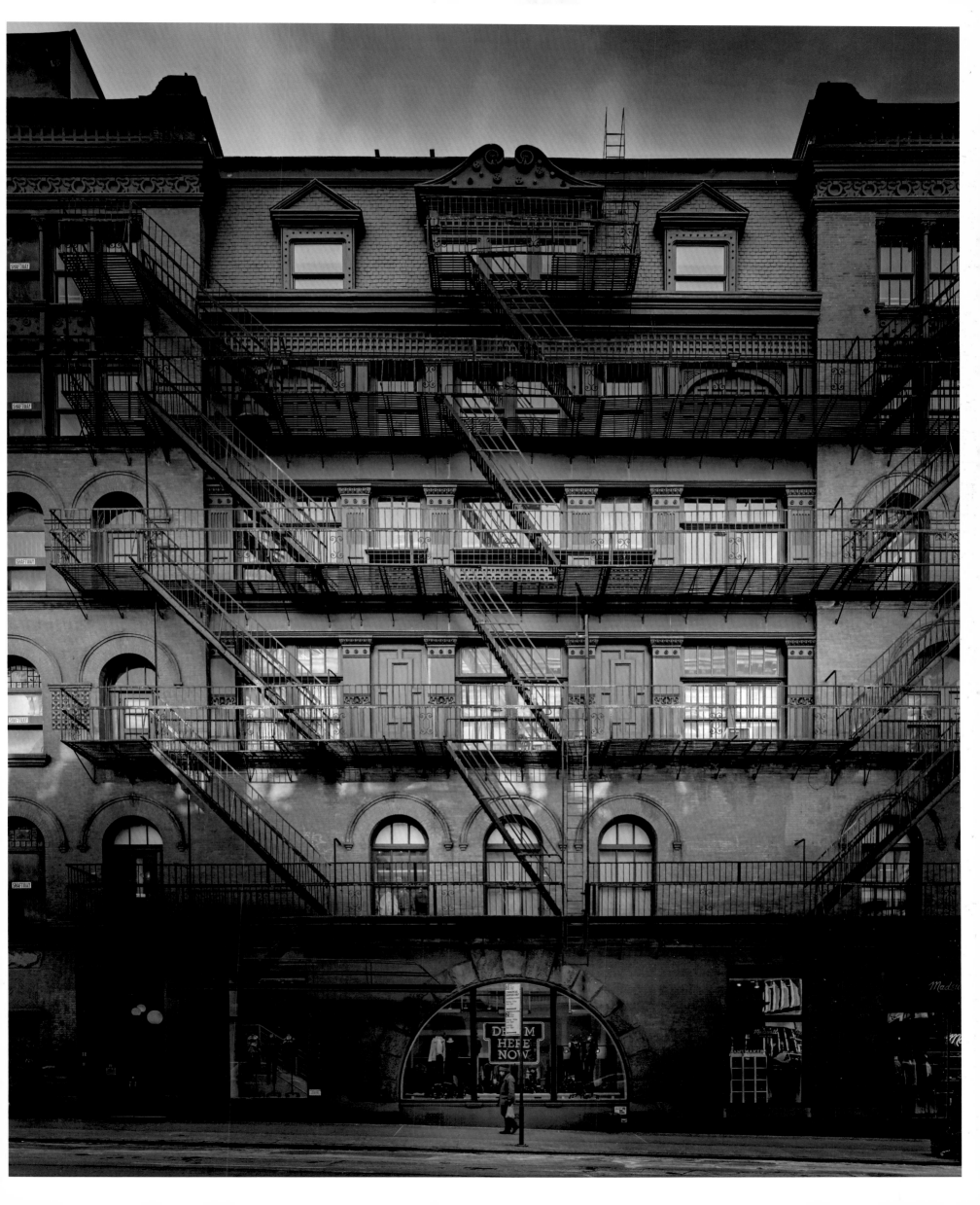

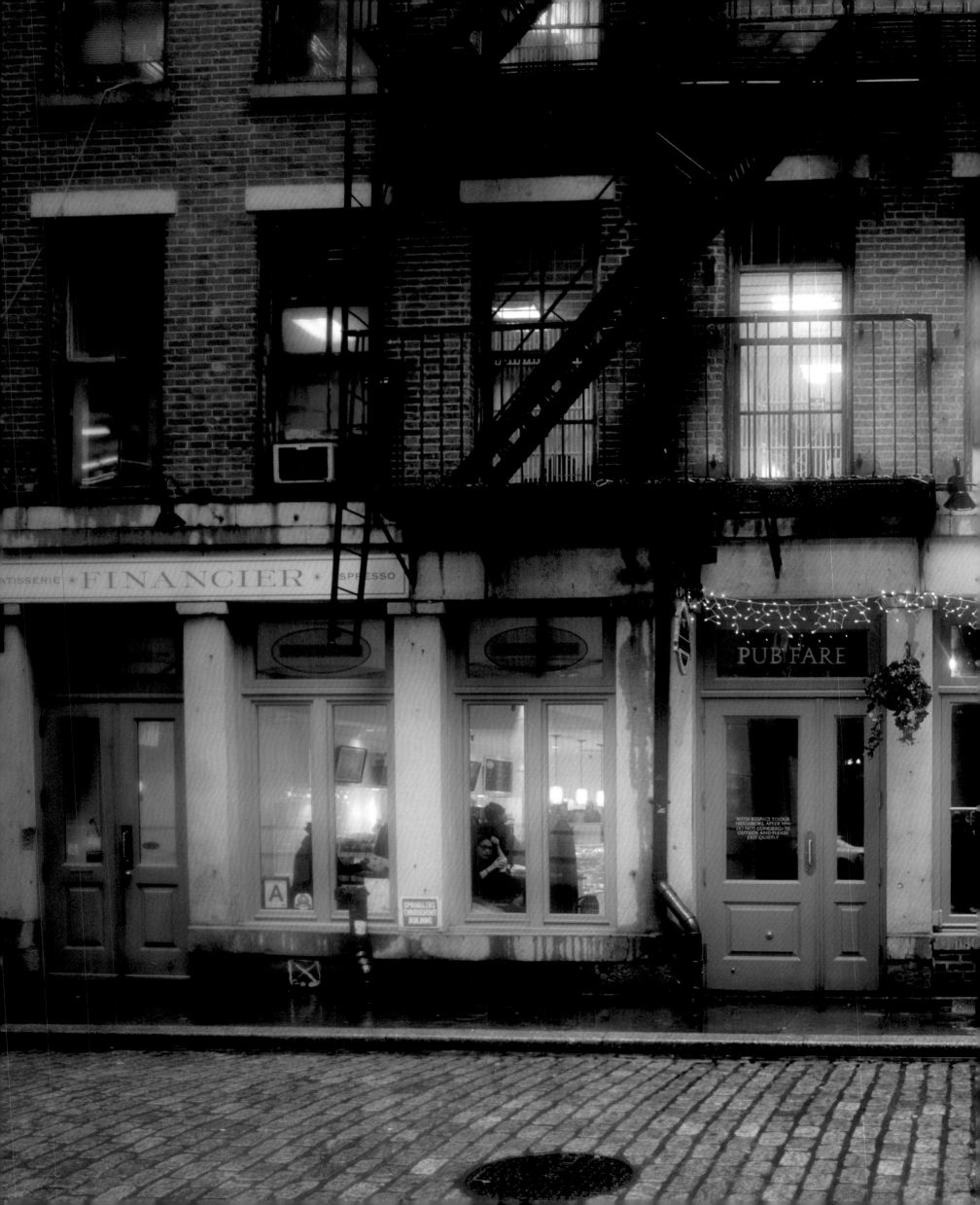

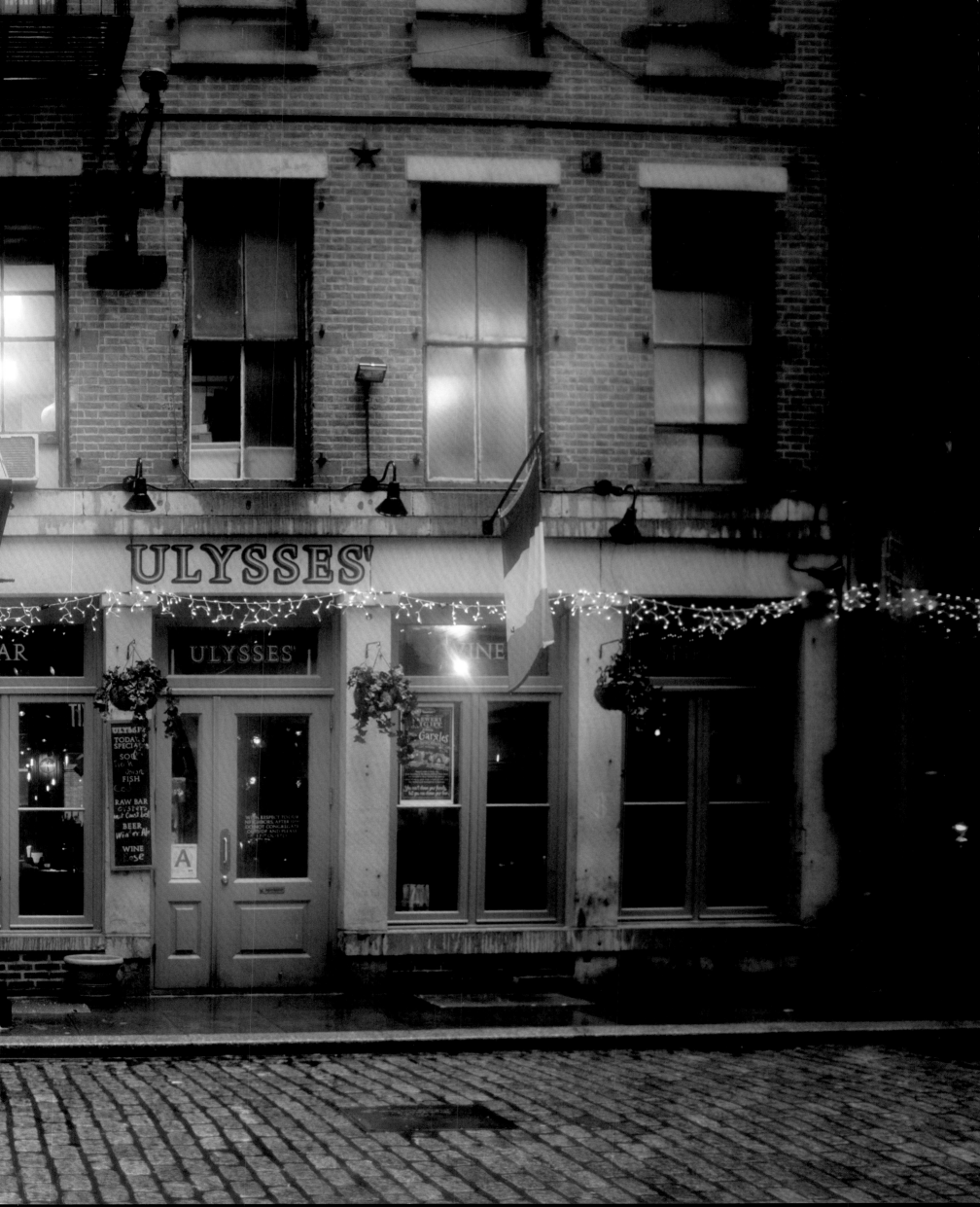

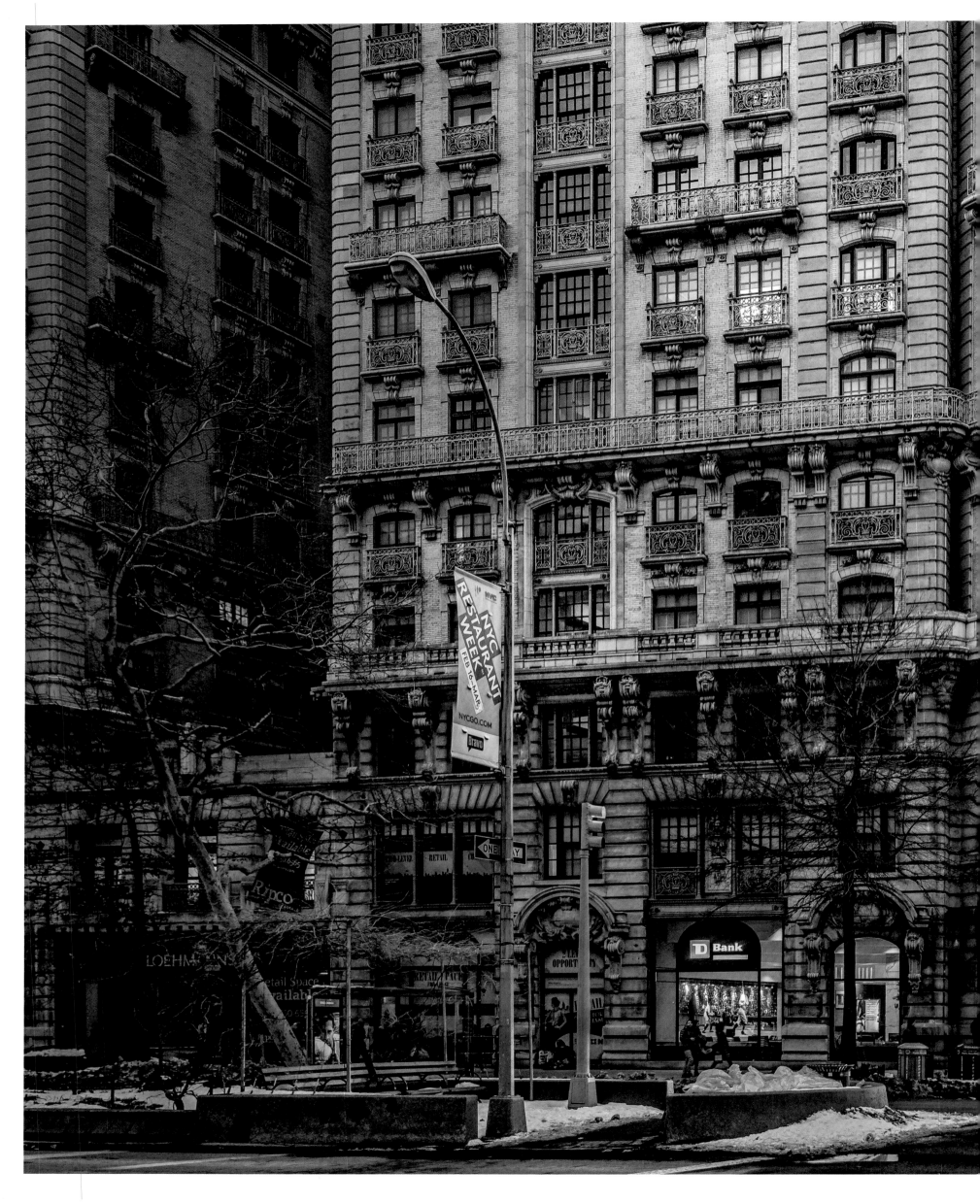

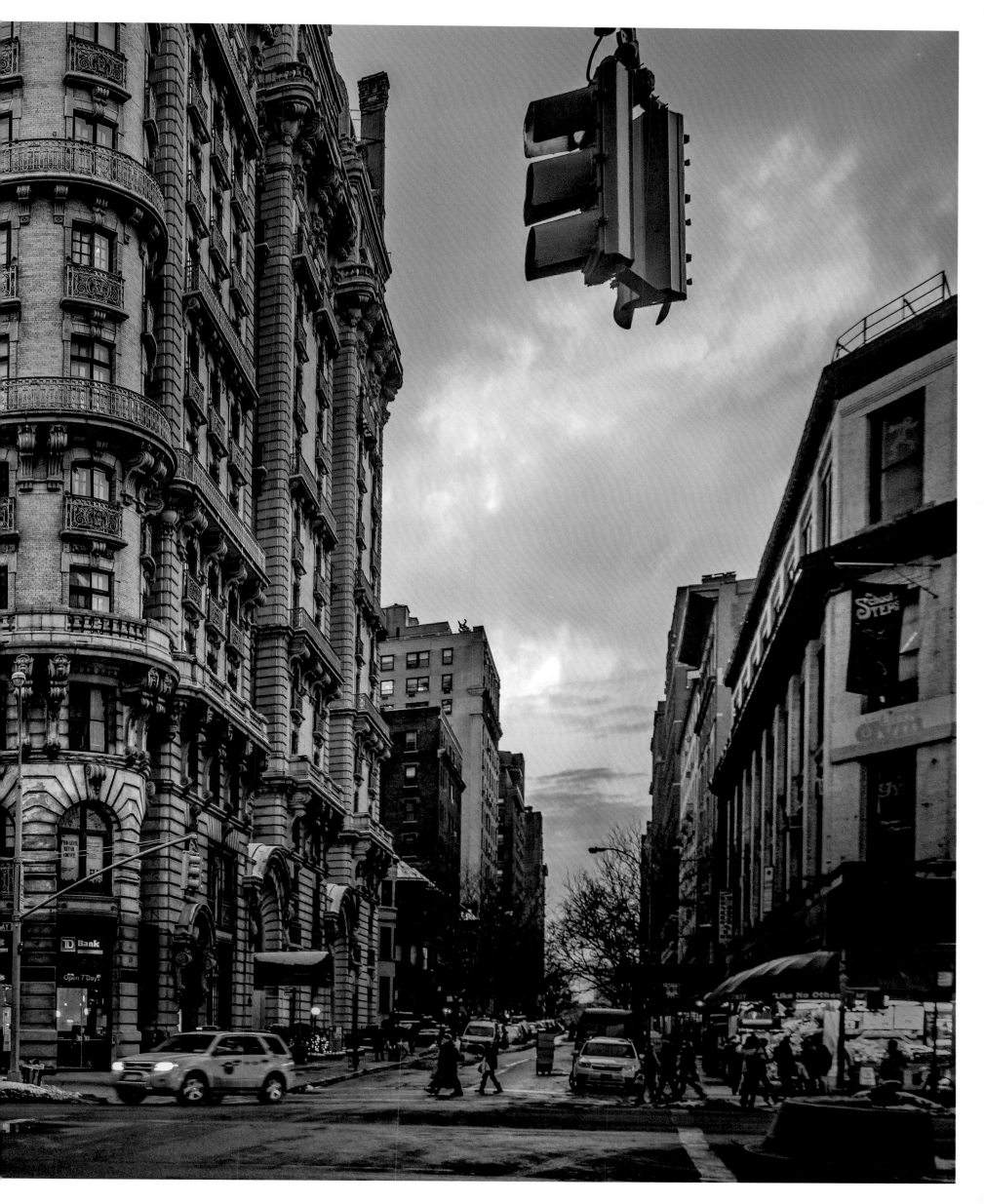

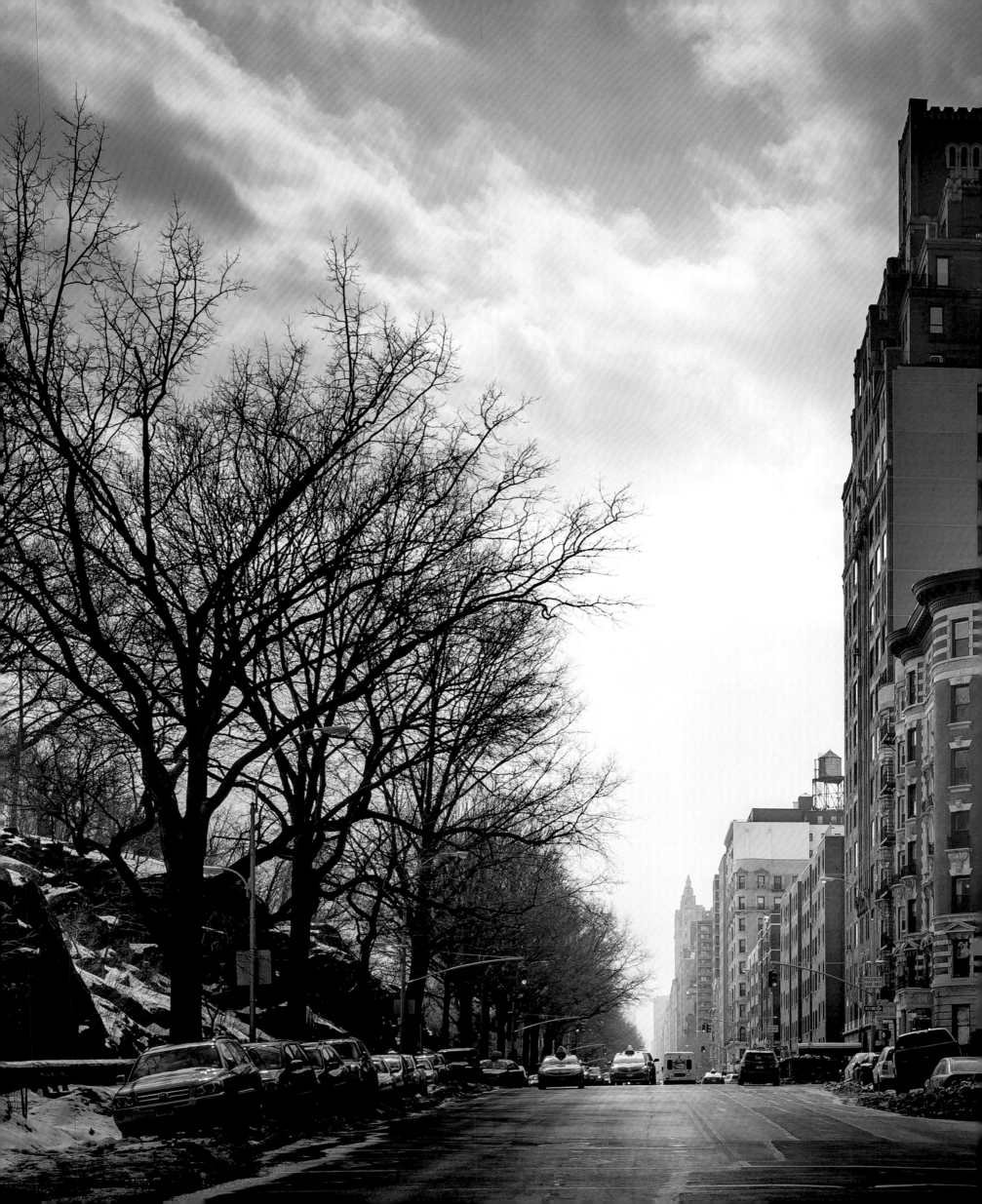

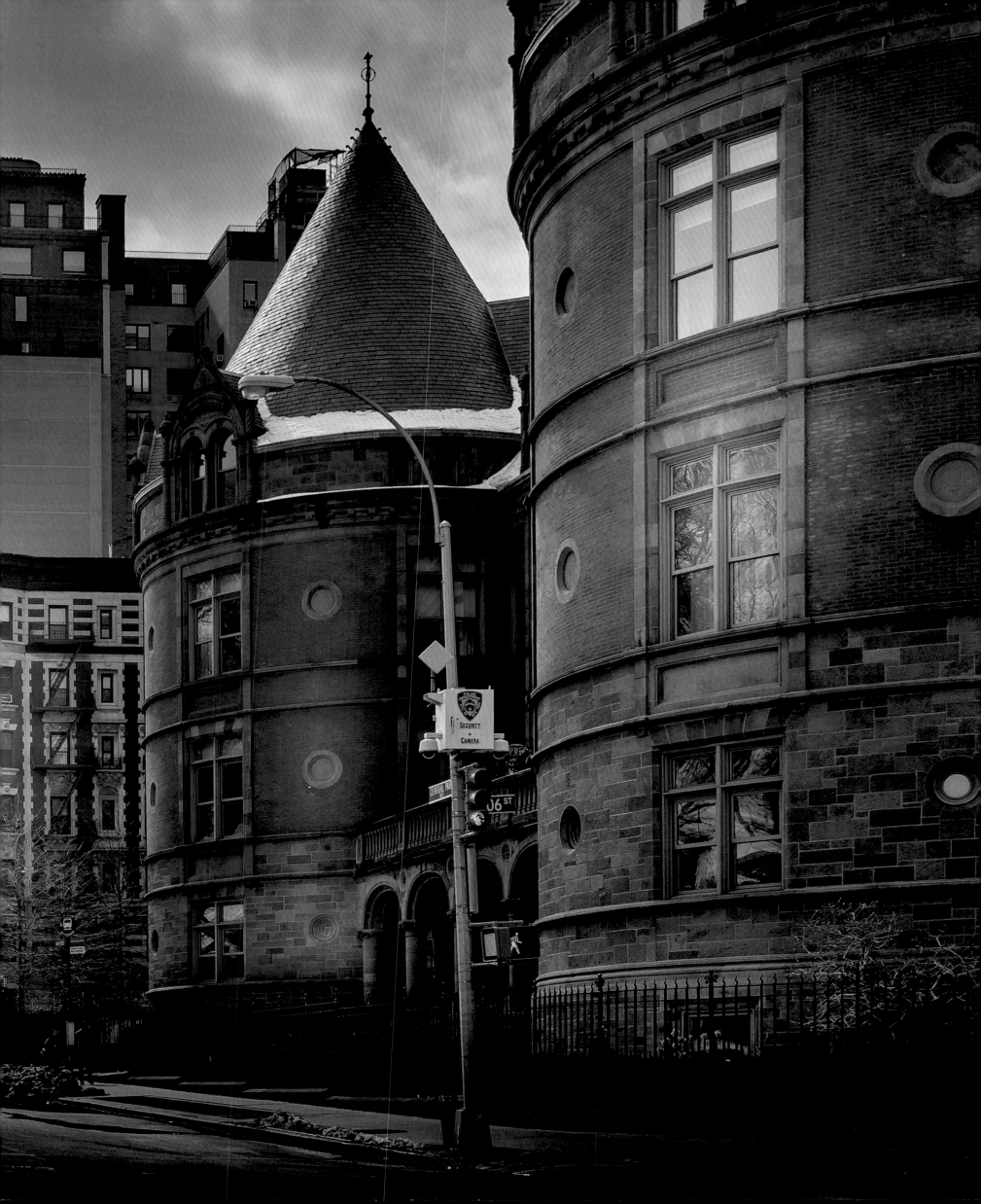

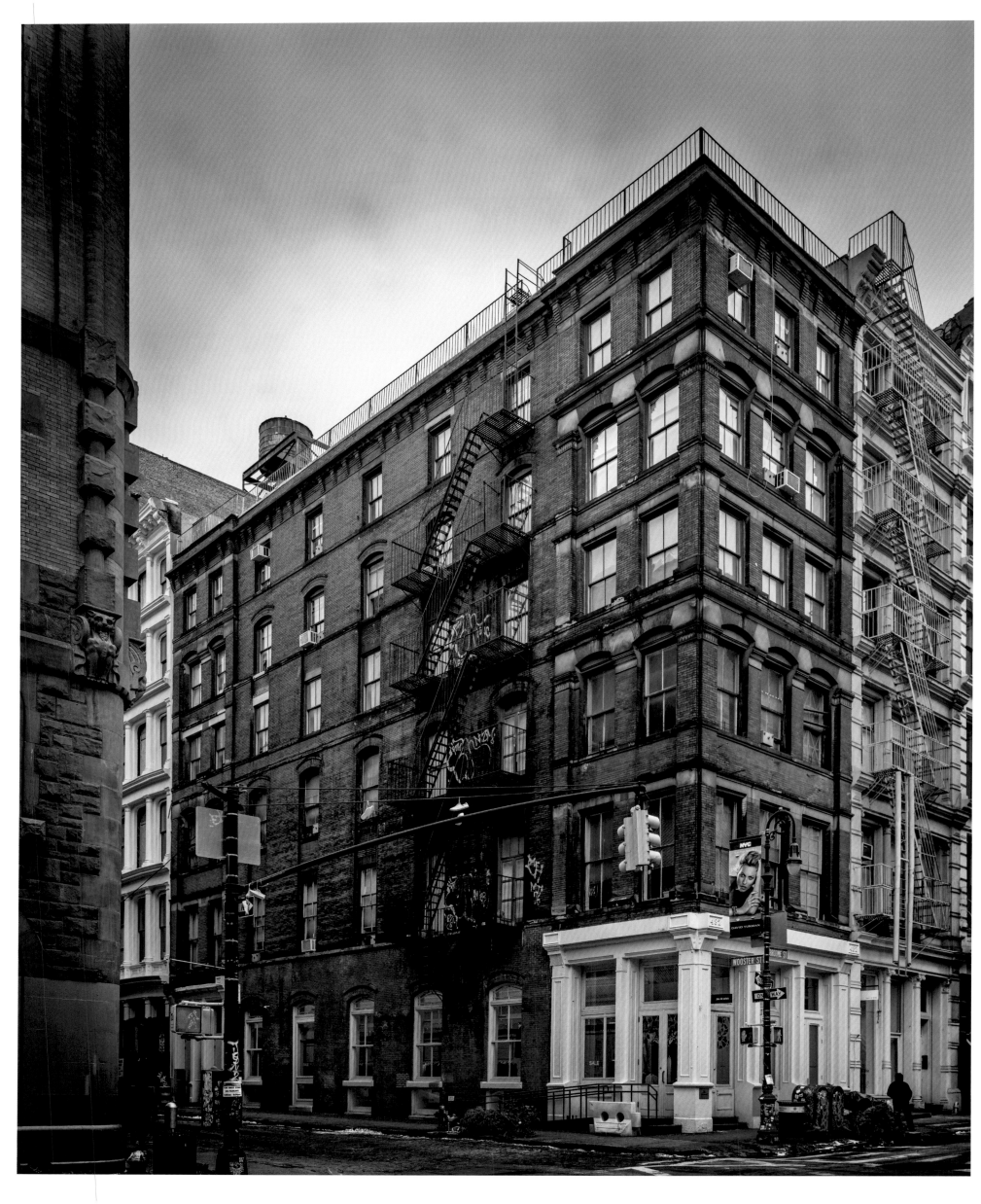

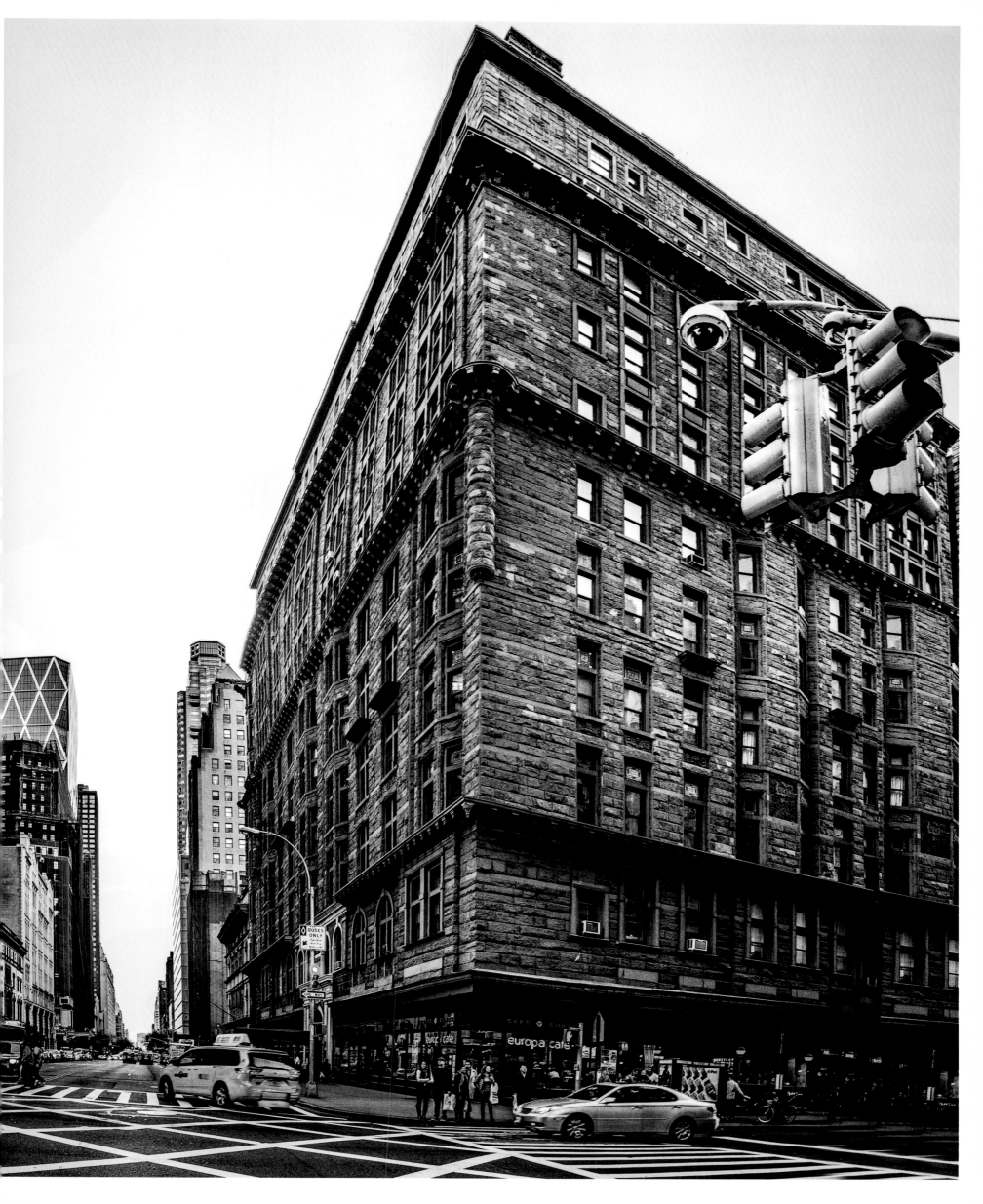

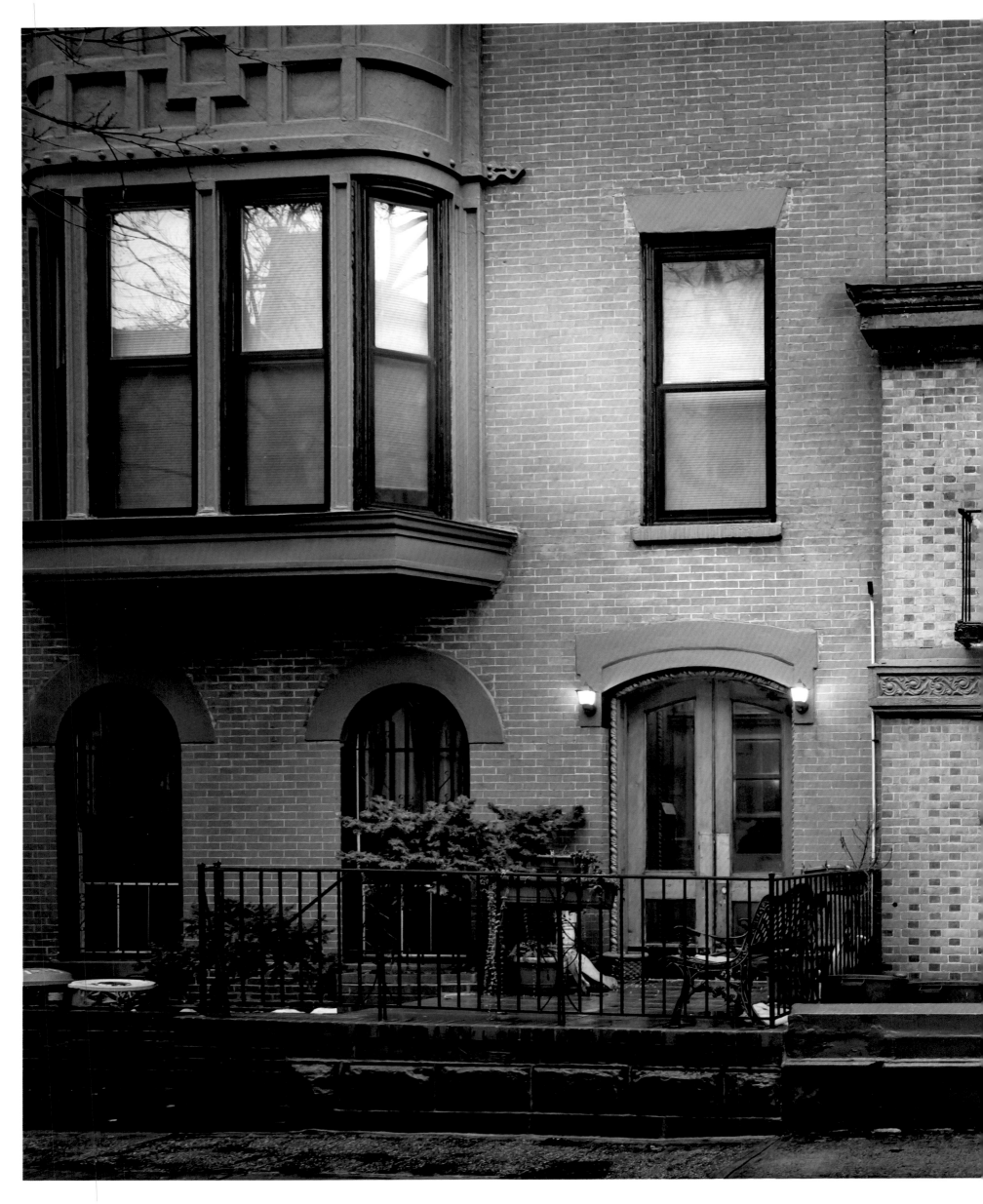

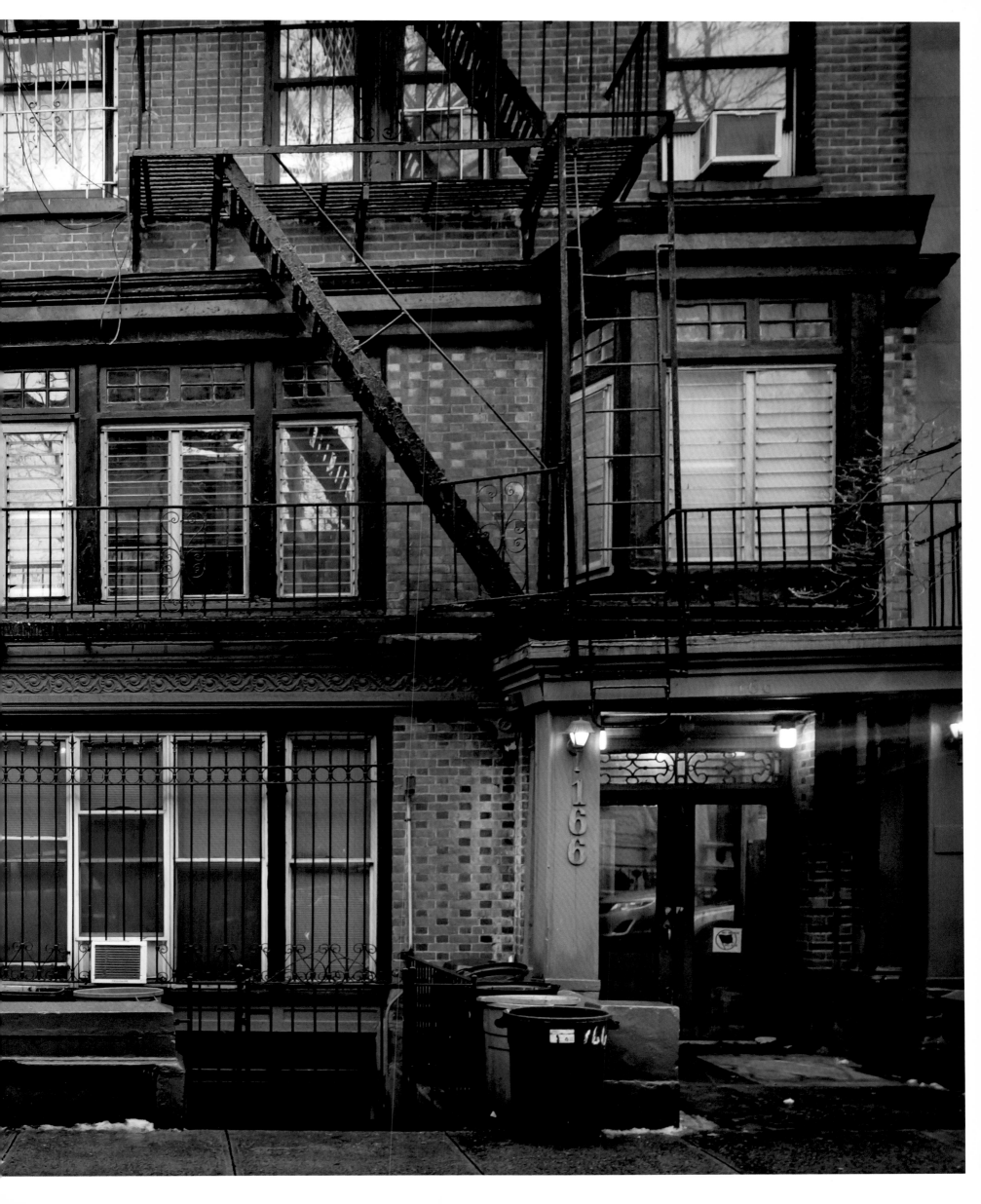

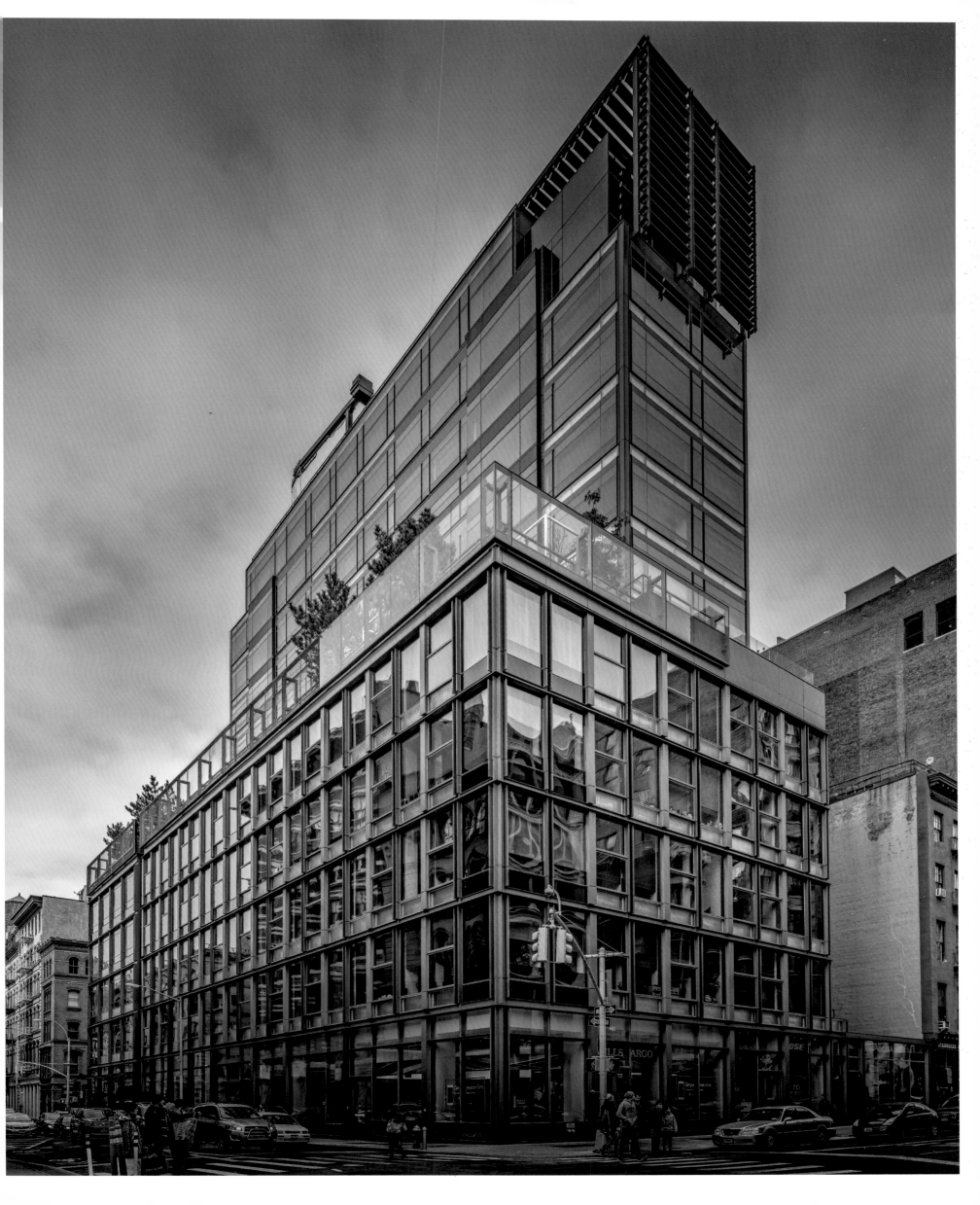

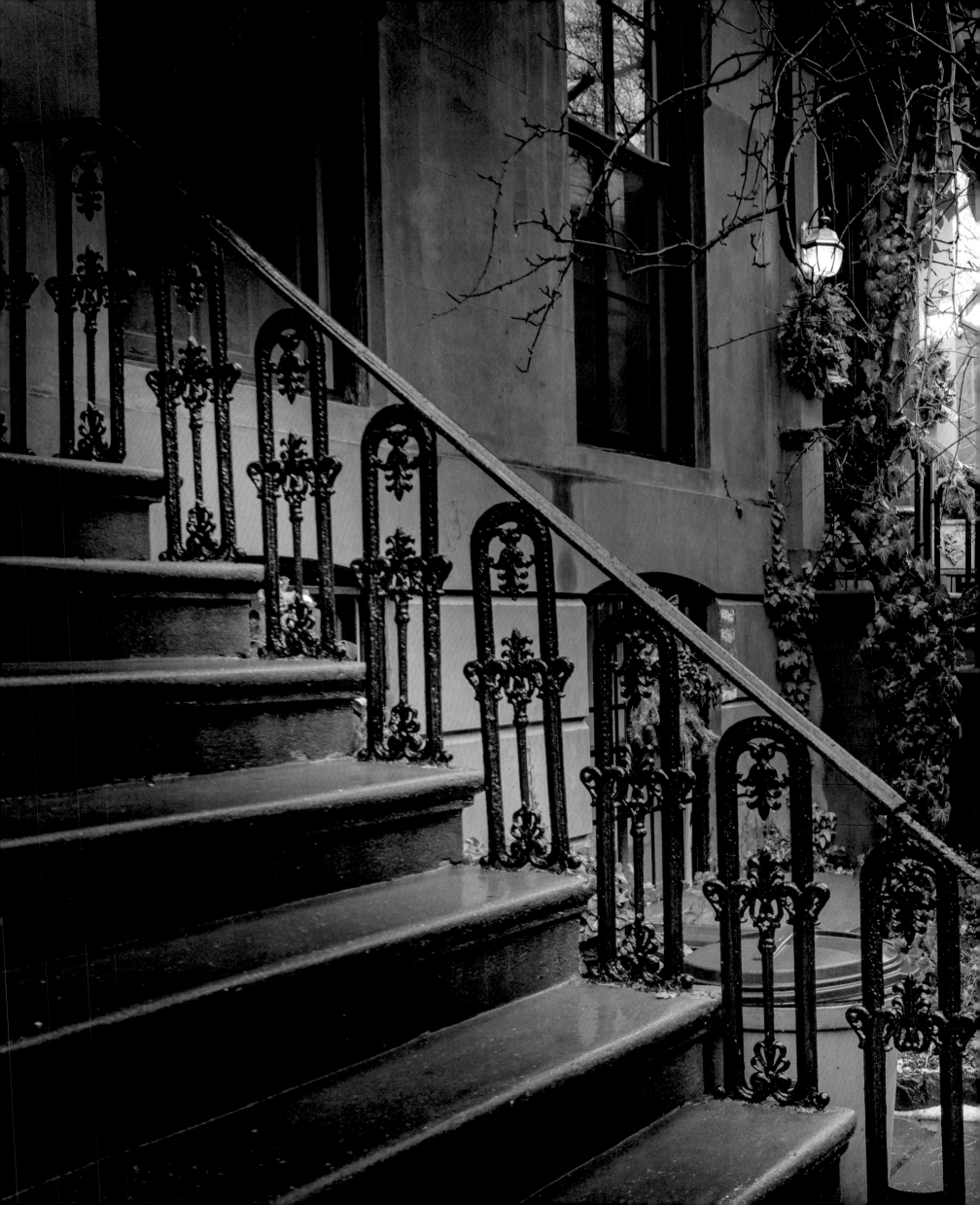

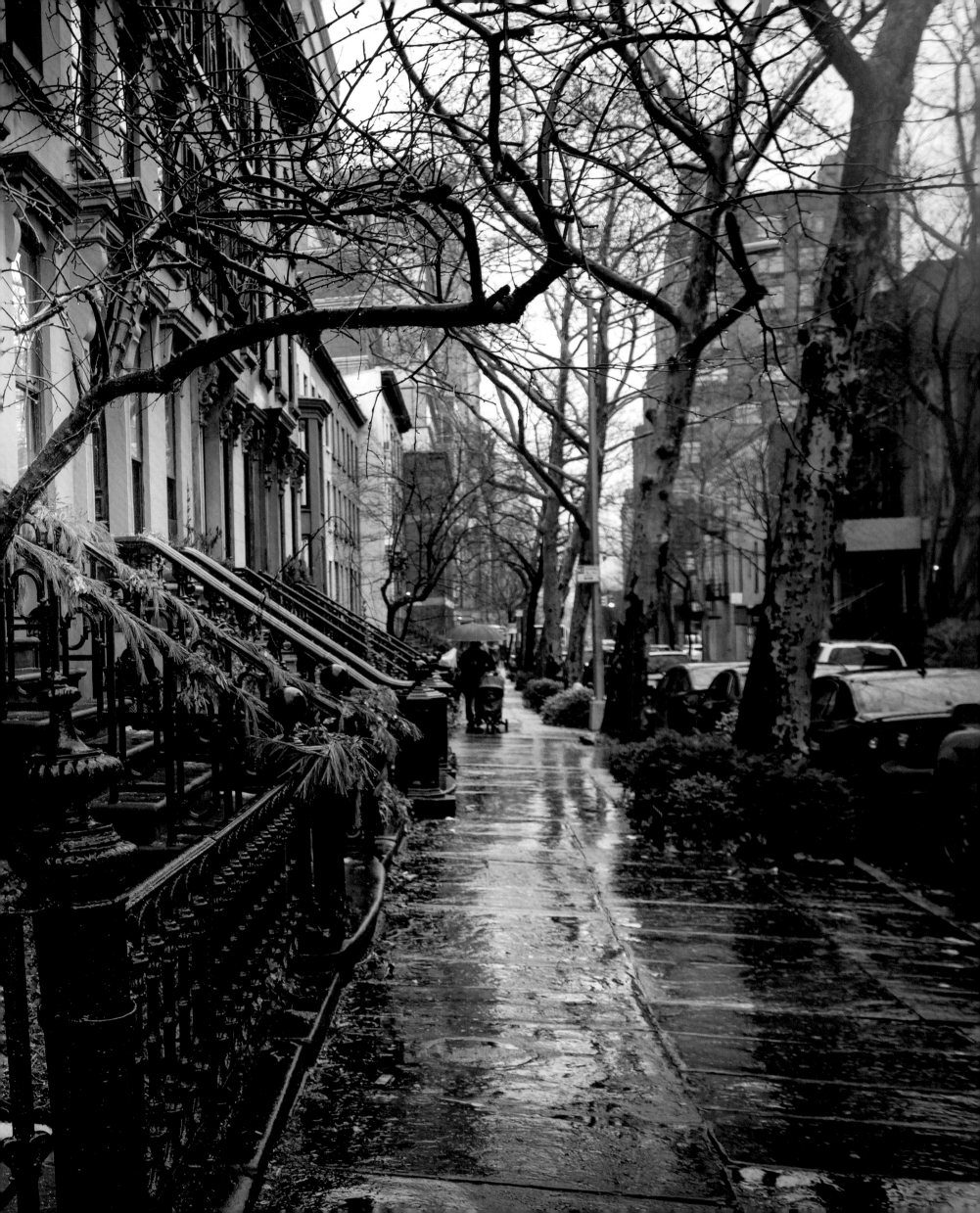

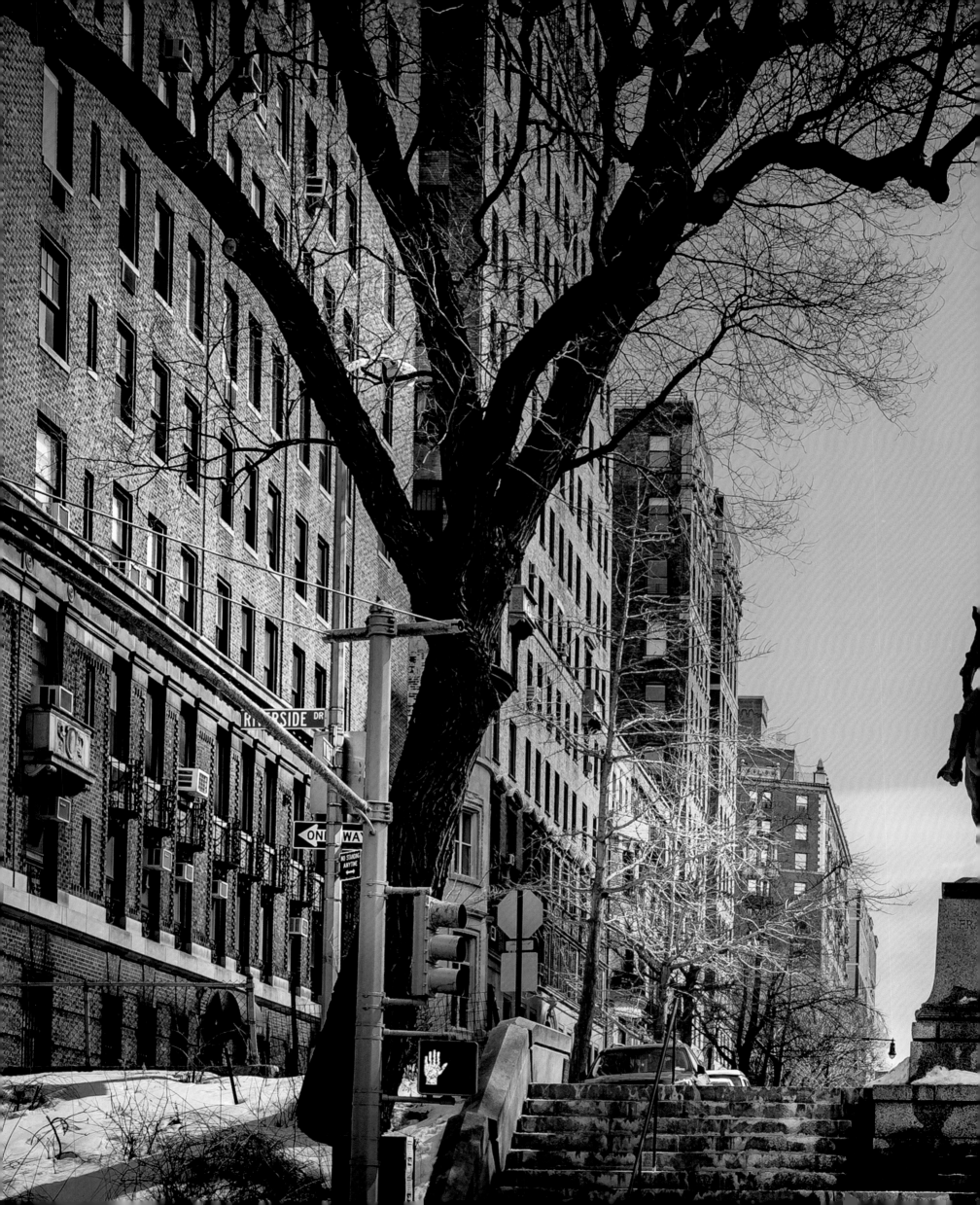

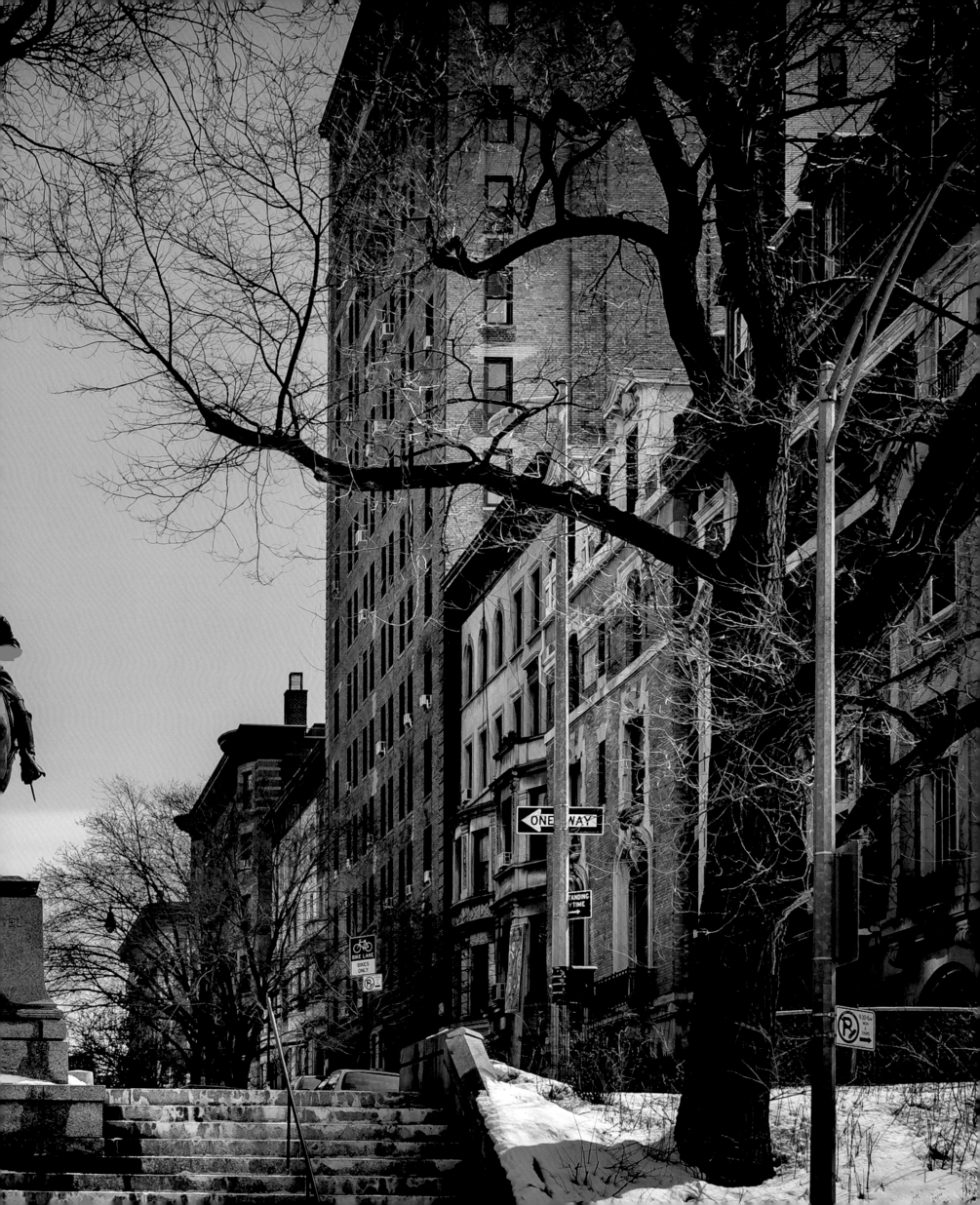

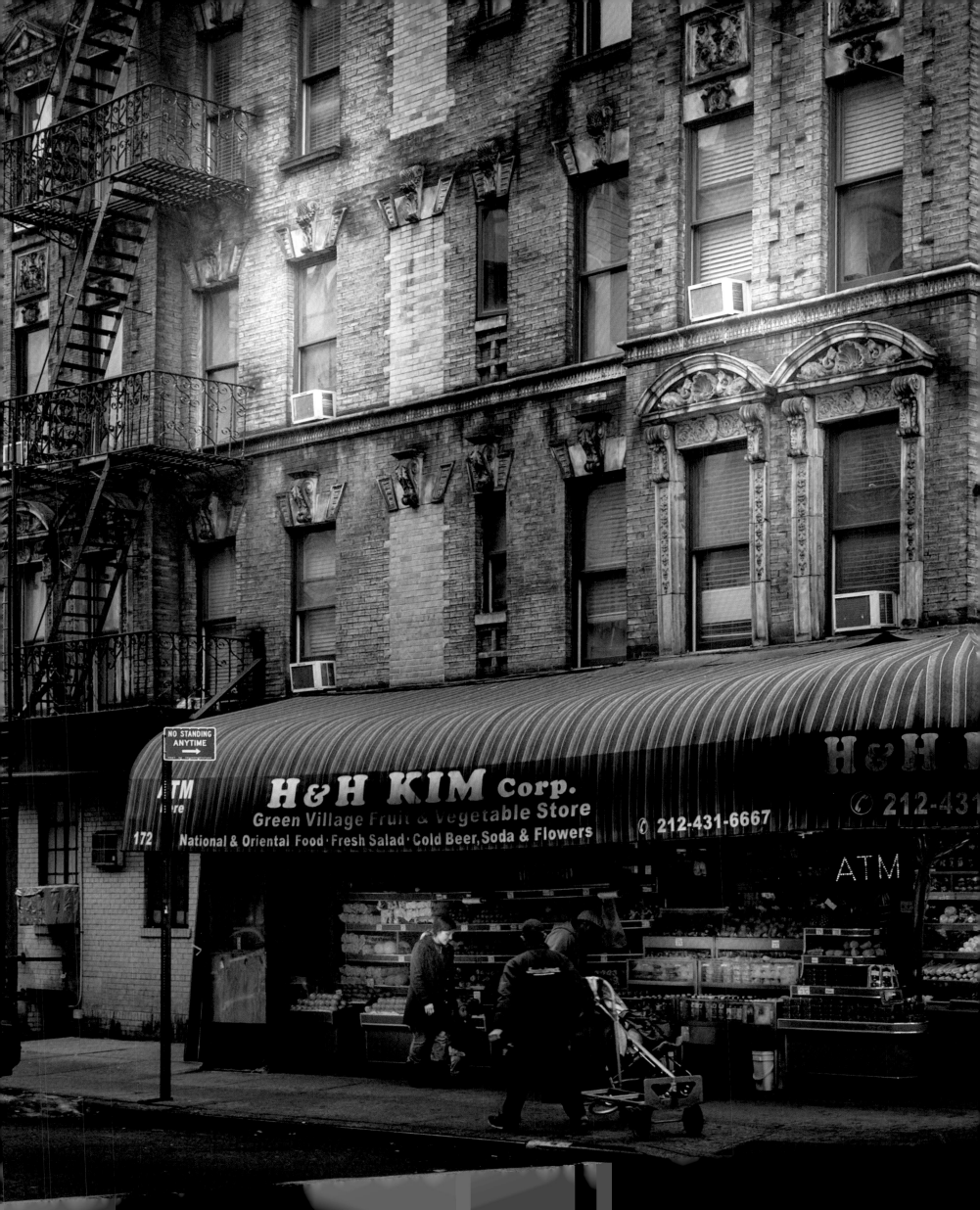

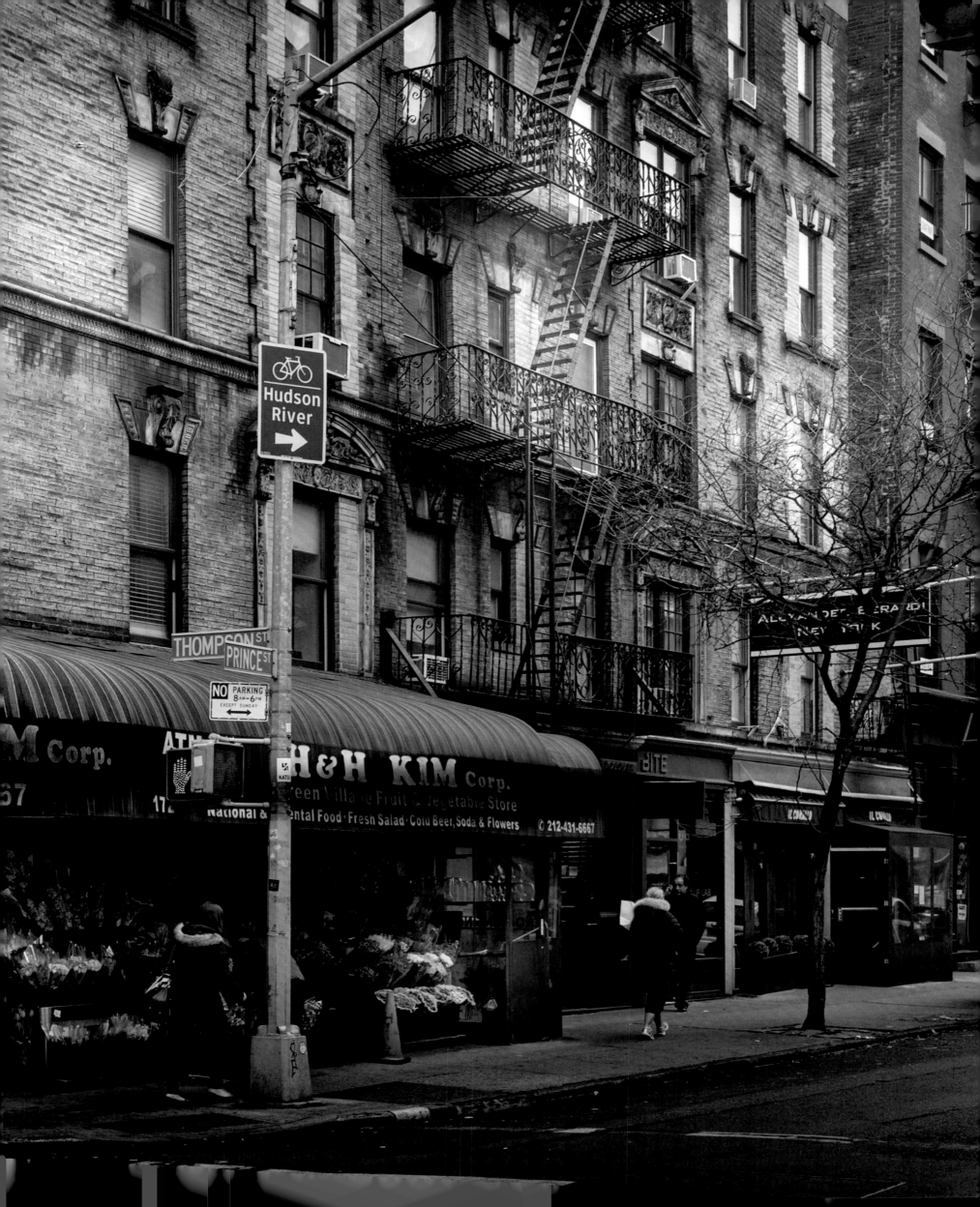

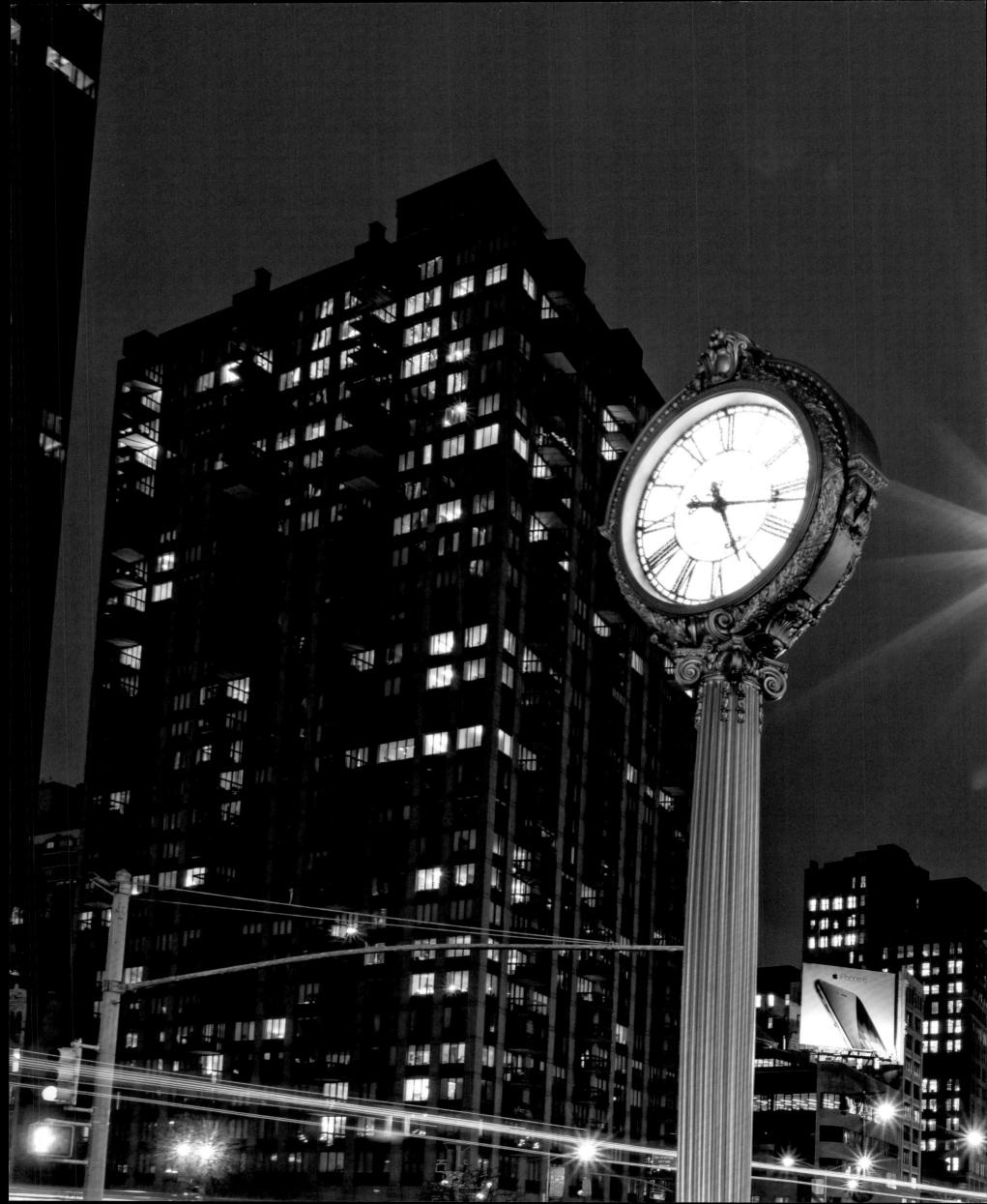

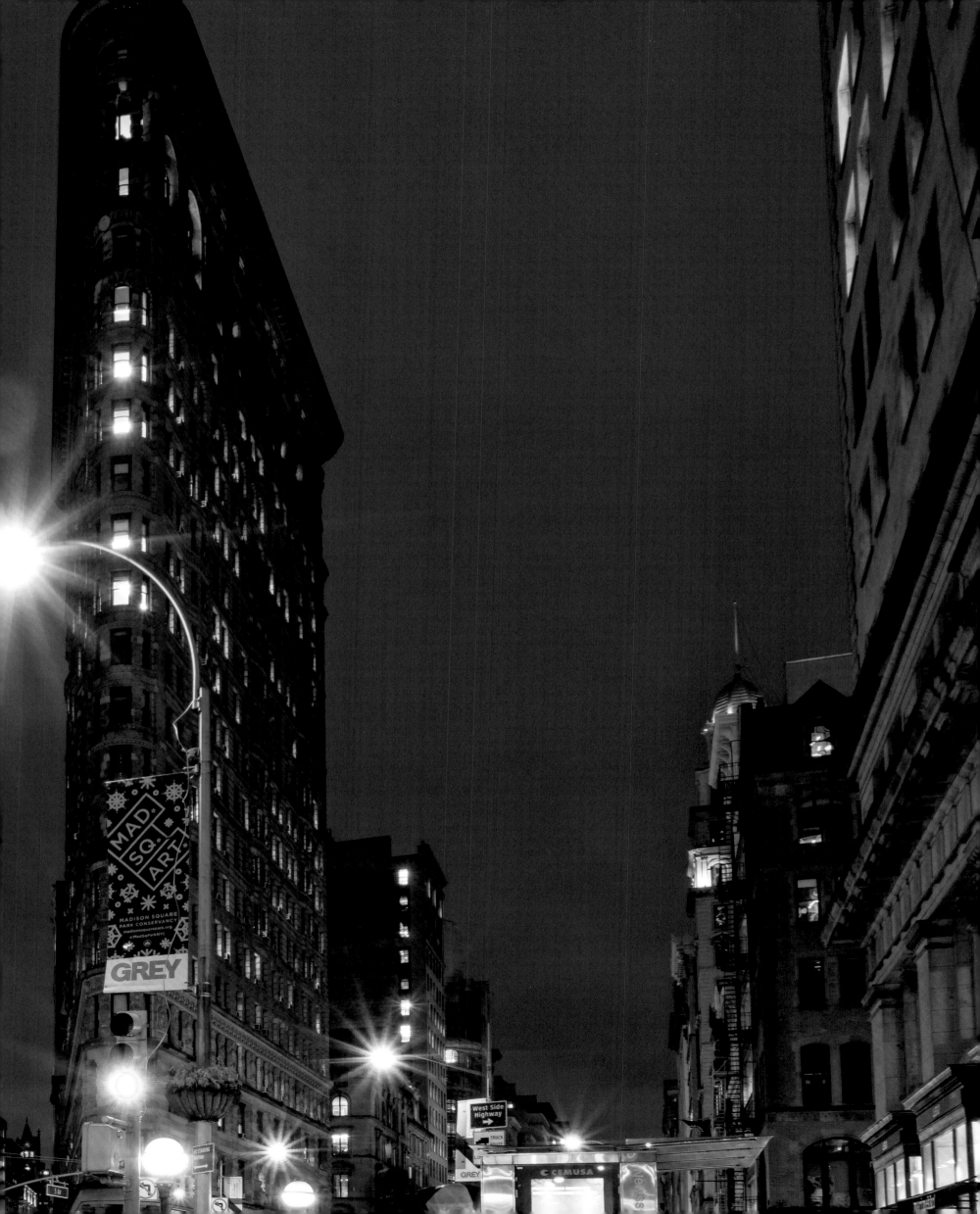

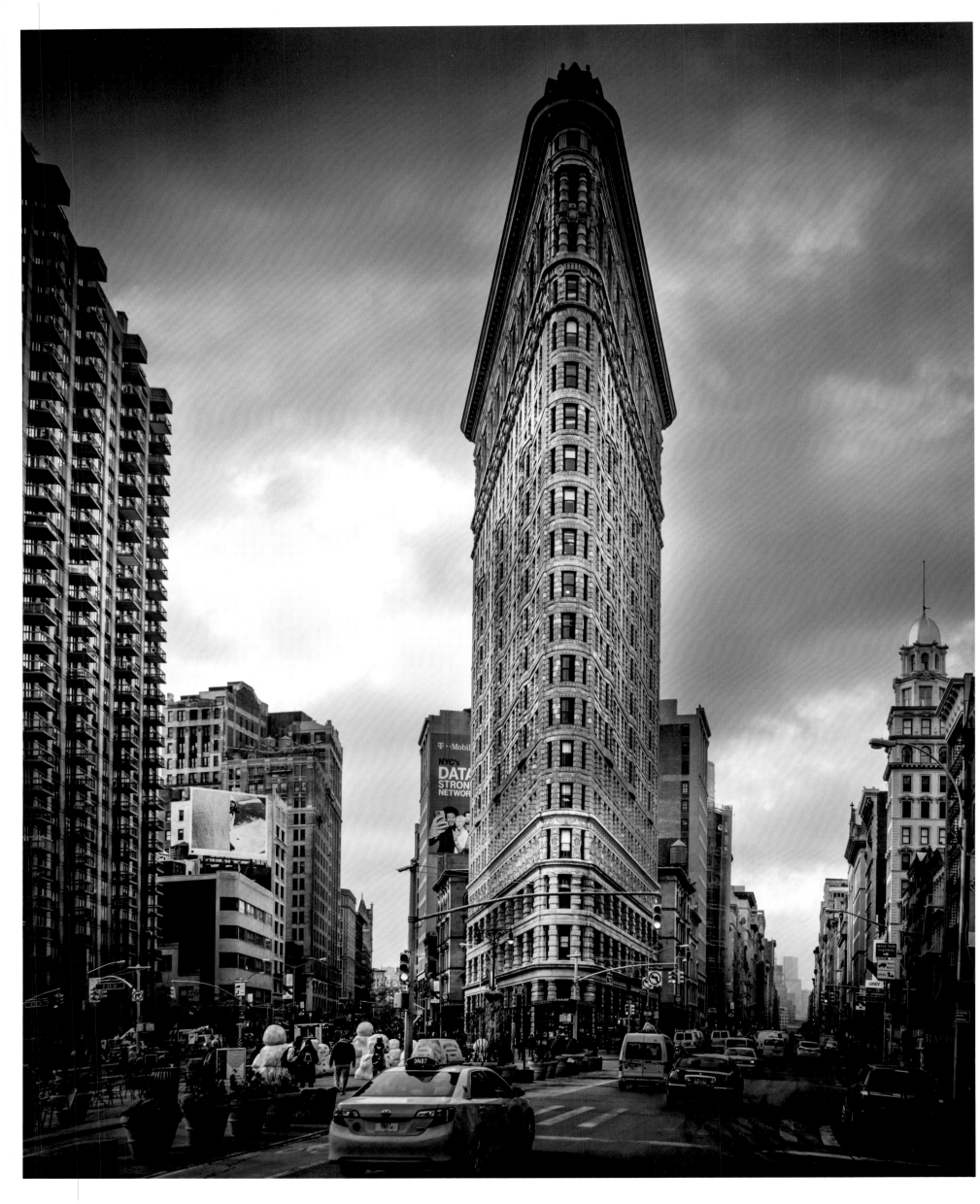

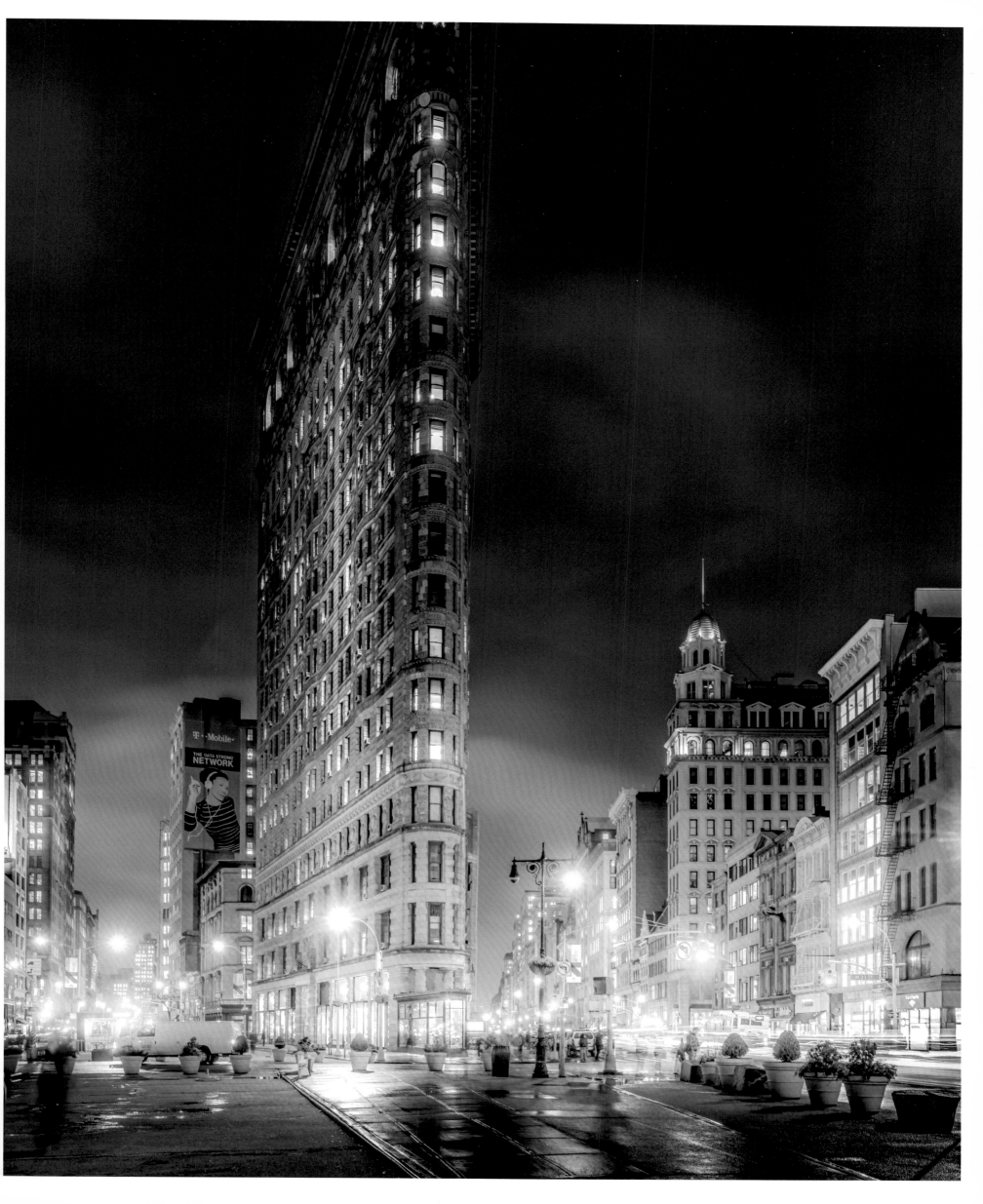

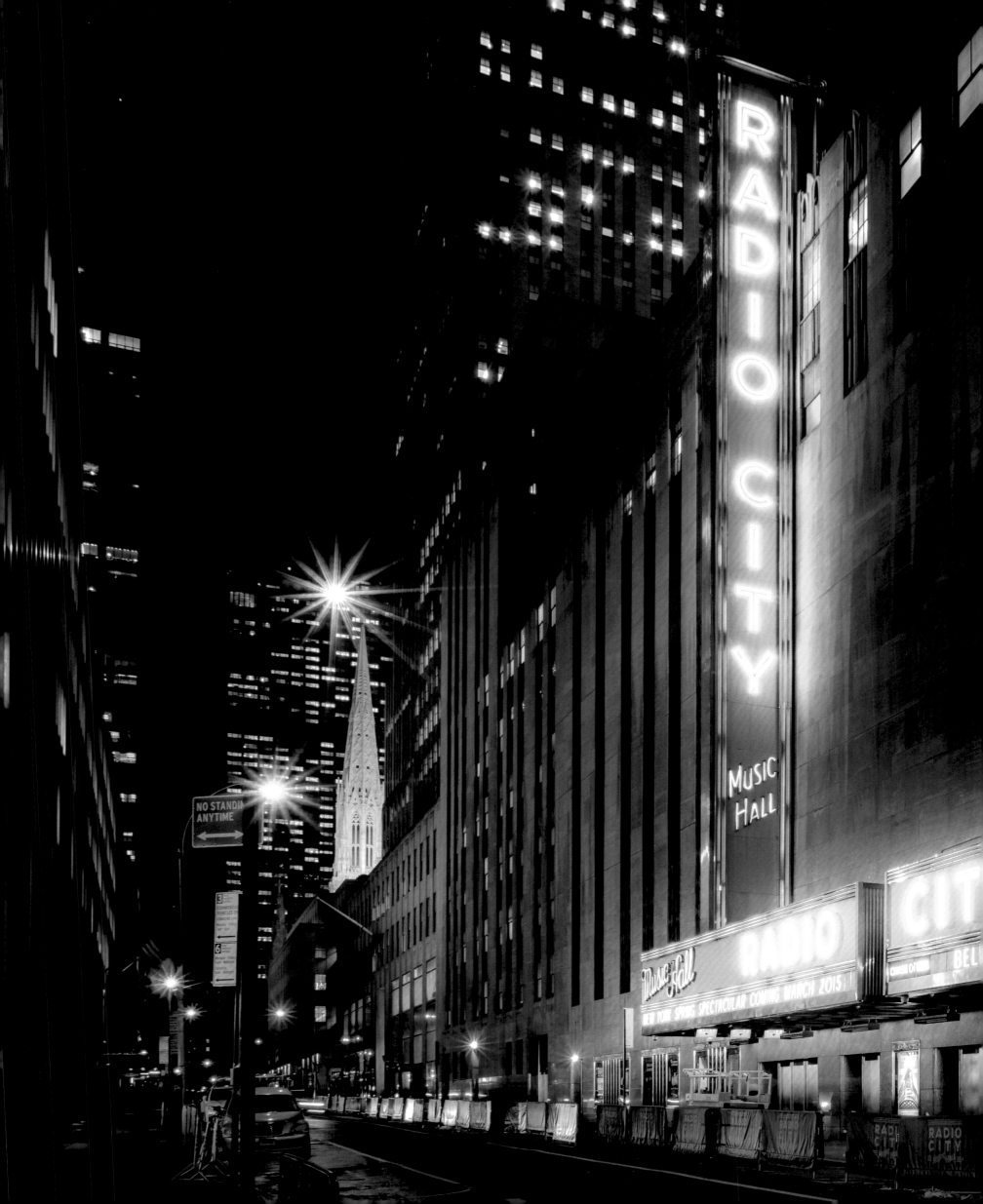

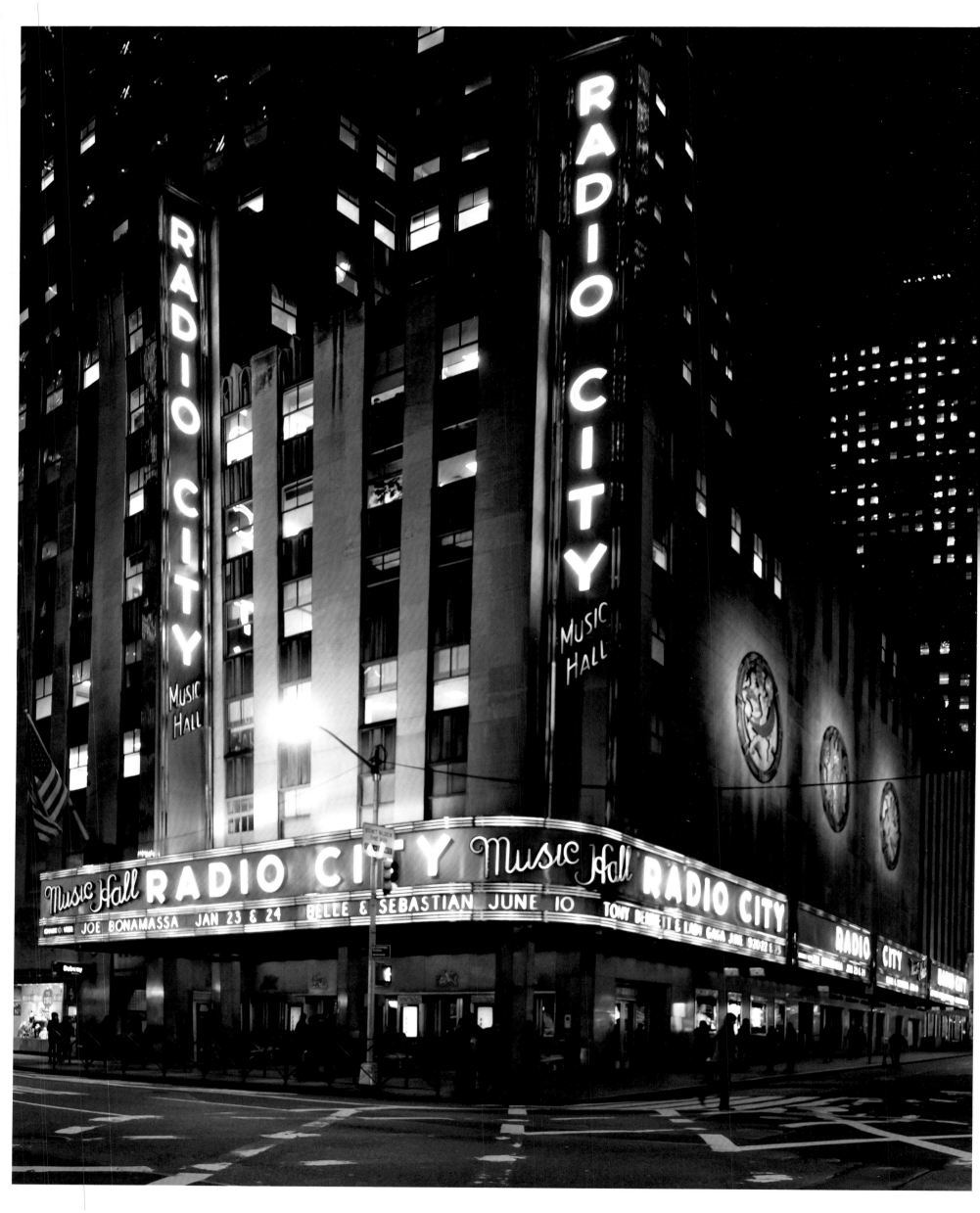

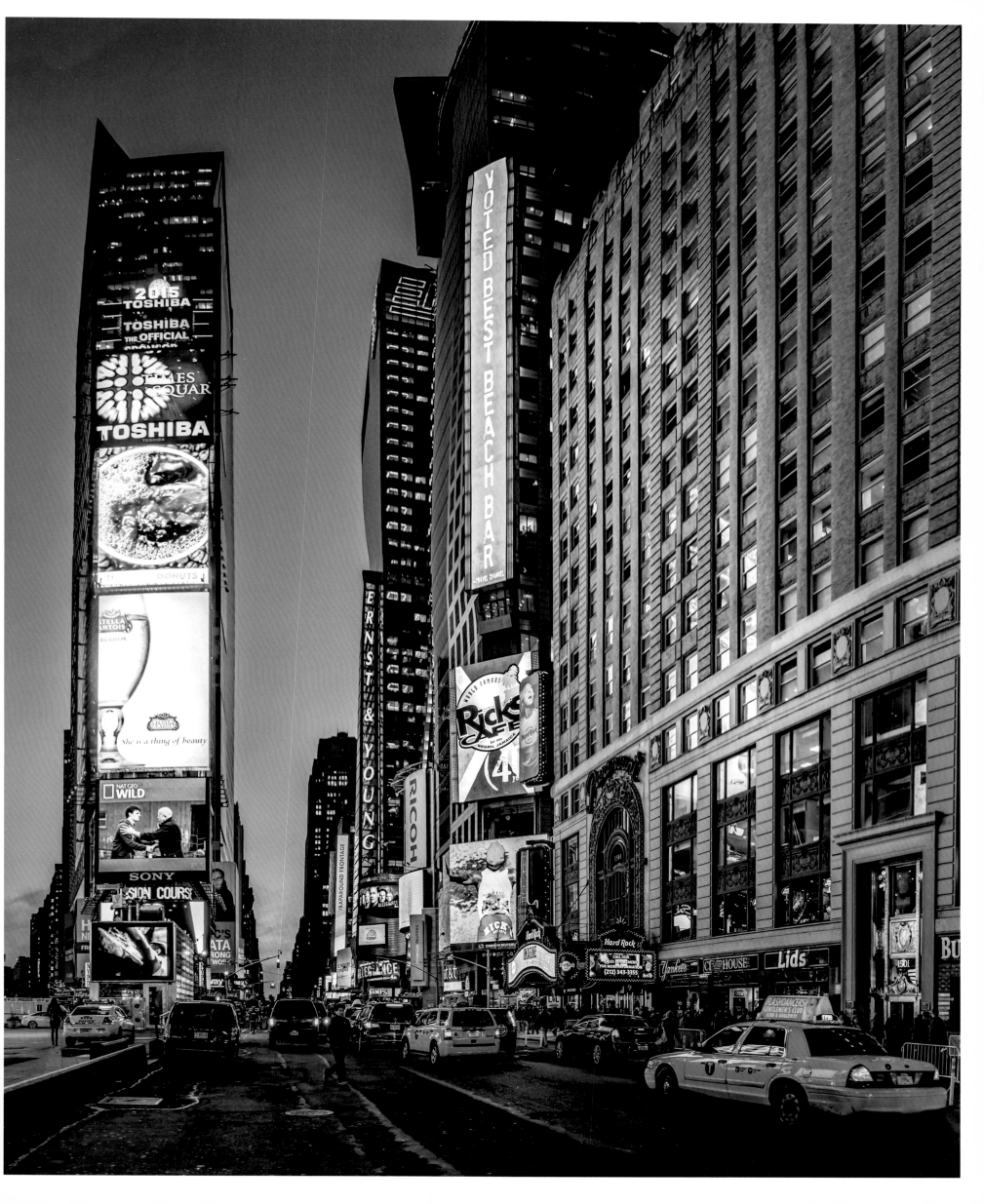

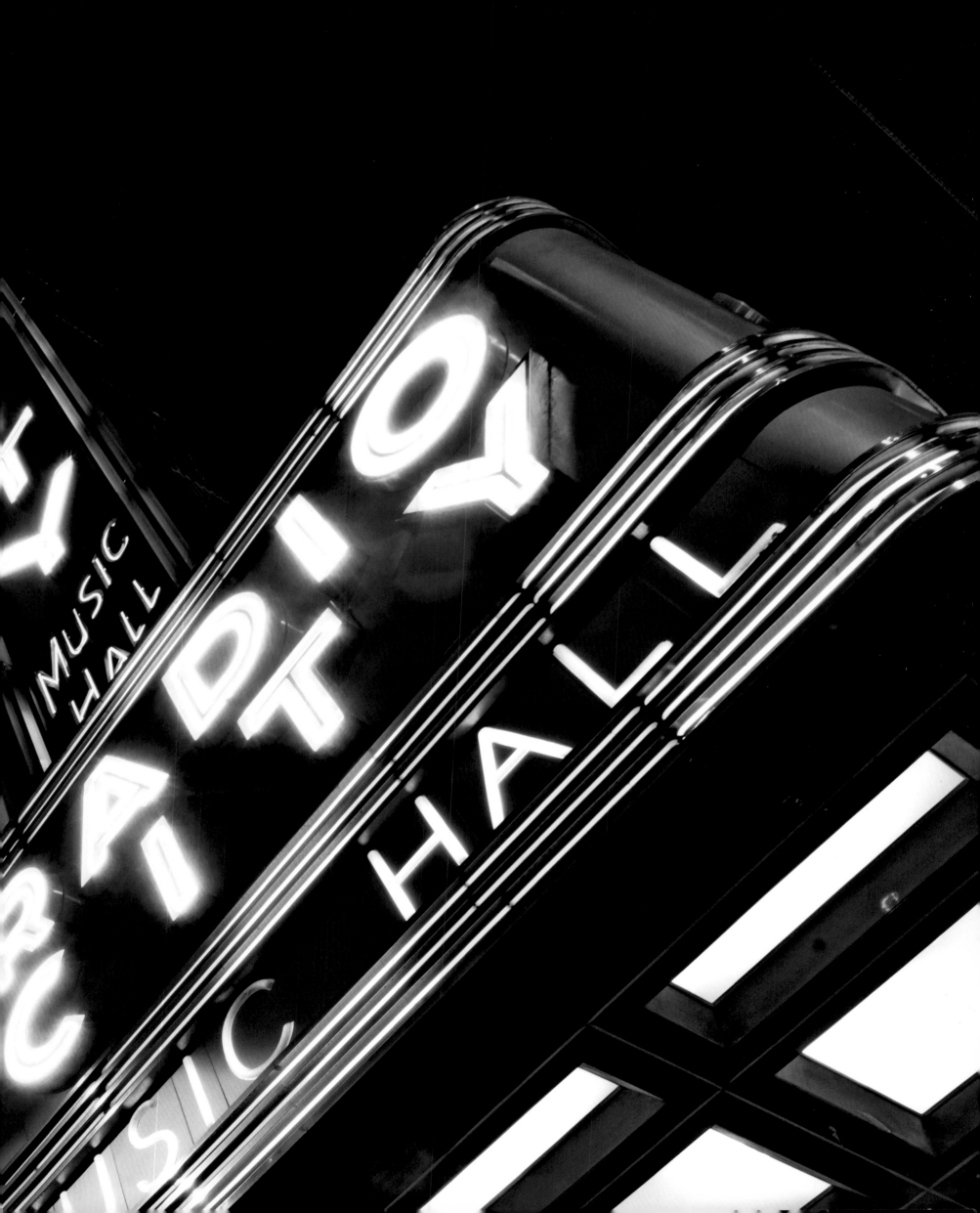

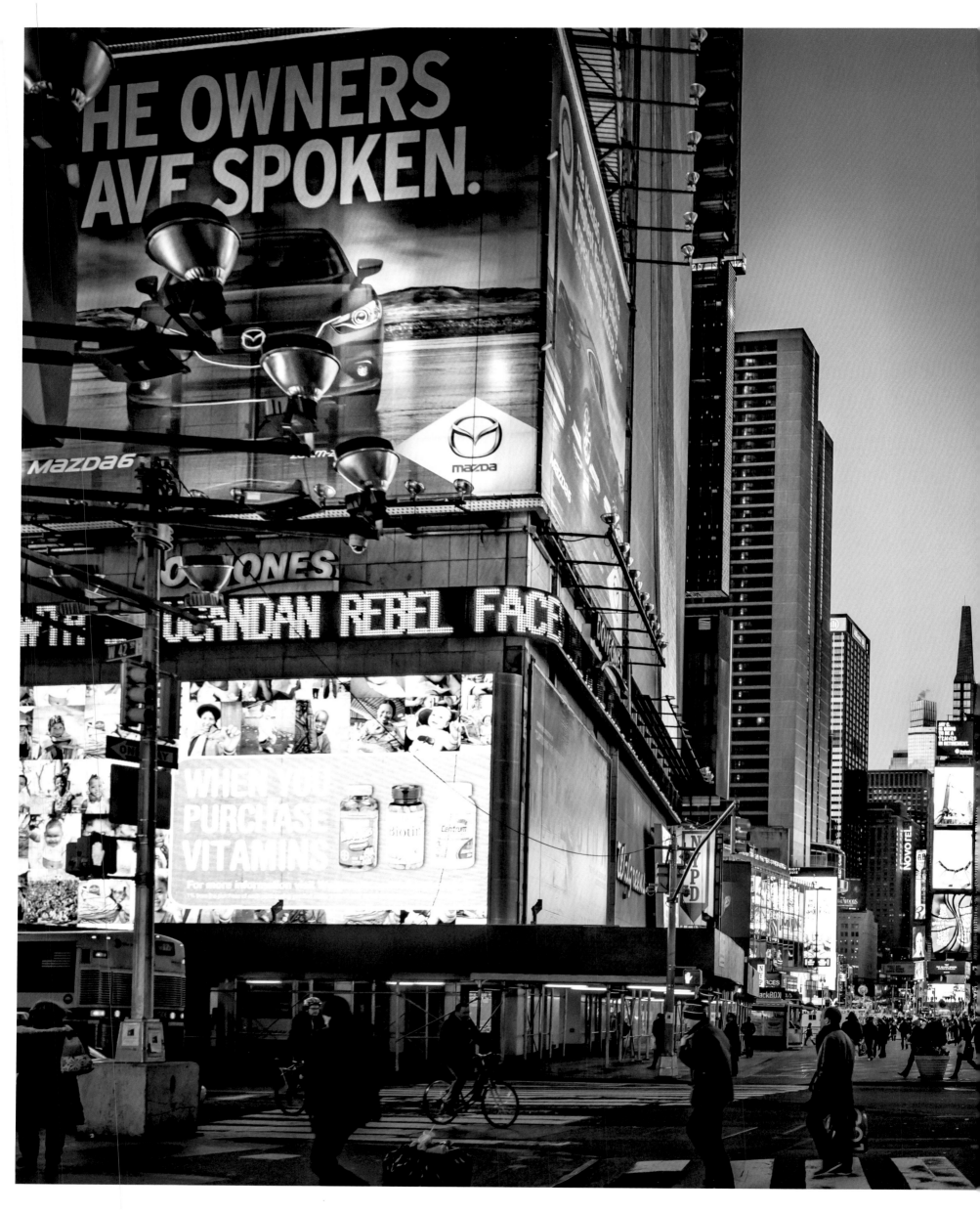

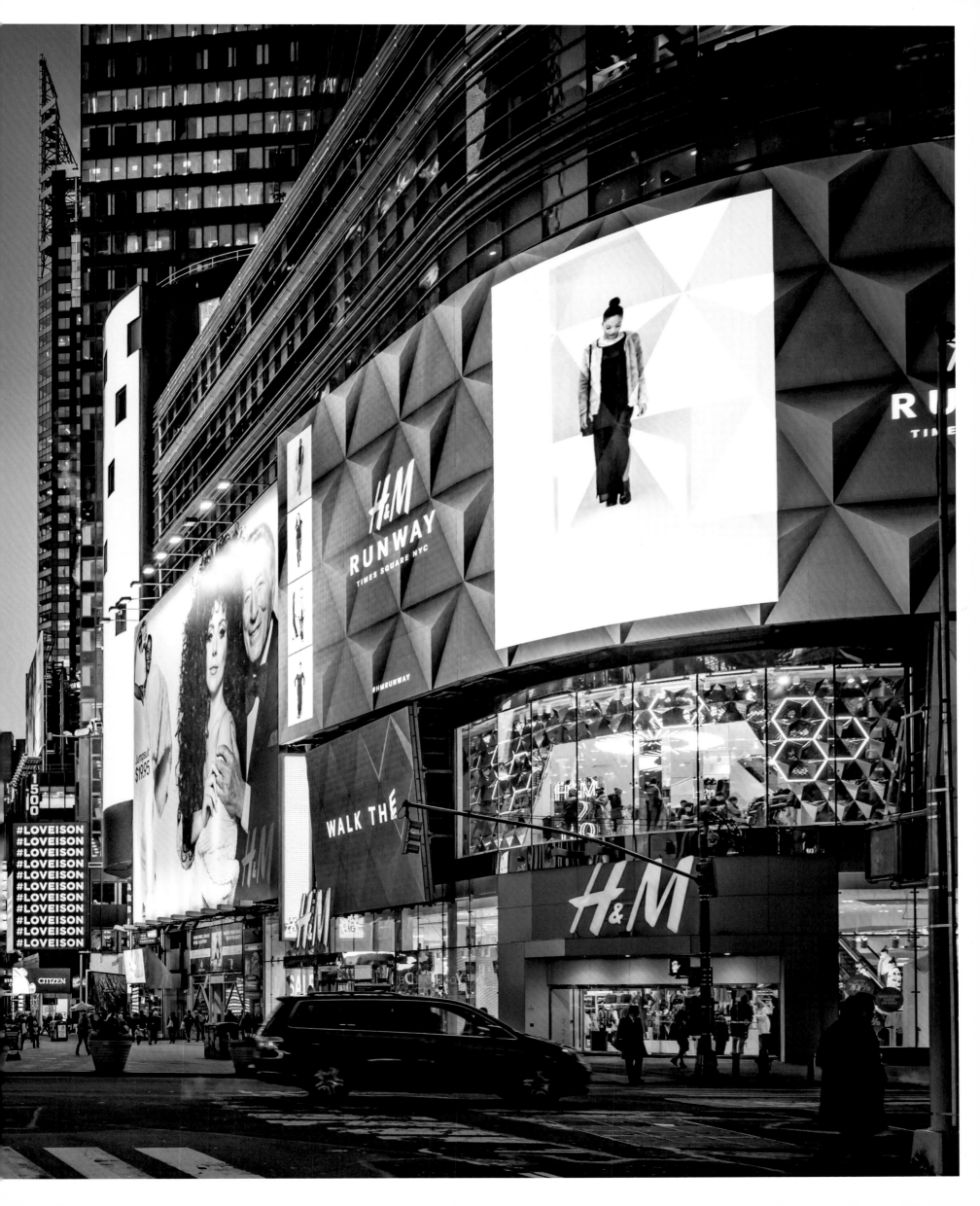

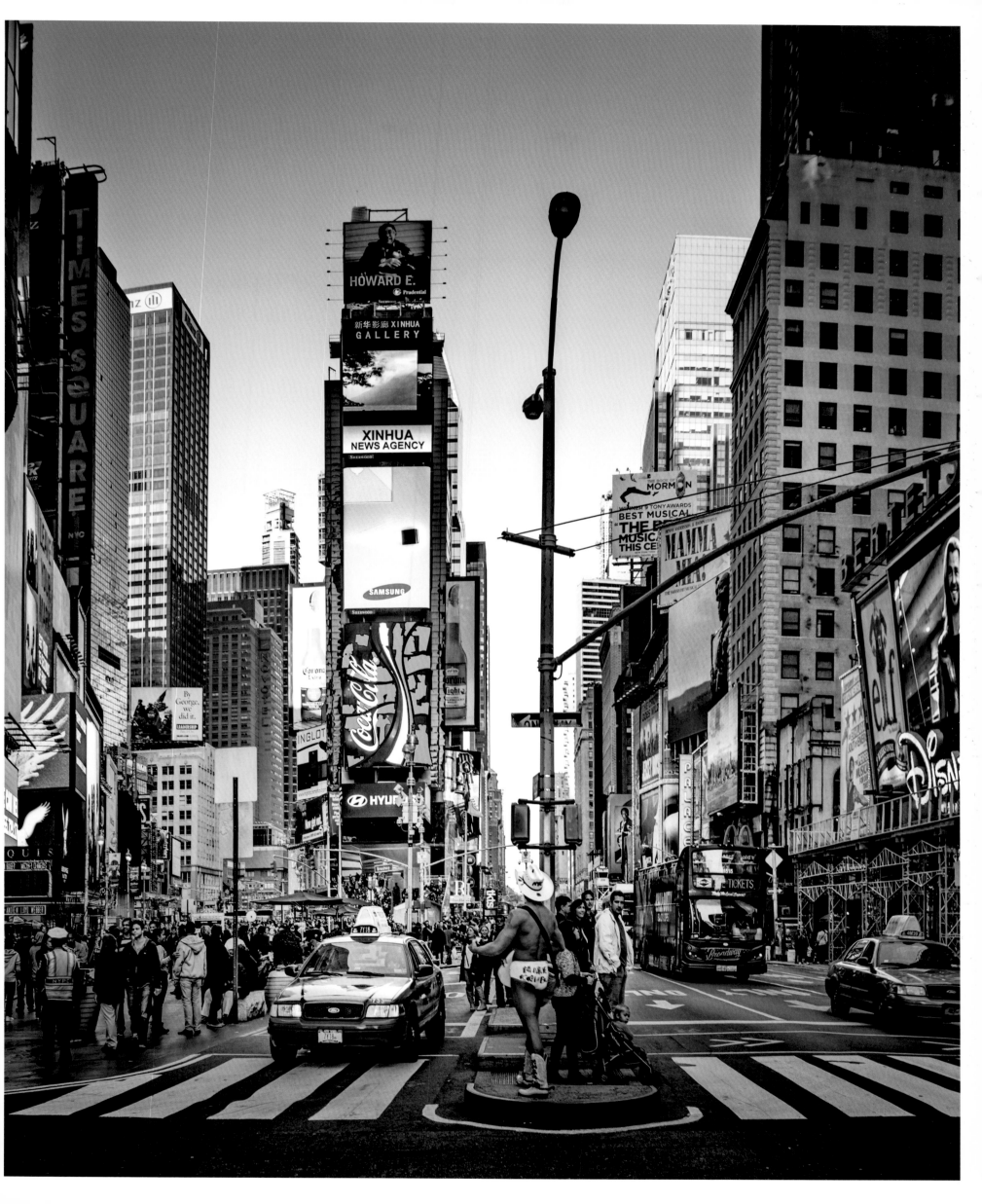

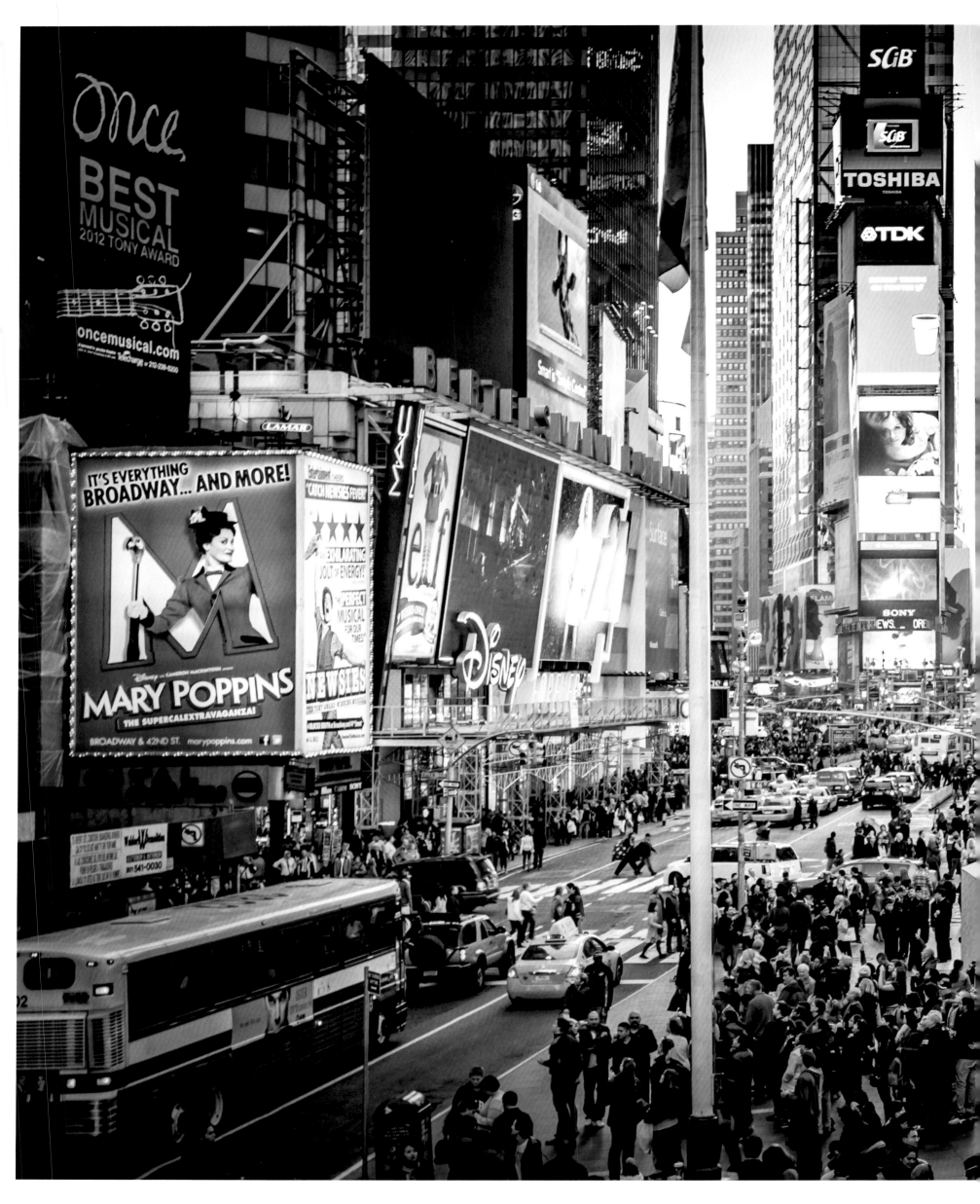

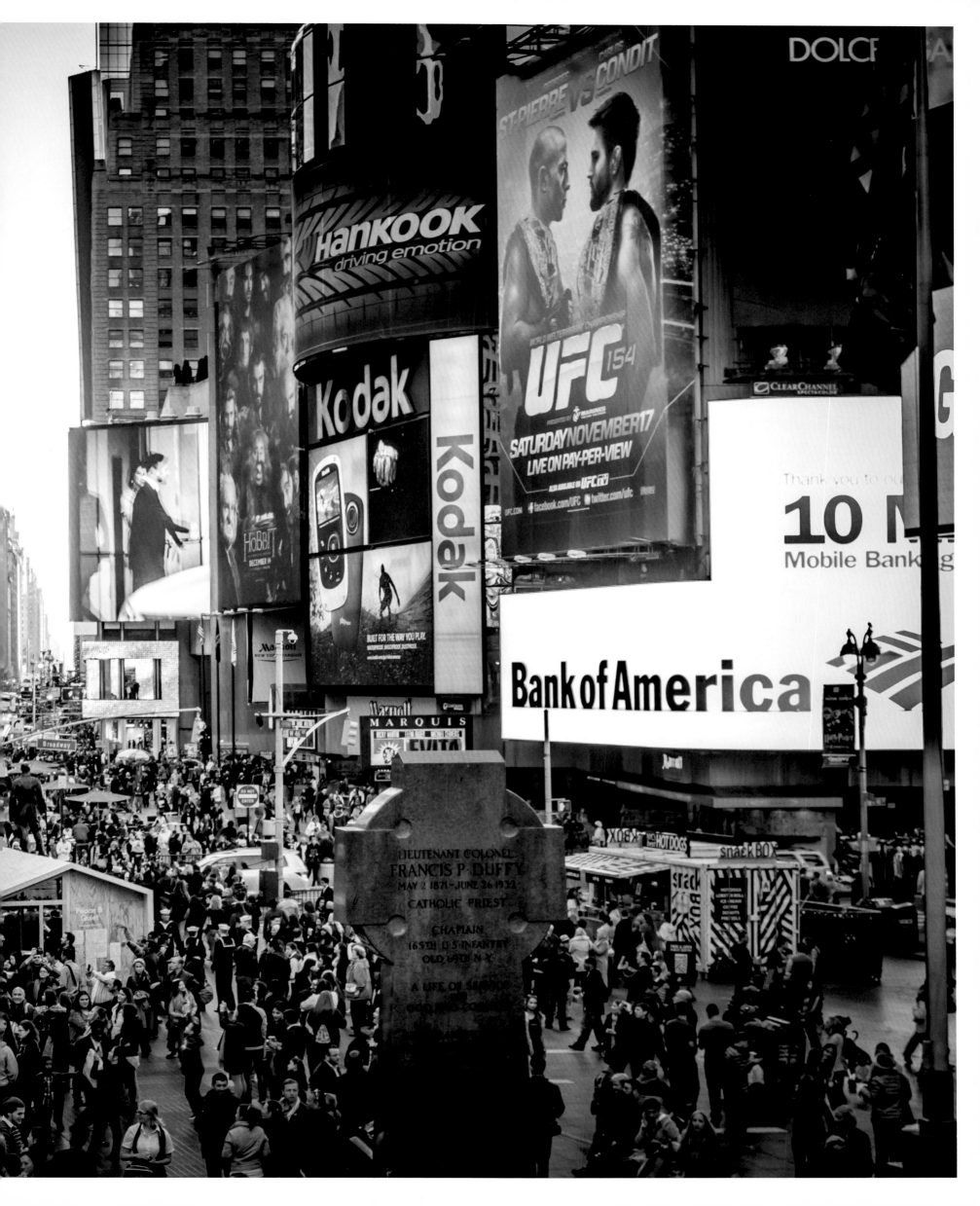

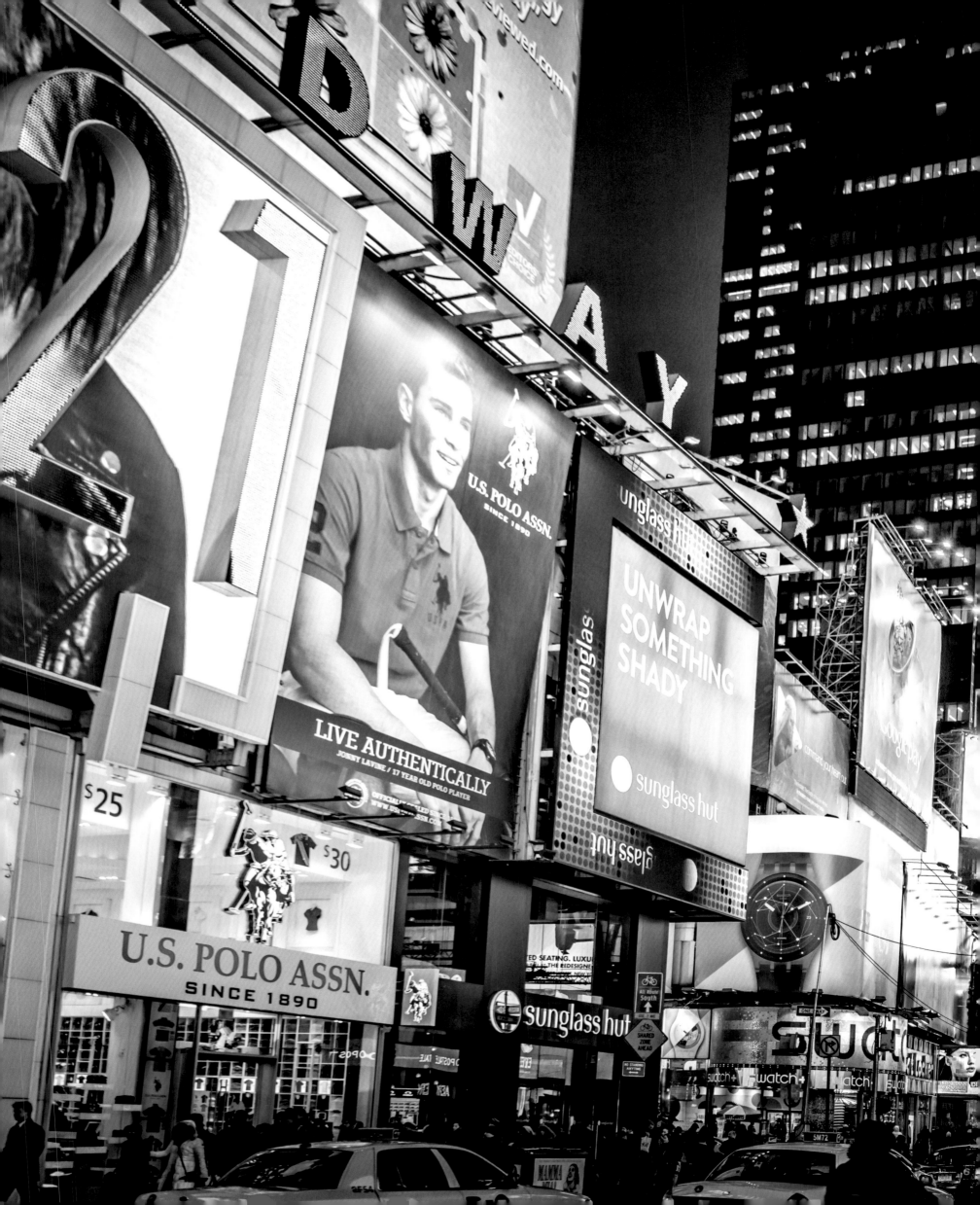

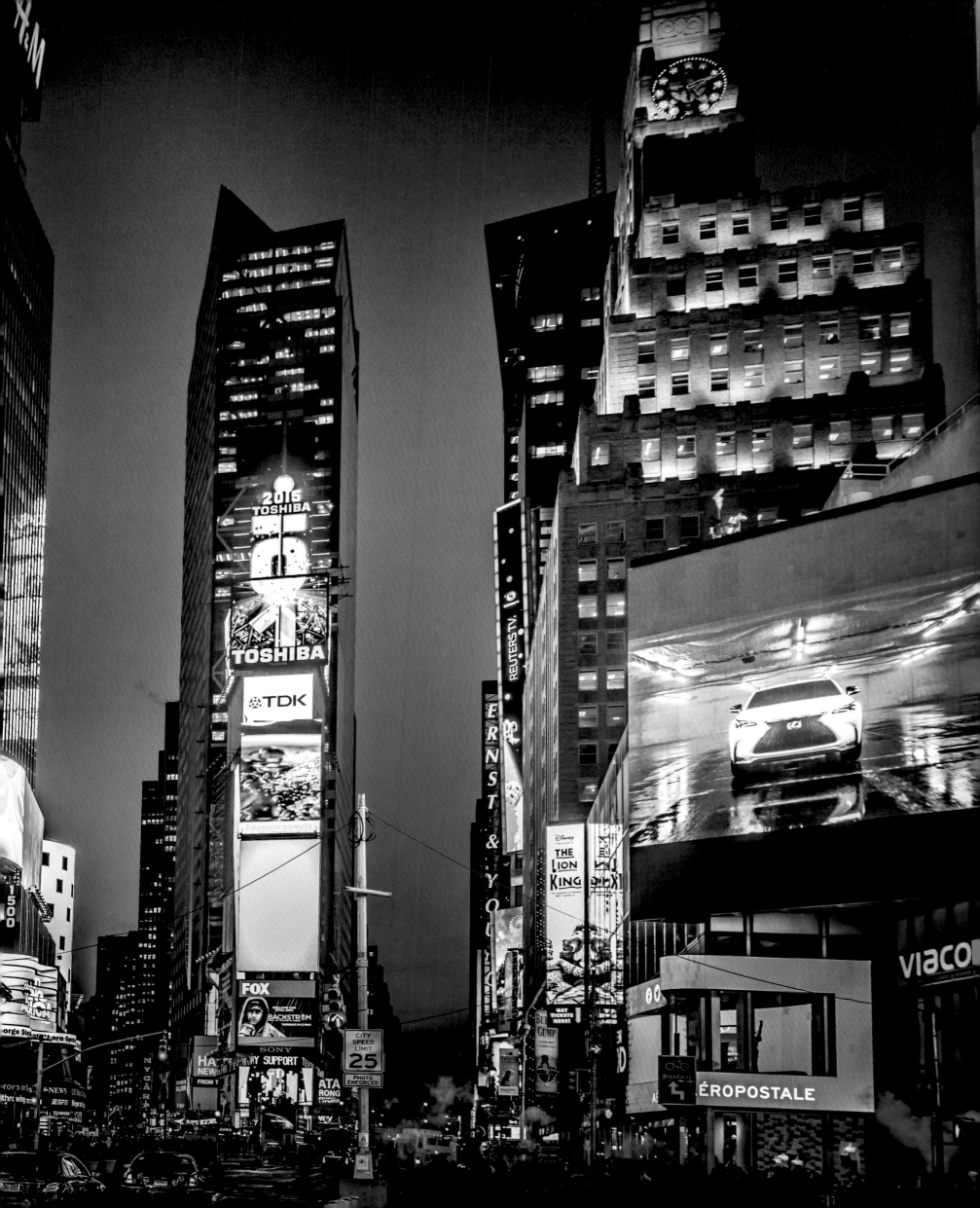

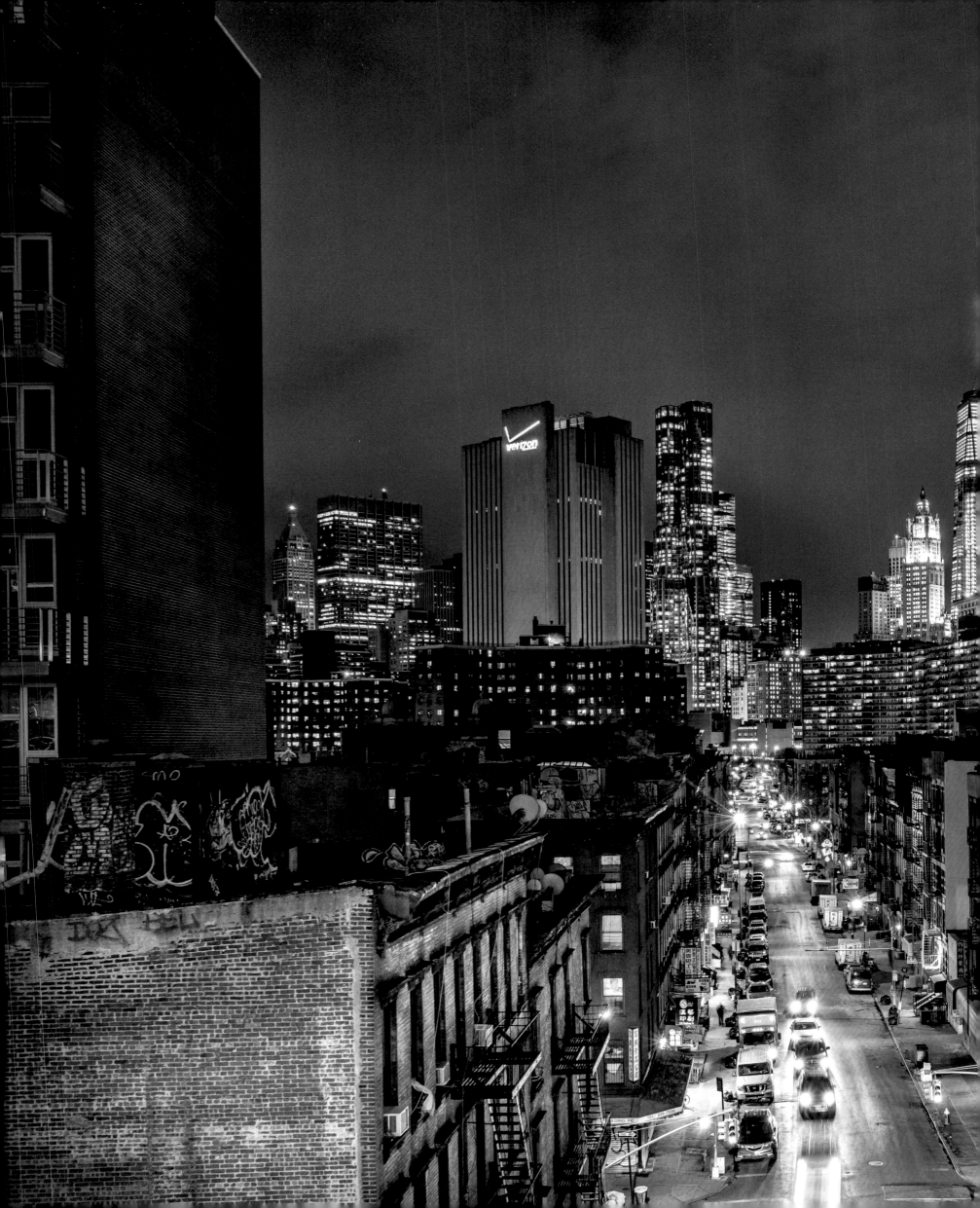

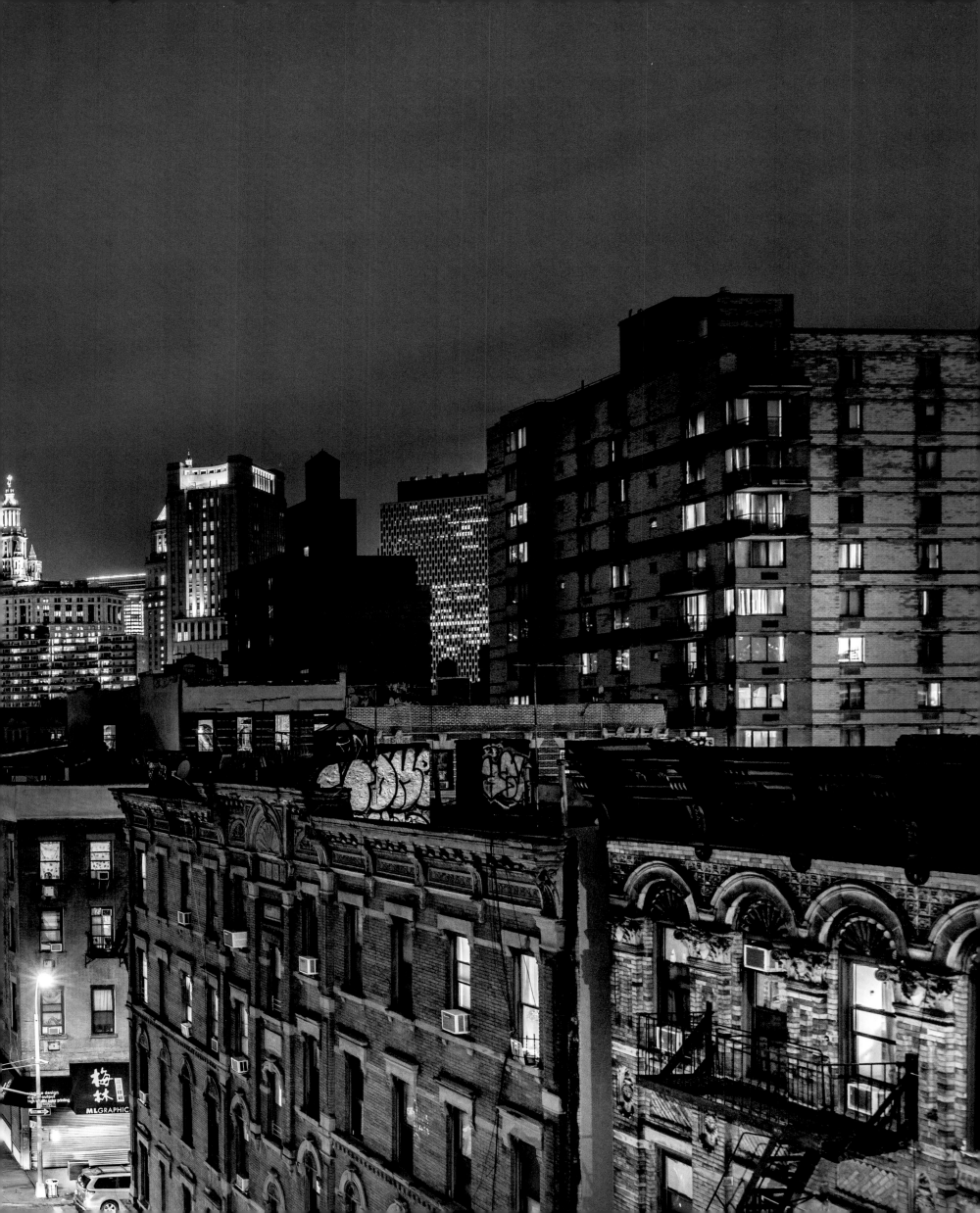

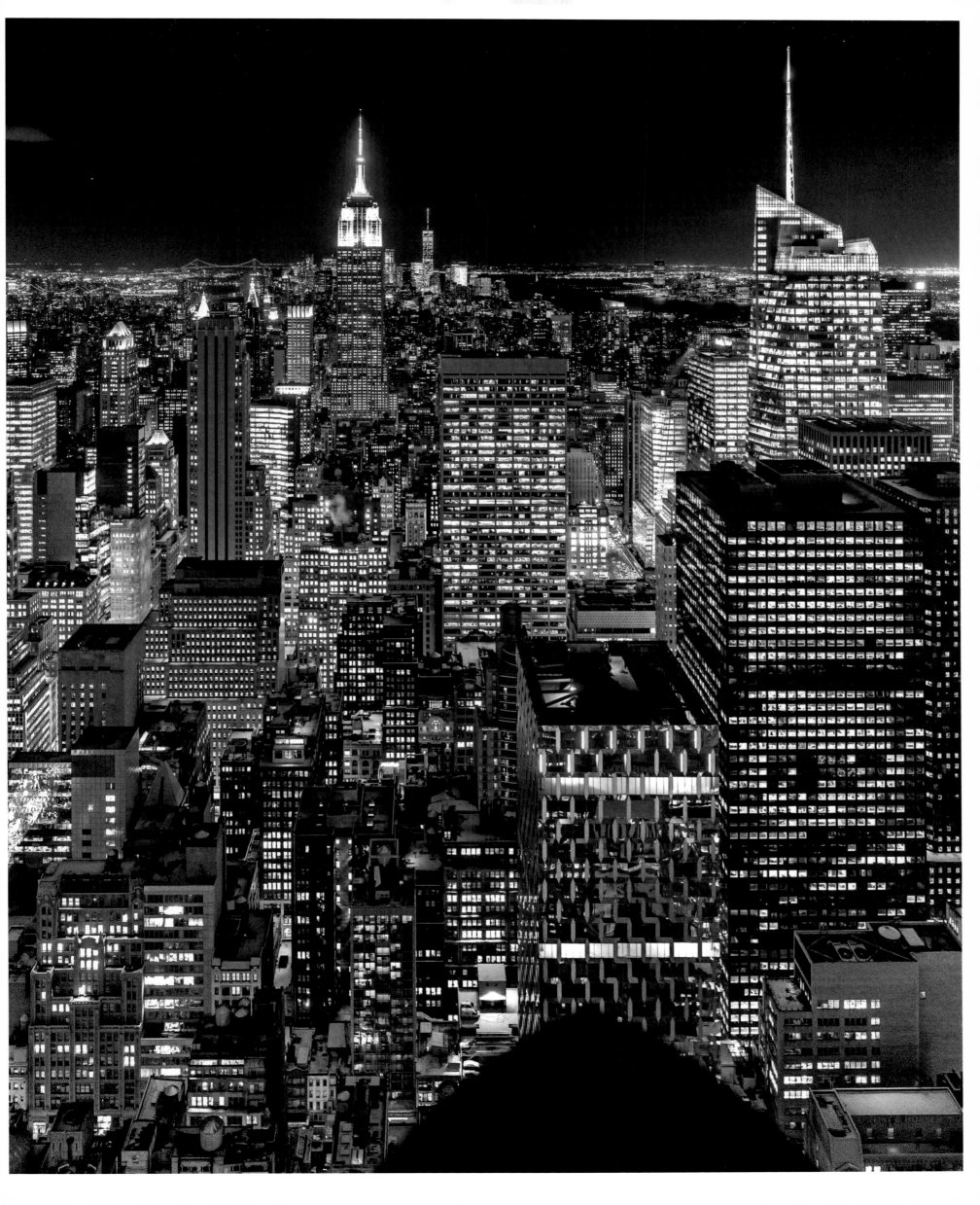

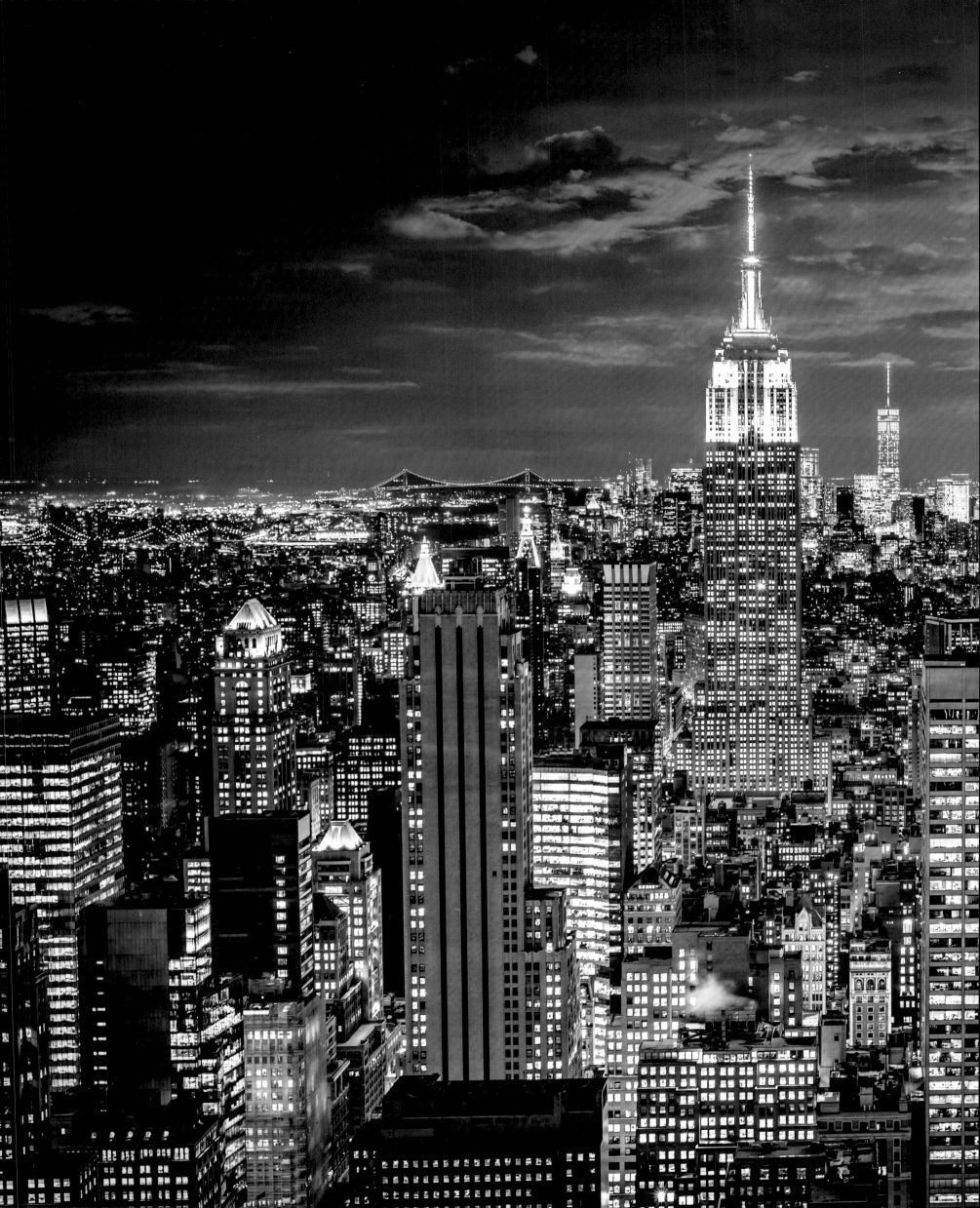

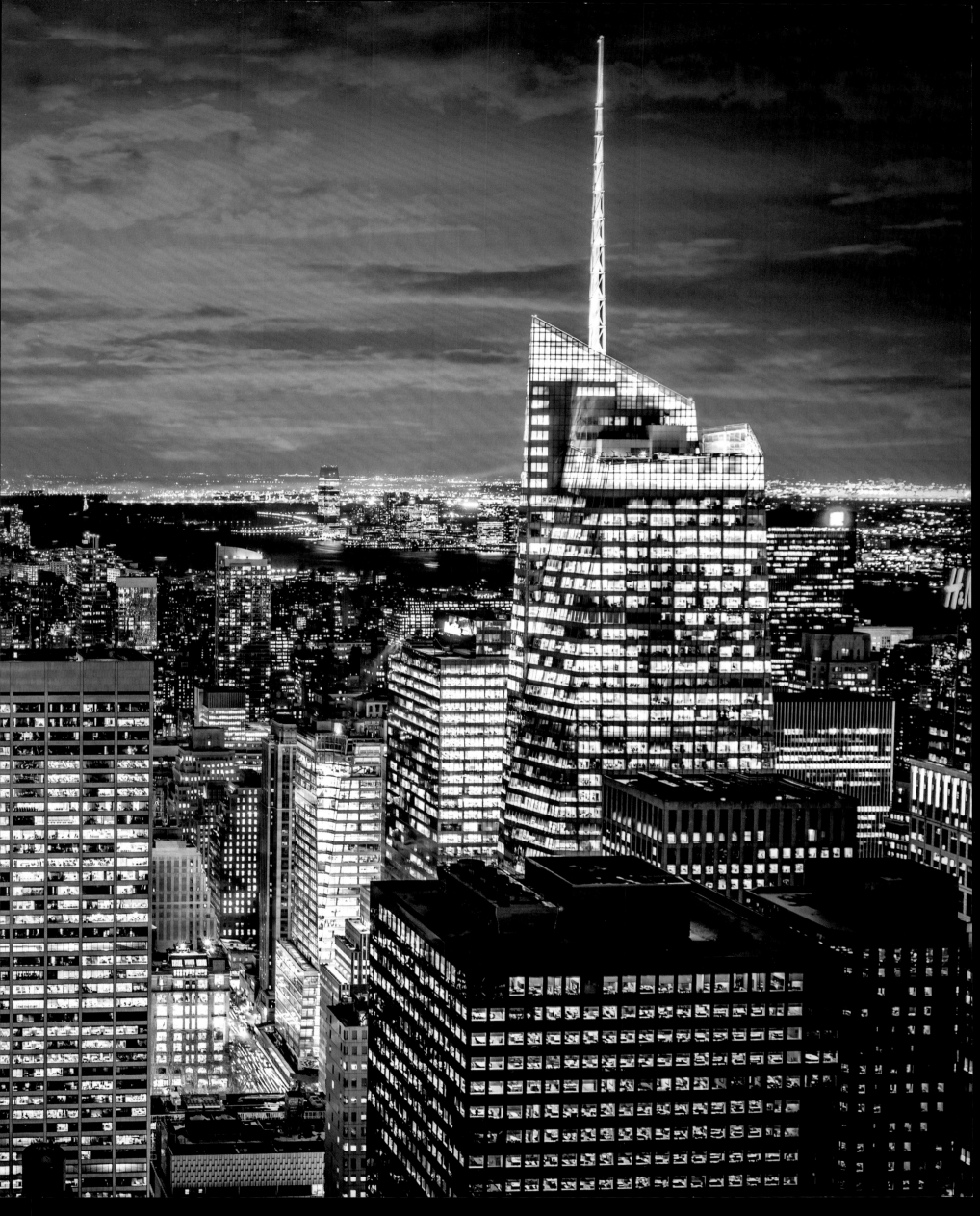

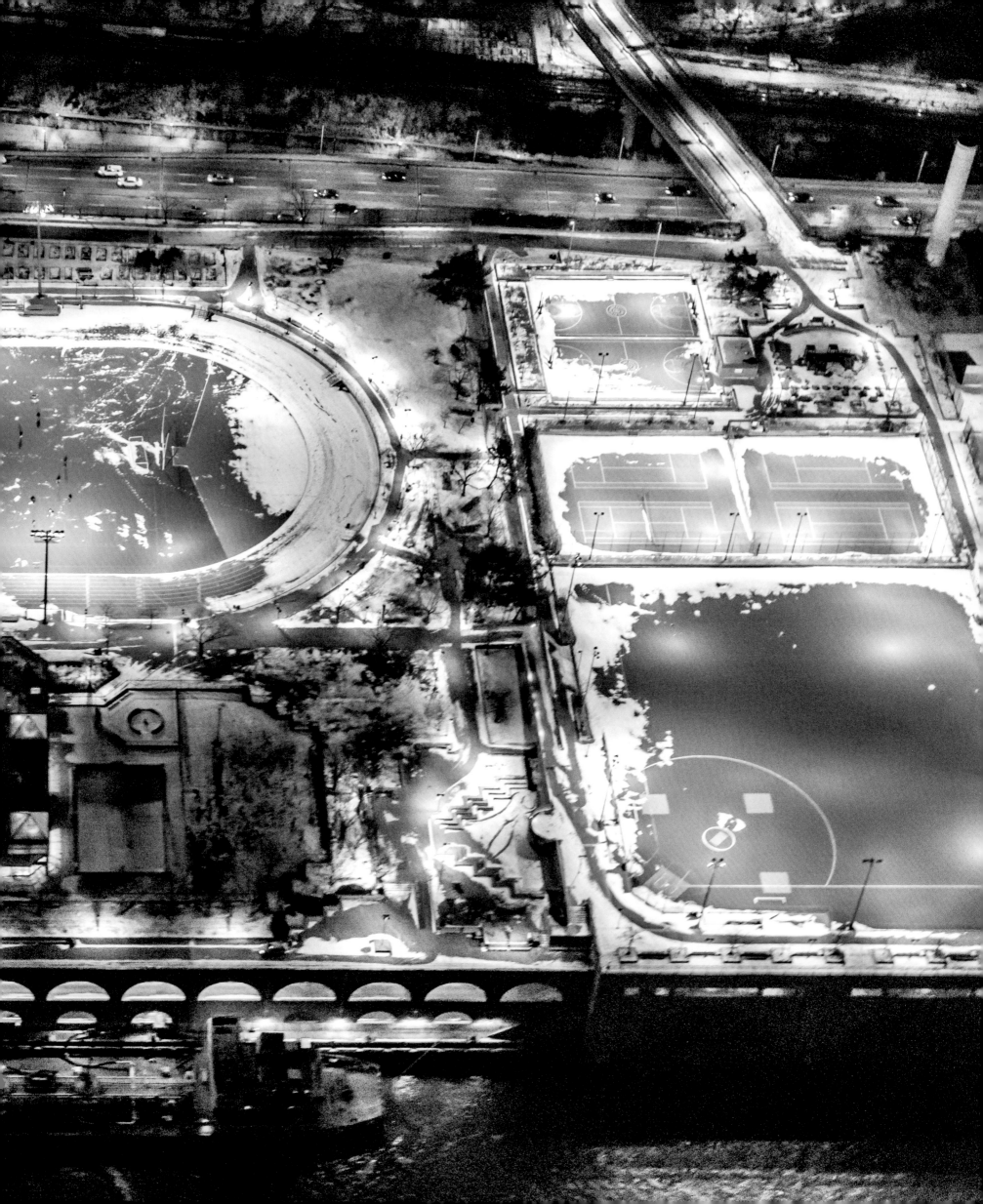

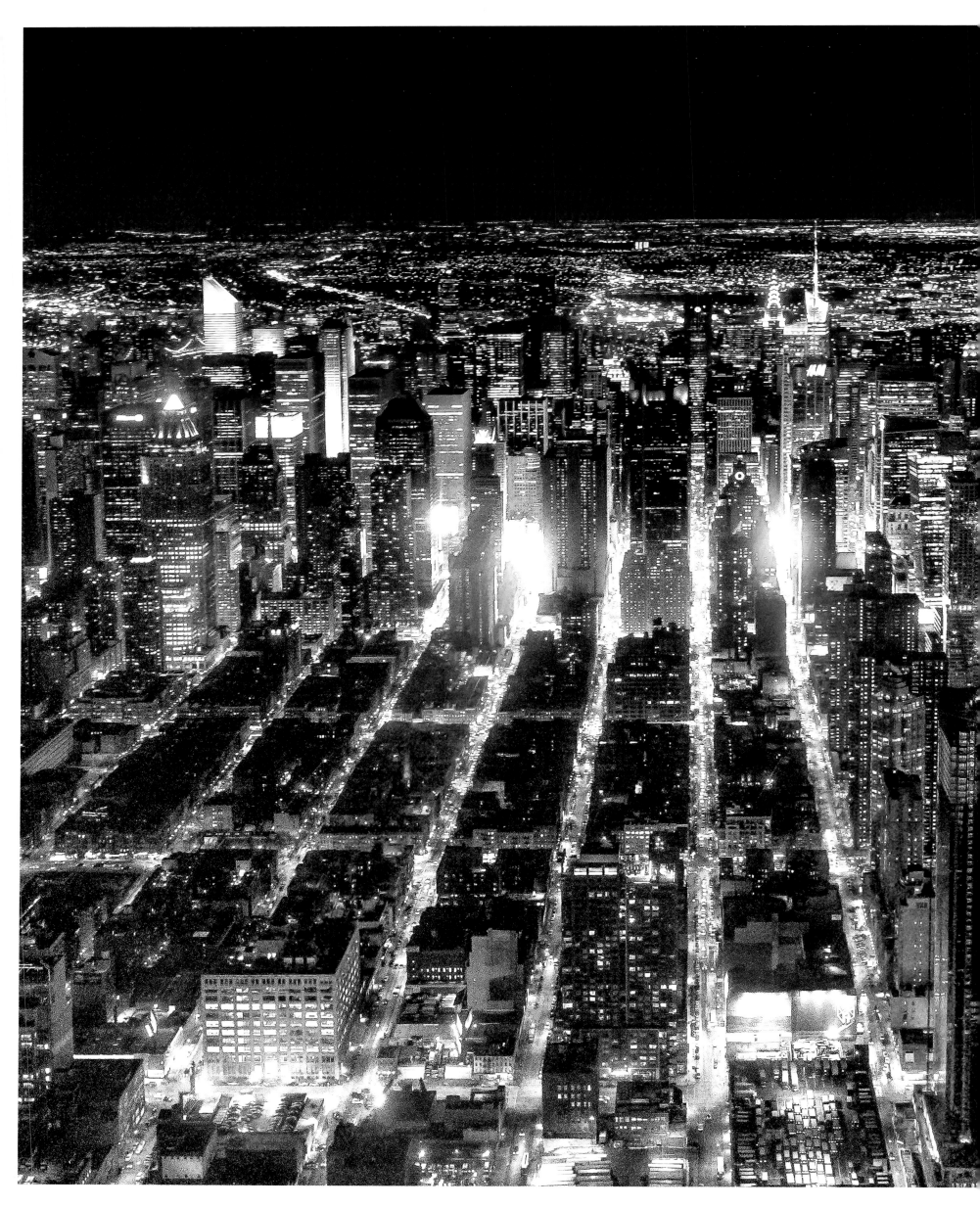

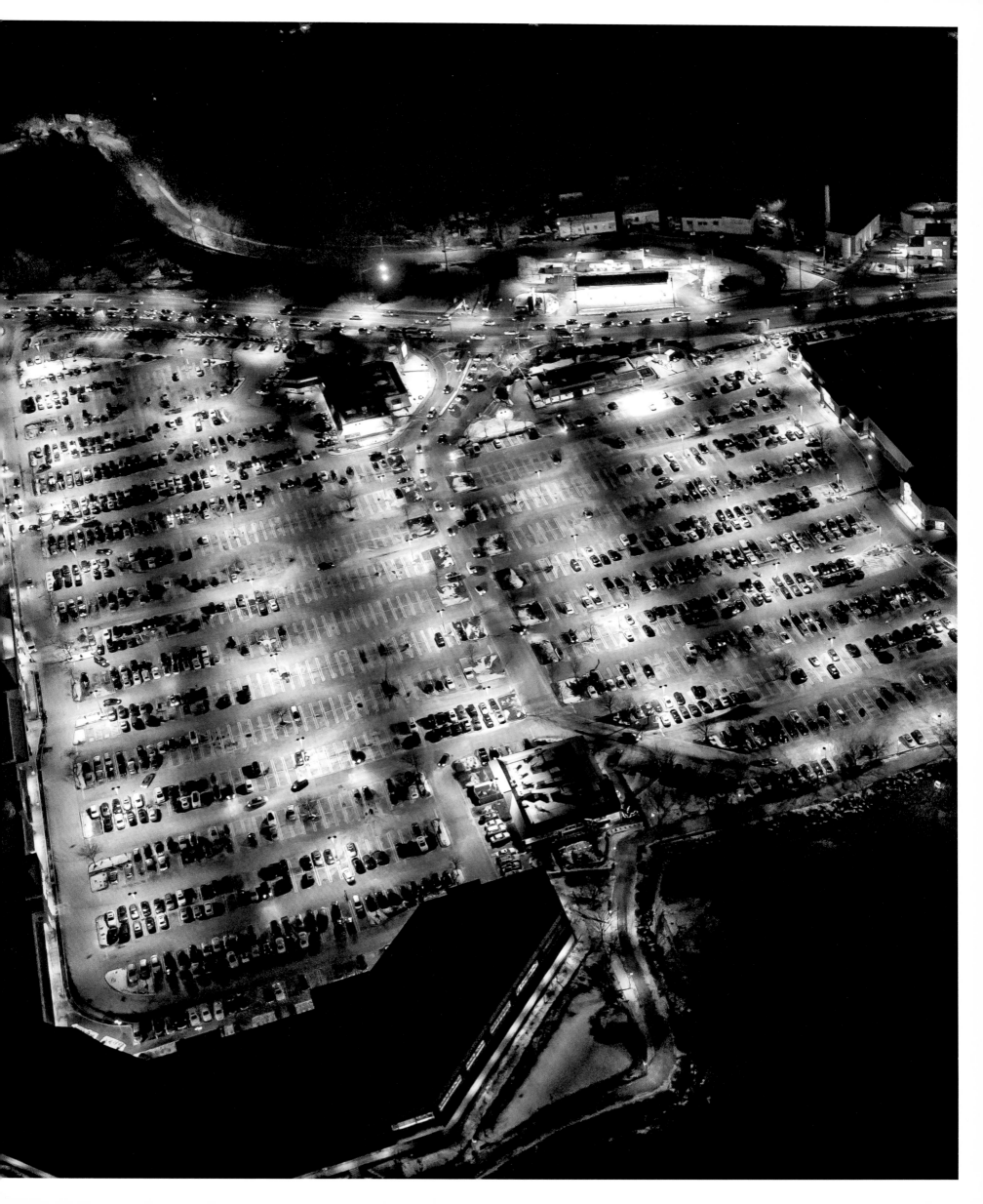

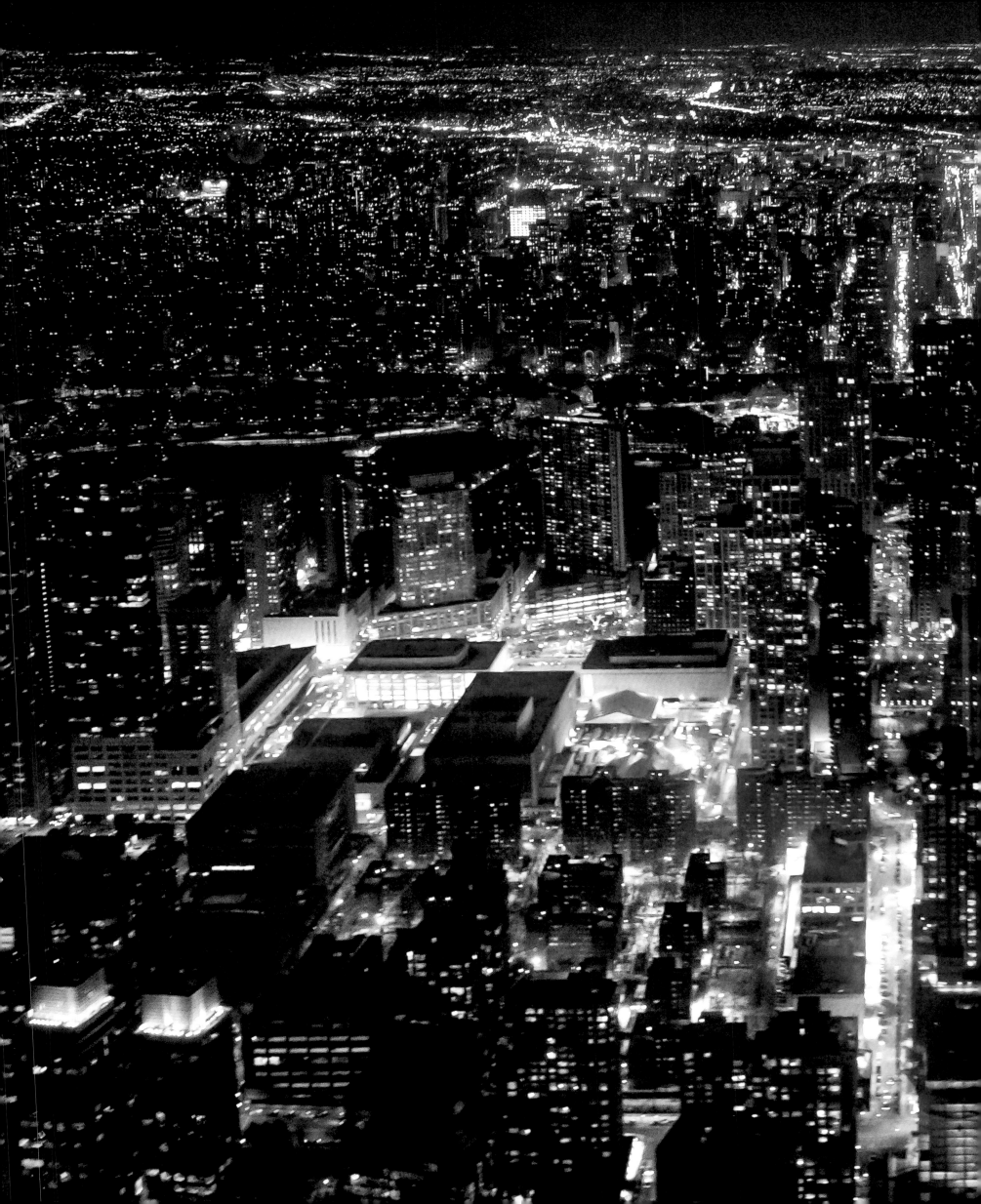

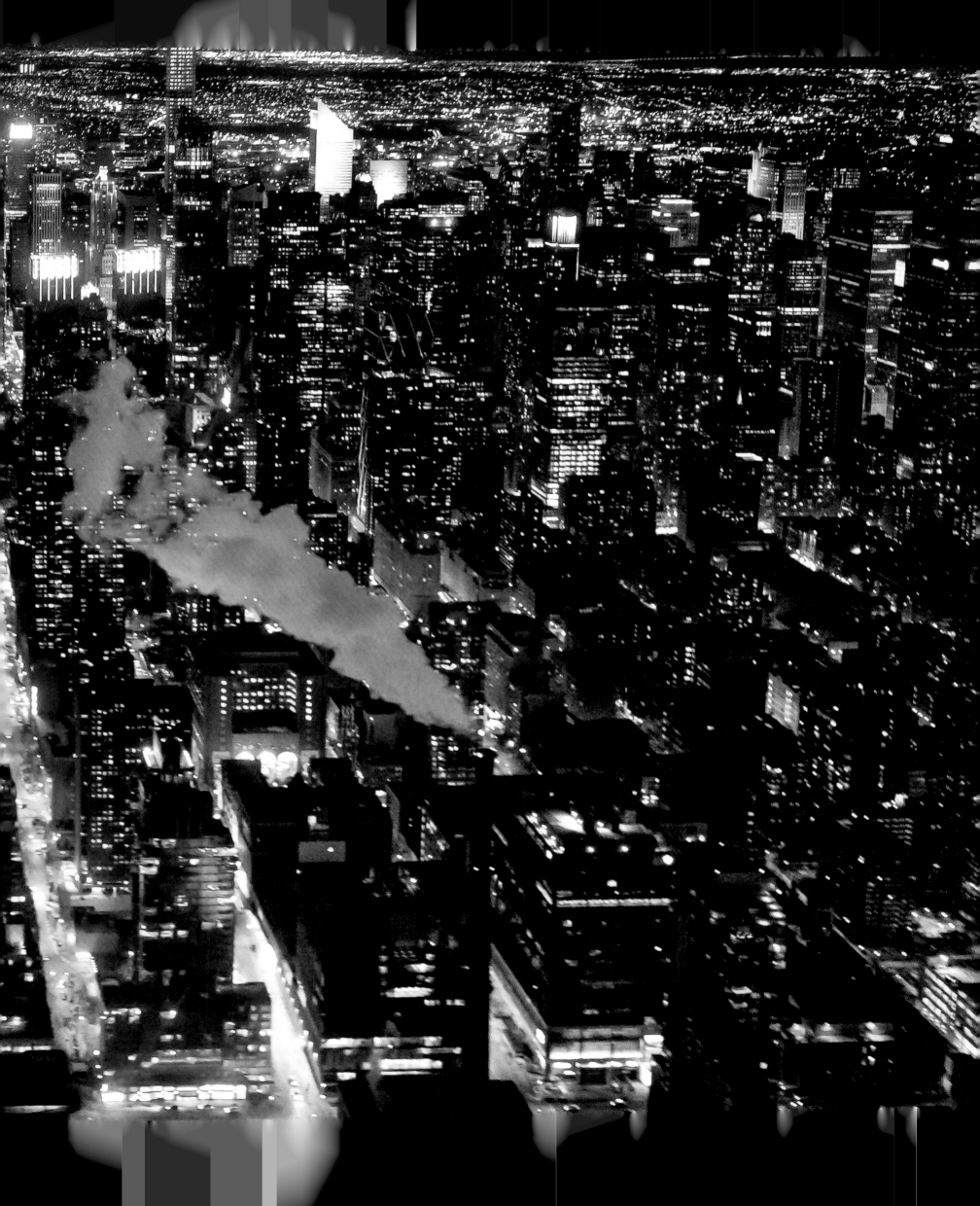

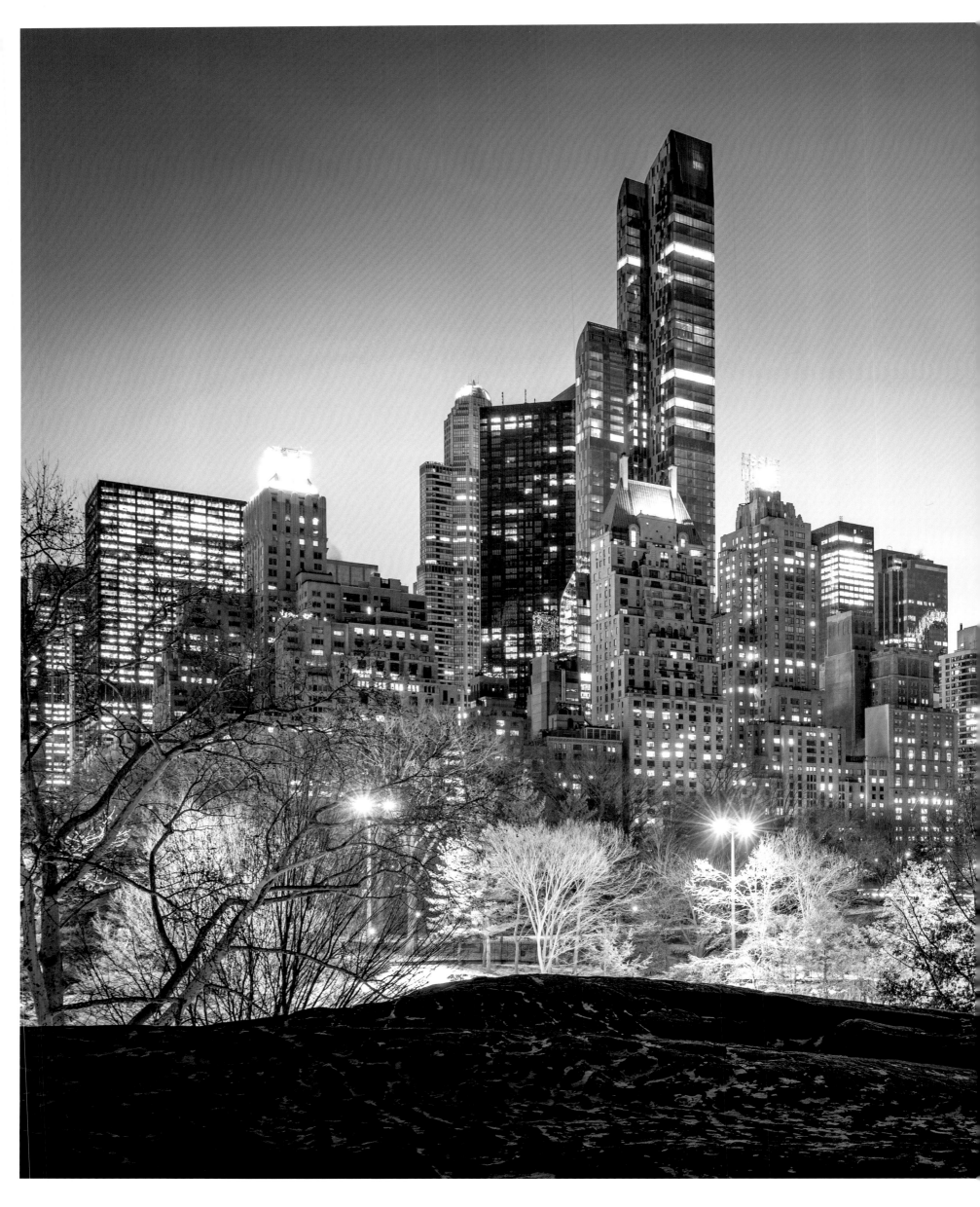

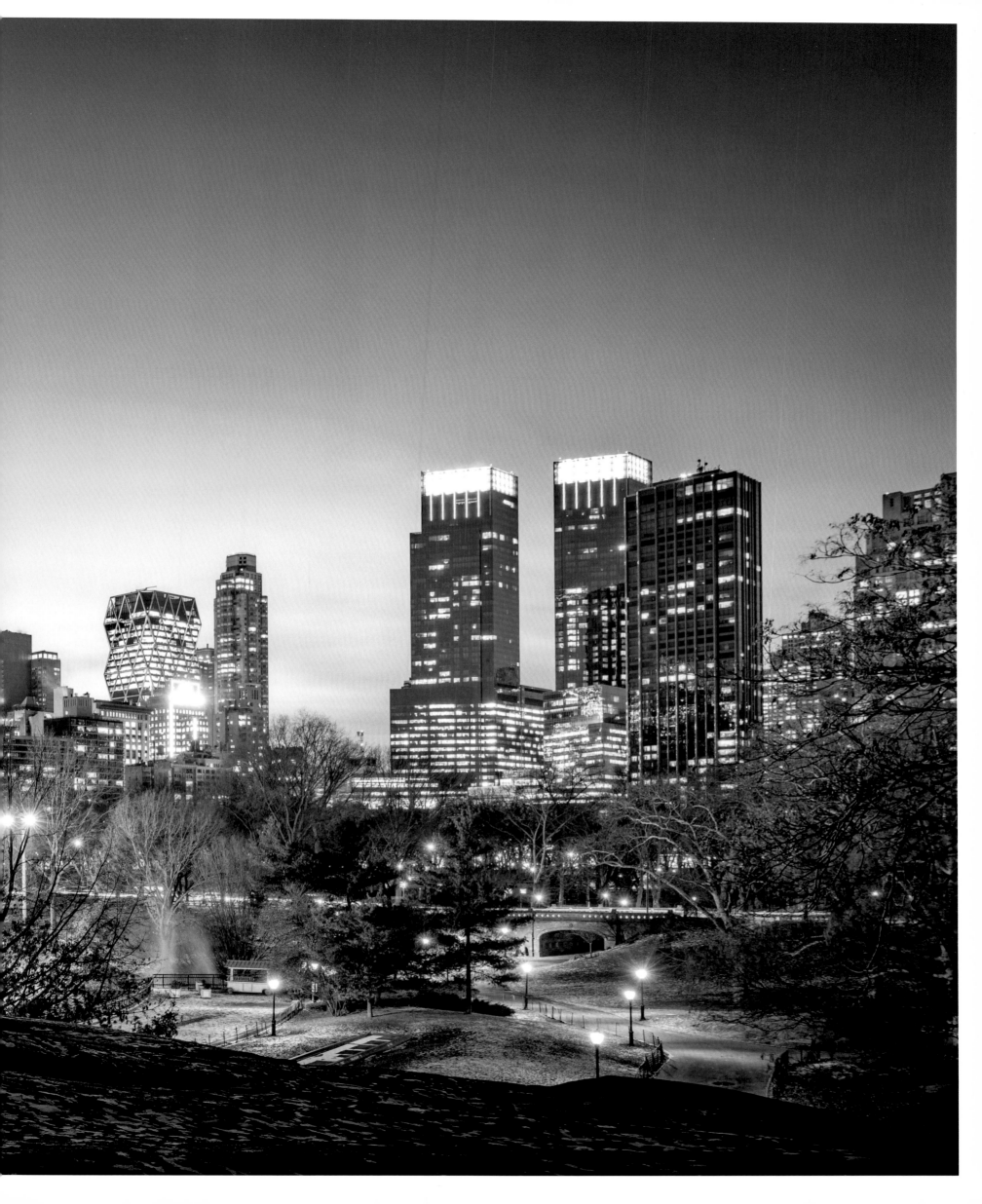

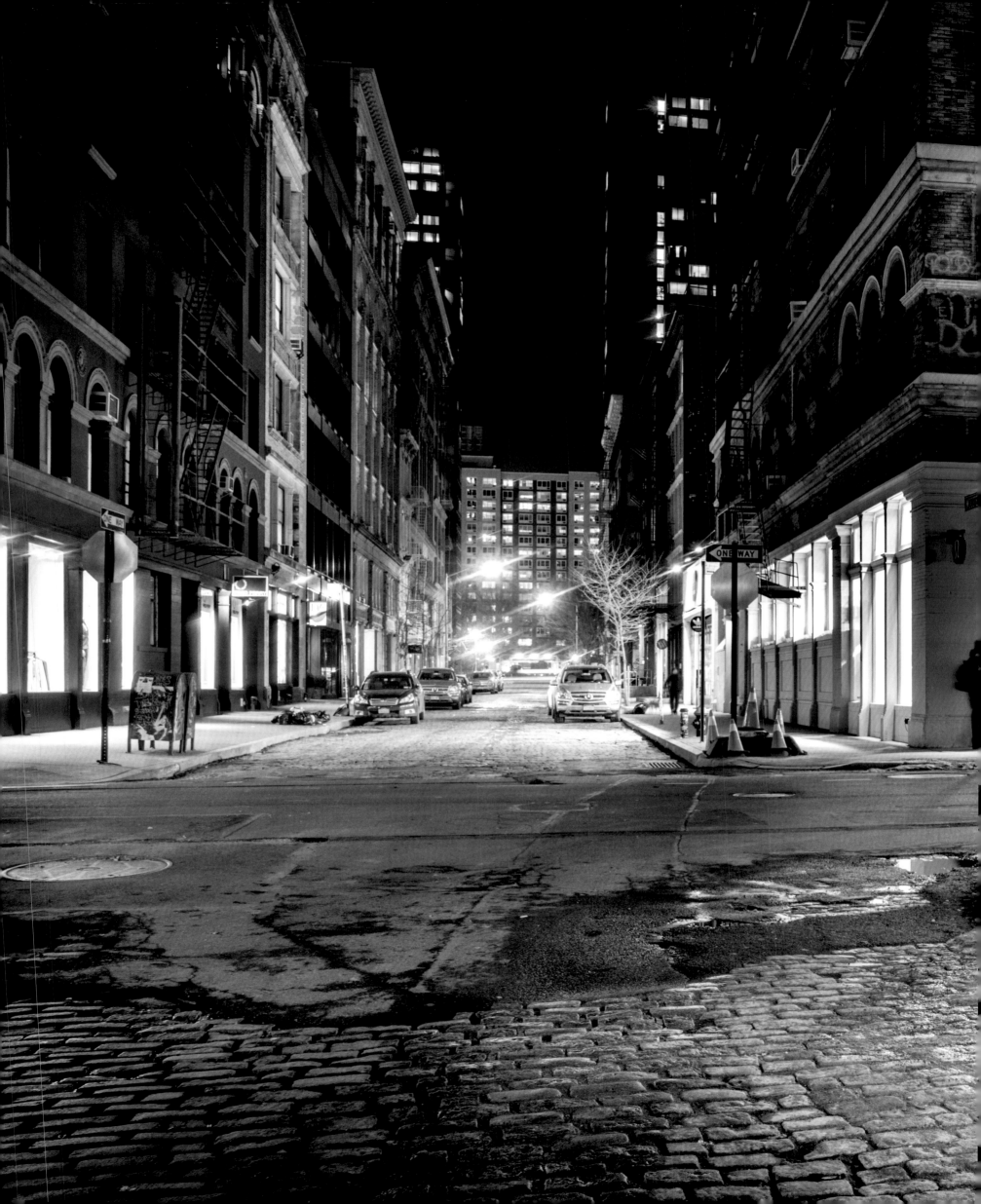

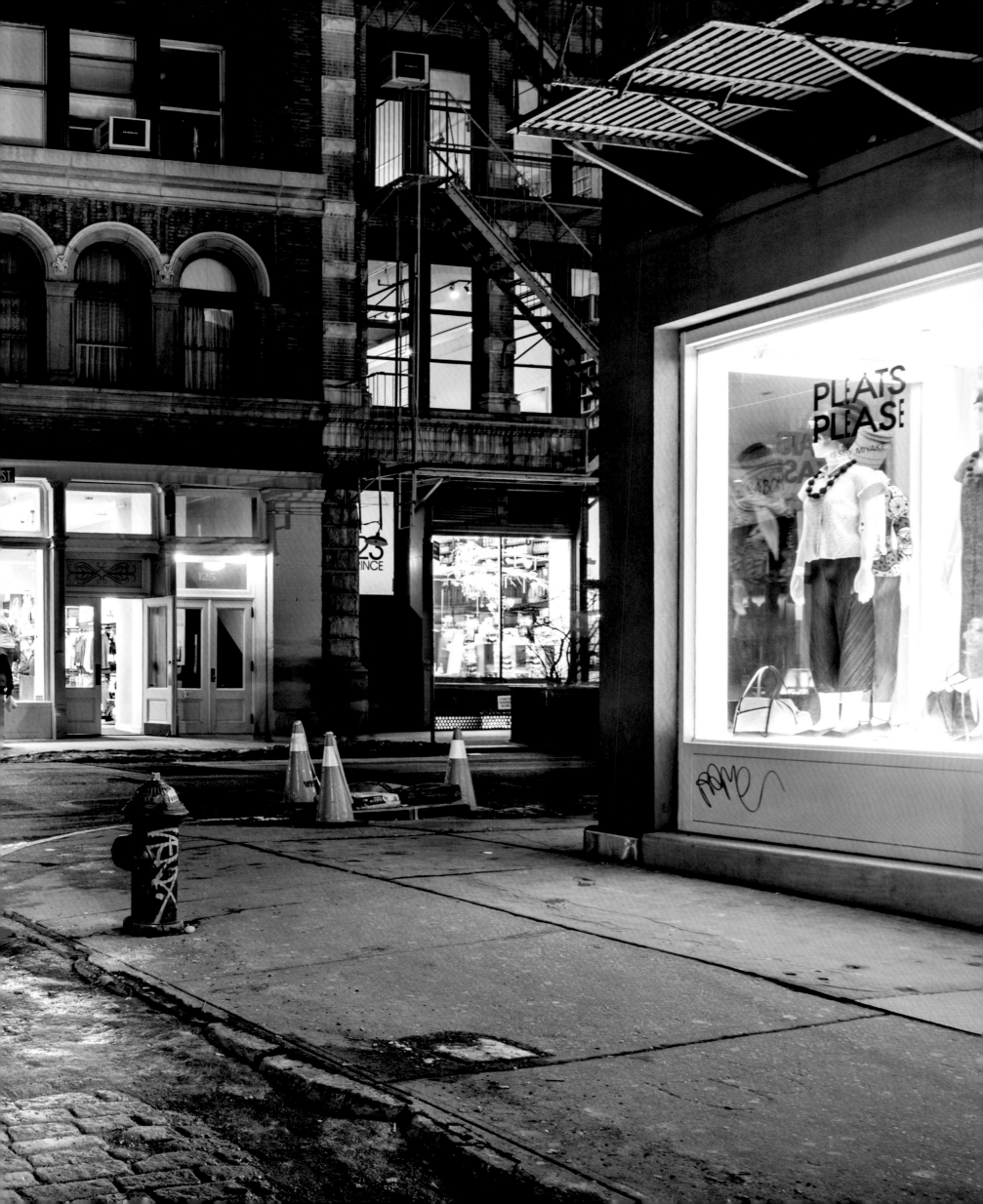

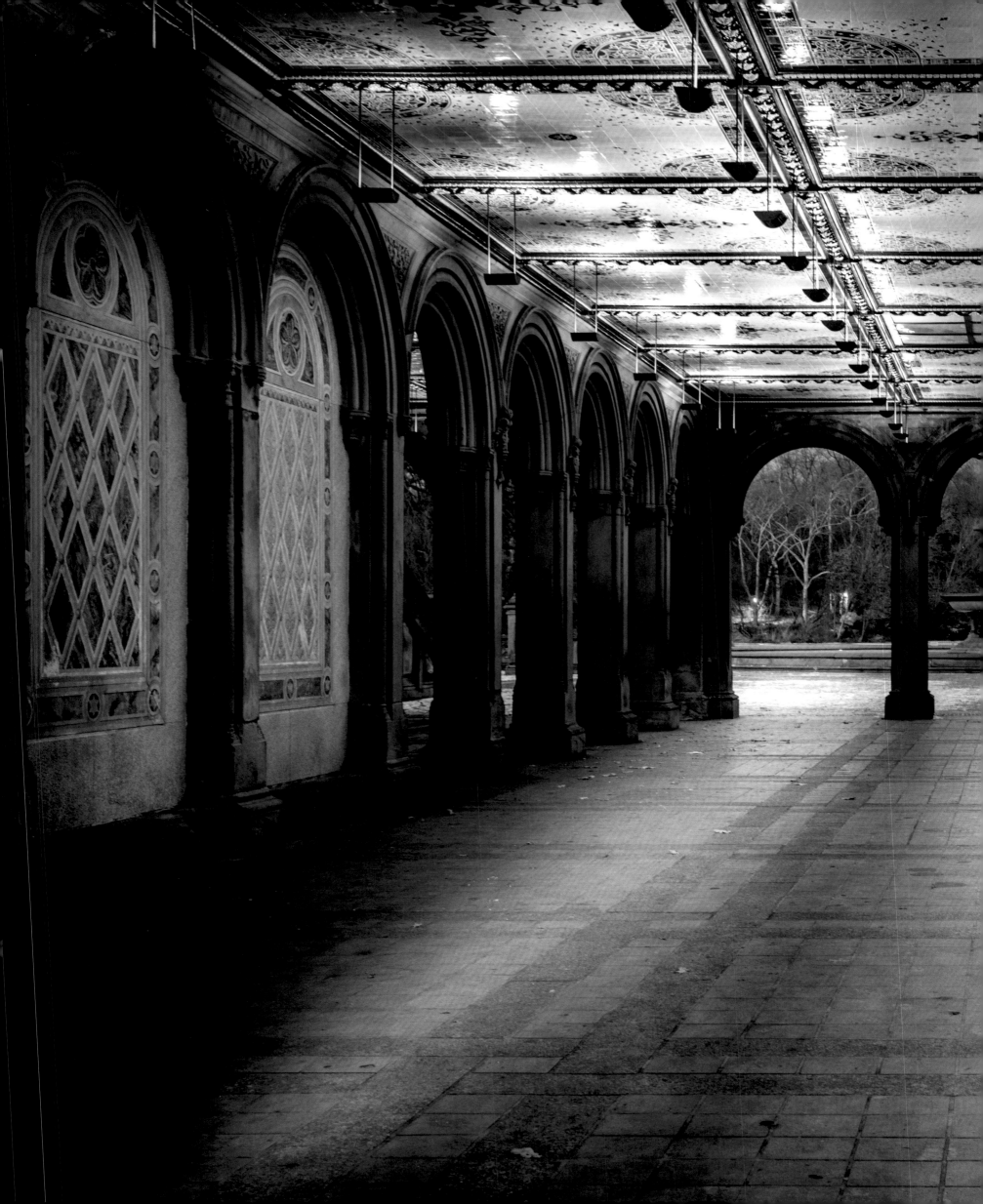

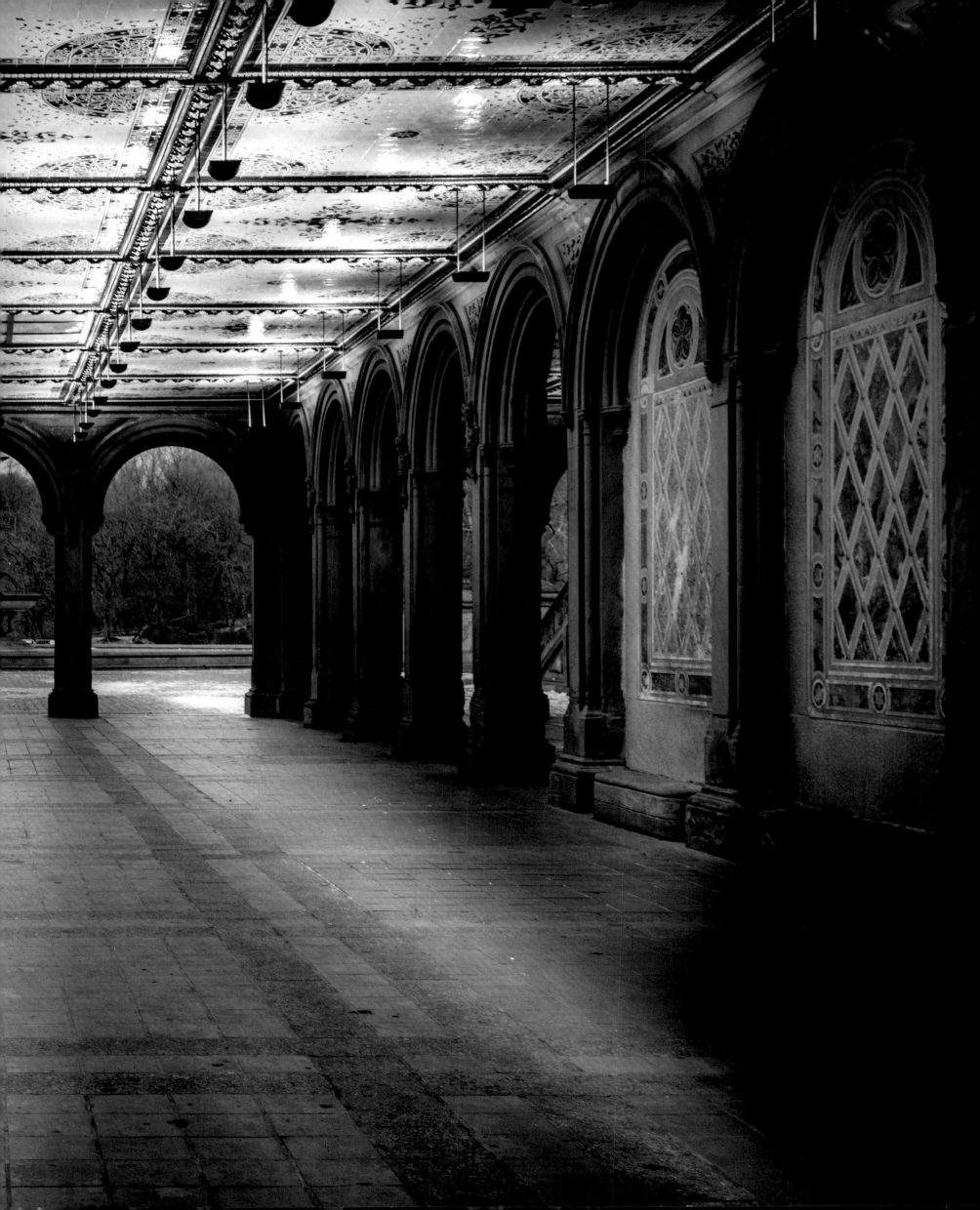

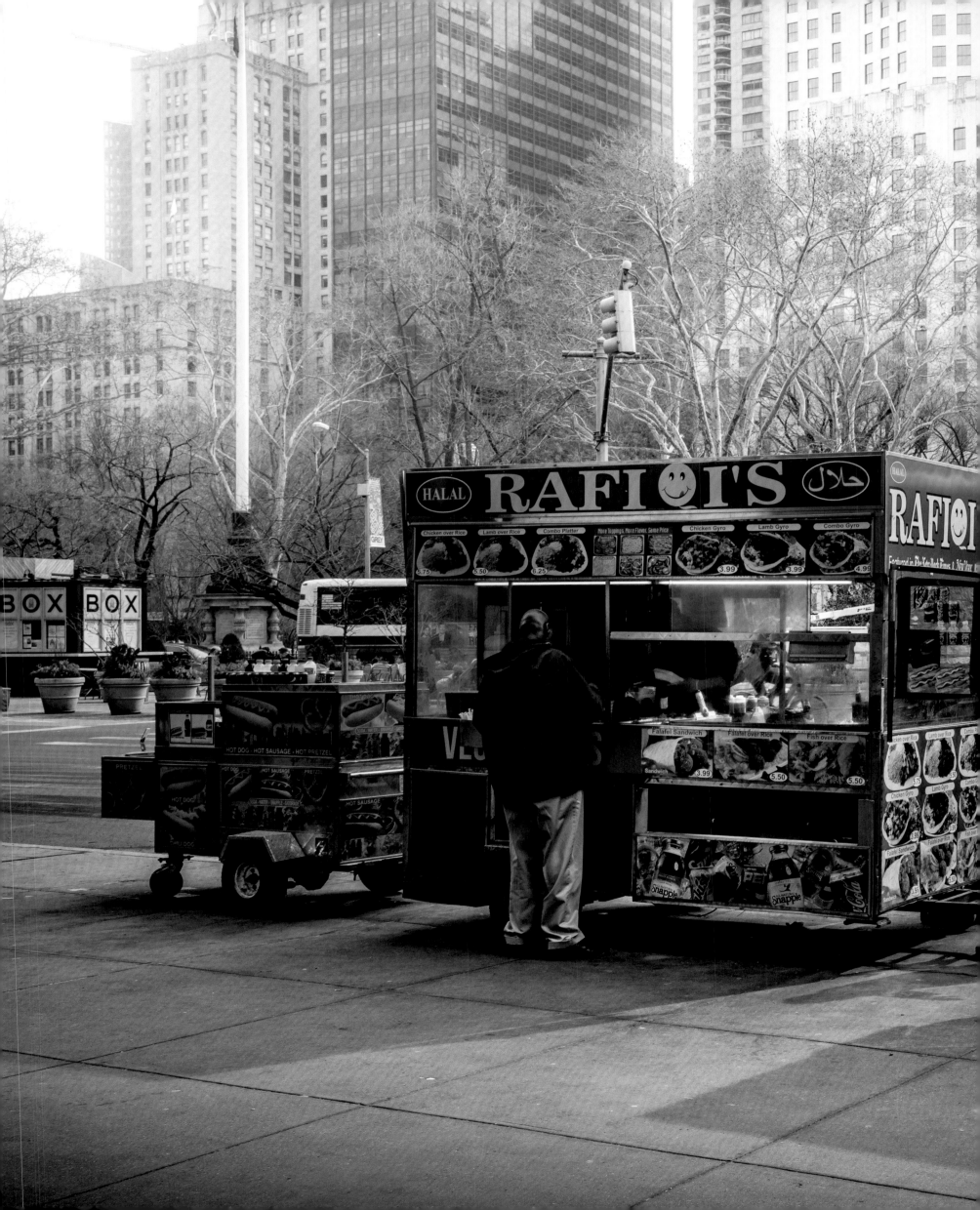

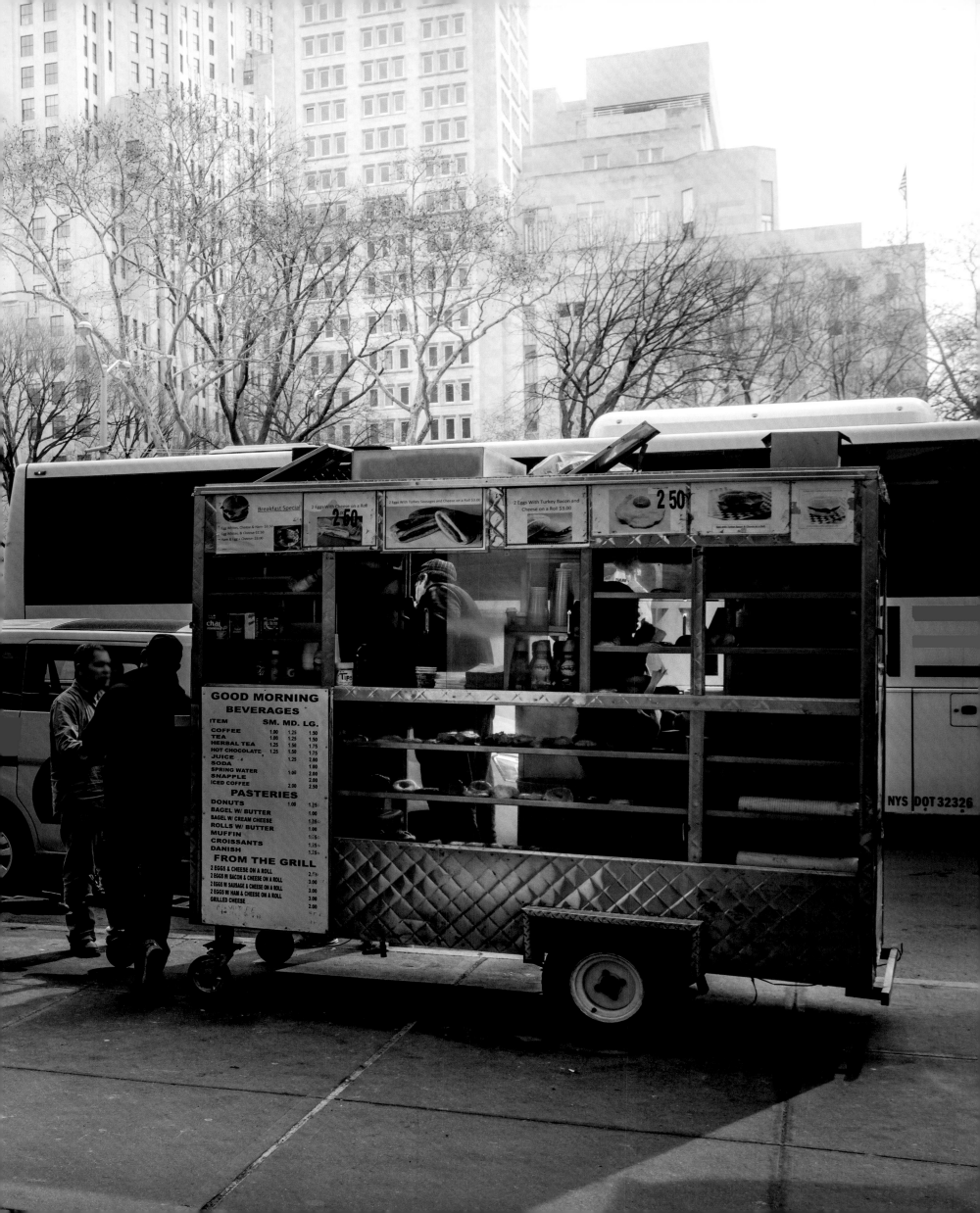

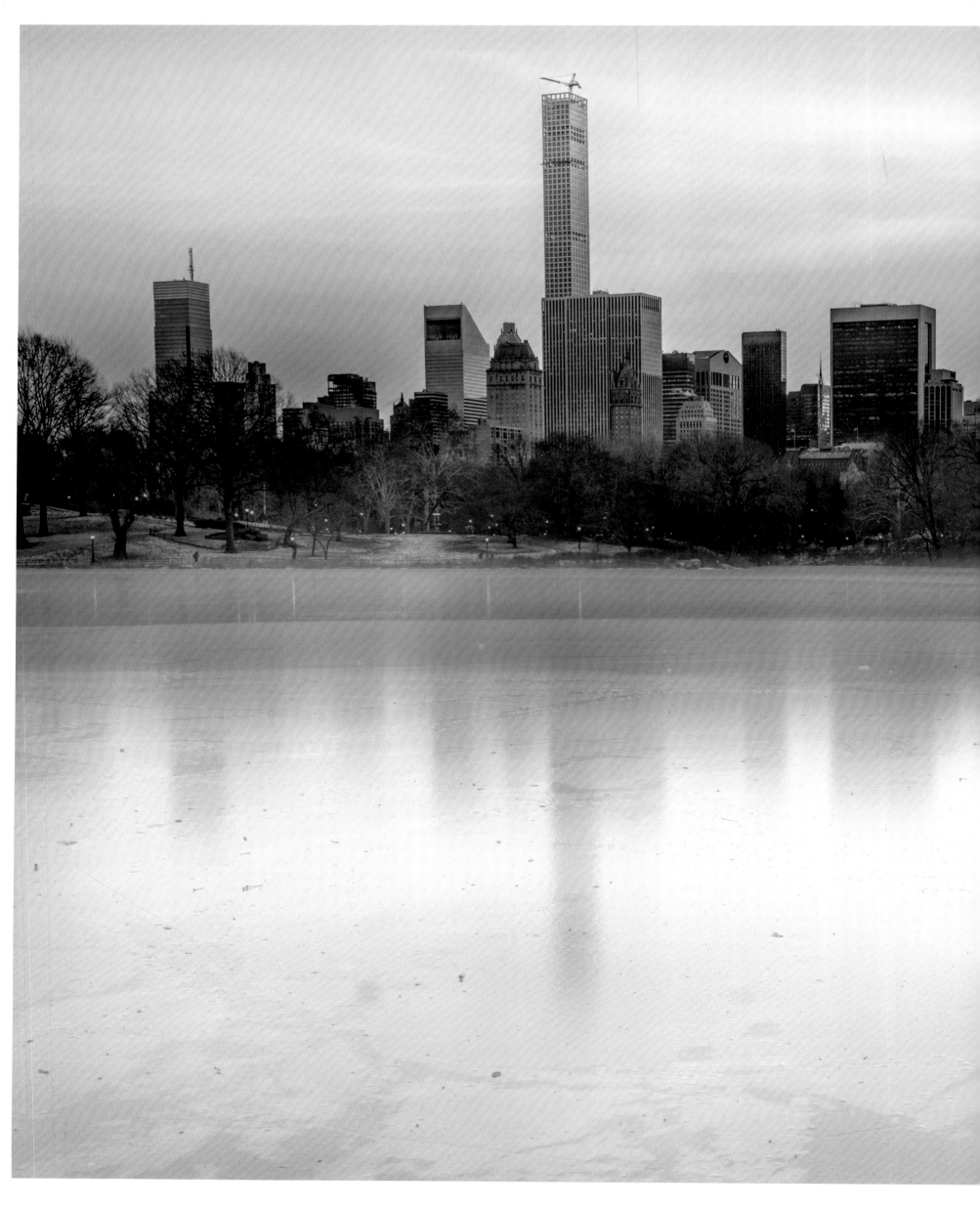

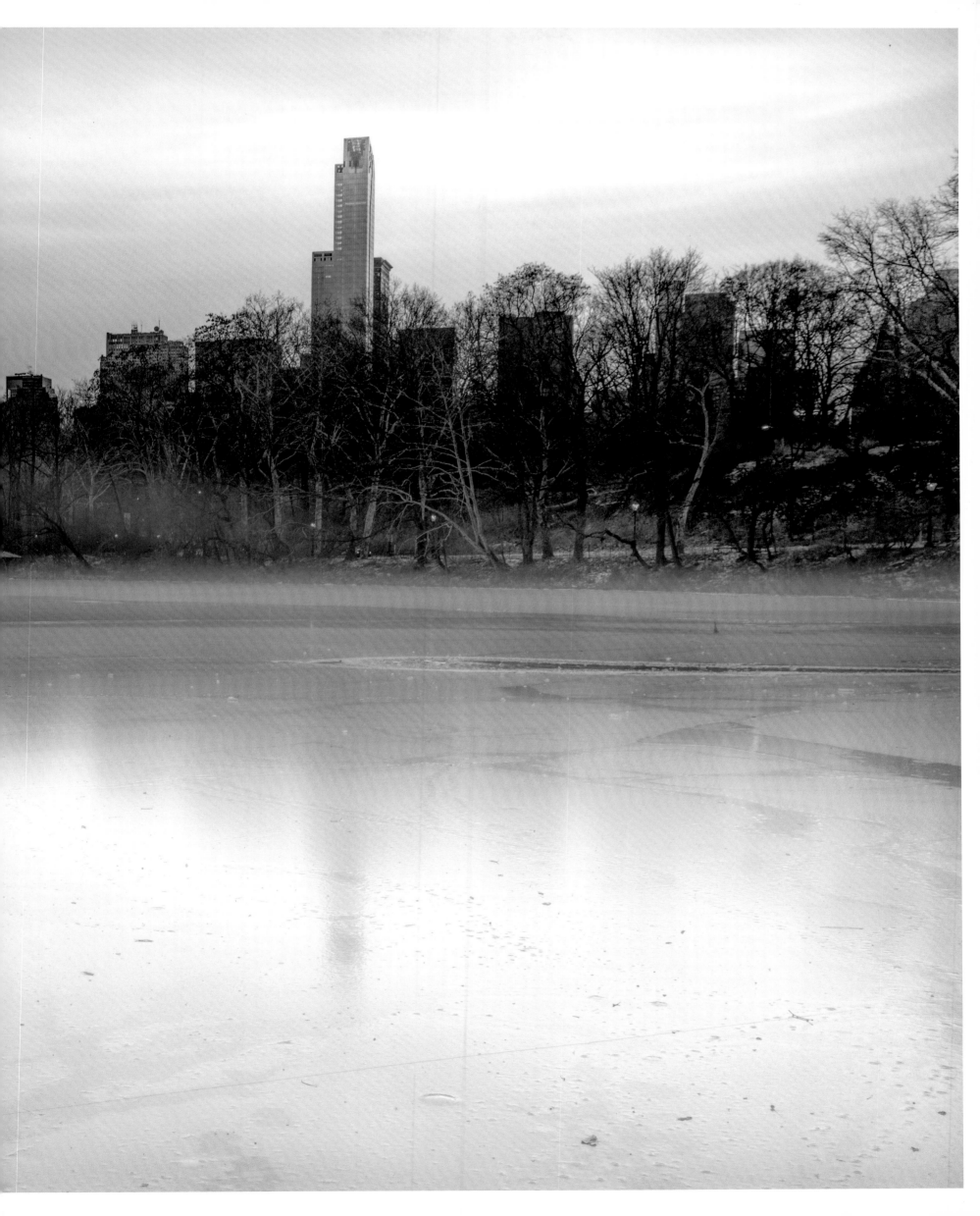

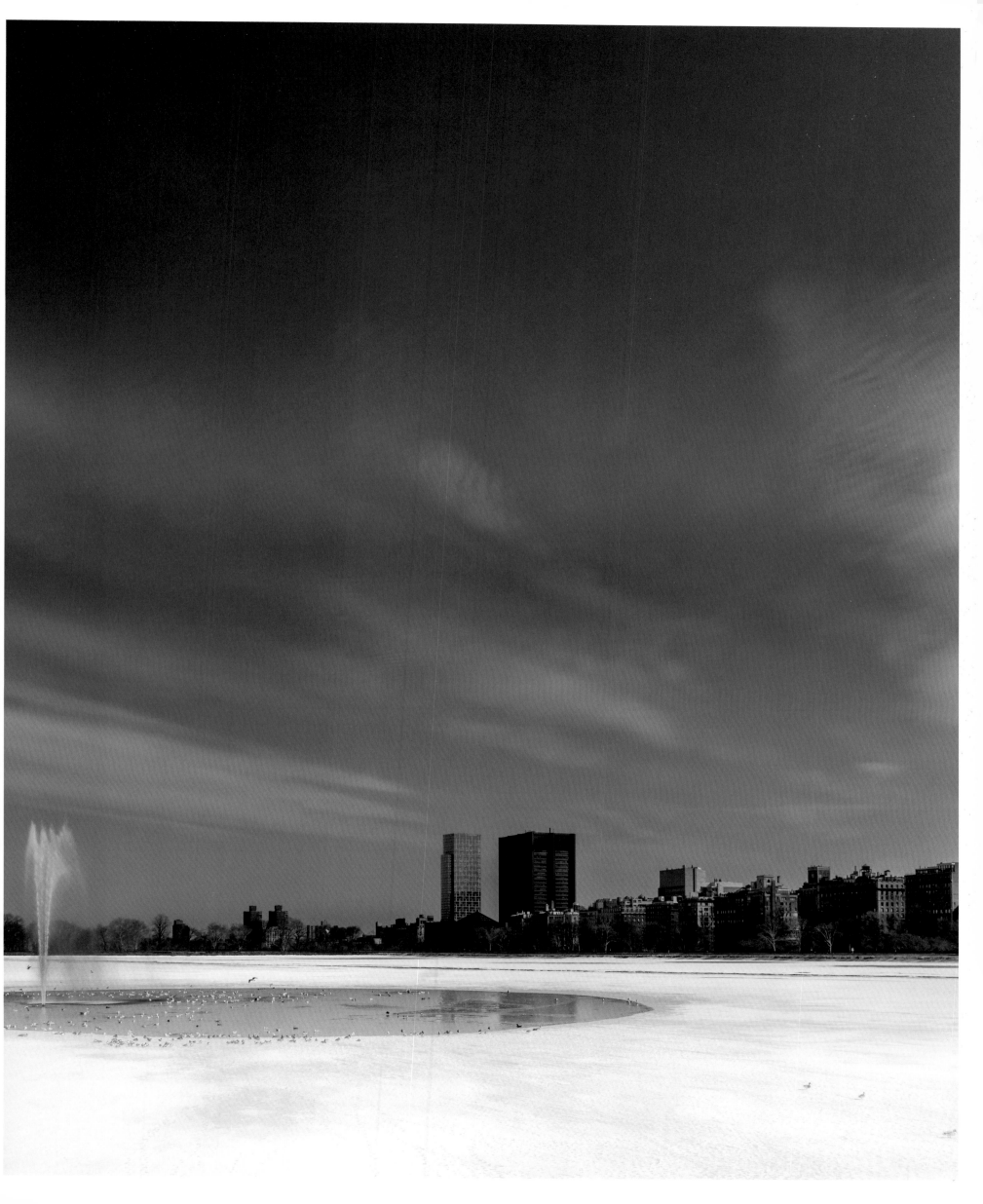

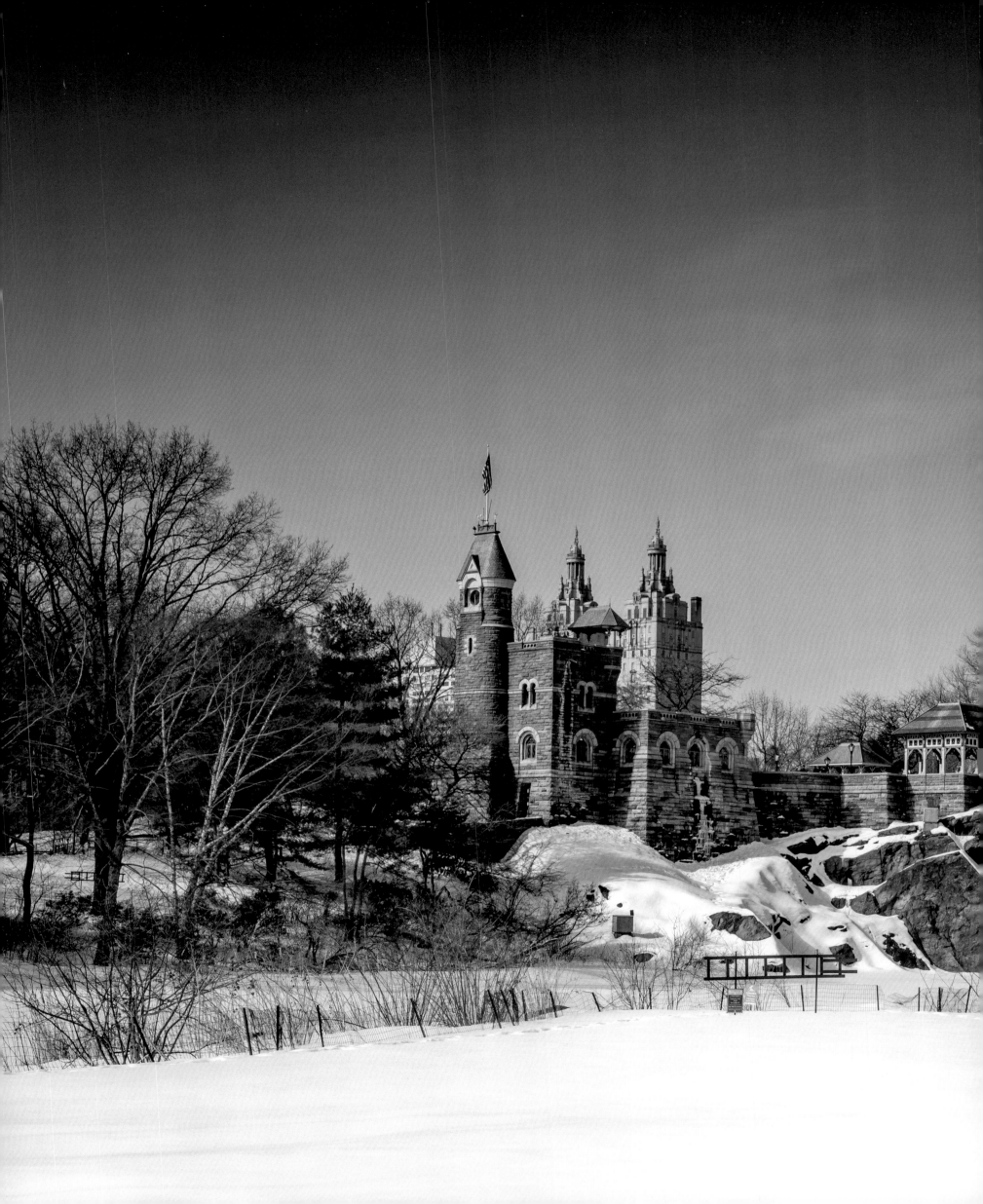

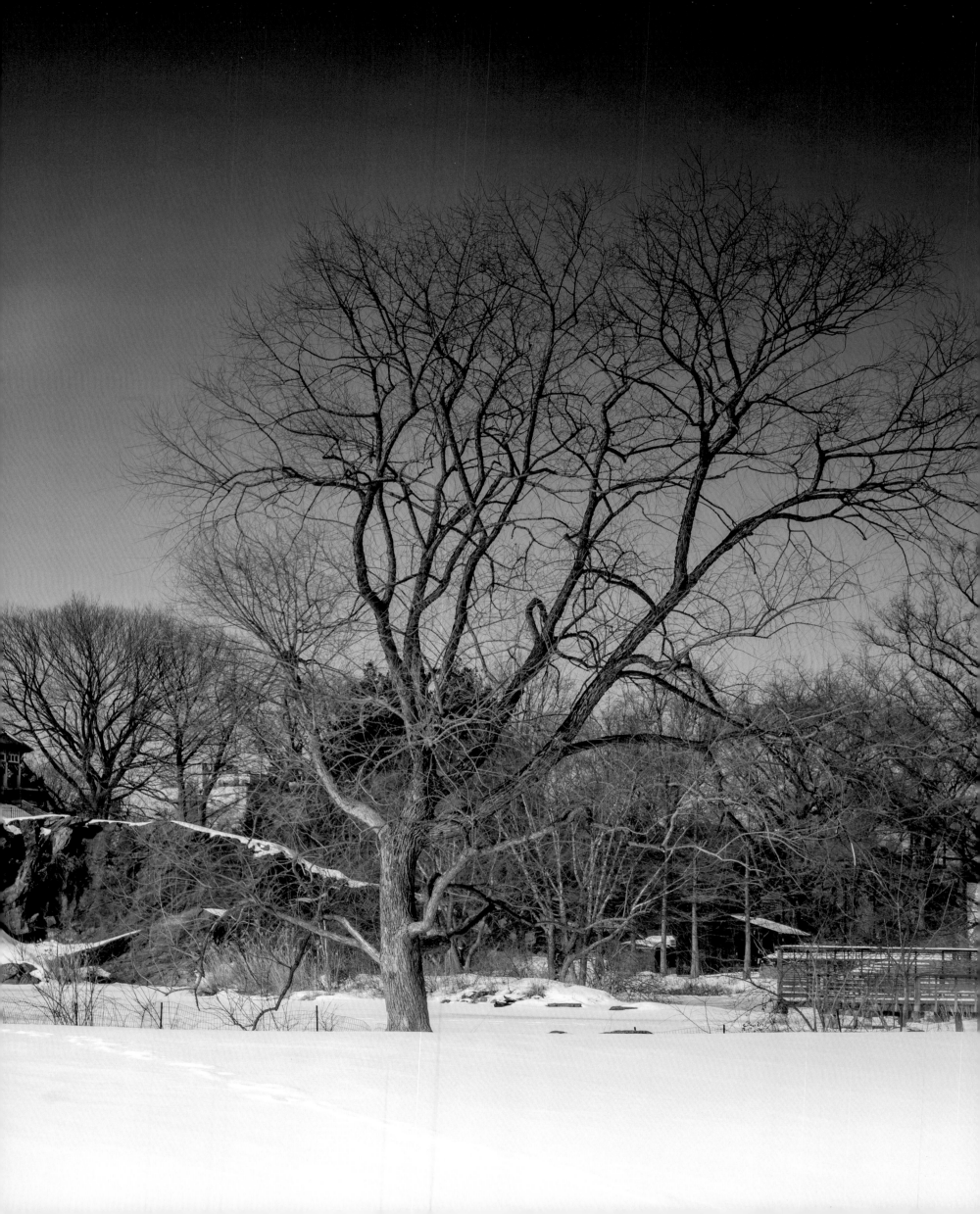

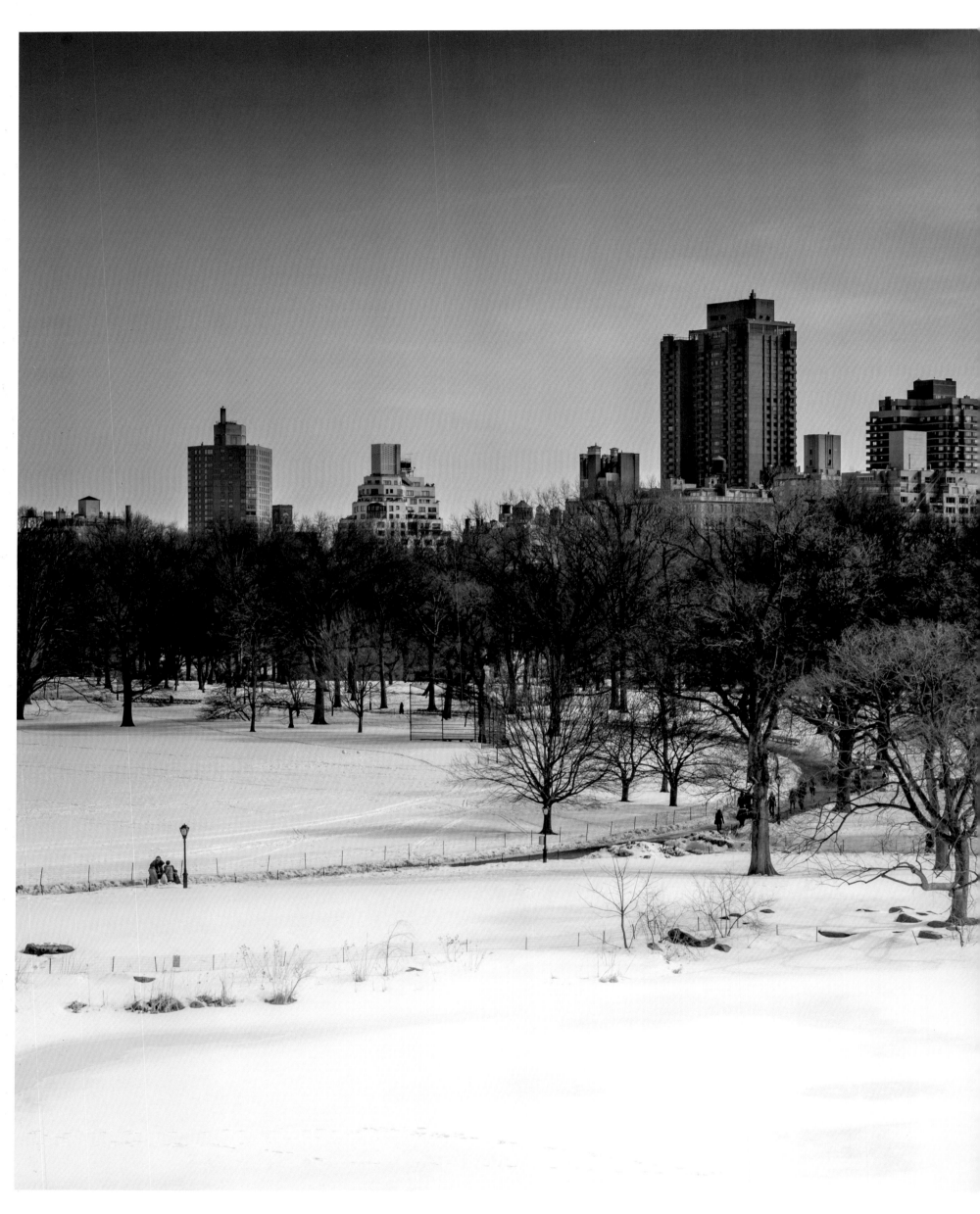

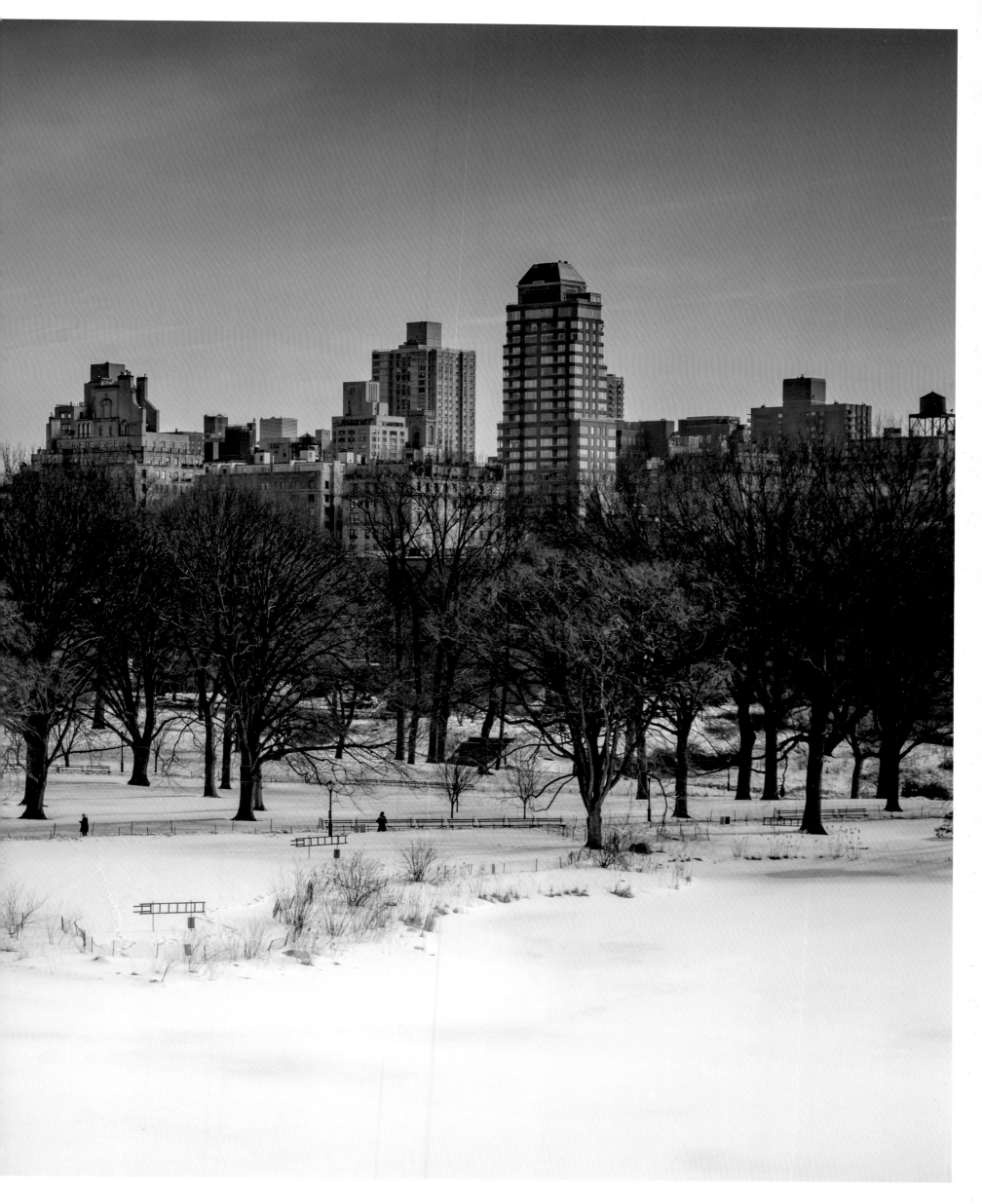

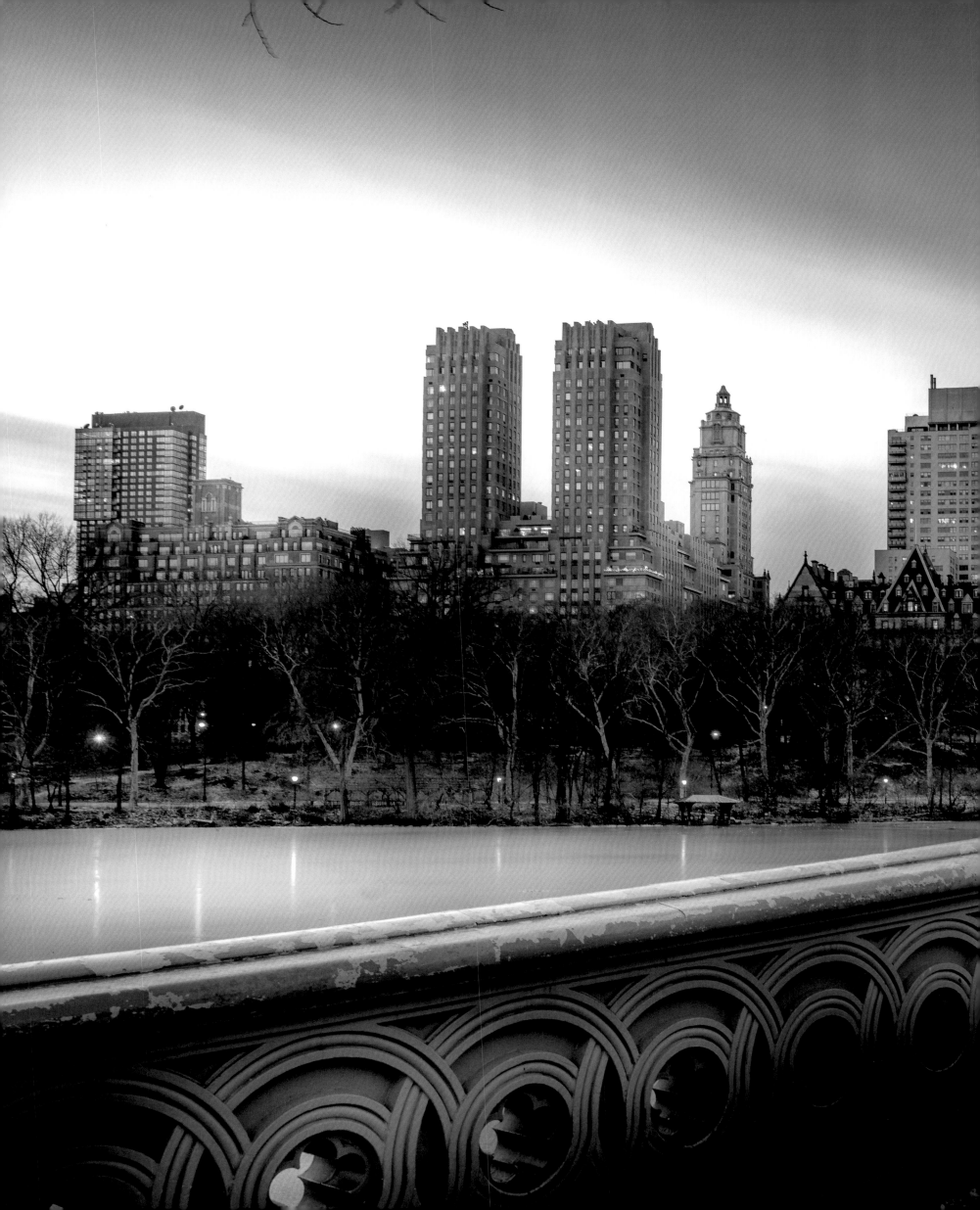

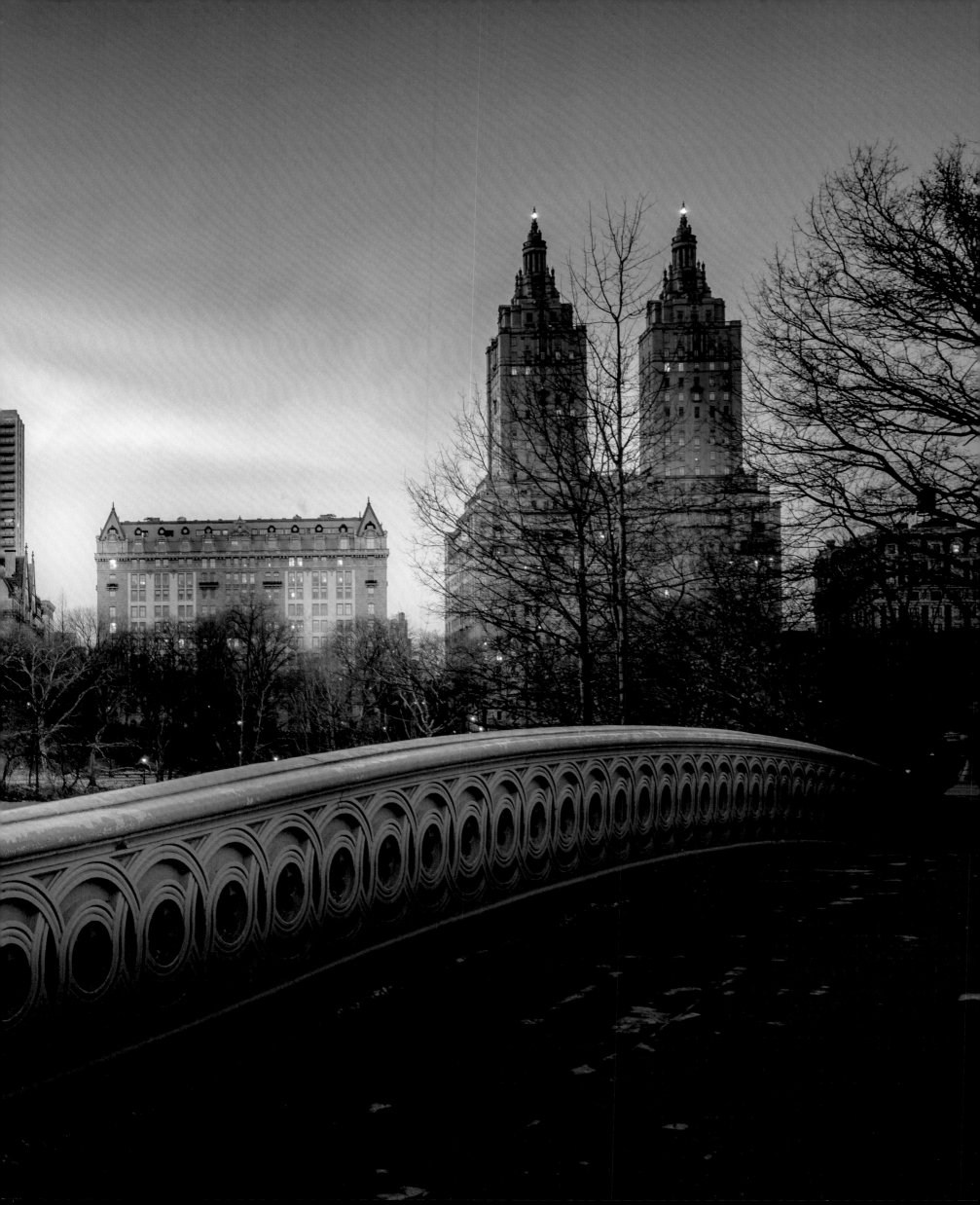

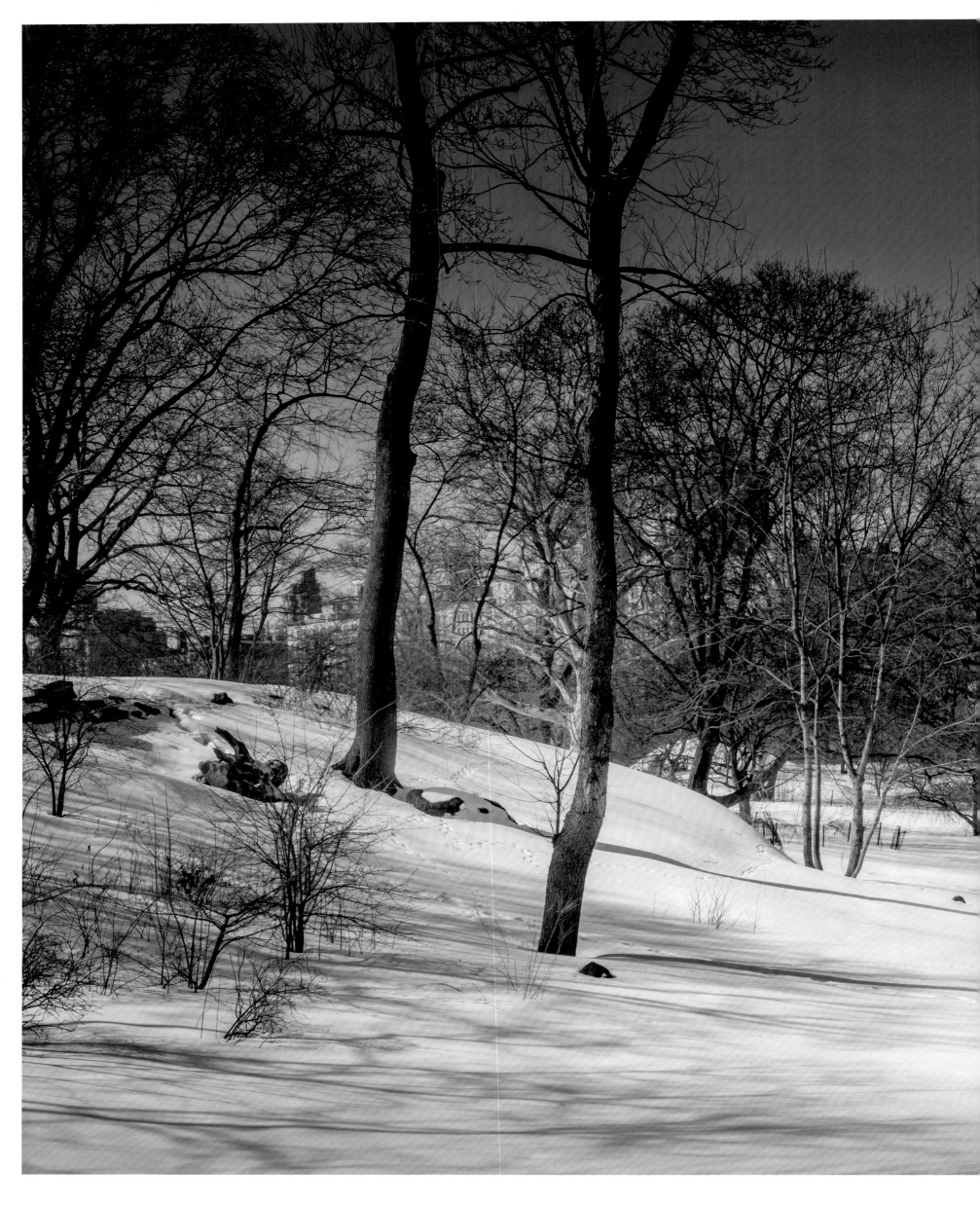

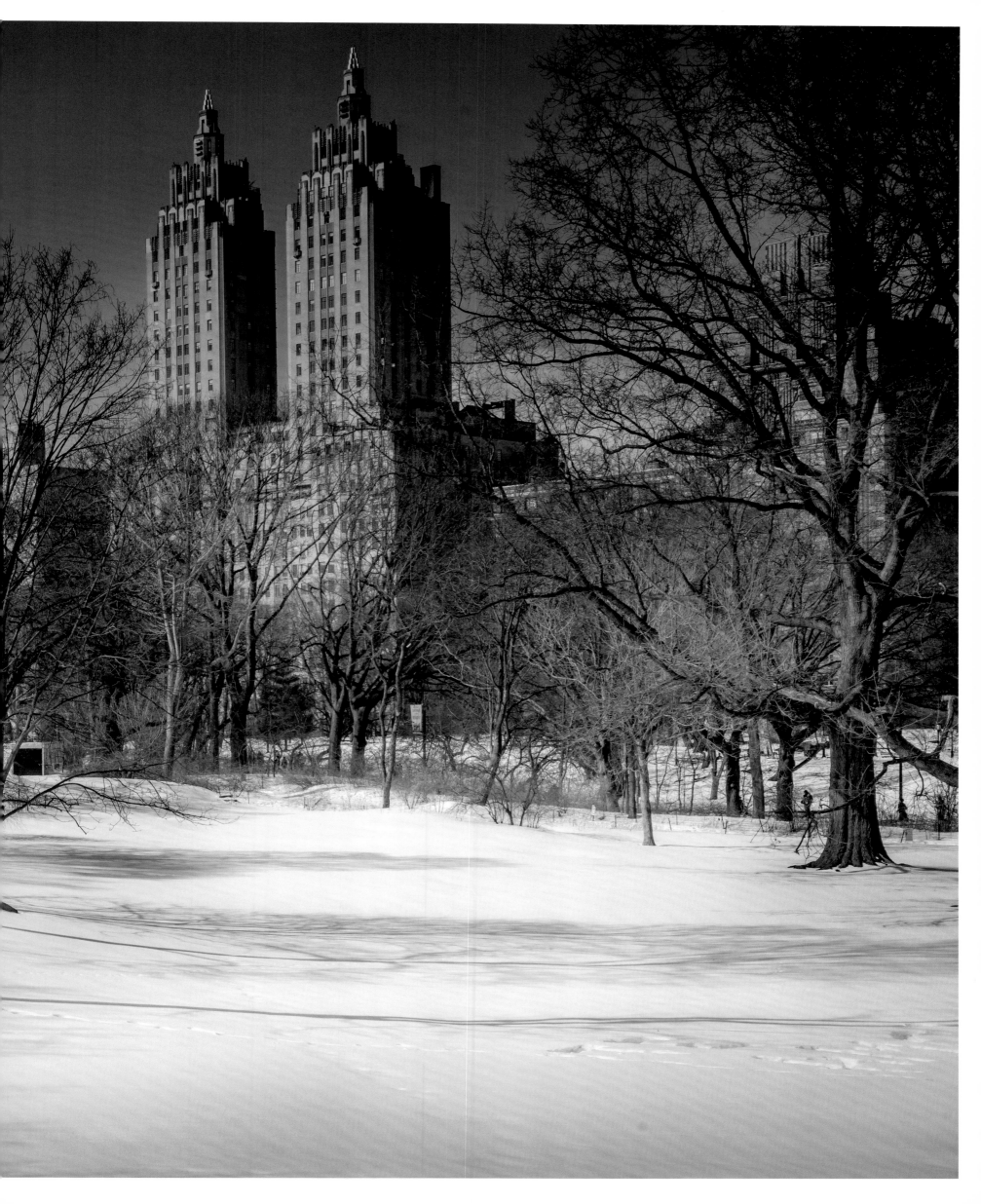

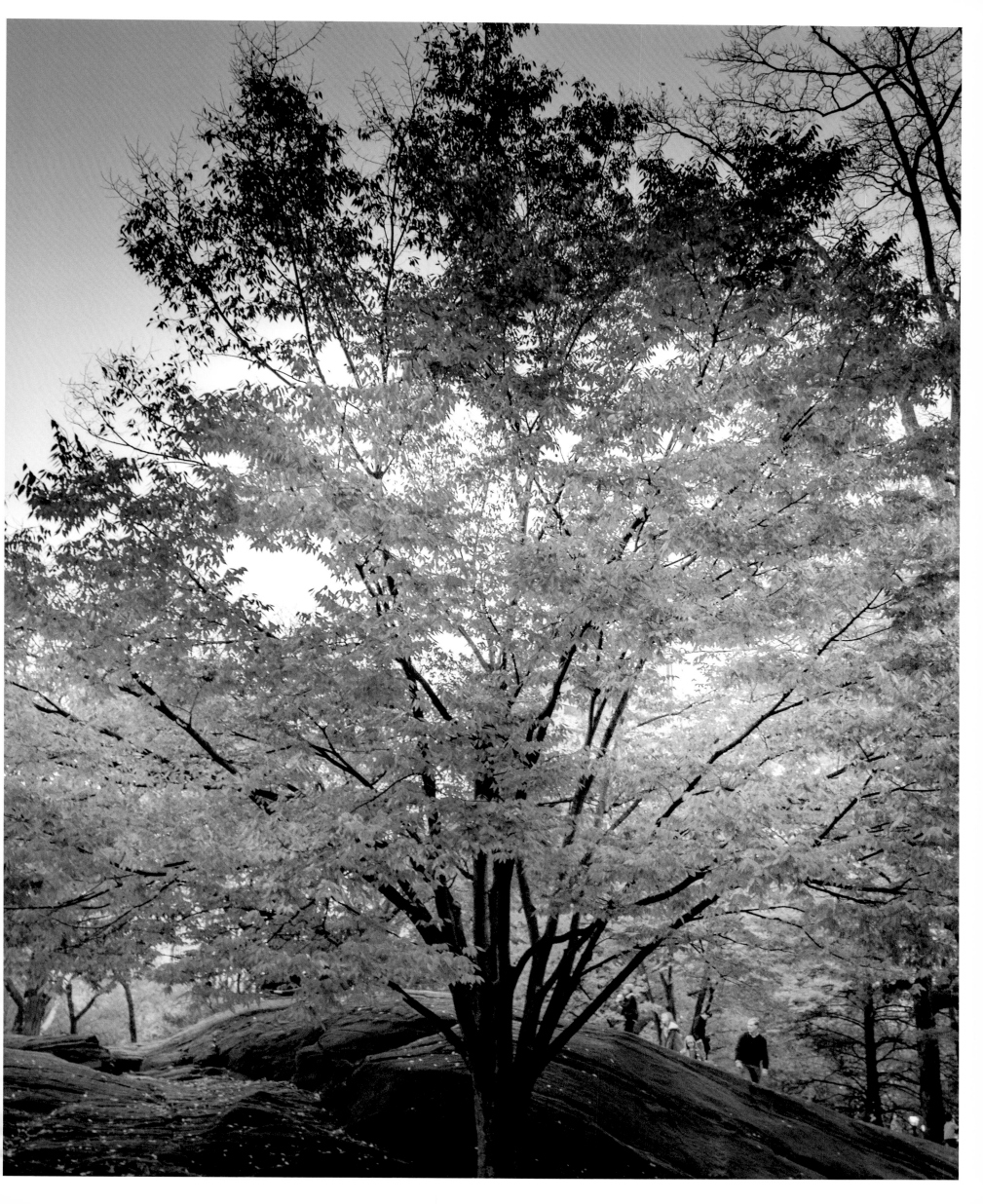

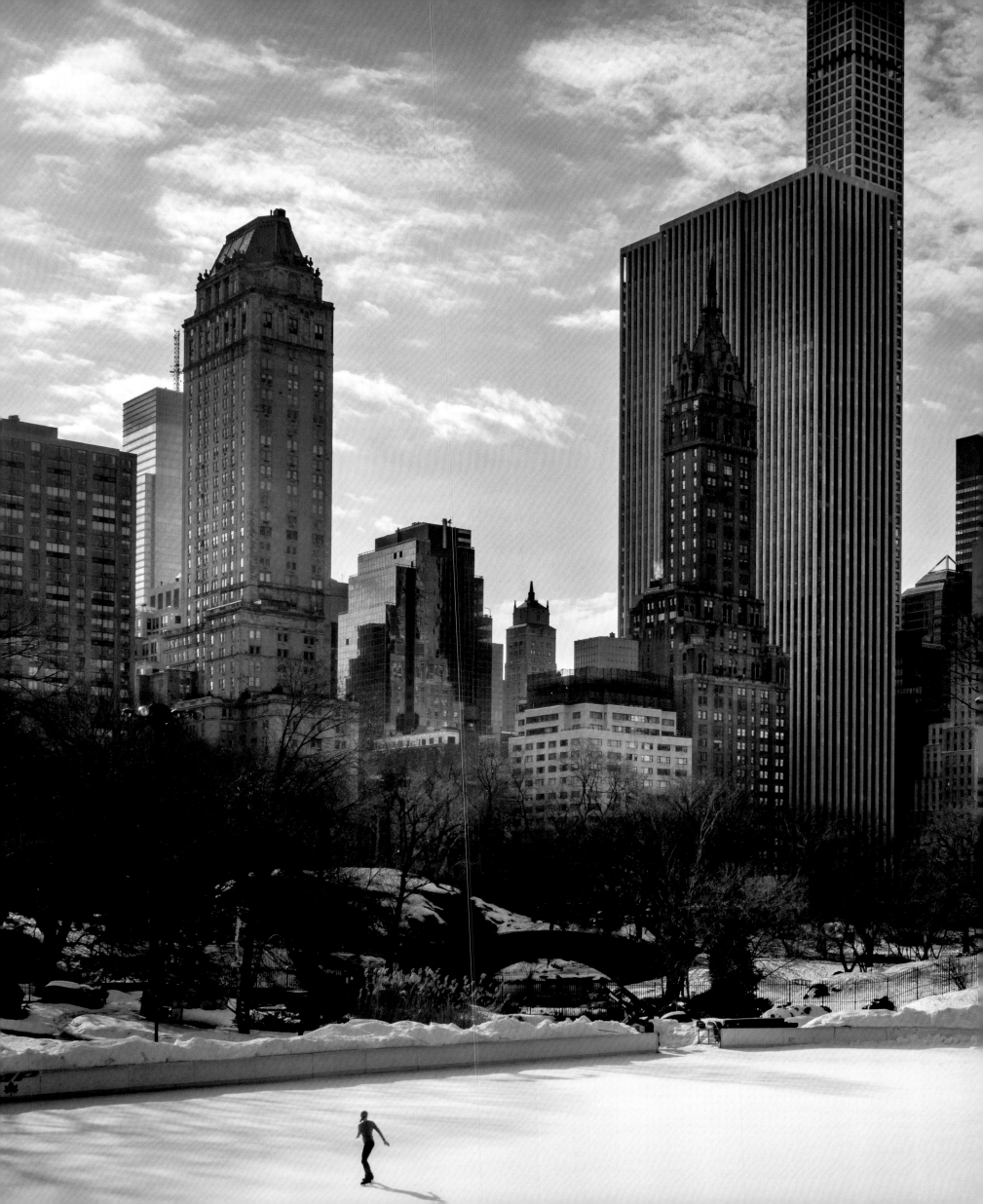

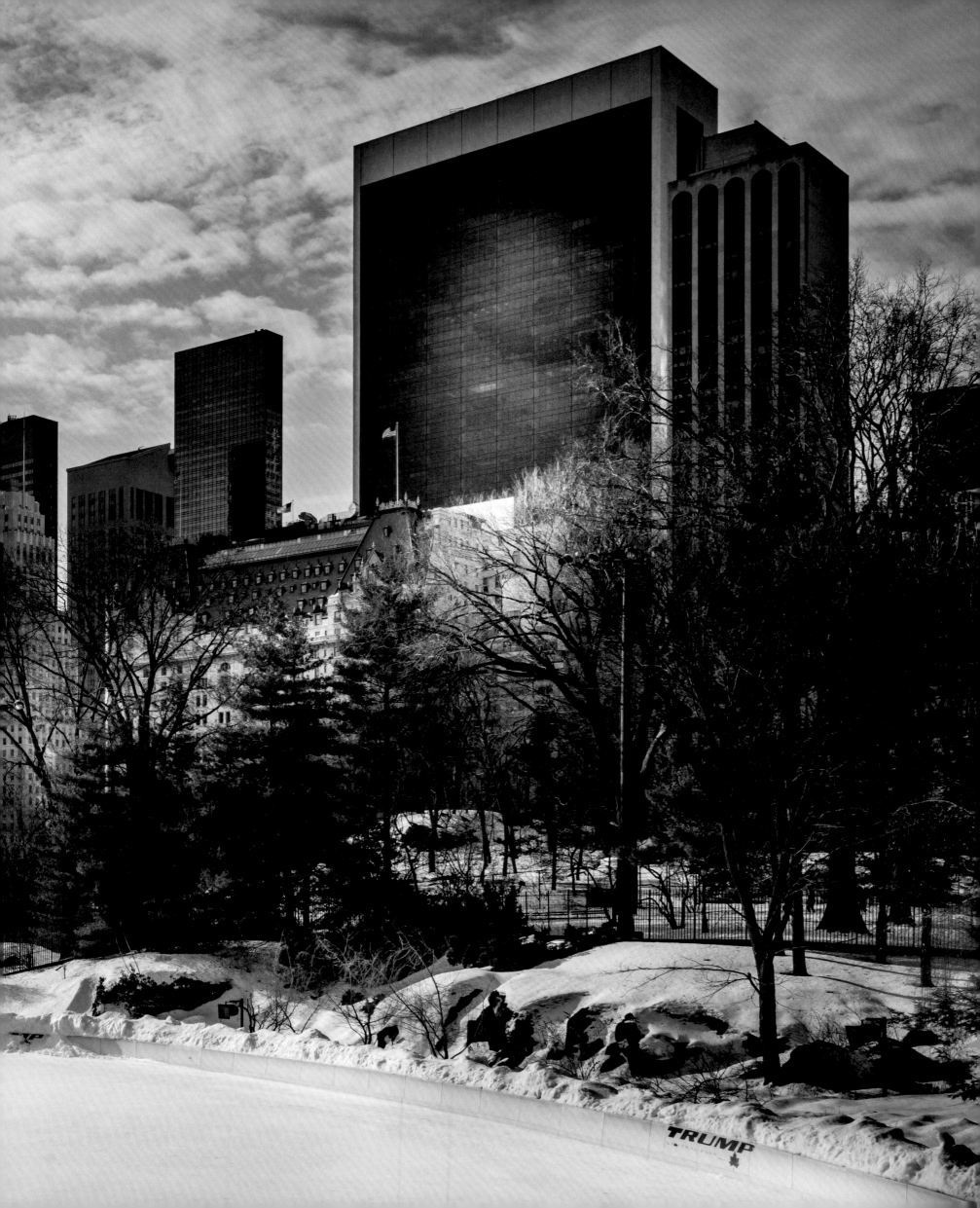

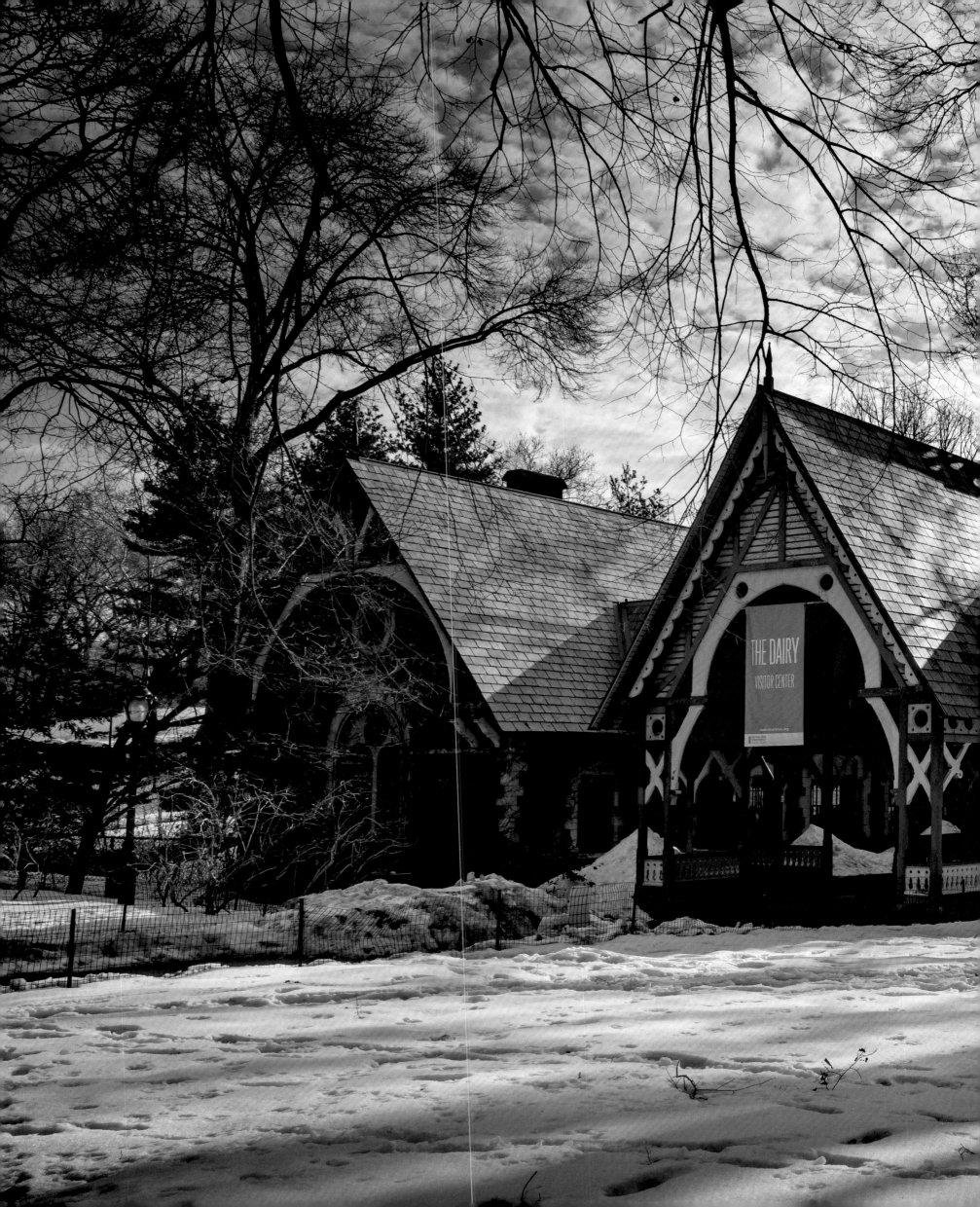

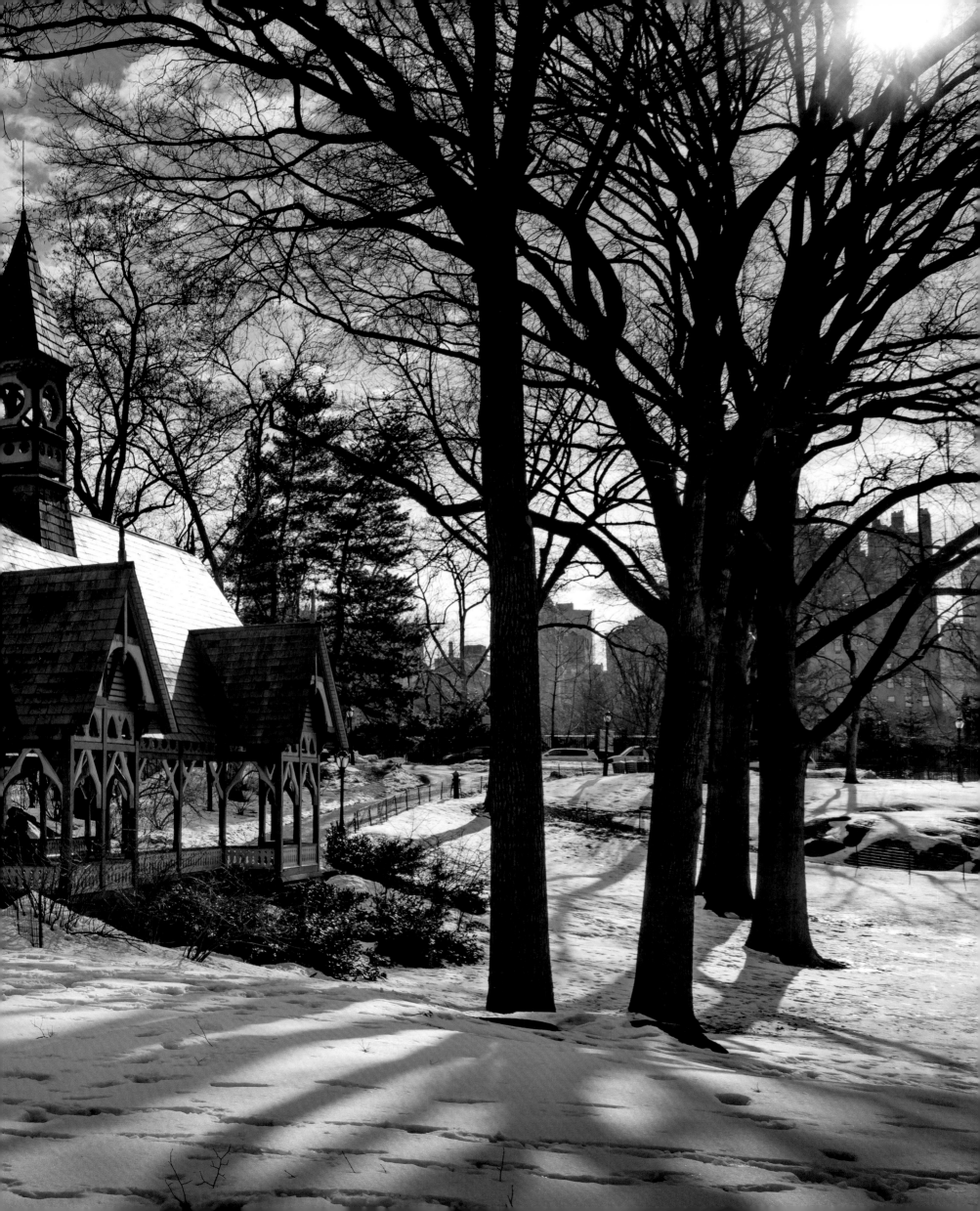

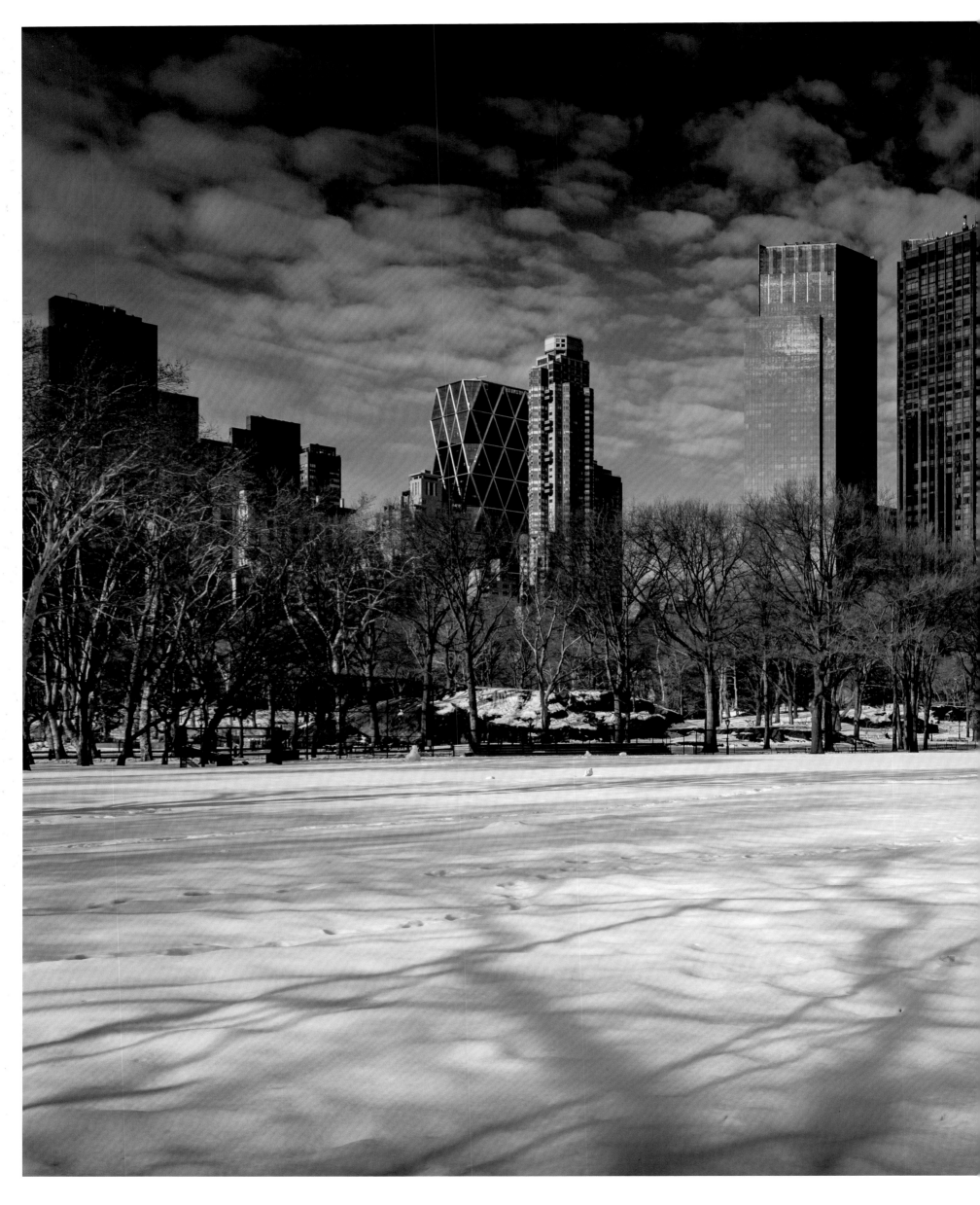

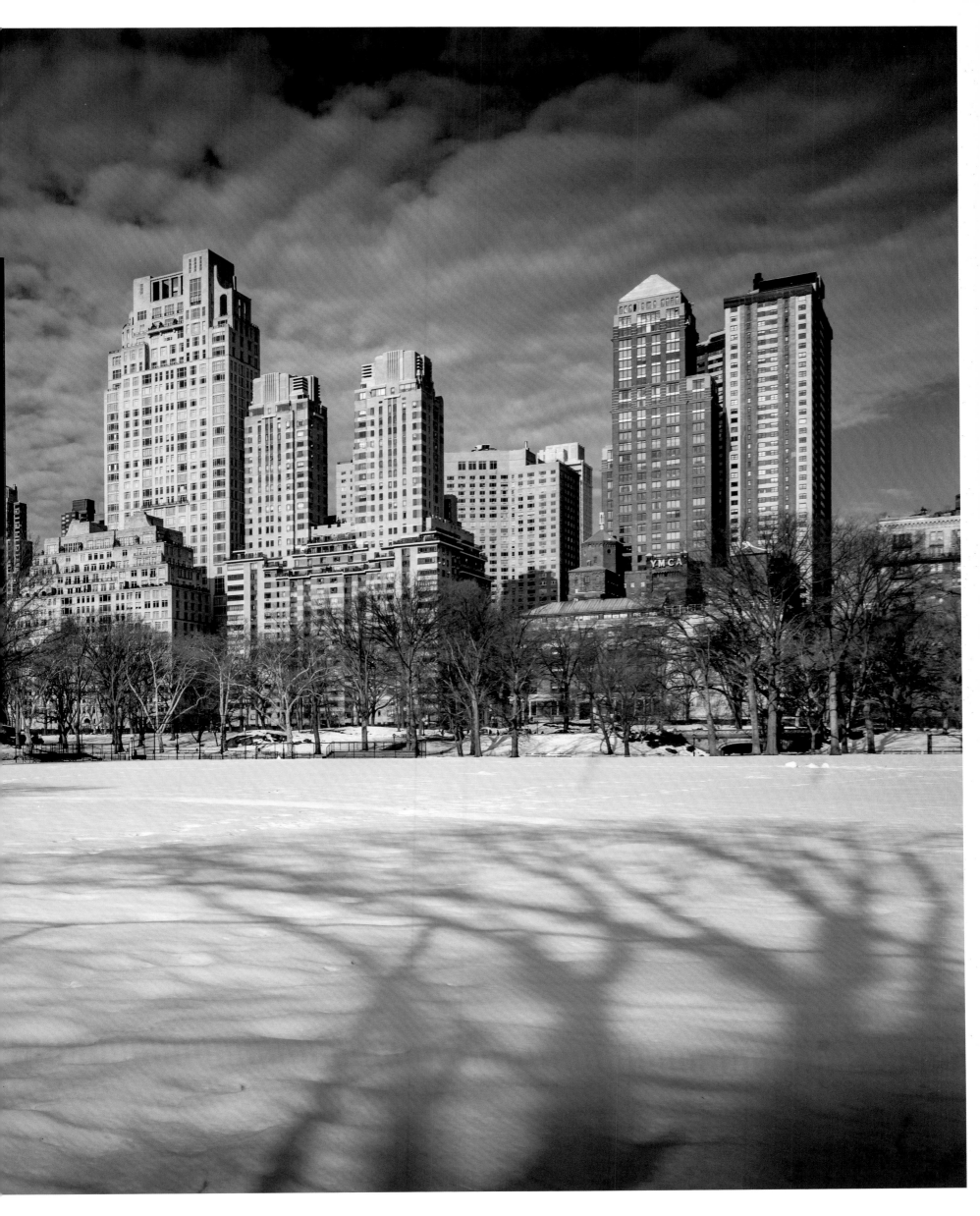

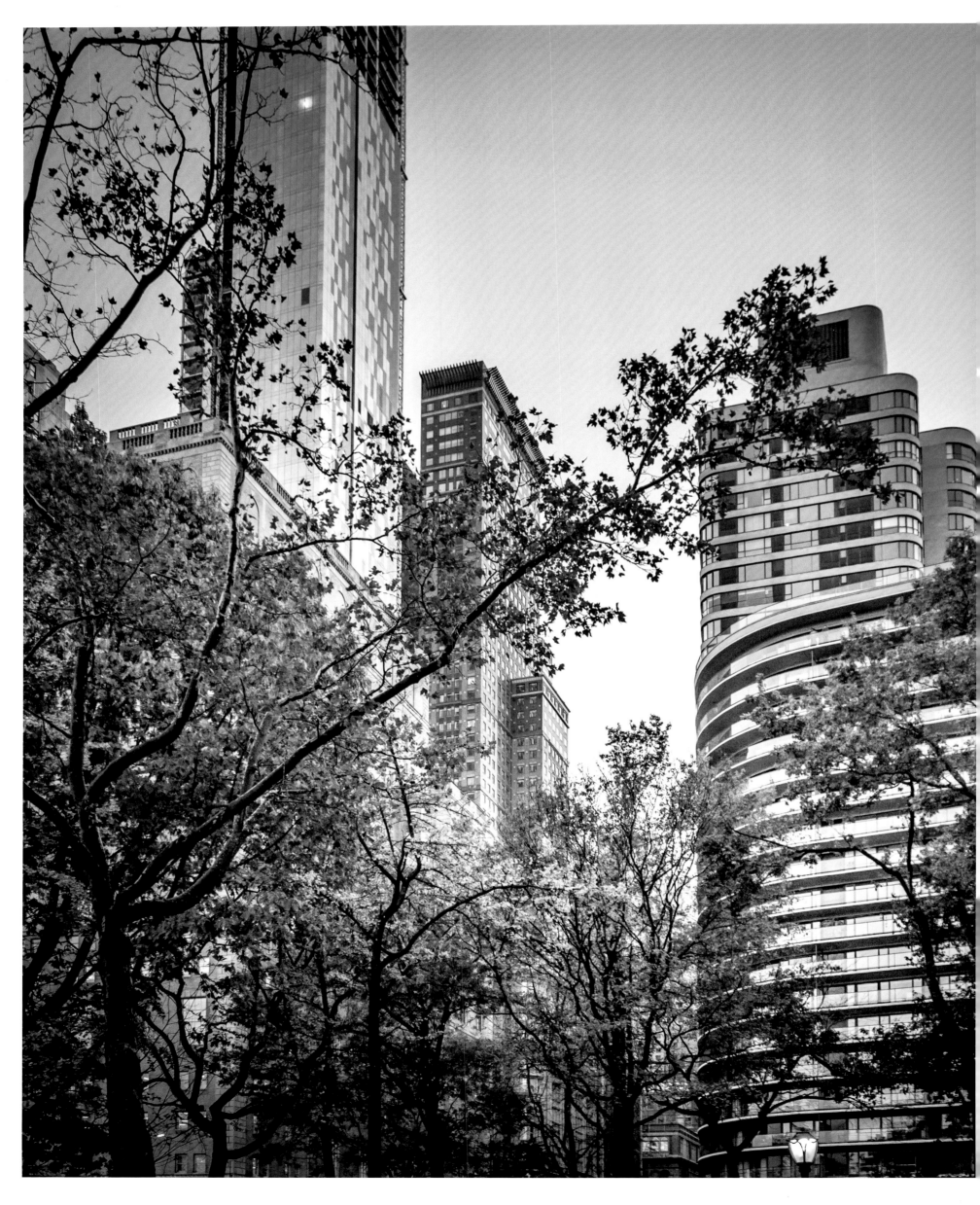

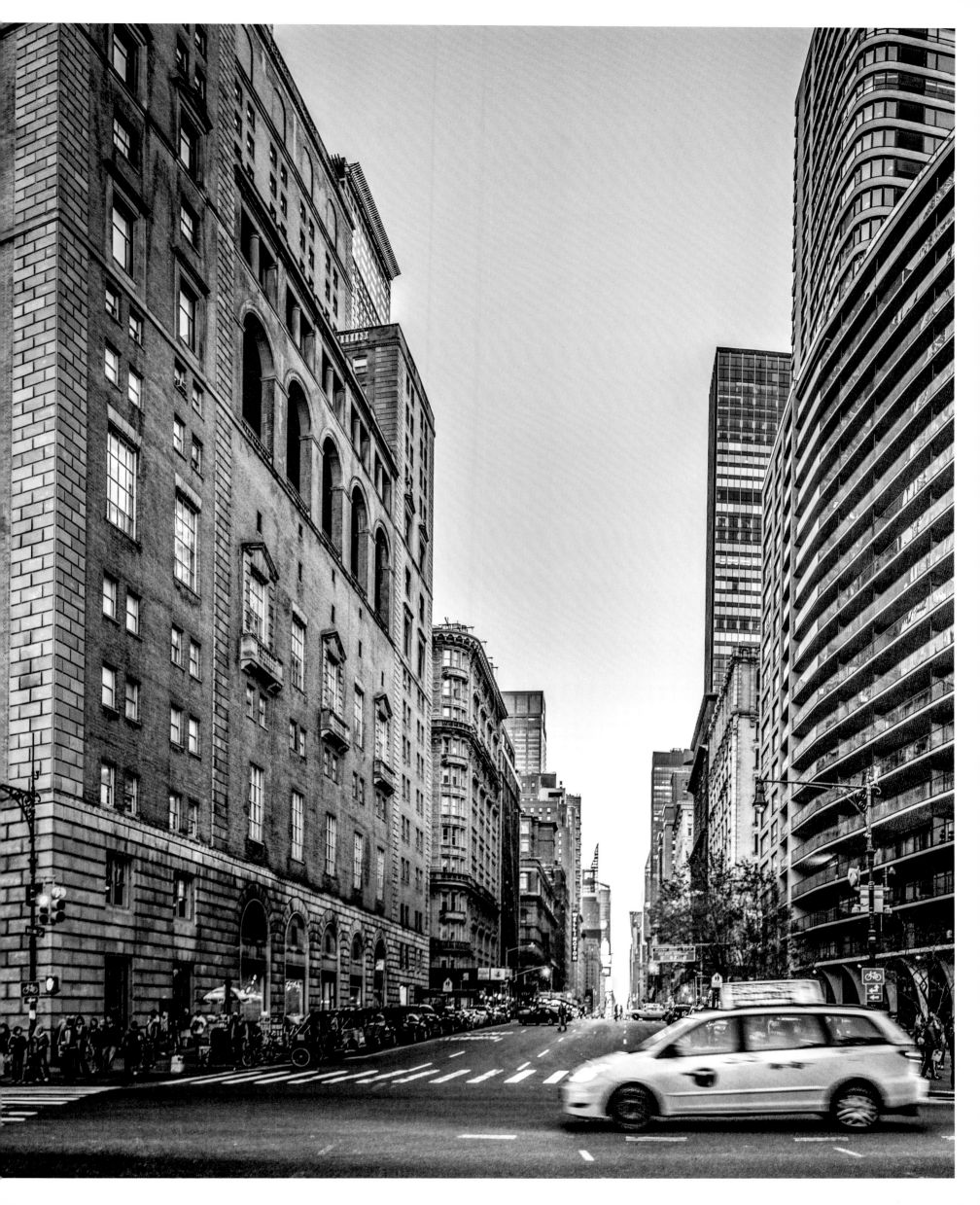

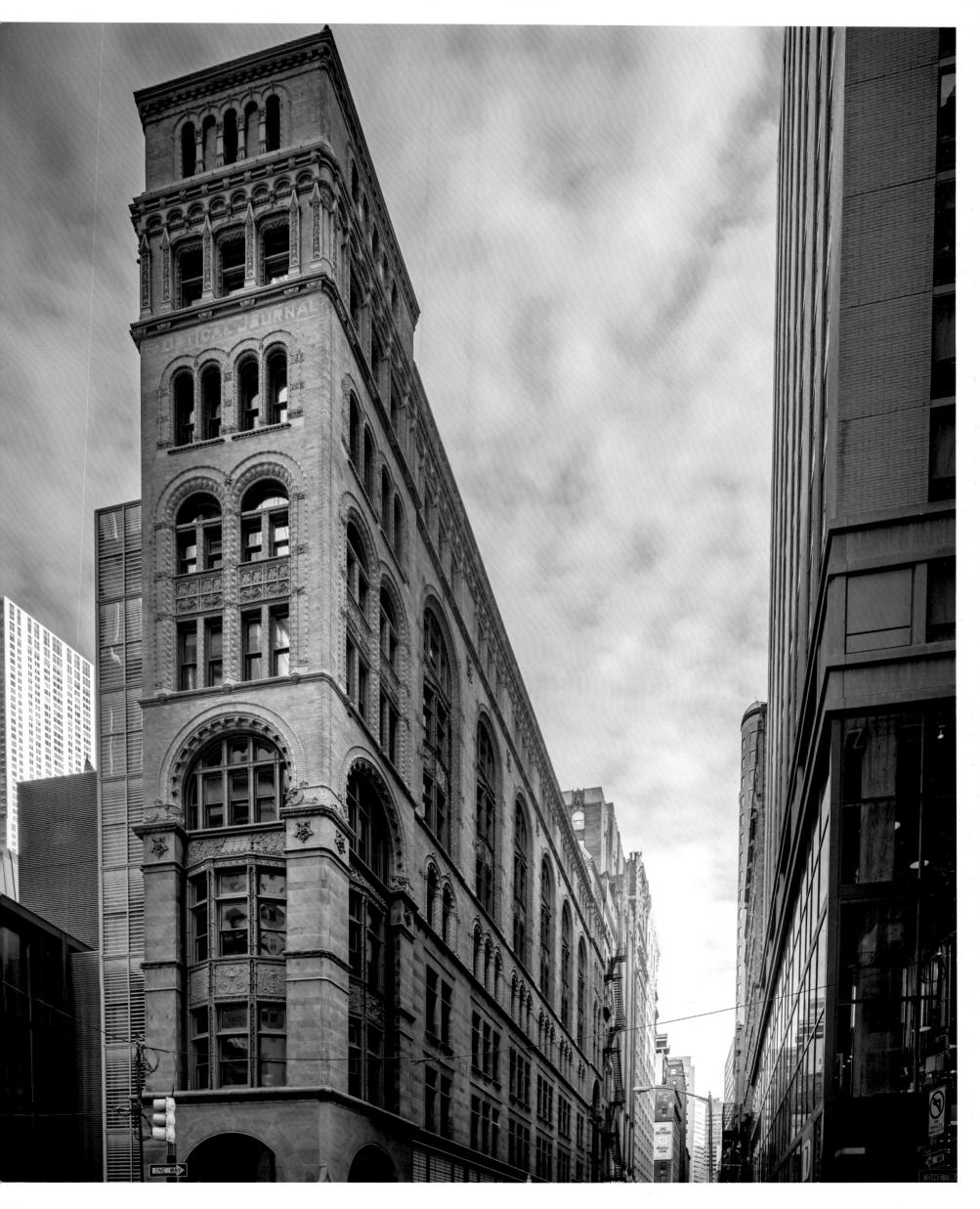

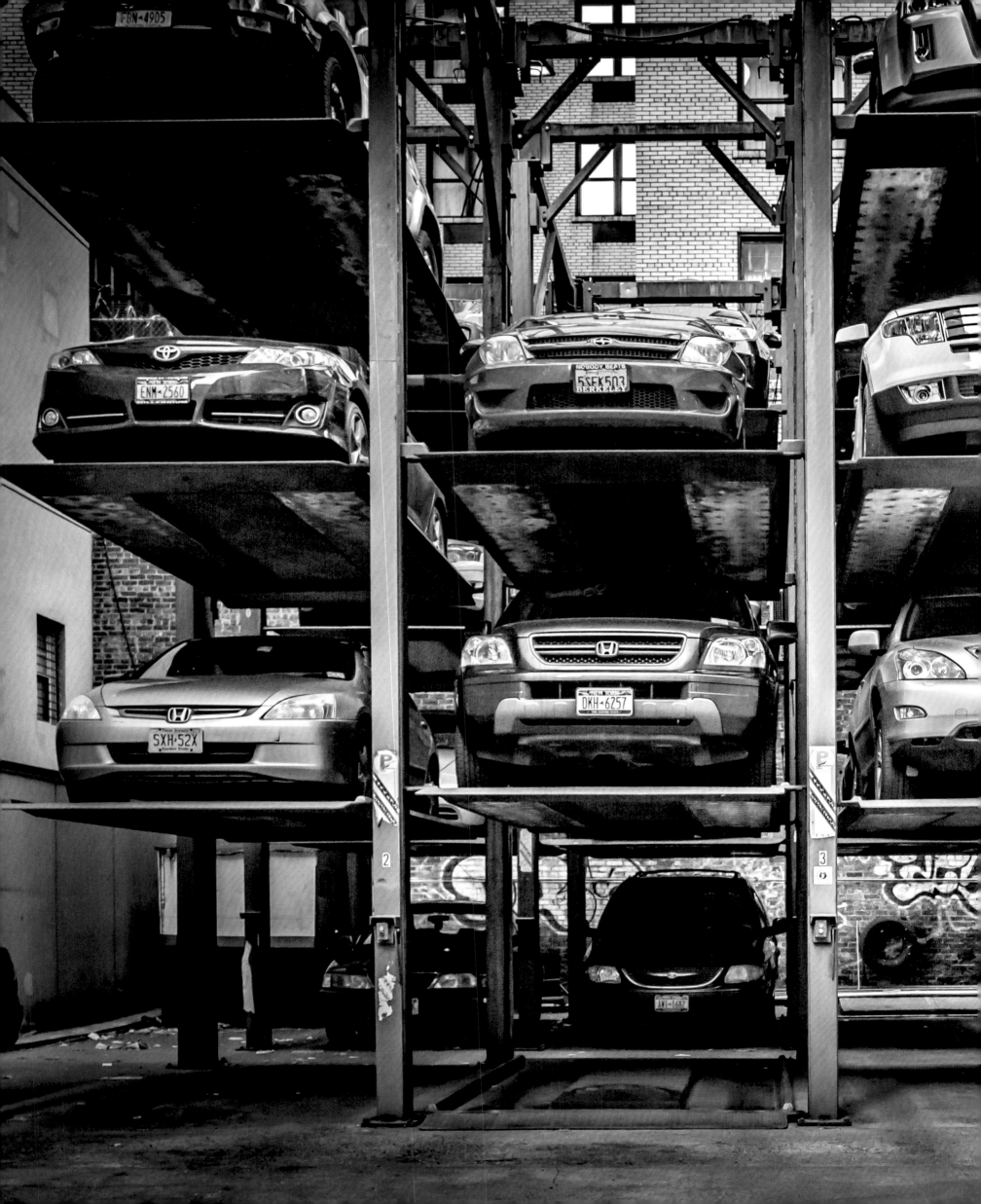

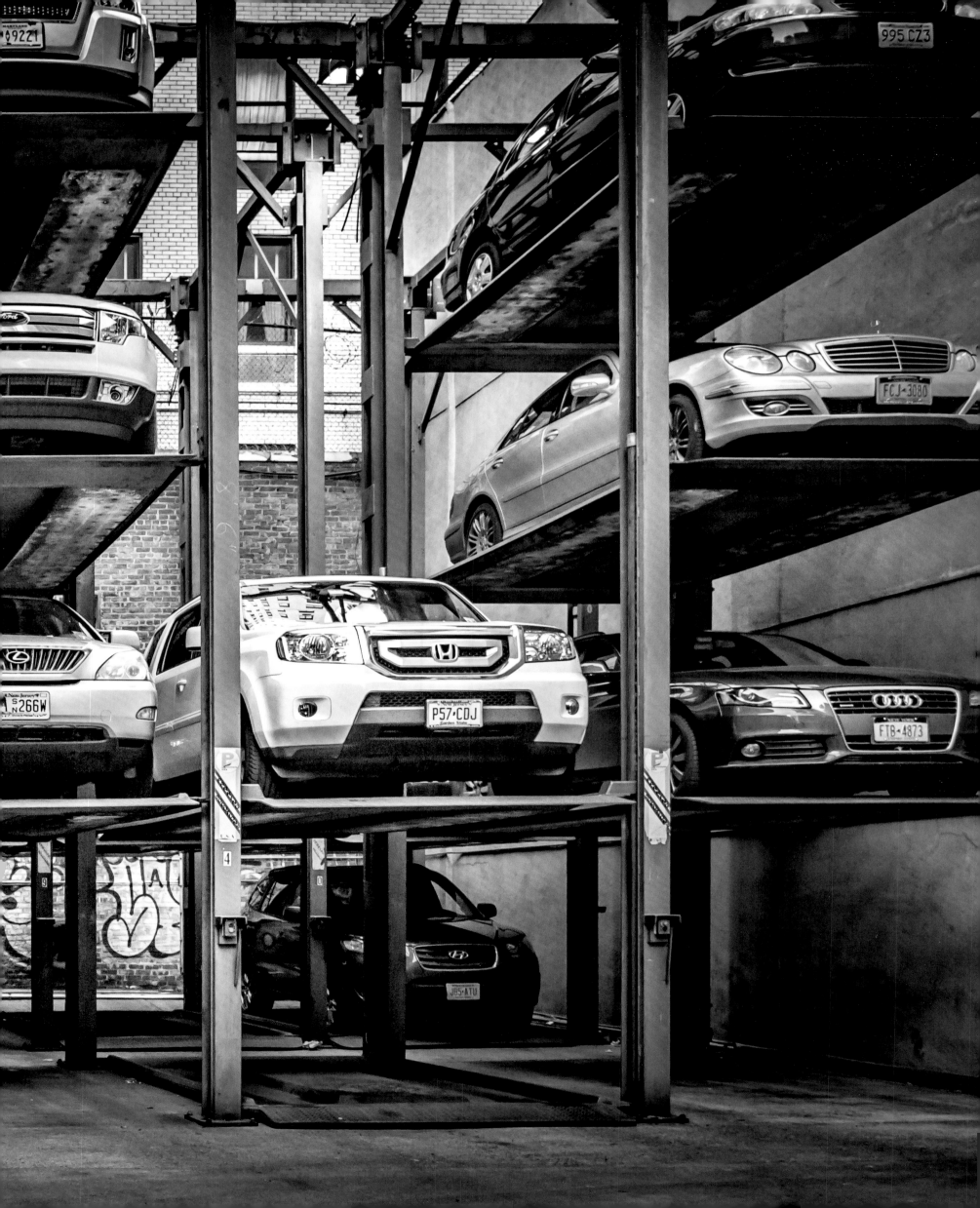

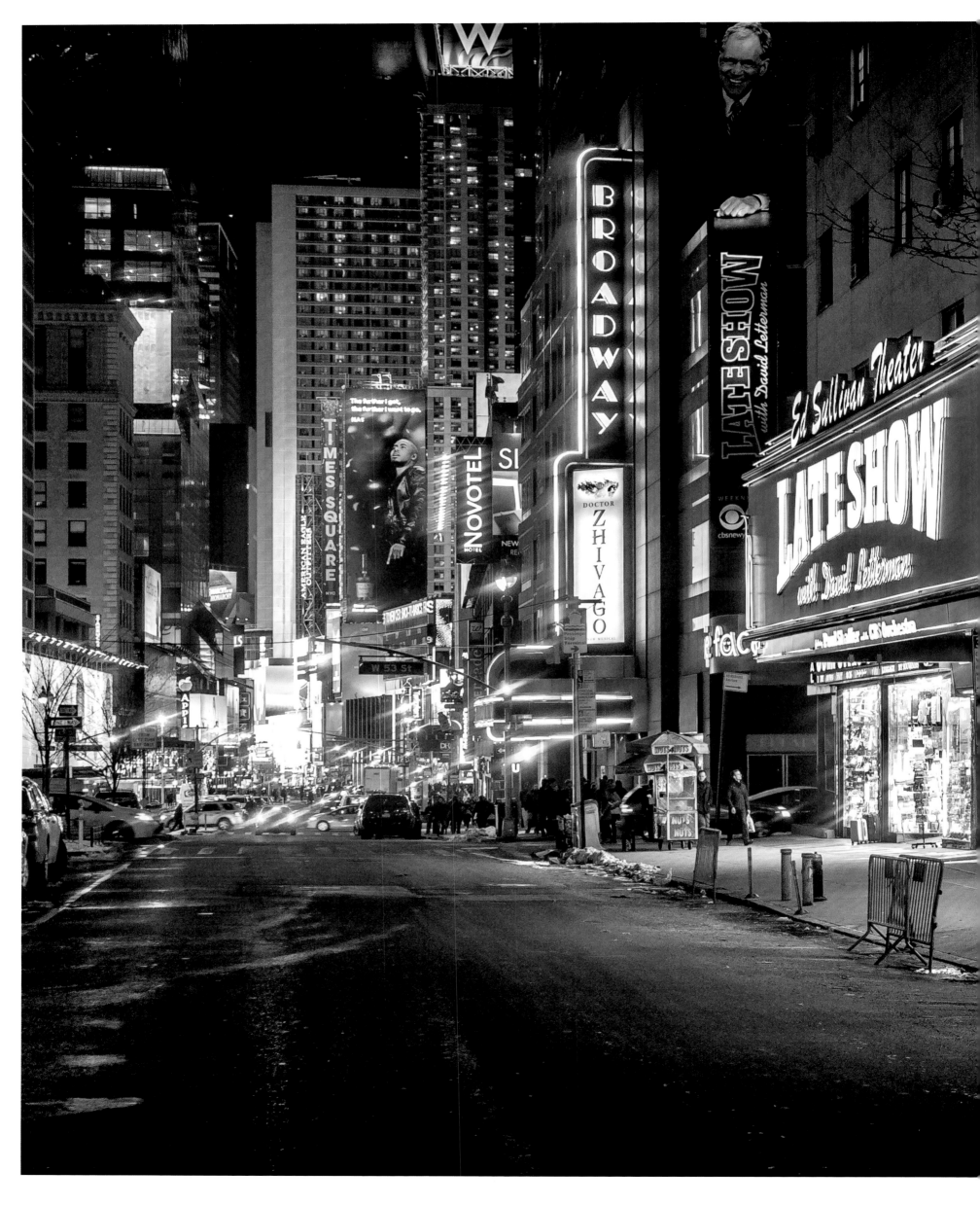

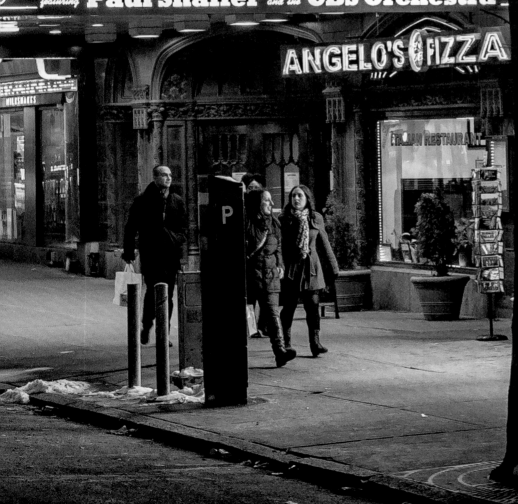

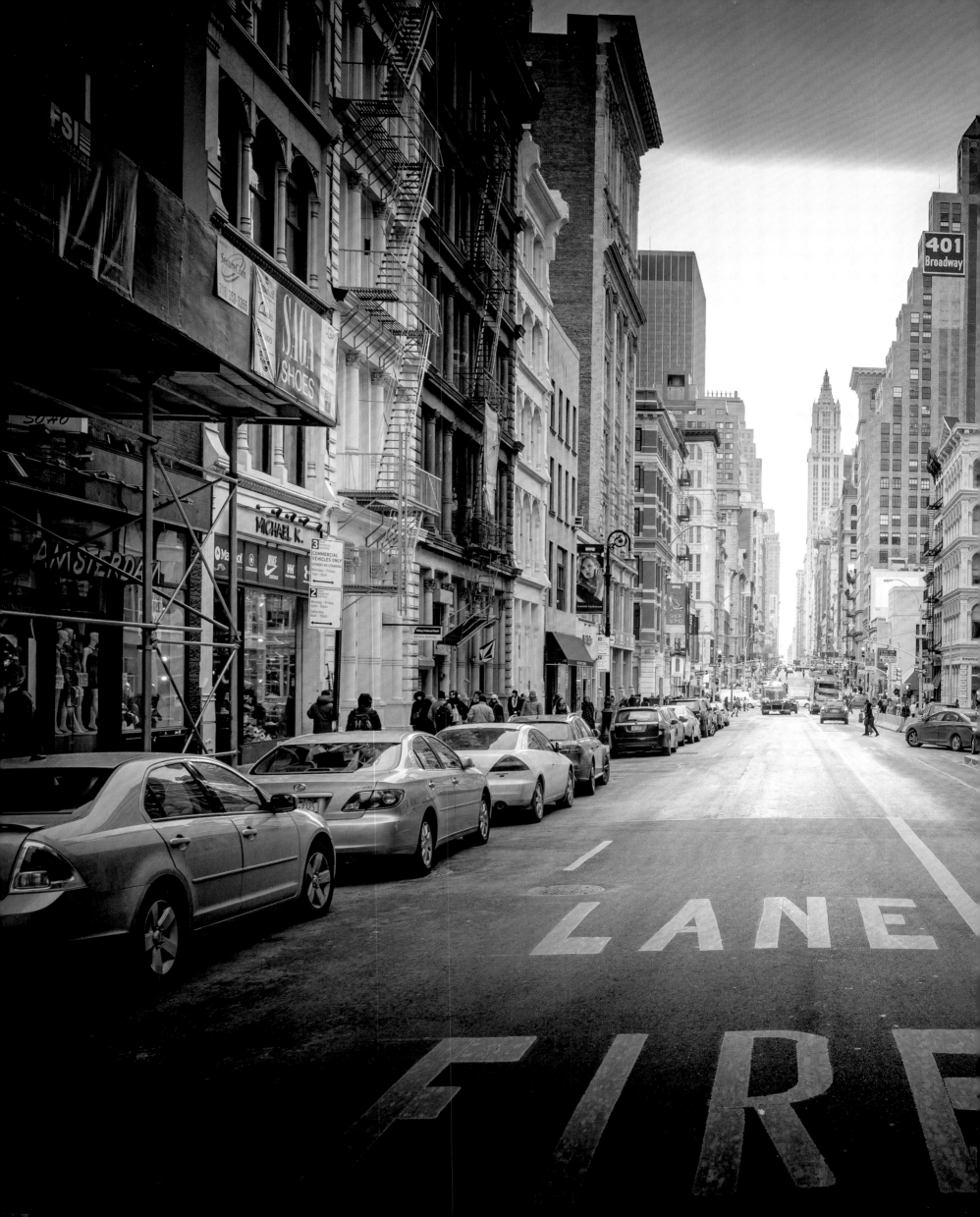

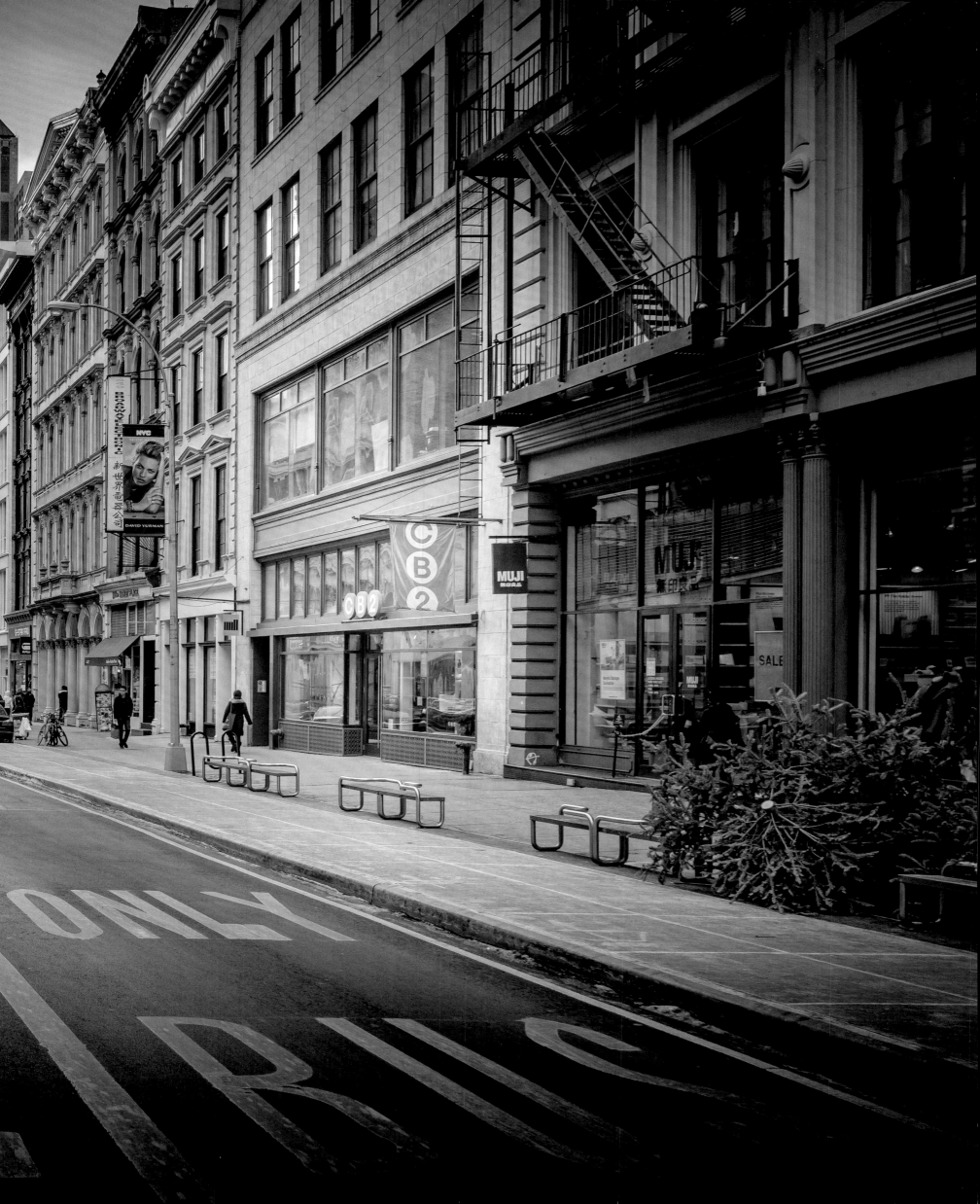

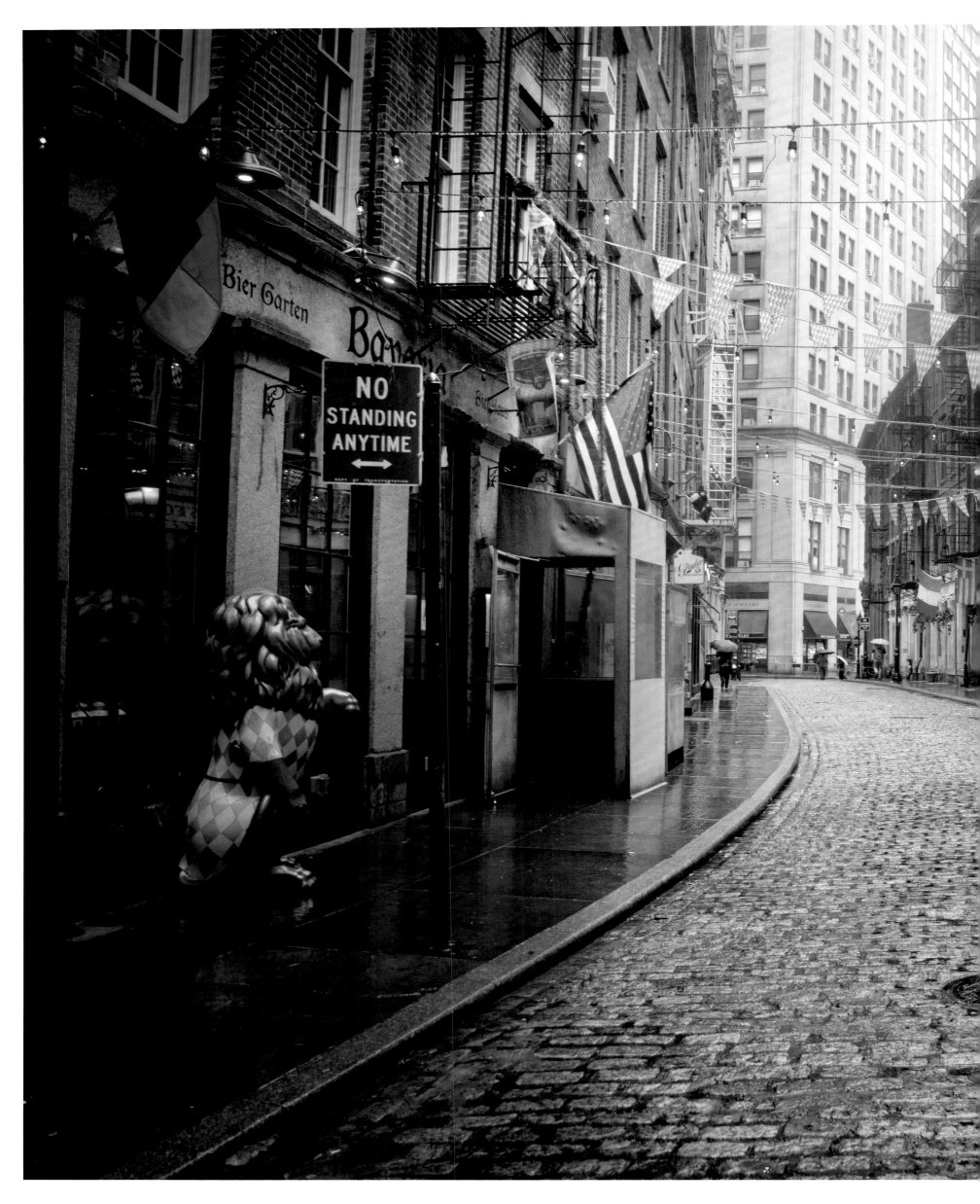

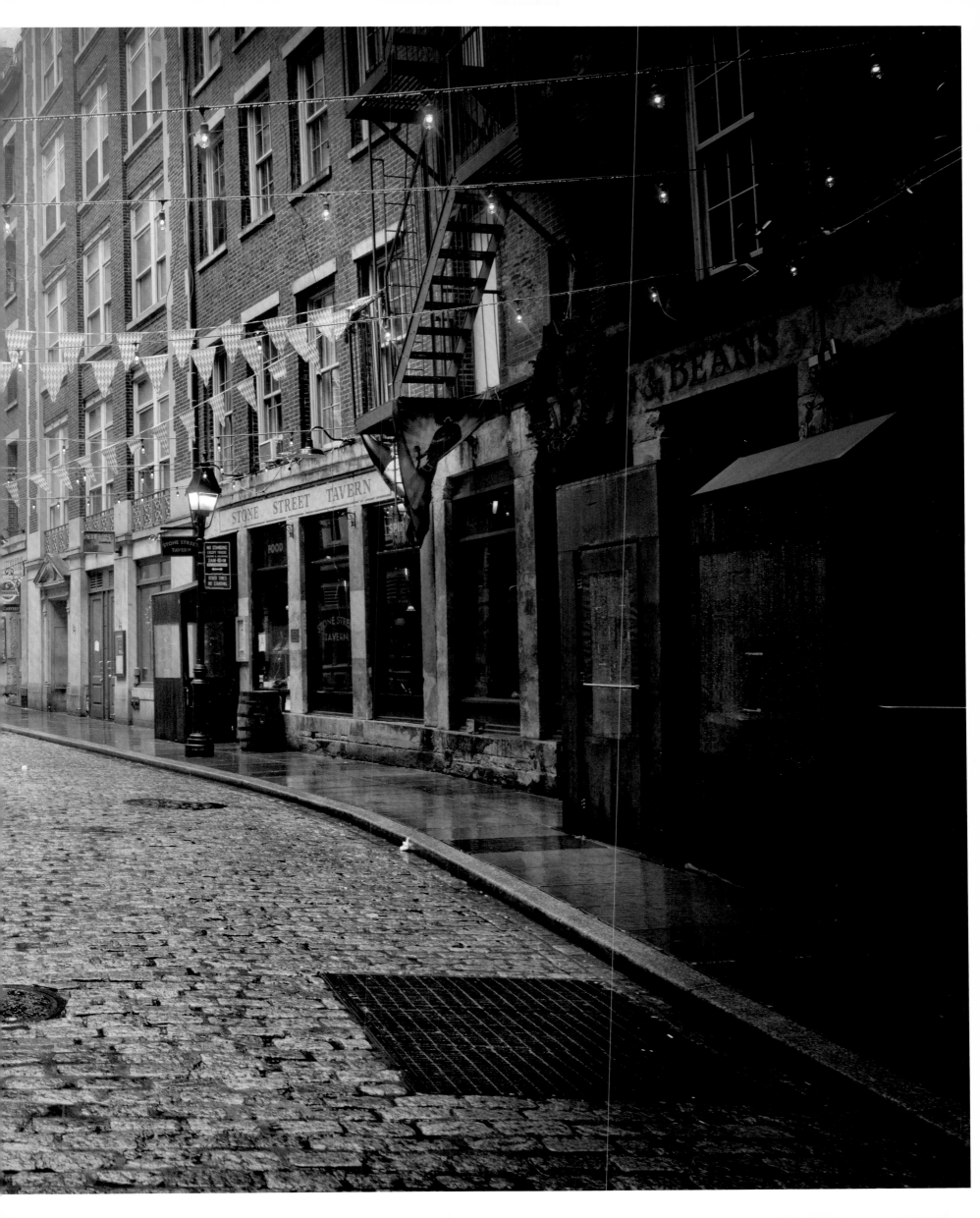

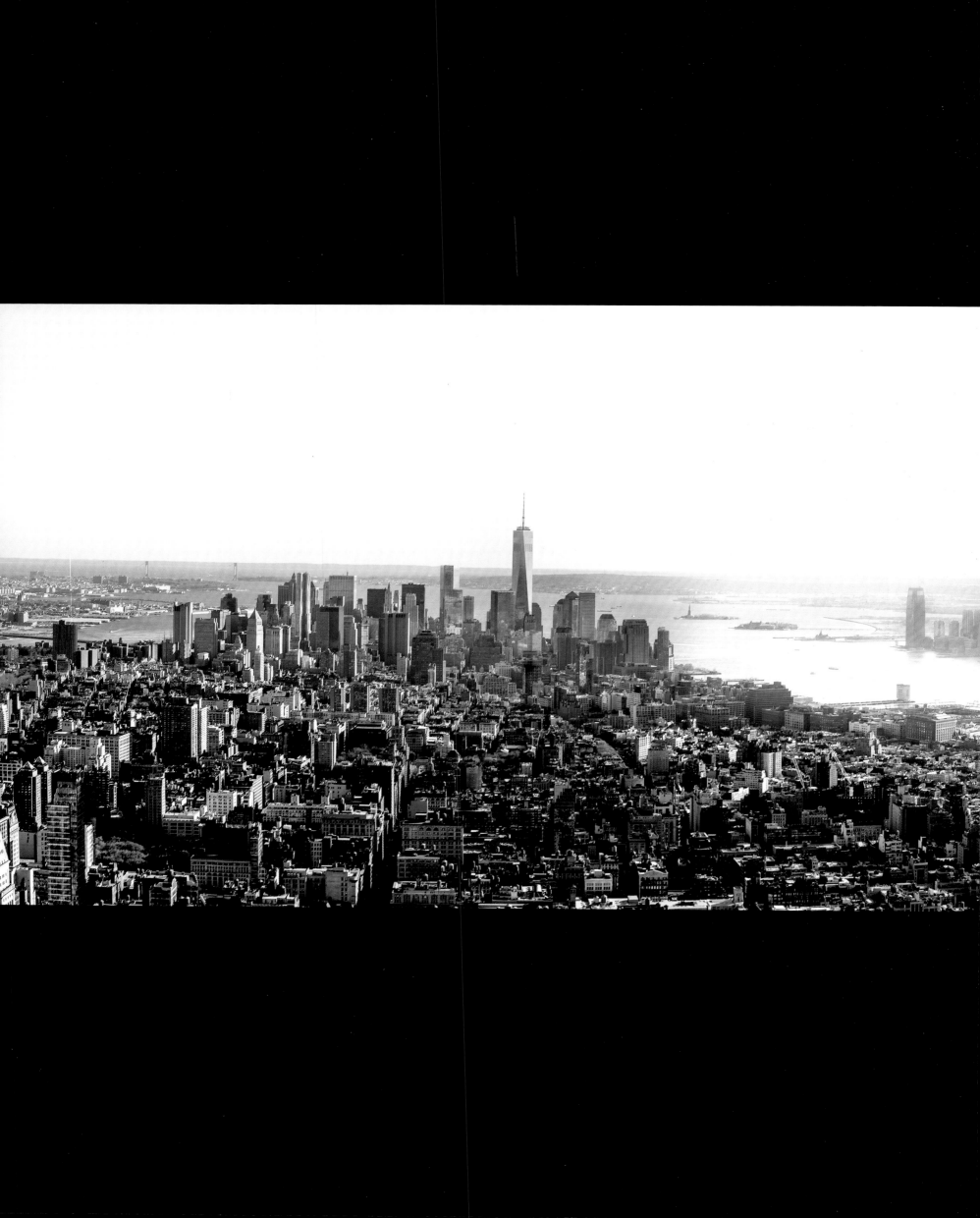

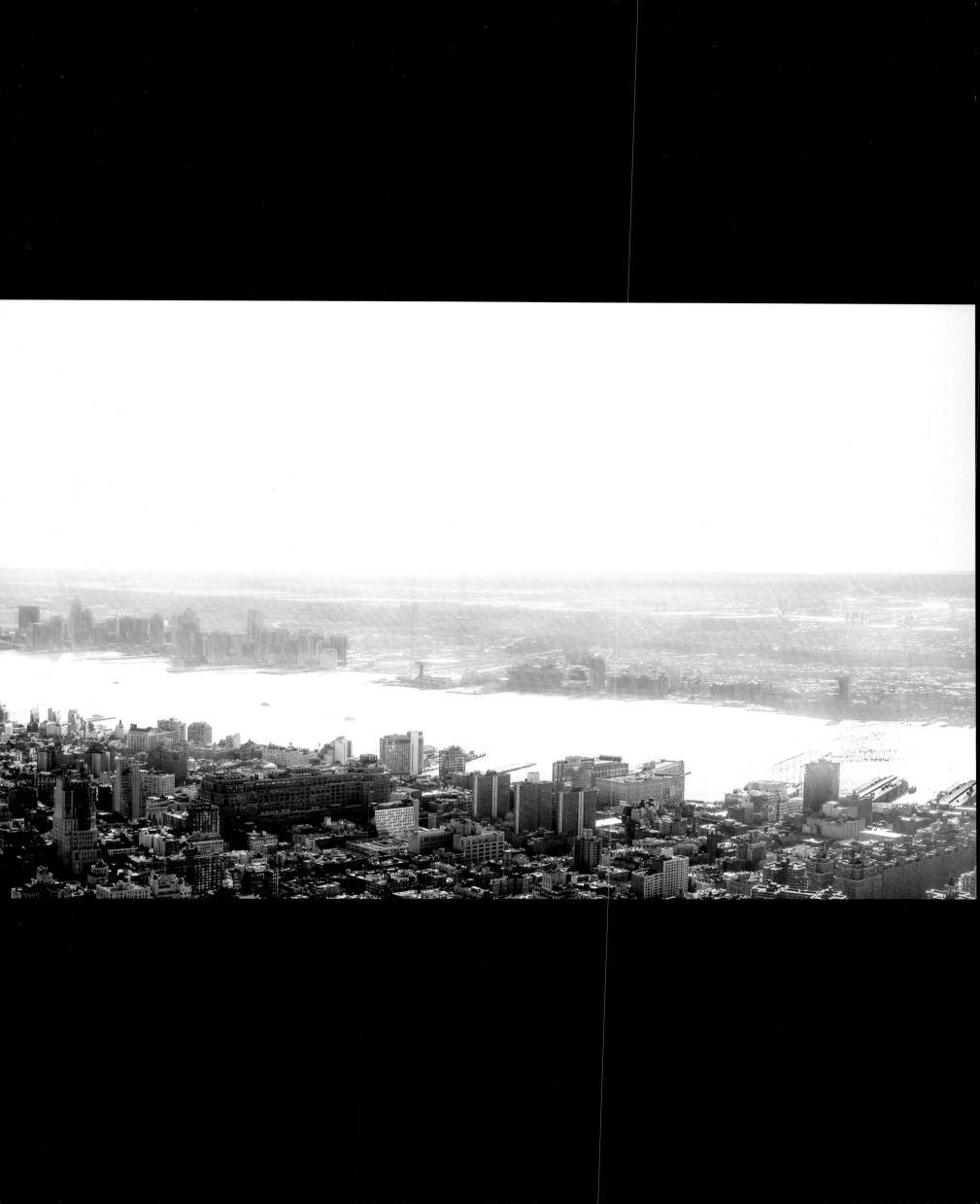

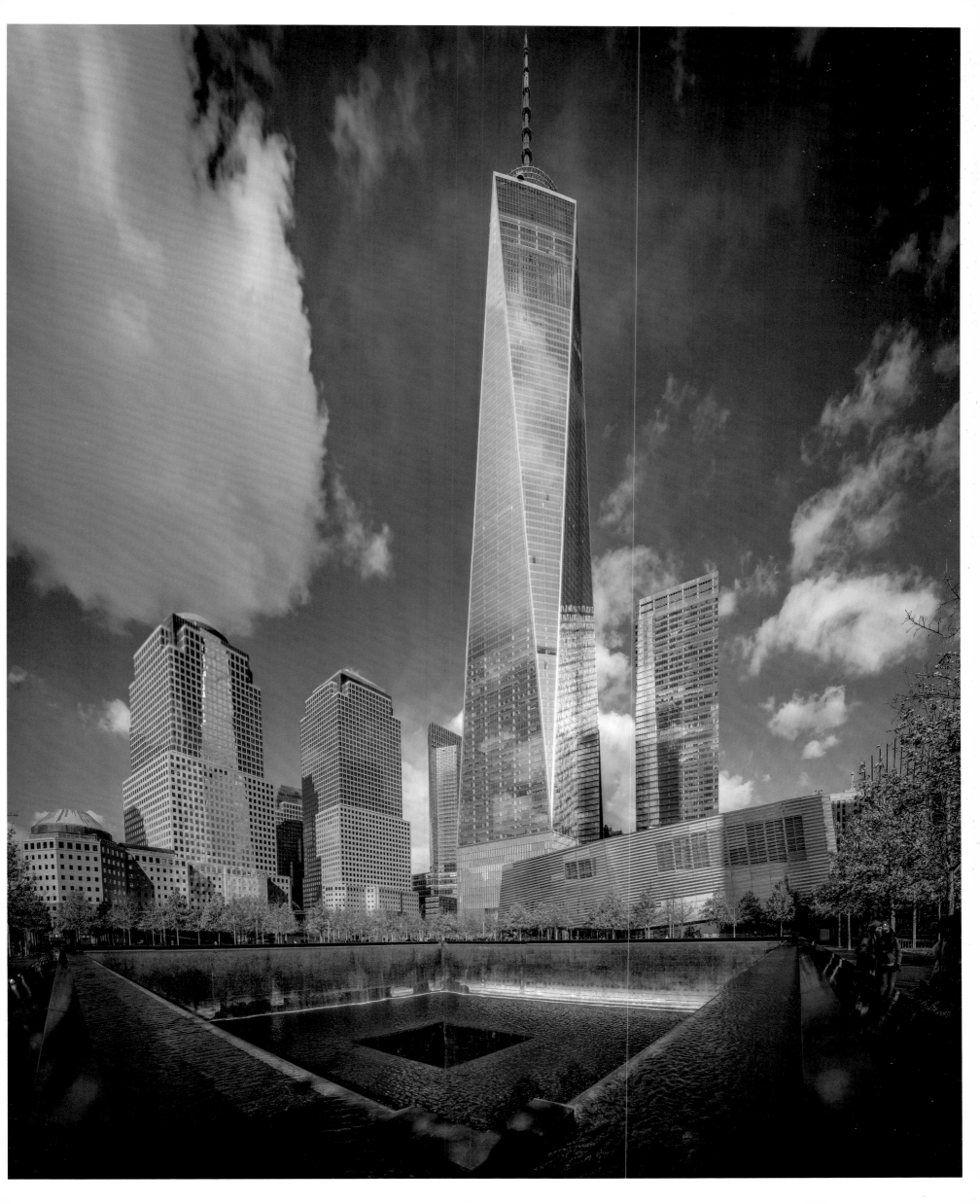

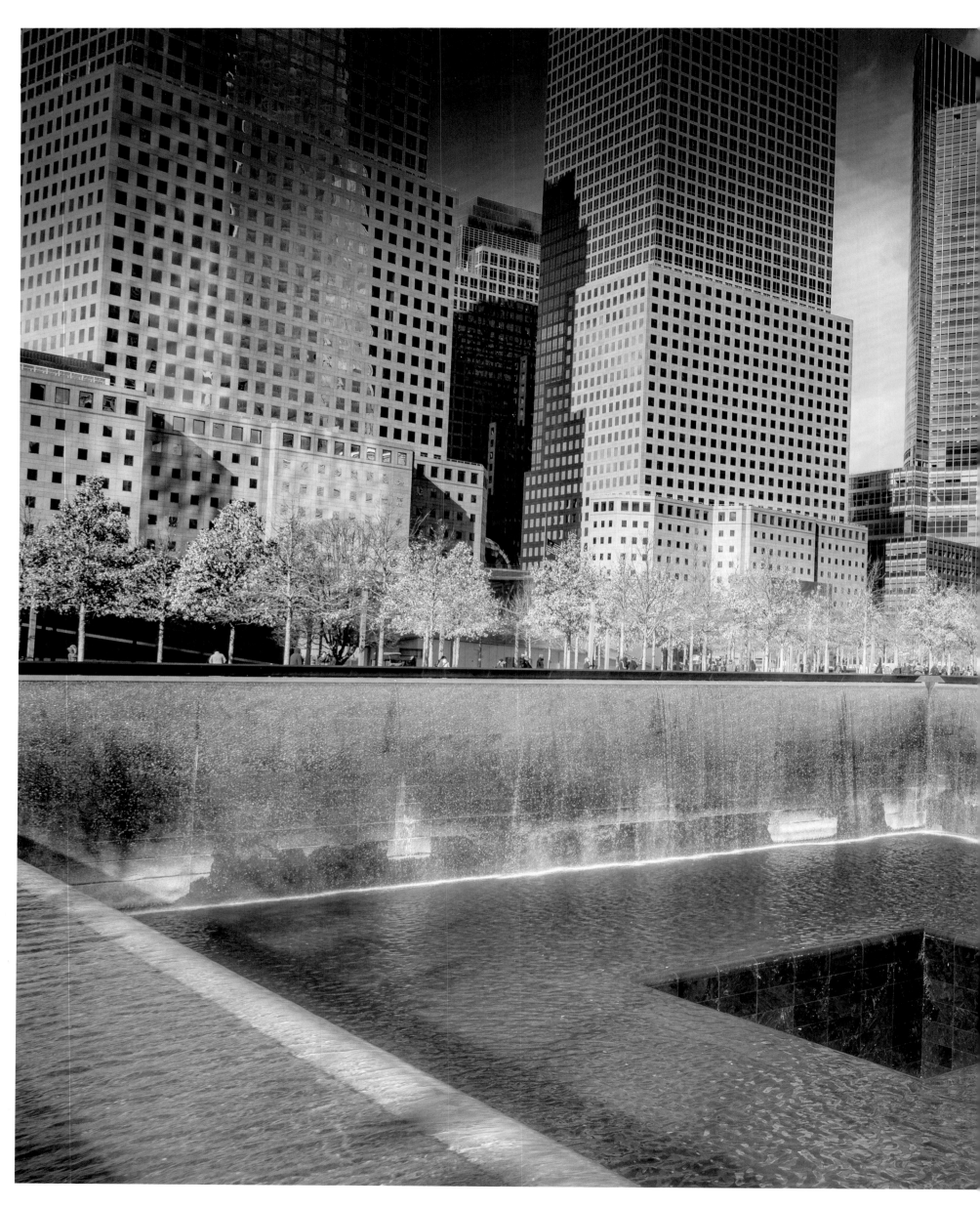

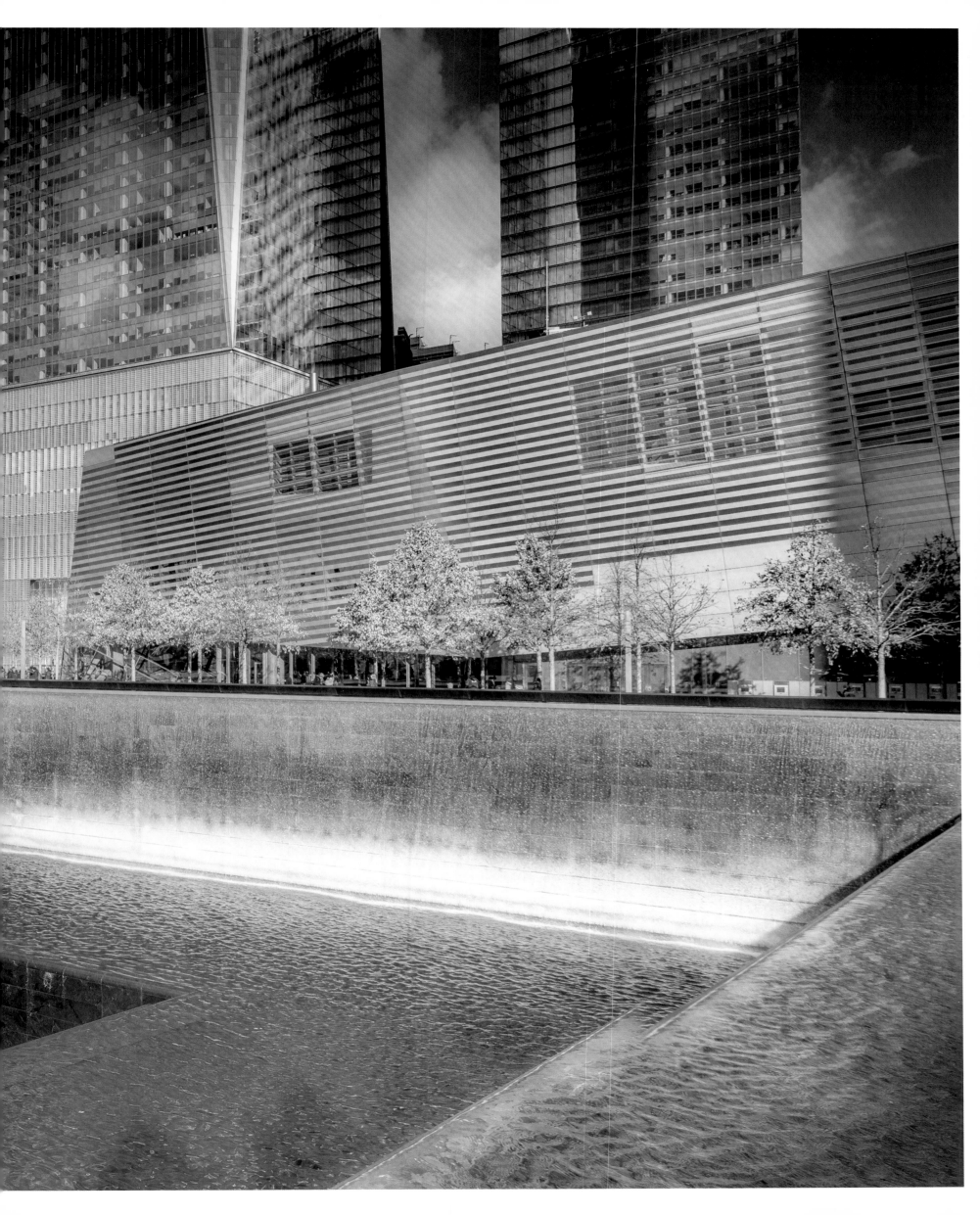

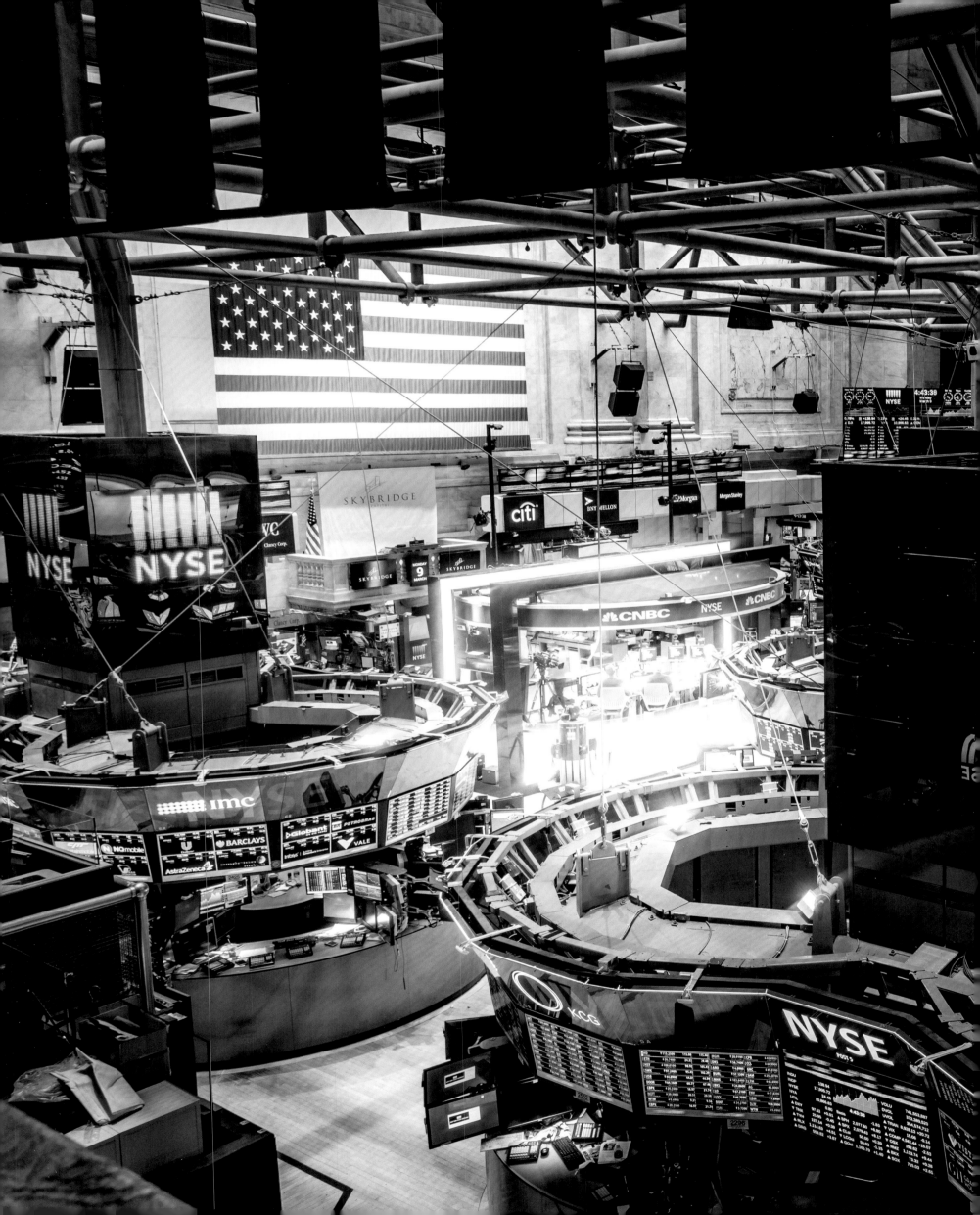

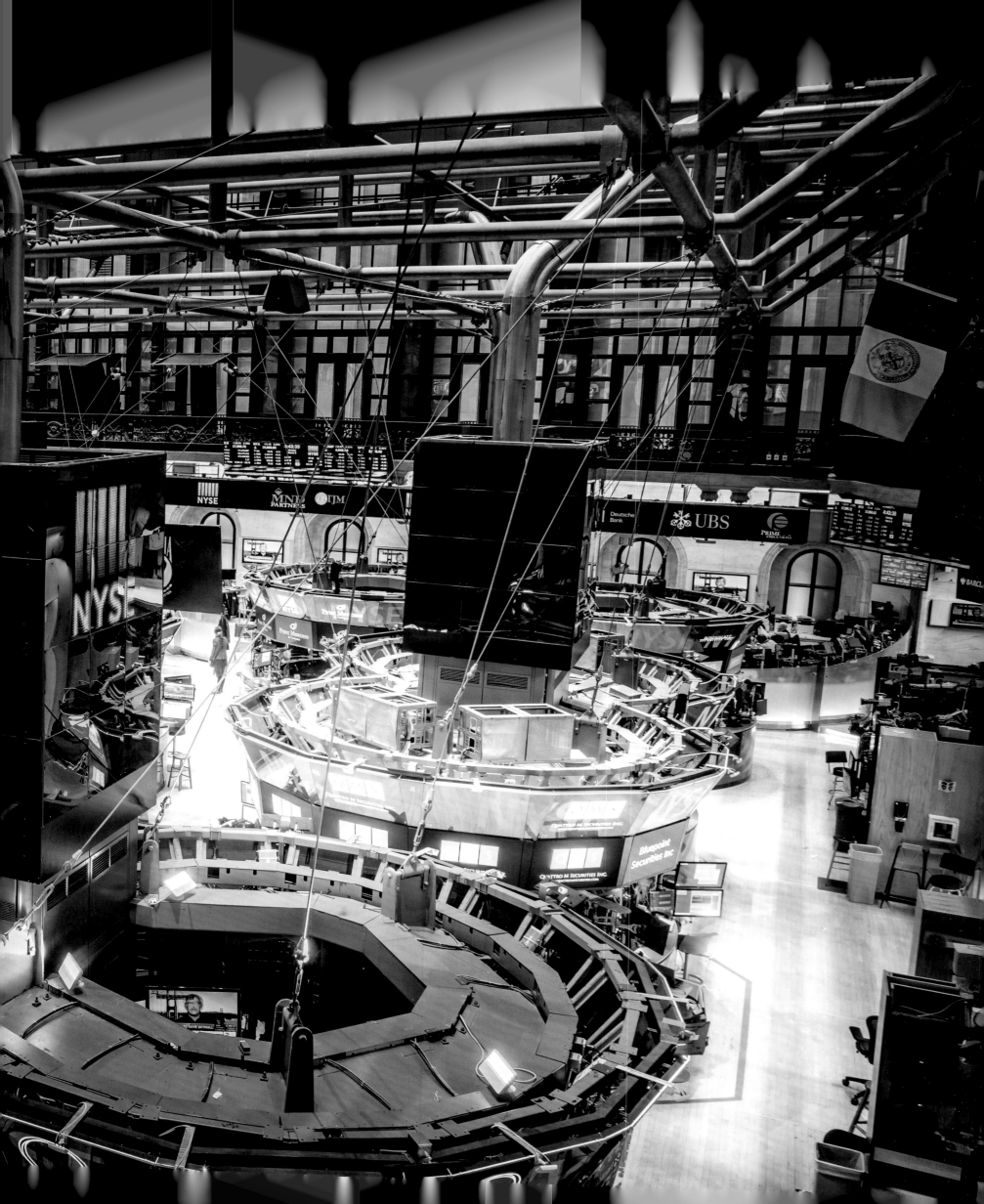

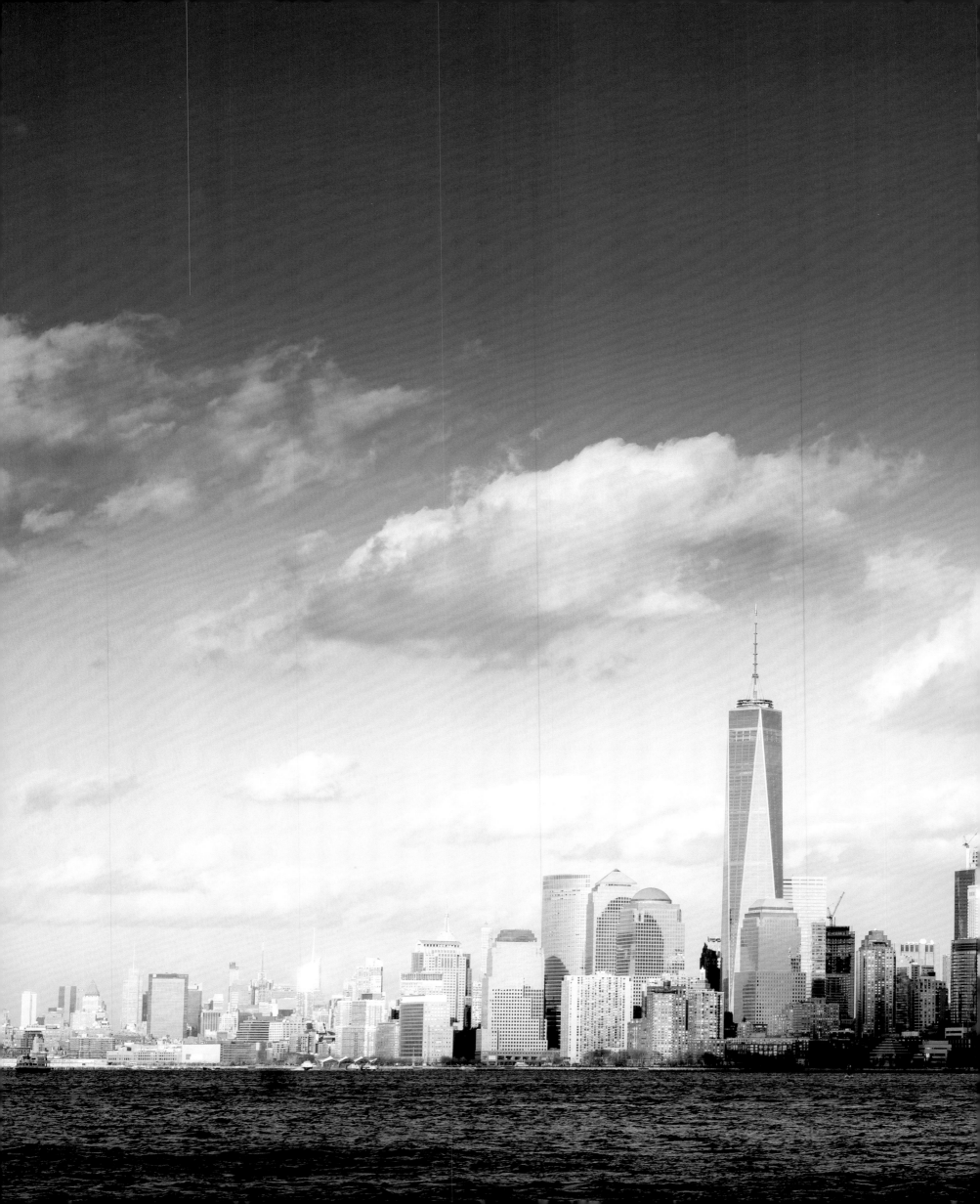

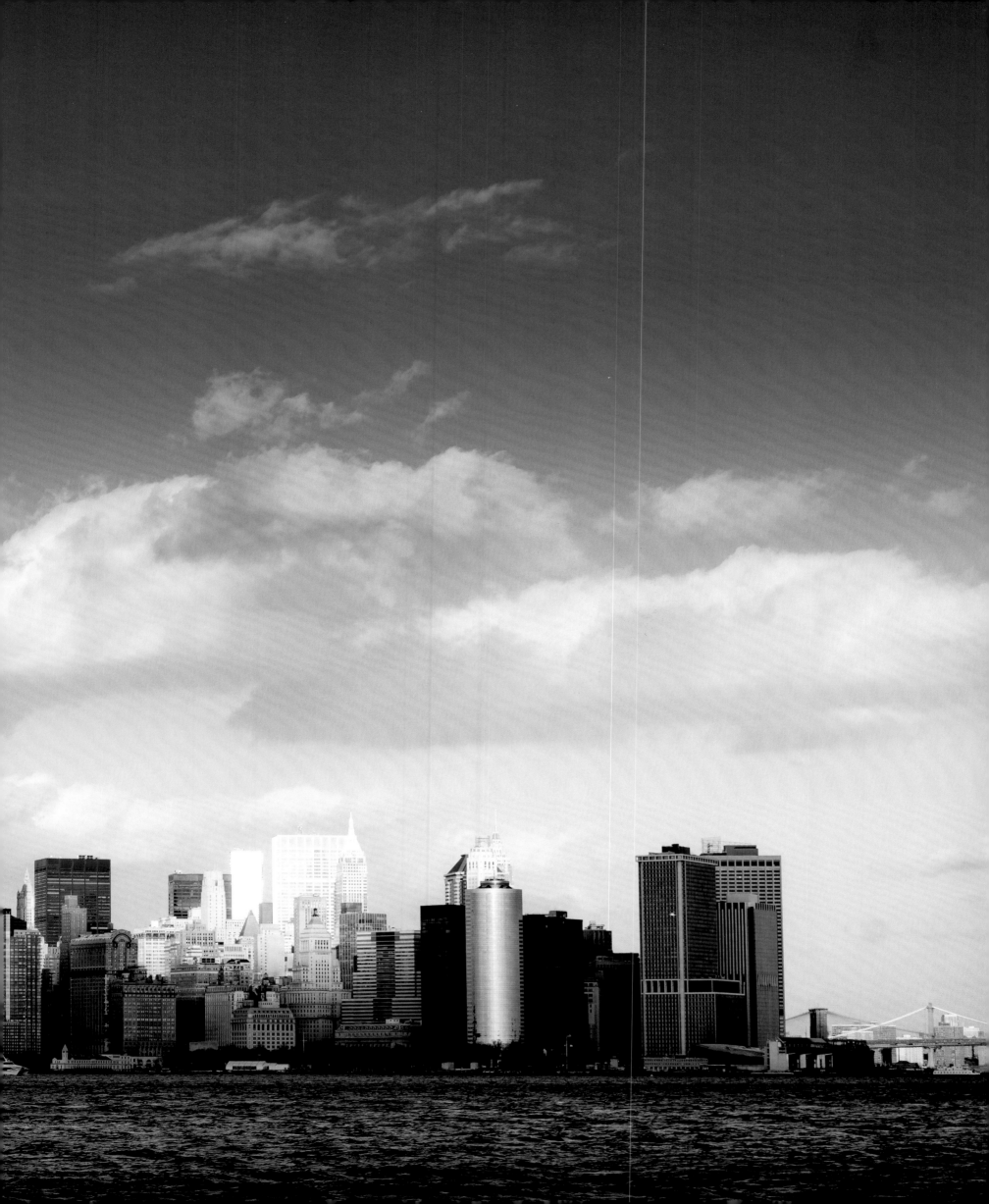

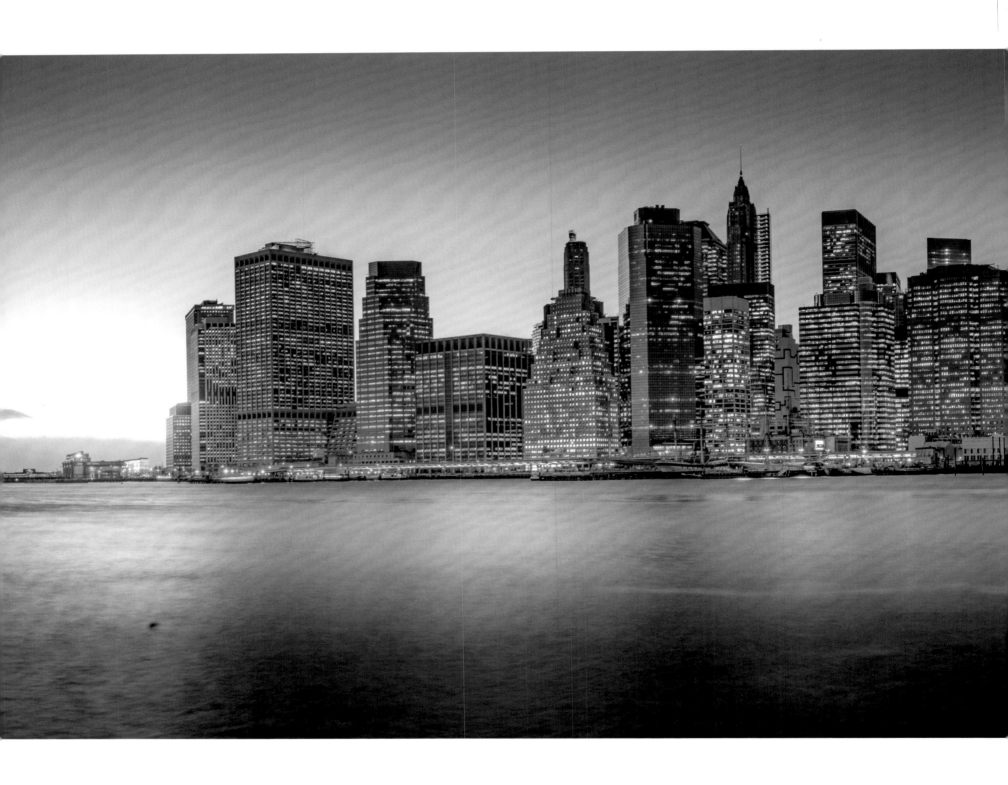

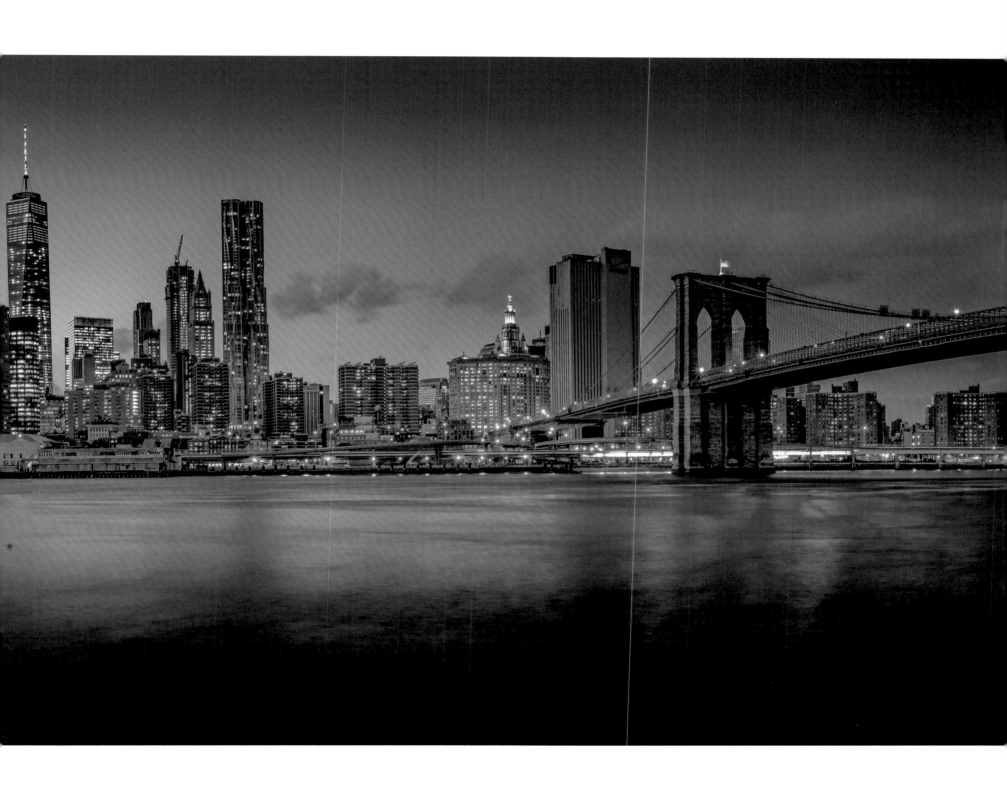

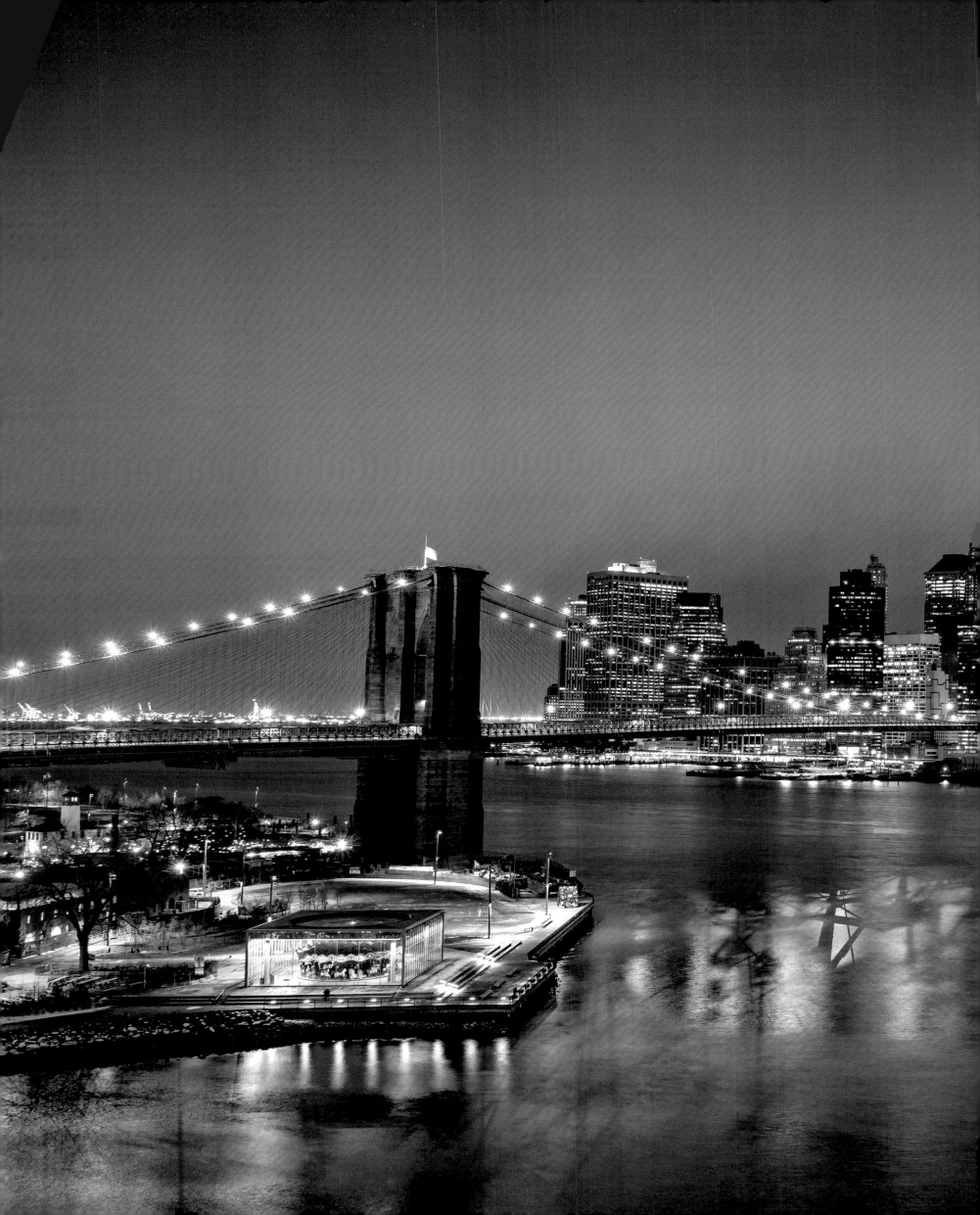

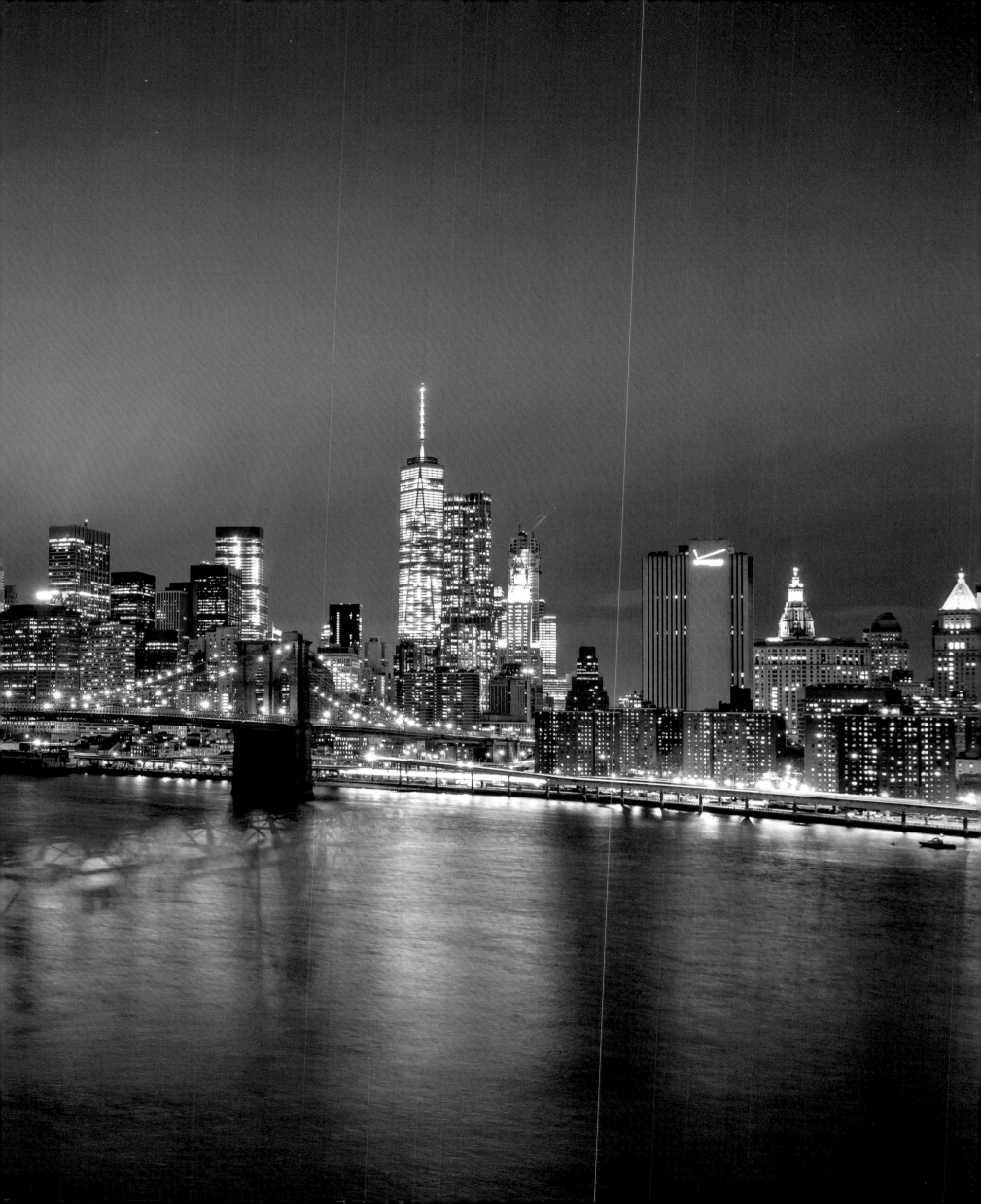

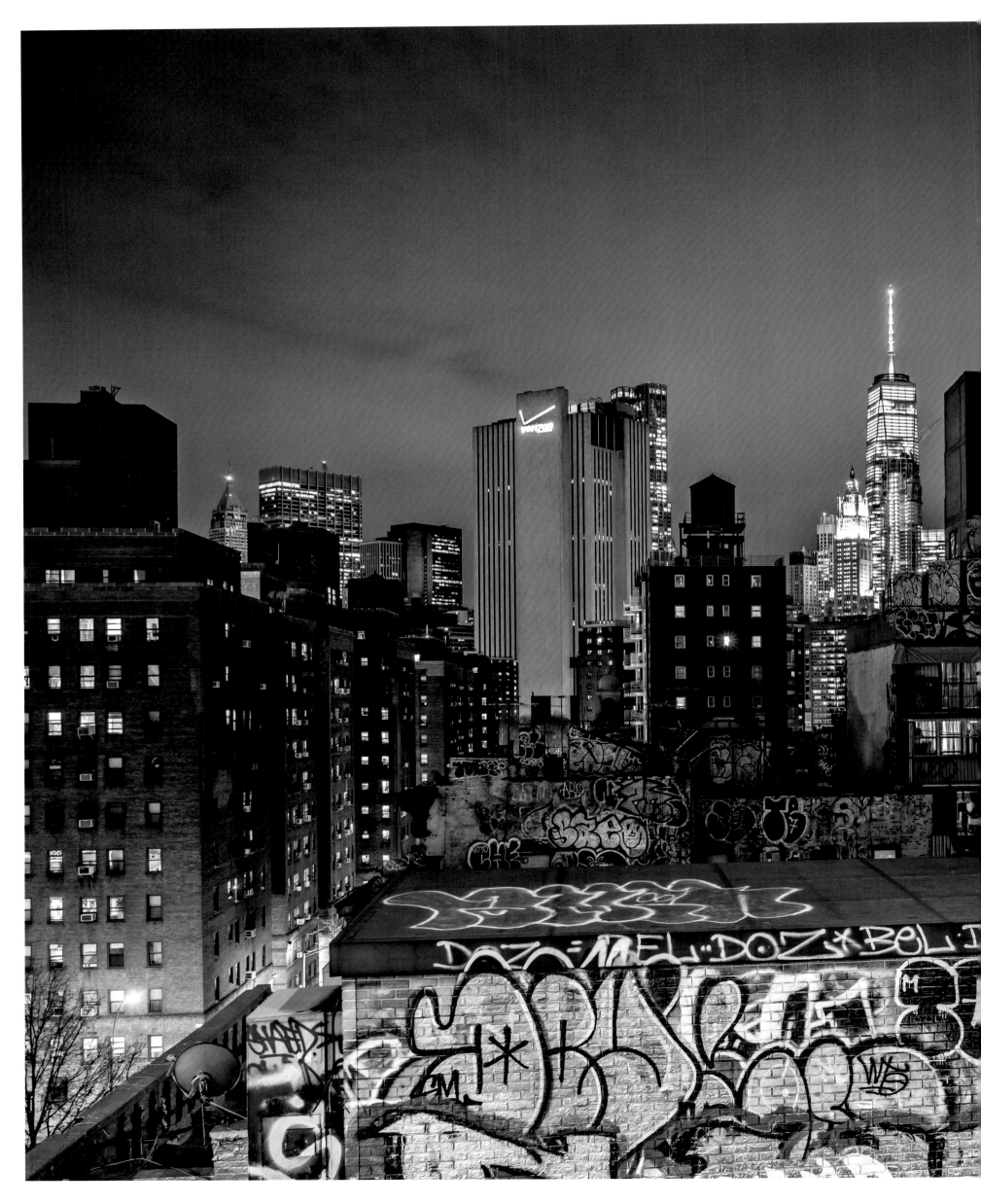

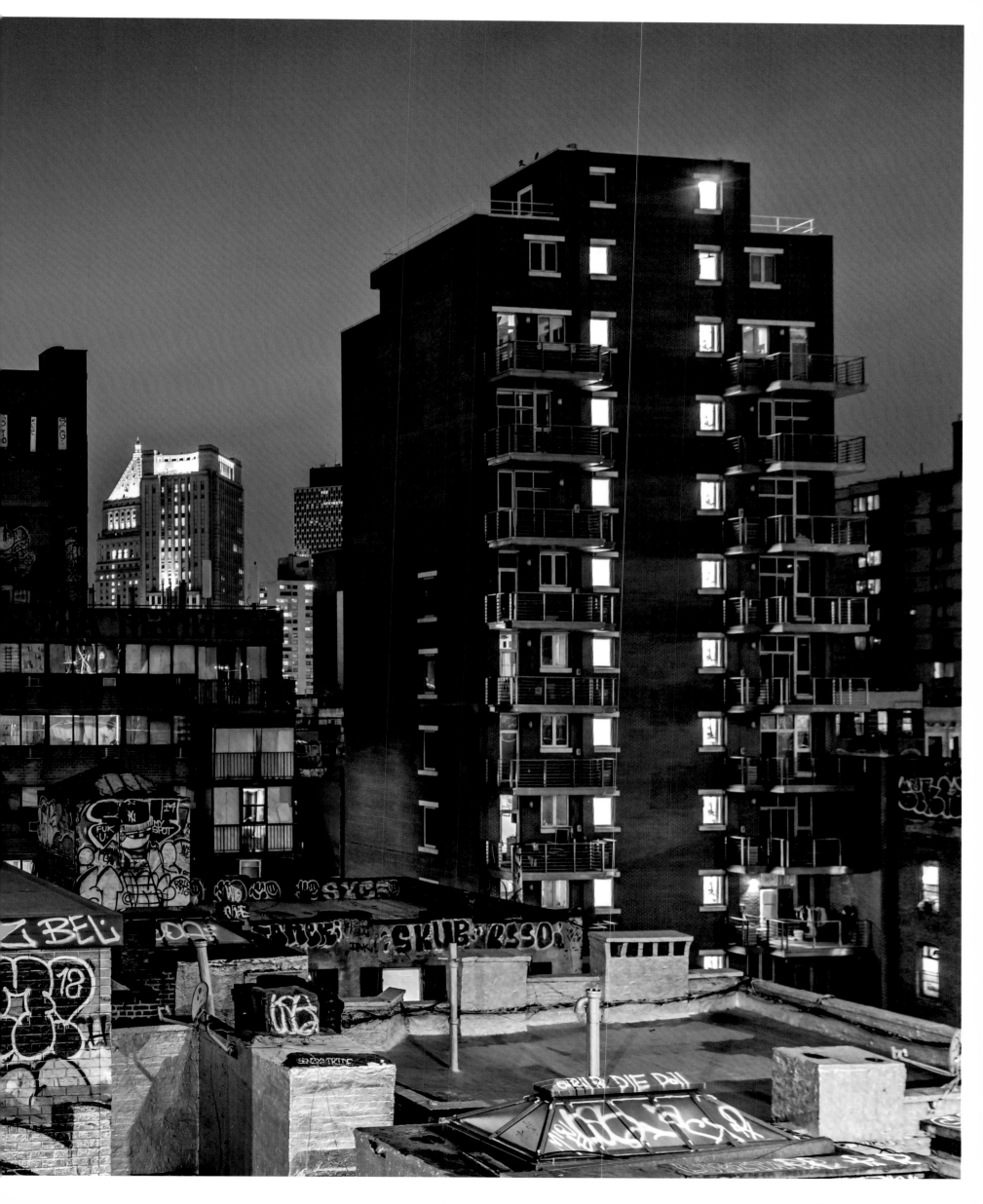

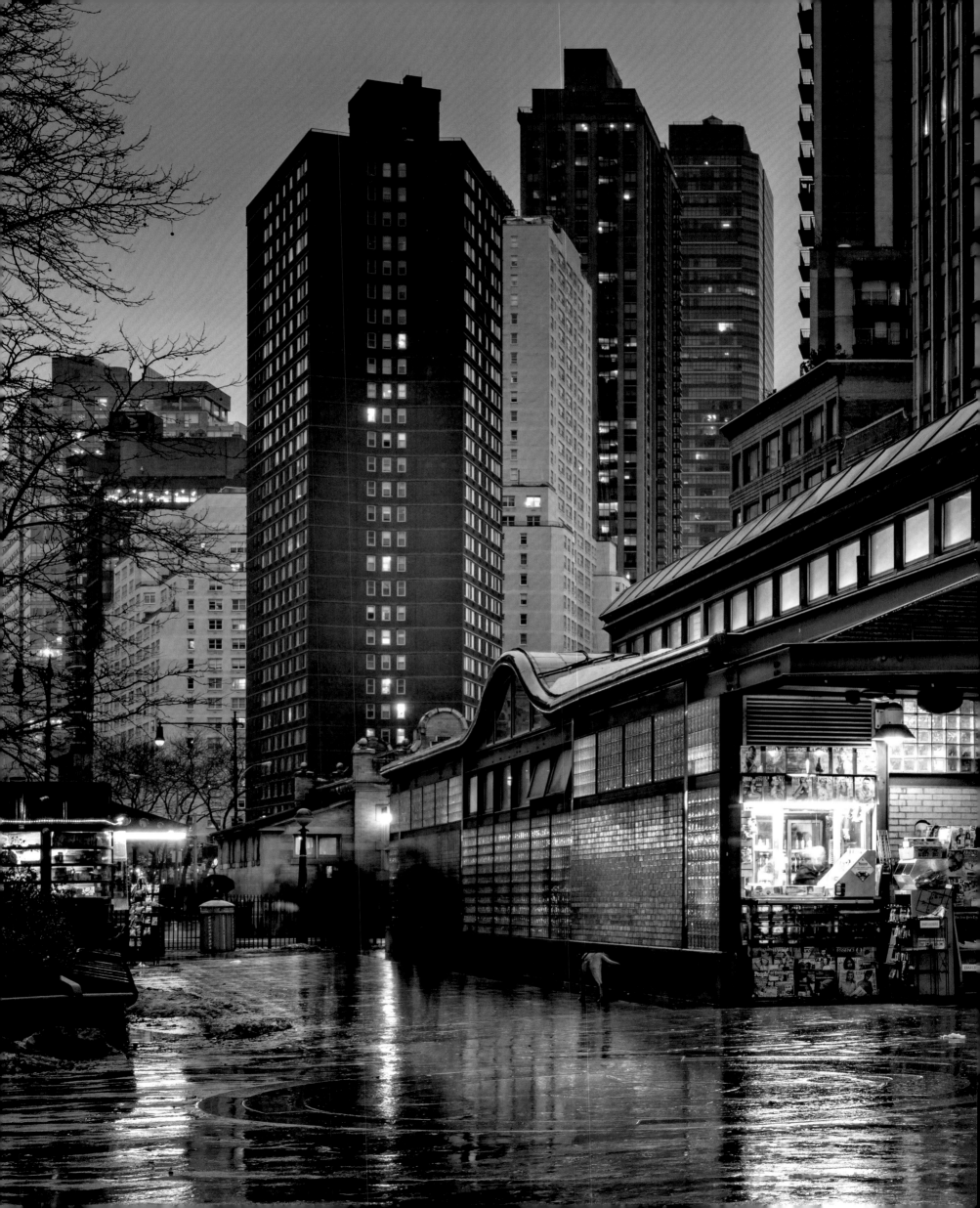

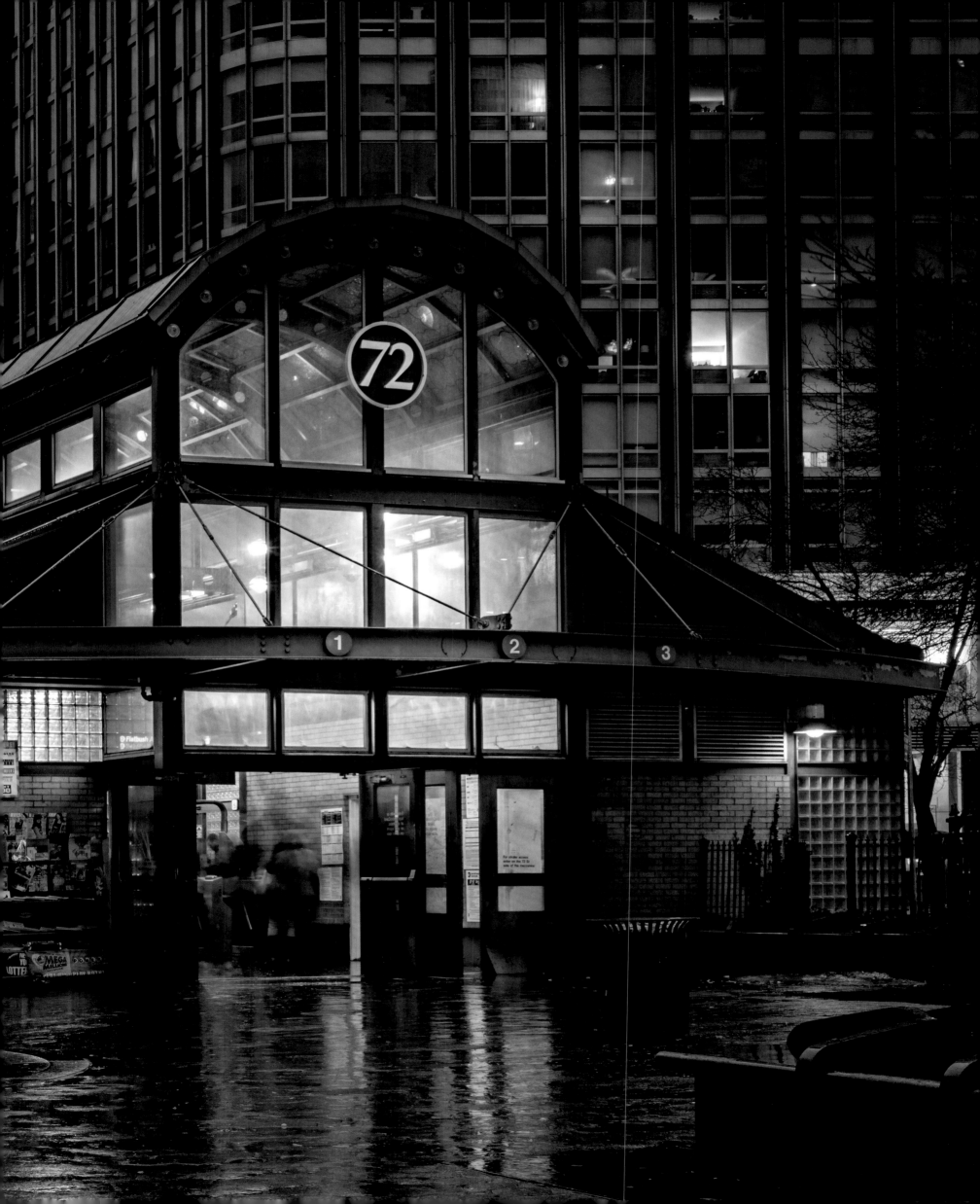

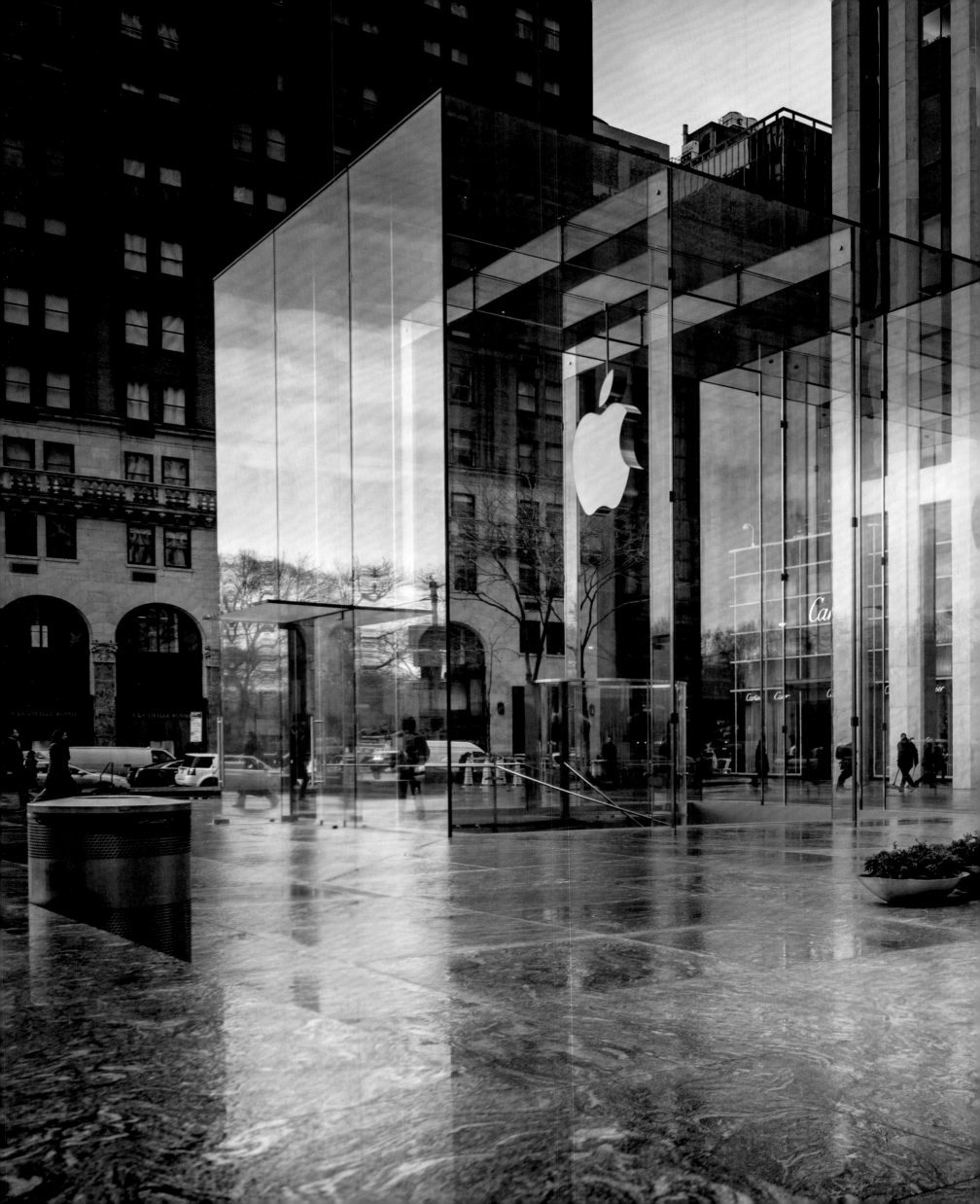

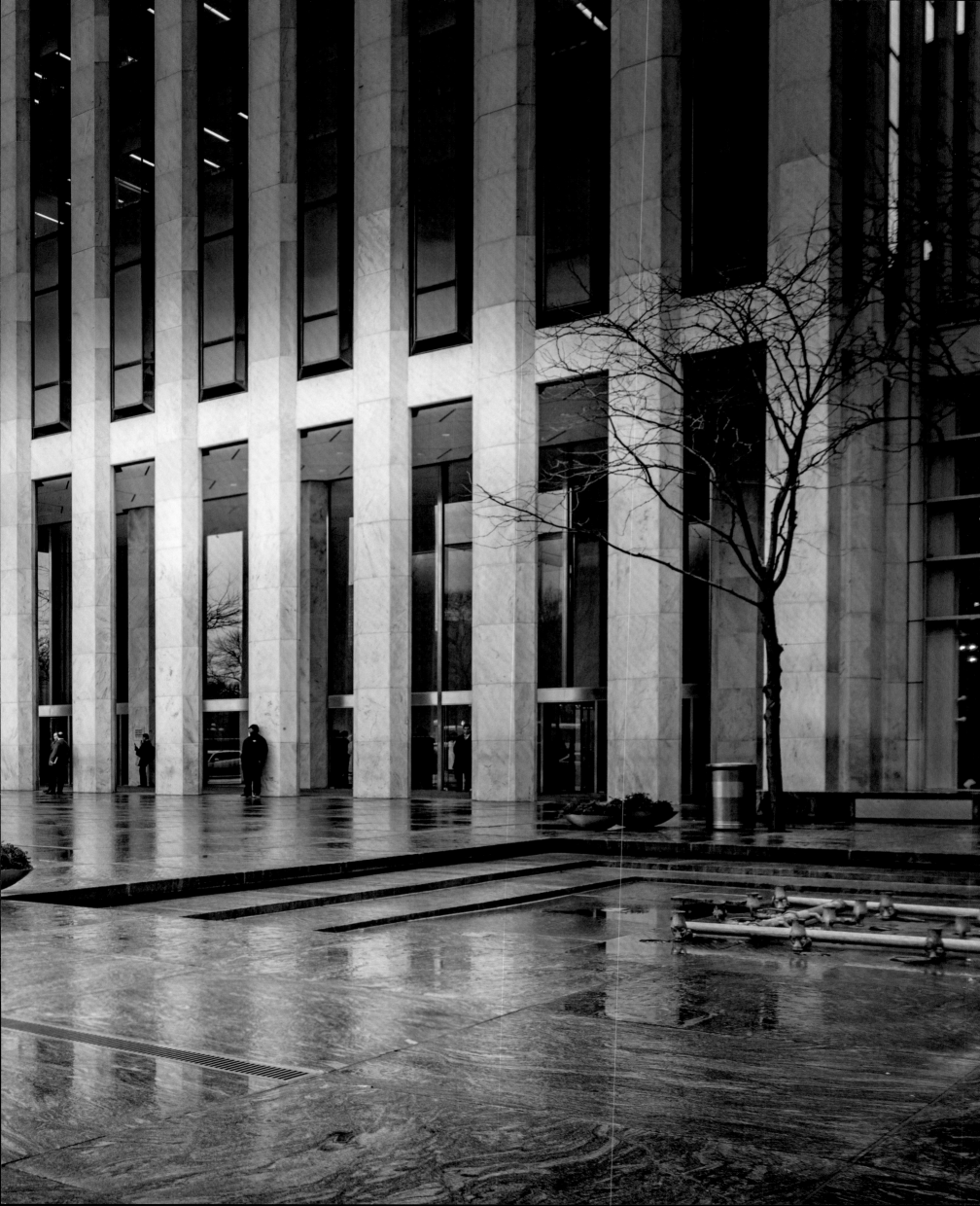

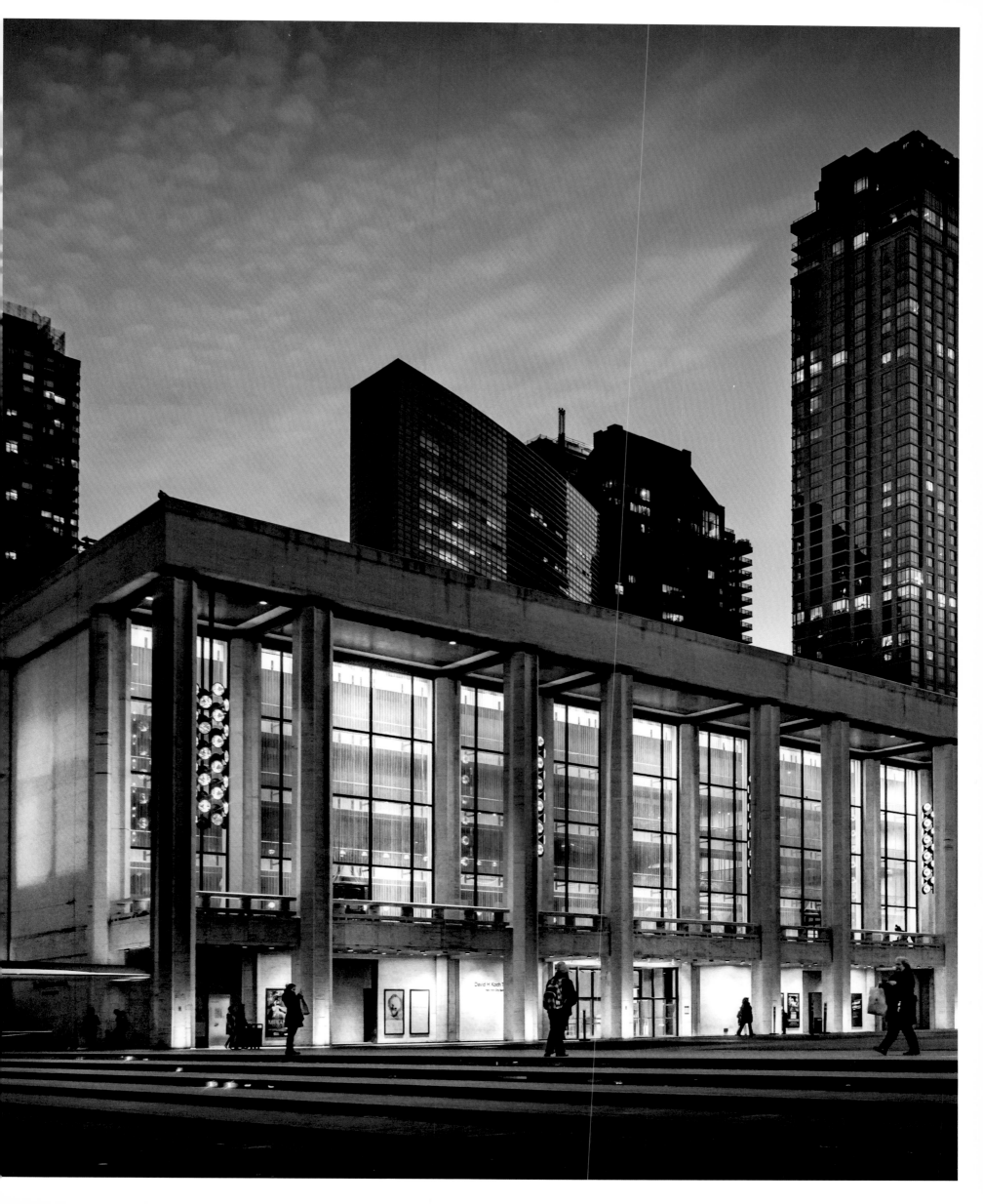

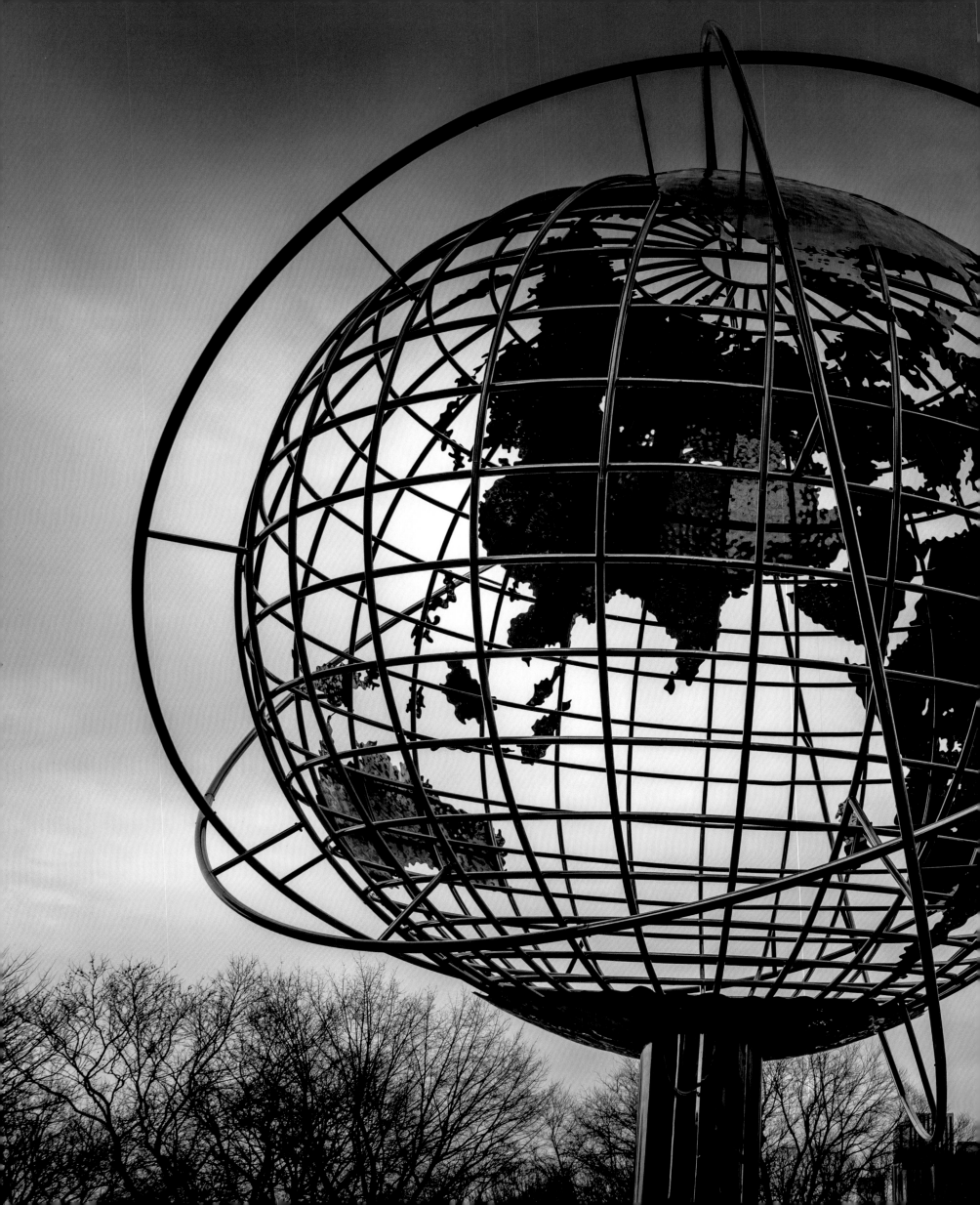

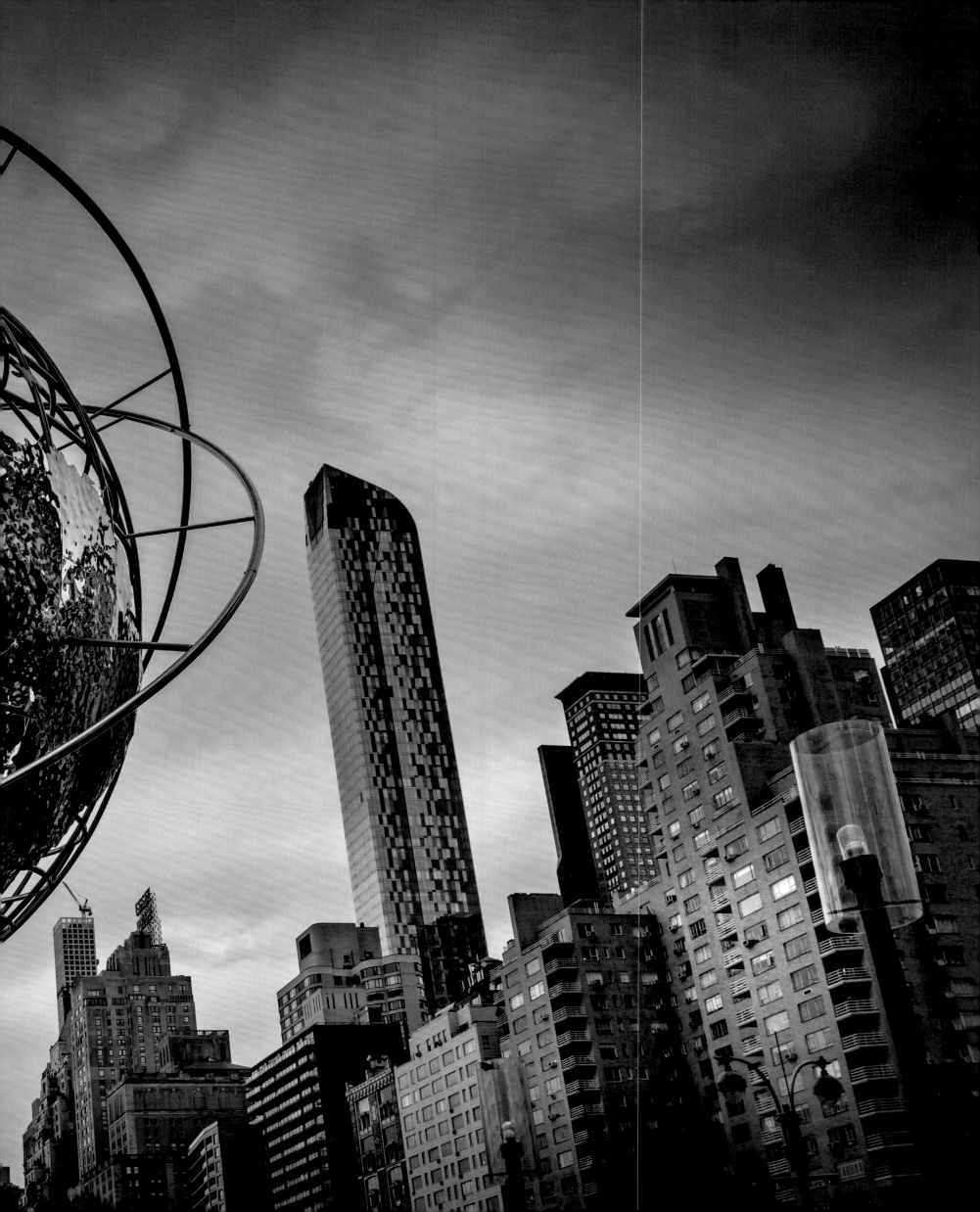

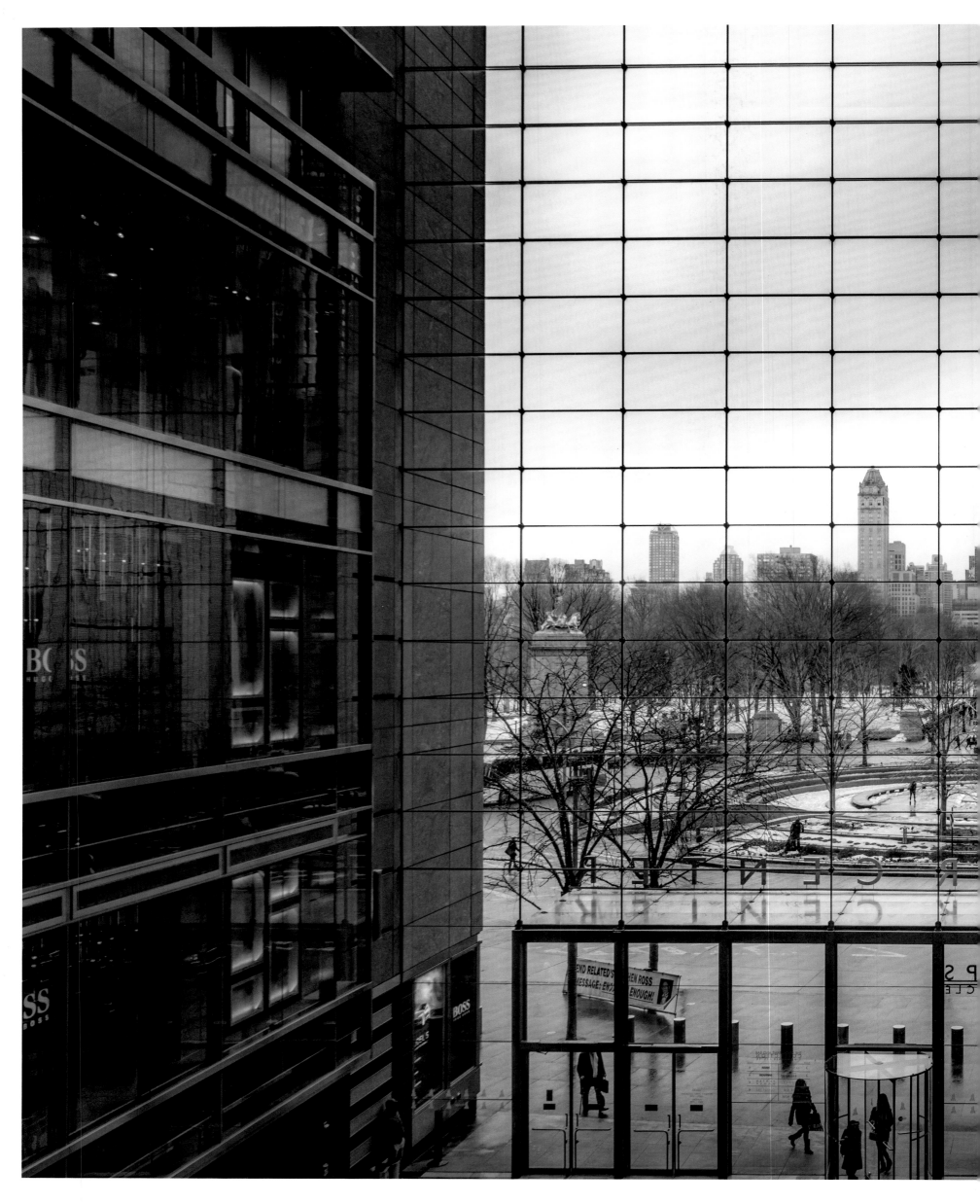

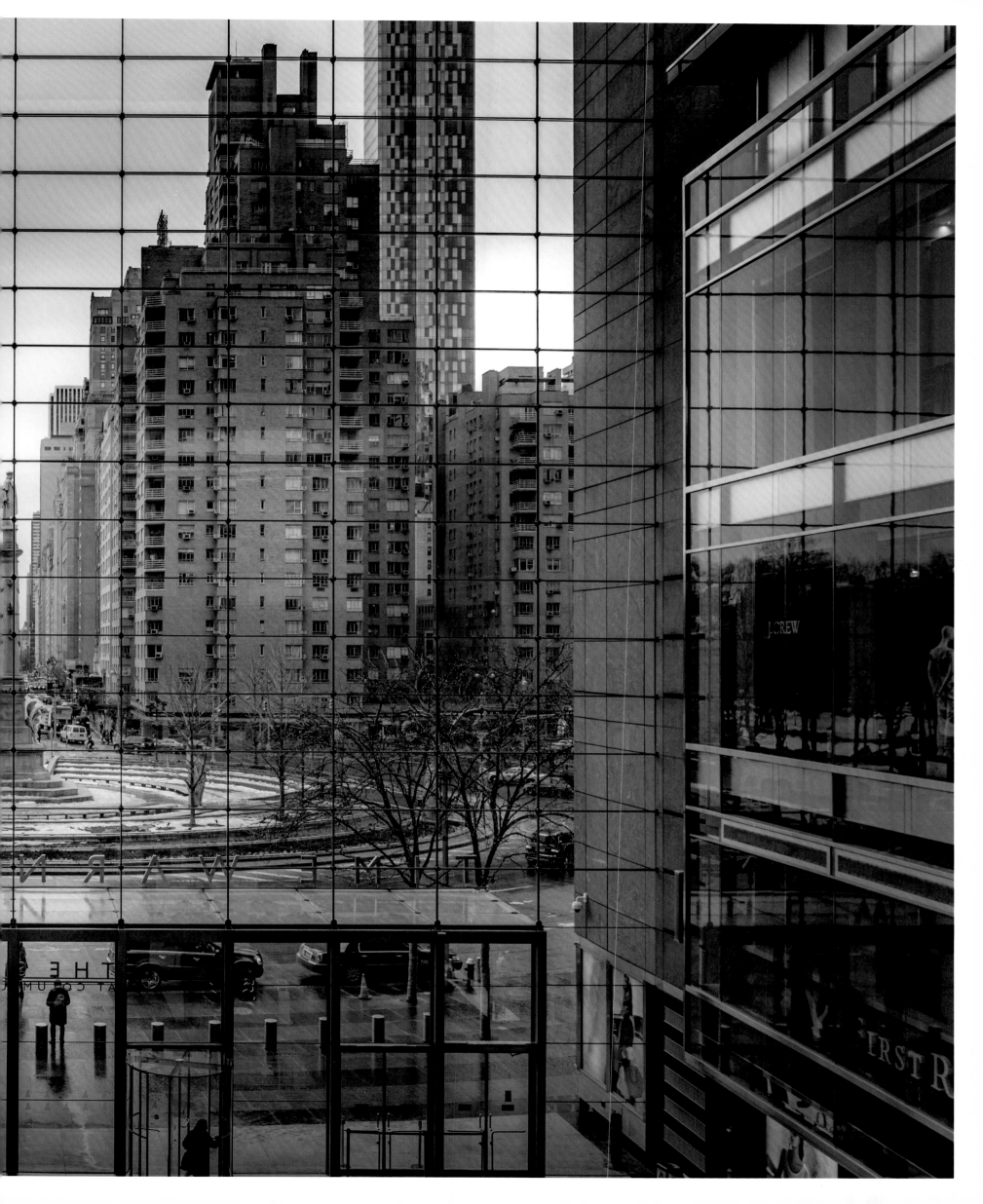

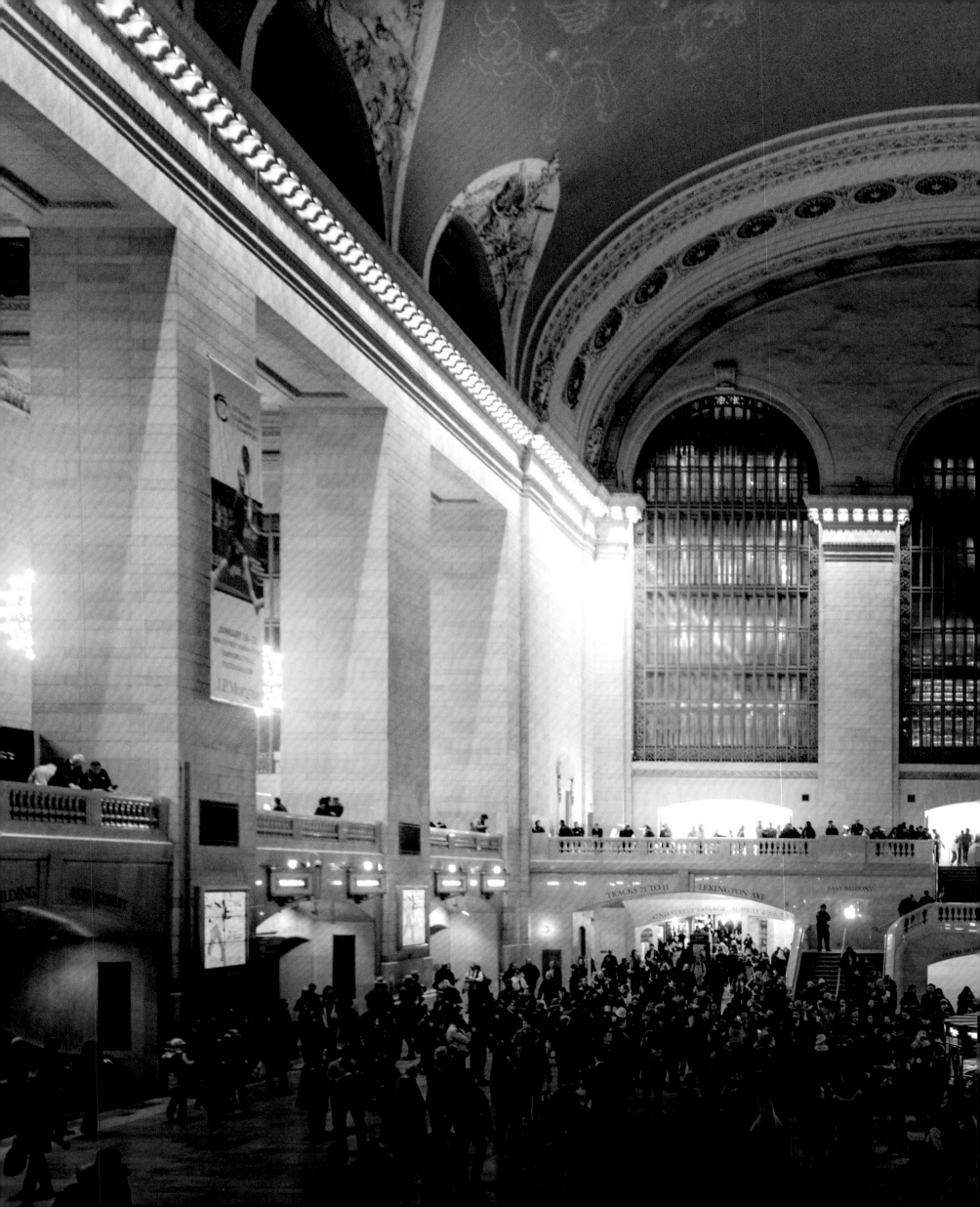

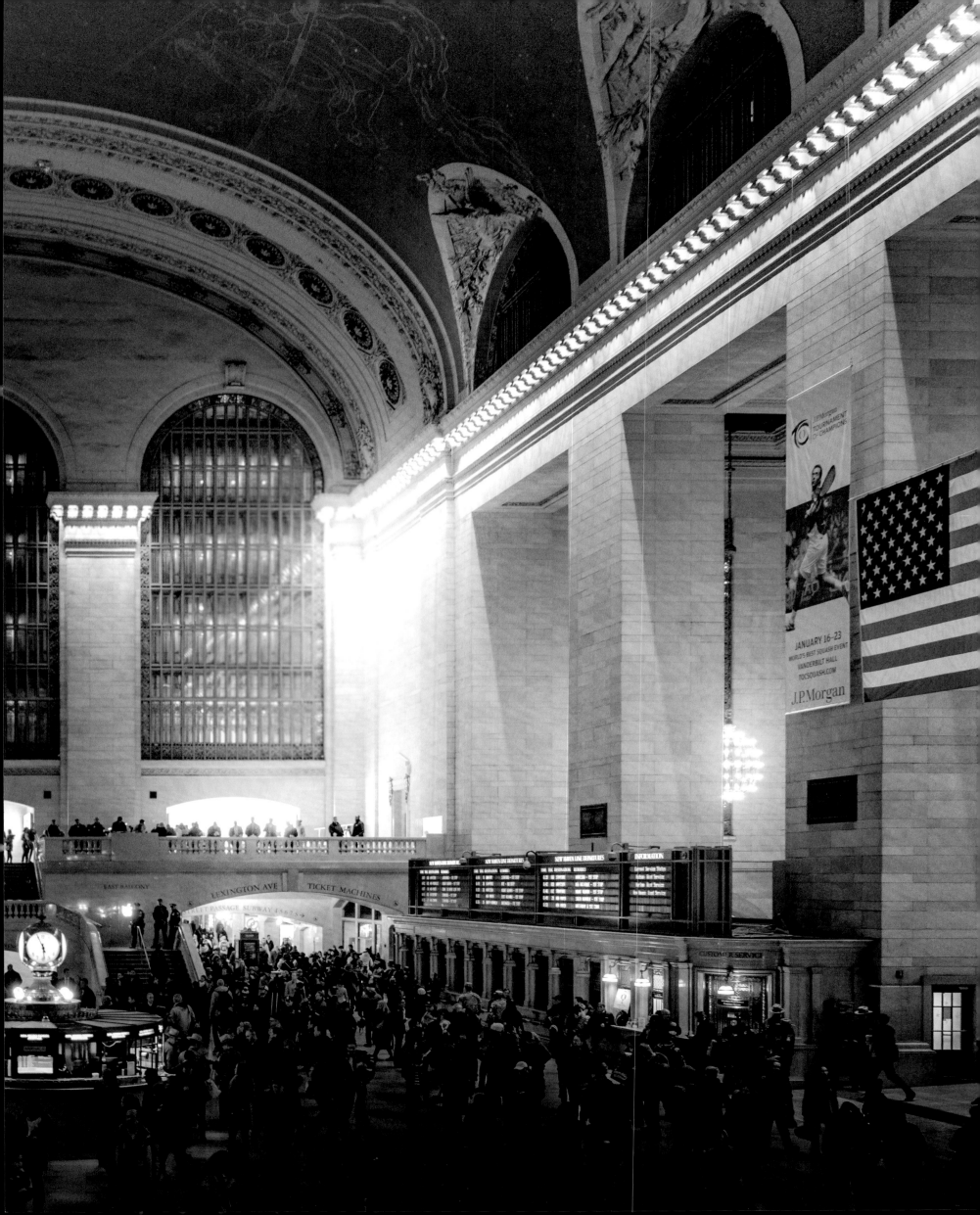

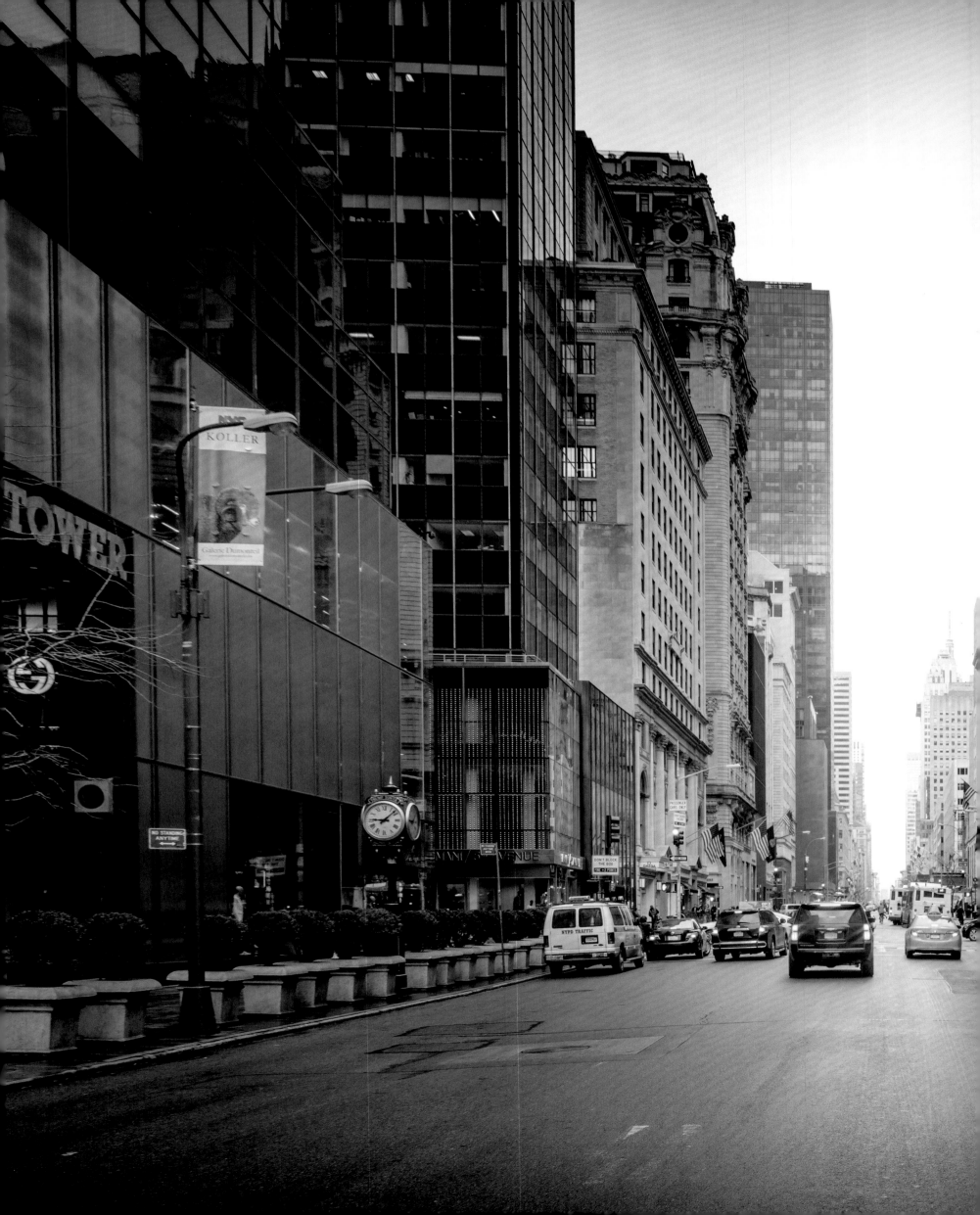

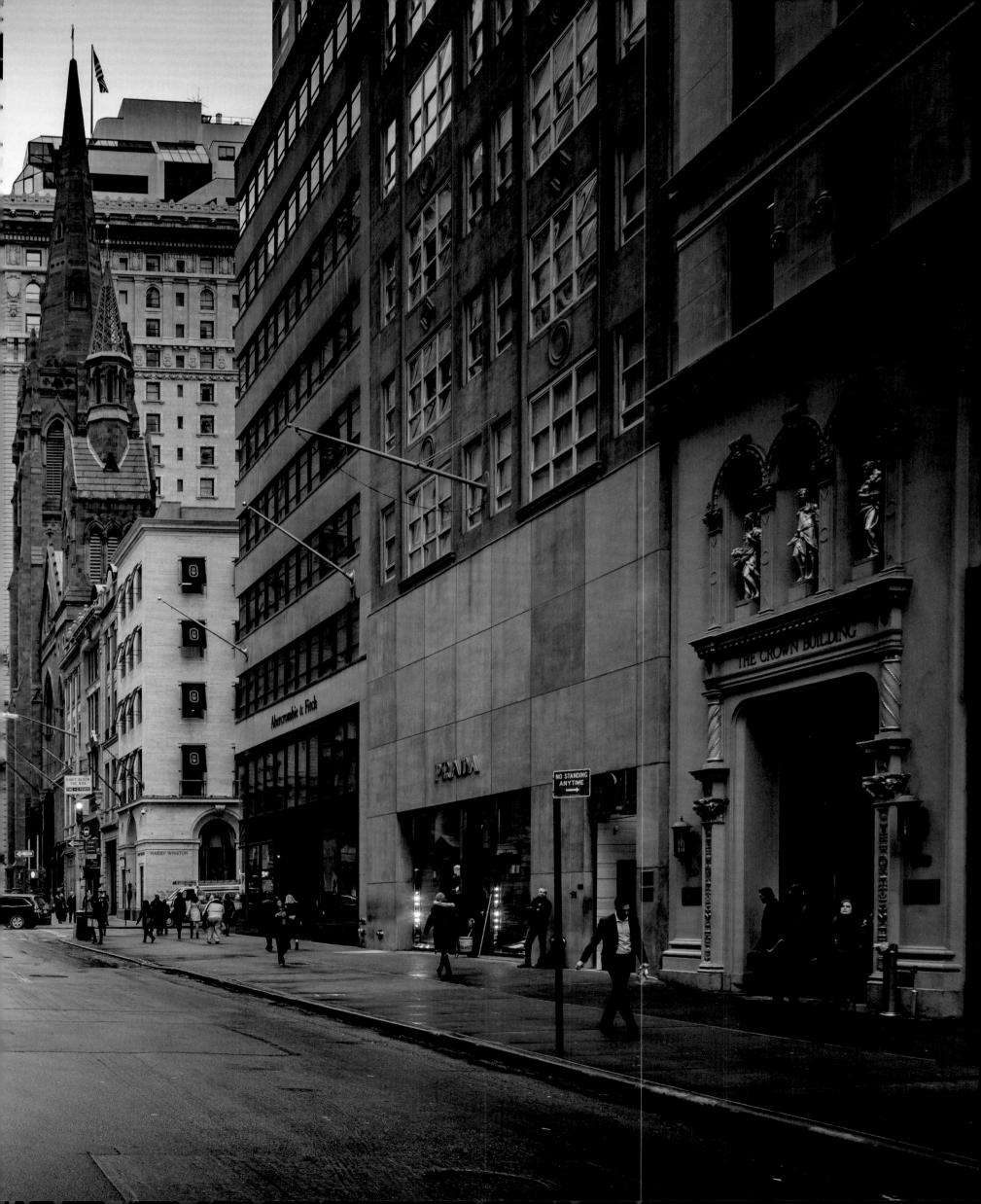

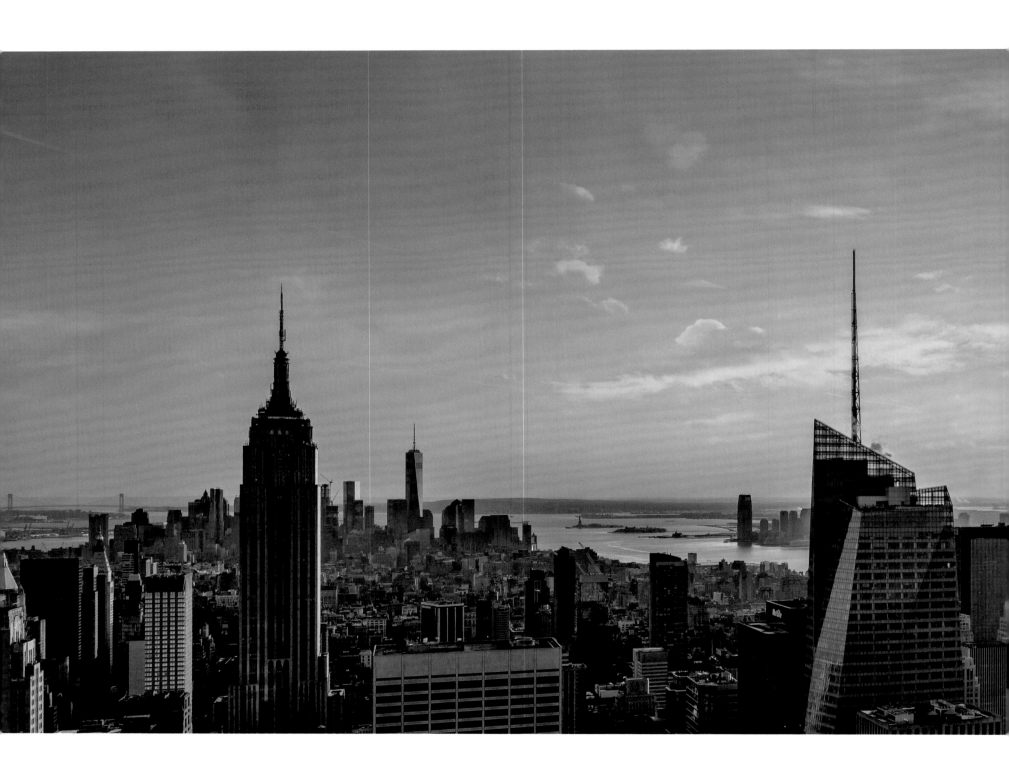

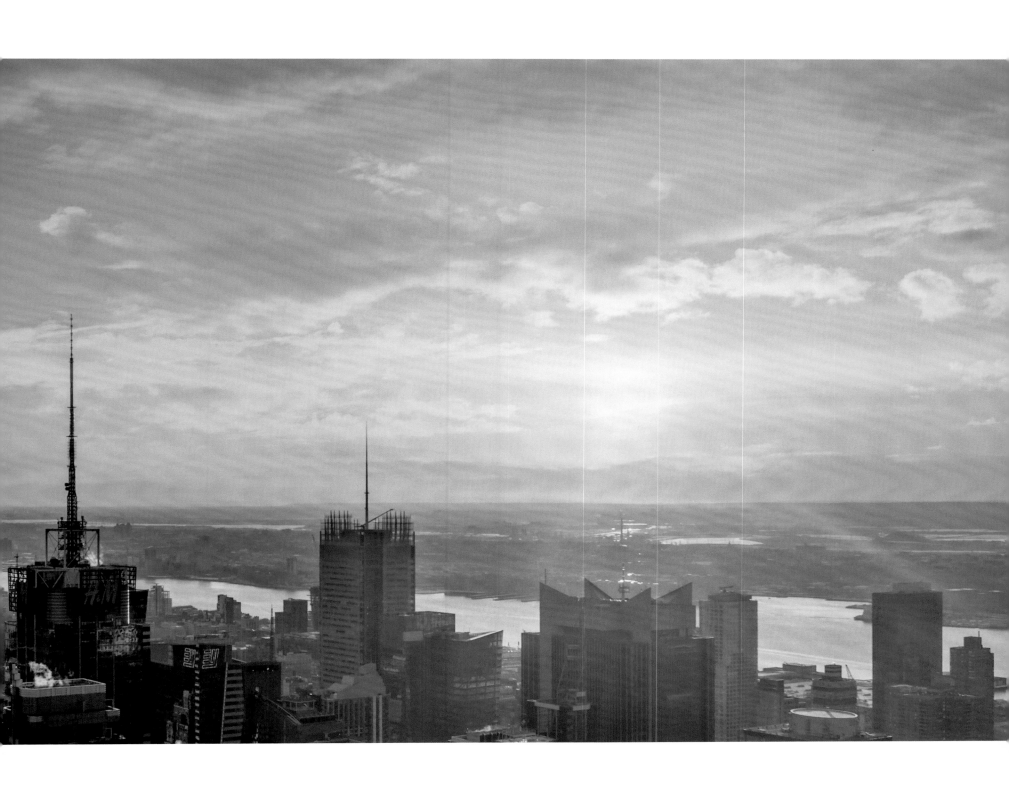

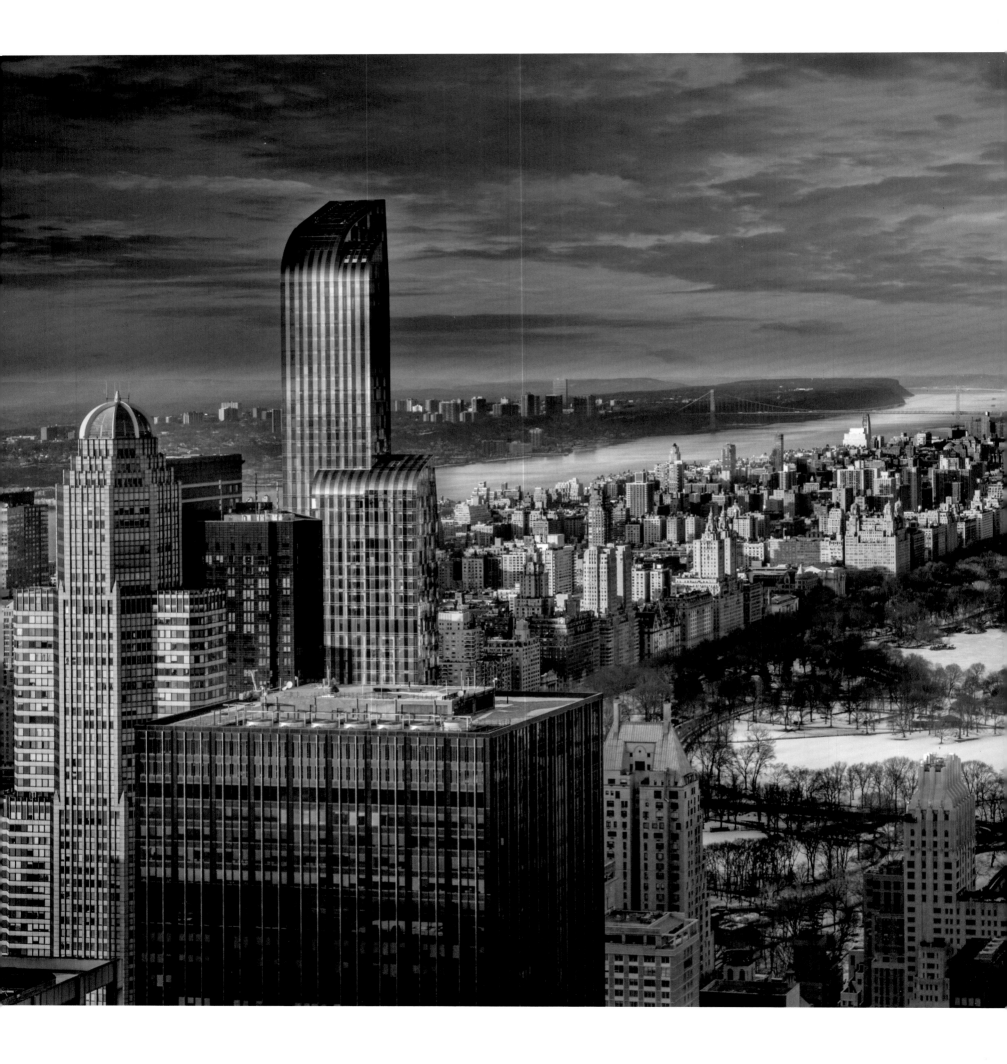

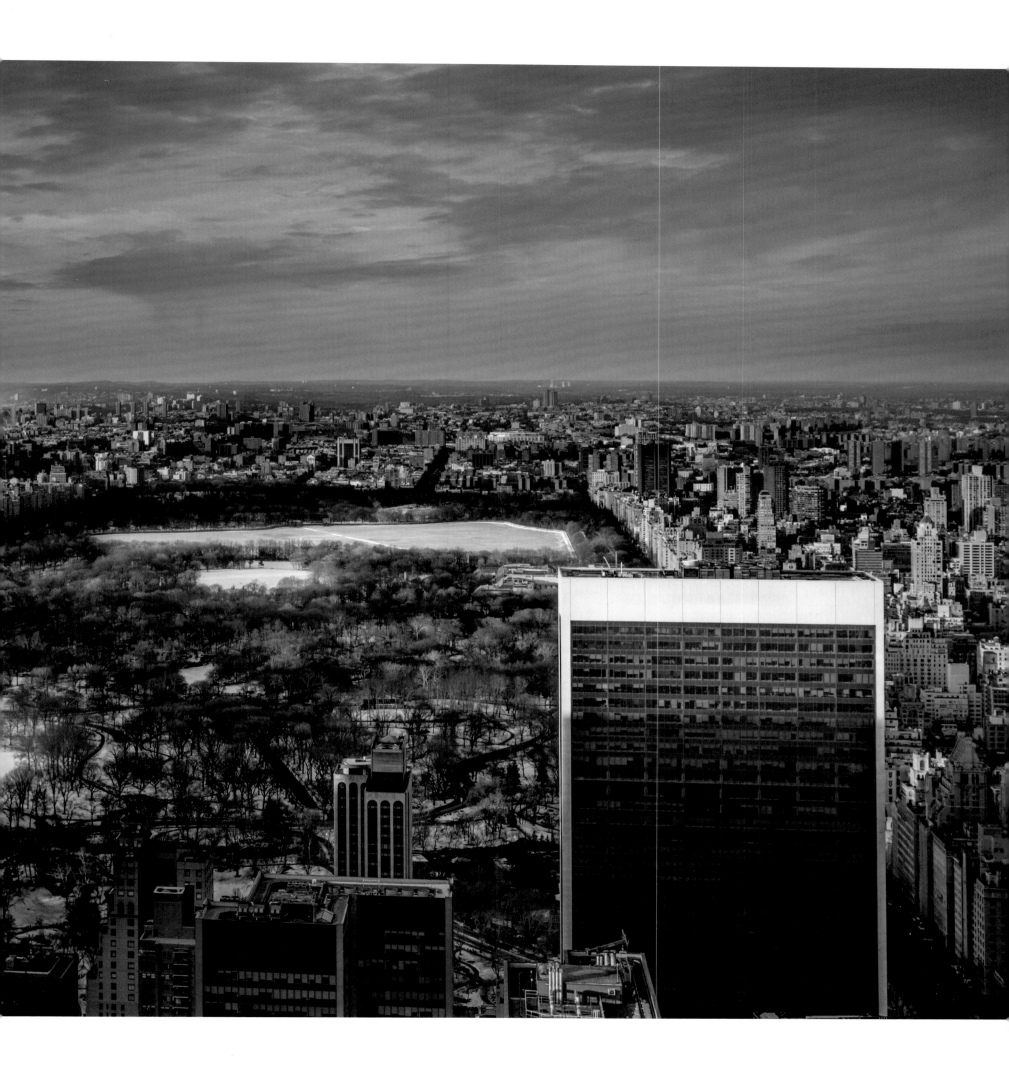

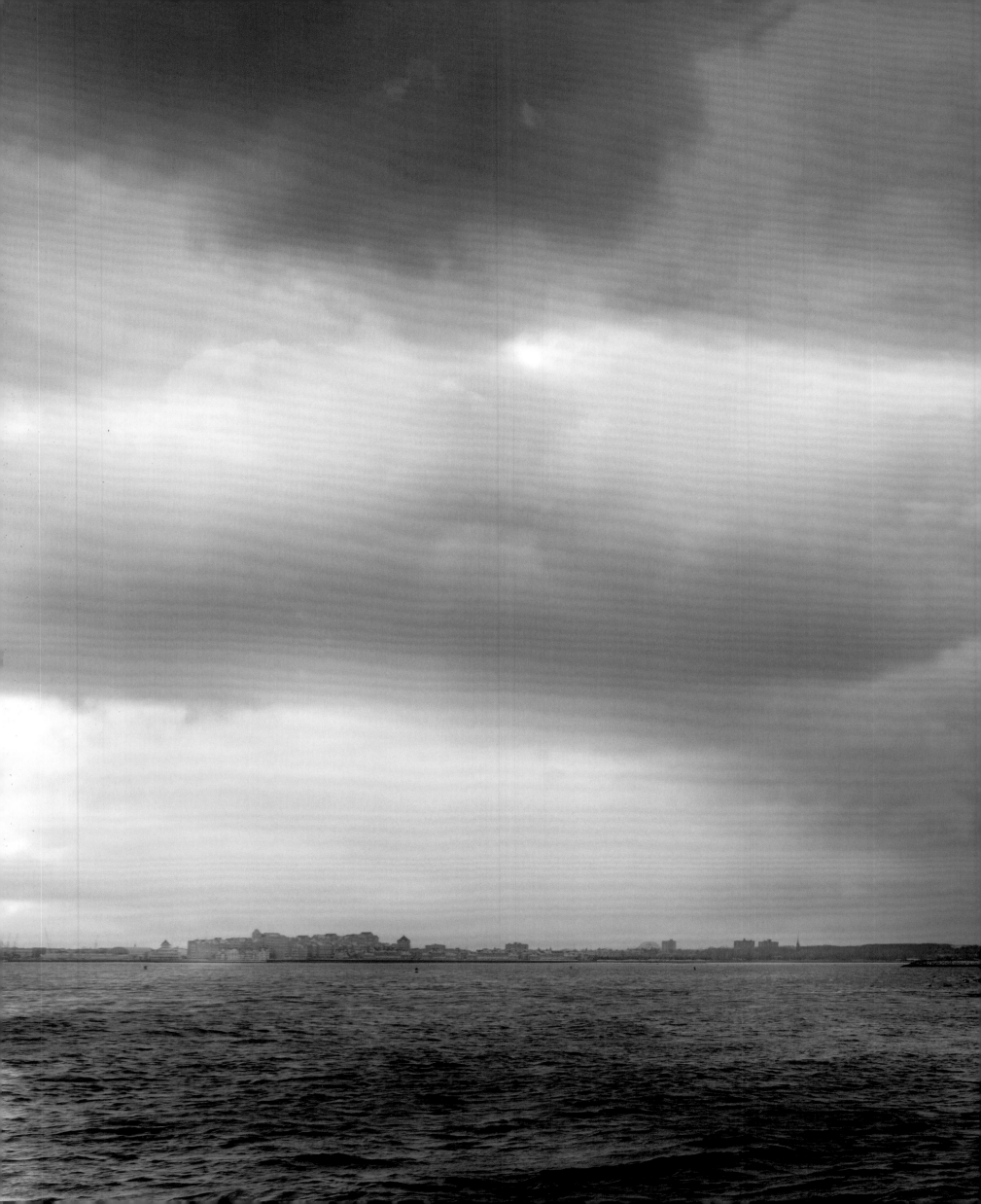

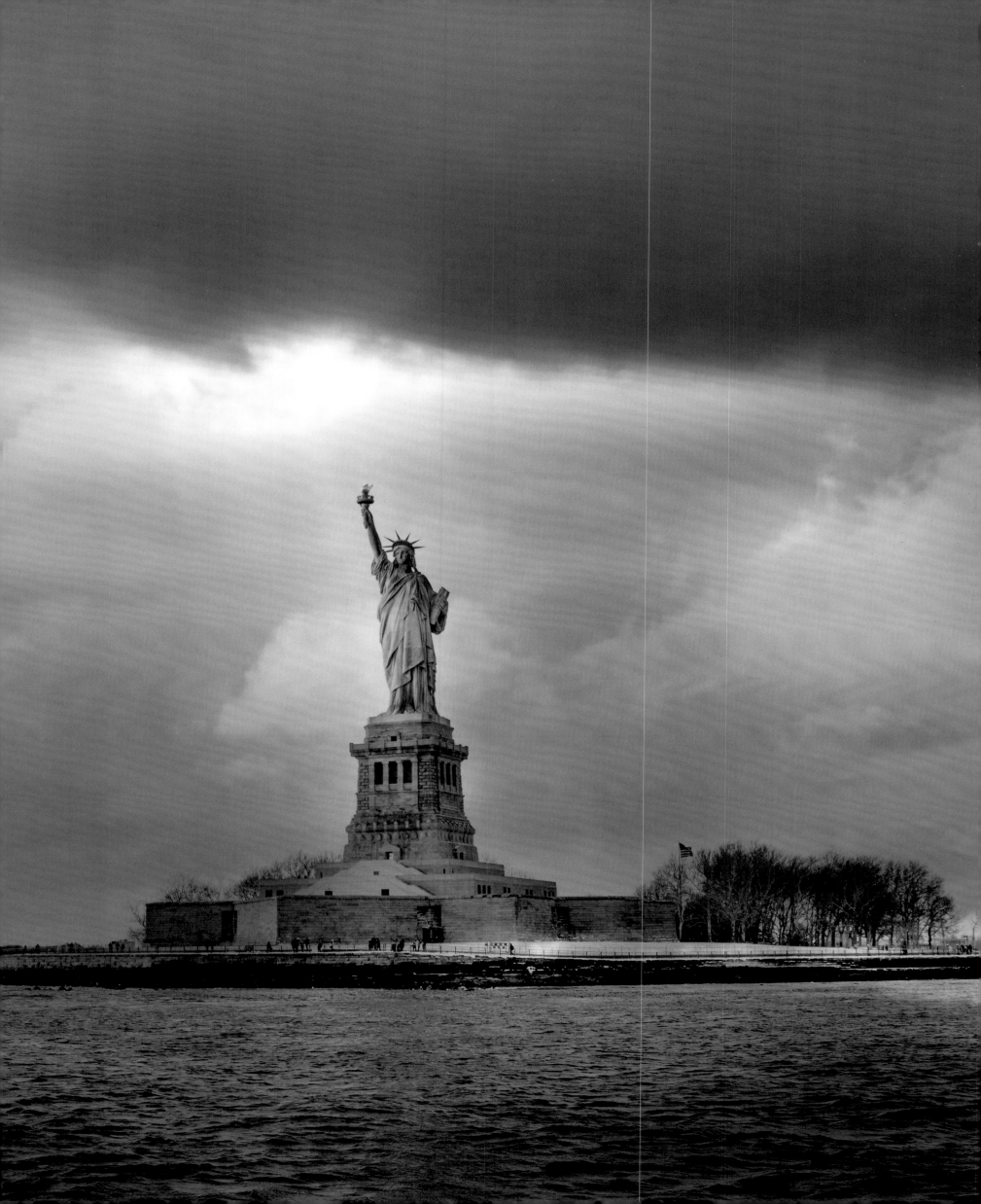

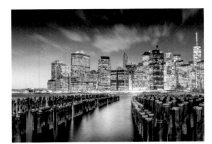

4-5. VIEW OF MANHATTAN FROM BROOKLYN

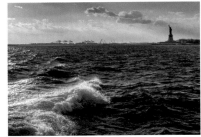

12-13. VIEW FROM THE BOAT

15. THE STATUE OF LIBERTY

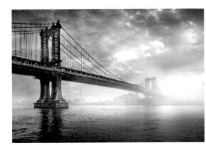

16-17. THE MANHATTAN BRIDGE

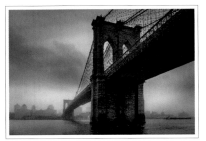

18-19. THE BROOKLYN BRIDGE

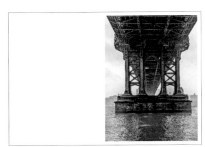

21. UNDER THE MANHATTAN BRIDGE

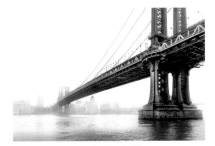

22-23. THE MANHATTAN BRIDGE IN FOG

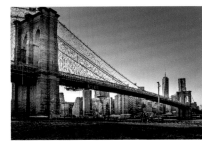

24-25. THE BROOKLYN GARDEN

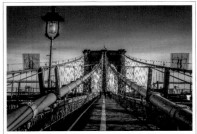

26-27. TOP OF THE BROOKLYN BRIDGE

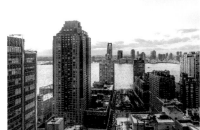

28-29. FINANCIAL DISTRICT AND THE HUDSON RIVER

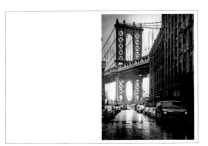

31. CLASSIC VIEW OF THE MANHATTAN BRIDGE IN BROOKLYN

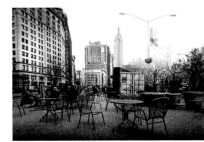

32-33. A COFFEE WITH THE VIEW OF THE EMPIRE STATE BUILDING

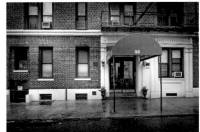

34-35. CLASSIC BROOKLYN ENTRANCE

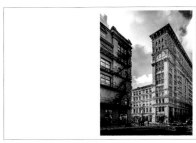

37. CORNER IN SOHO

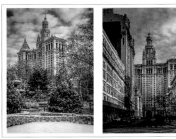

38. NEW YORK CITY TOWN HALL
39. NEW YORK CITY HALL

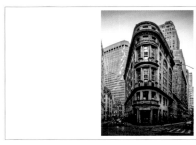

41. FINANCIAL DISTRICT

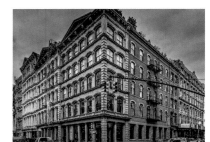

42-43. FASHION AND SOHO

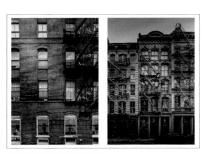

44. MODELS AND BUILDINGS
45. CLASSIC SOHO STAIRS

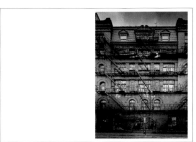

47. CLASSIC SOHO

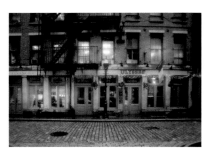

48-49. ULYSSES ON WALL STREET

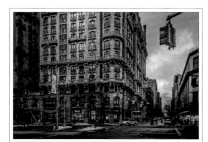

50-51. UPPER WEST SIDE

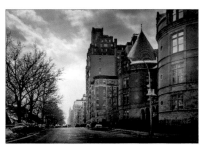

52-53. ALONG CENTRAL PARK

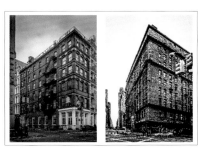

54. IN THE HEART OF MANHATTAN
55. SOHO STREETS

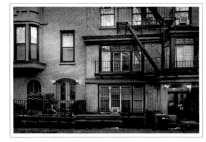

56-57. BROOKLYN HOUSES

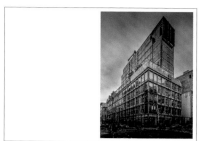

59. NEW BUILDINGS IN SOHO

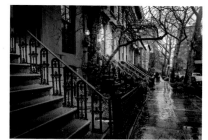

60-61. THE STAIRS OF BROOKLYN

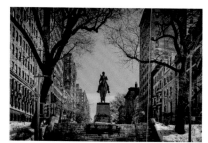

62-63. THE STATUE AND THE UPPER WEST SIDE

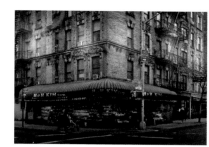

64-65. WEST VILLAGE

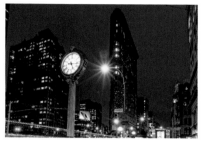

66-67. THE CLOCK AND THE FLATIRON BUILDING

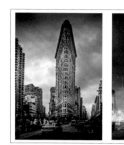

68. FLATIRON BUILDING BY DAY
69. FLATIRON BUILDING

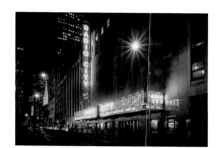

70-71. RADIO CITY MUSIC HALL

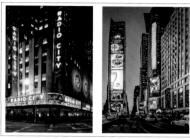

72. RADIO CITY MUSIC HALL
73. TIMES SQUARE

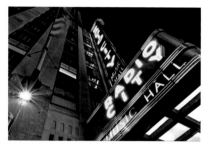

74-75. RADIO CITY MUSIC HALL

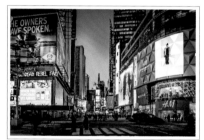

76-77. TIMES SQUARE II

79. TIMES SQUARE BY DAY – COVER

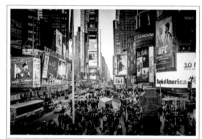

80-81. TIMES SQUARE III

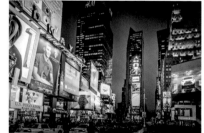

82-83. TIMES SQUARE IV

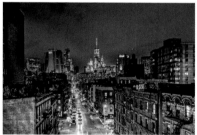

84-85. GOING TO CHINATOWN

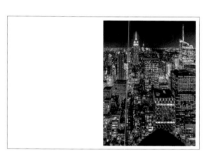

87. VIEW FROM THE ROCK I

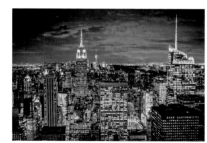

88-89. THE EMPIRE STATE BUILDING

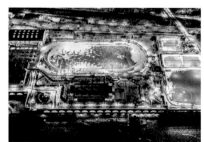

90-91. NEW YORK FROM THE AIR I

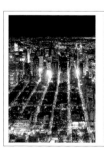

92. NEW YORK FROM THE AIR II
93. PARKING FROM ABOVE

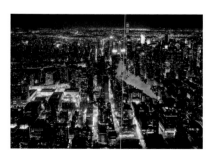

94-95. NEW YORK FROM THE AIR III

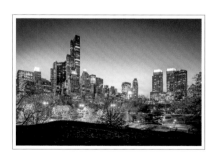

96-97. NATURE AND BUILDING

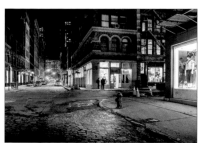

98-99. SOHO BY NIGHT

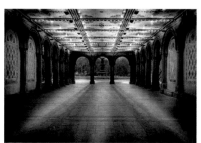

100-101. TUNNEL IN CENTRAL PARK

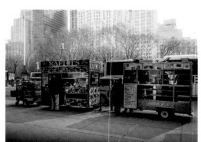

102-103. NEW YORK STREET FOOD

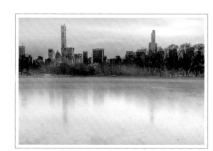

104-105. THE ICE AND CENTRAL PARK

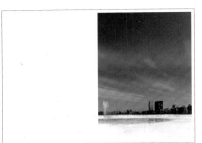

107. CENTRAL PARK WATER JET

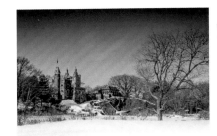

108-109. CENTRAL PARK CASTLE

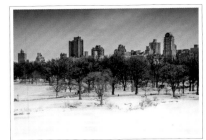

110-111. CENTRAL PARK AND THE SNOW

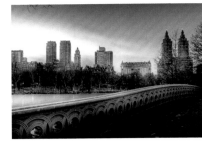

112-113. CENTRAL PARK BRIDGE

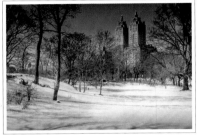

114-115. THE UPPER WEST SIDE FROM CENTRAL PARK

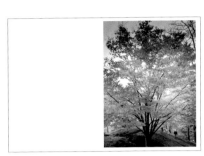

117. SPRING HAS ARRIVED

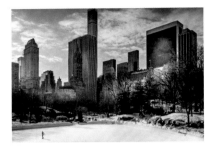

118-119. ICE SKATING IN CENTRAL PARK

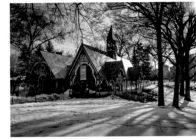

120-121. THE LITTLE HOUSE IN THE PARK

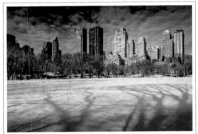

122-123. WINTER HAS ARRIVED

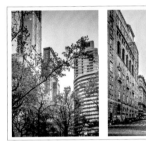

124. WALKING OUT OF CENTRAL PARK I
125. WALKING OUT OF CENTRAL PARK II

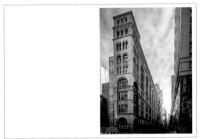

127. FINANCIAL DISTRICT

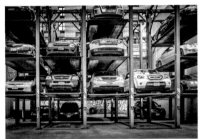

128-129. PARKING MADE EASY

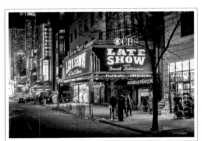

130-131. THE LATE SHOW

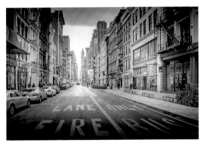

132-133. STREETS OF NEW YORK

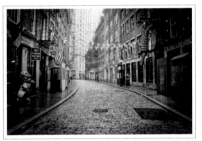

134-135. THE WALKING STREET – FINANCIAL DISTRICT

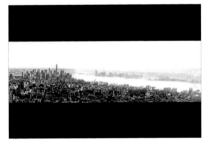

136-137. NEW JERSEY FROM THE EMPIRE STATE BUILDING

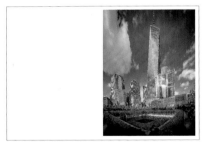

139. ONE WORLD TRADE CENTER

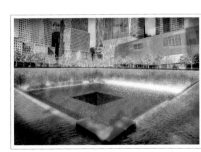

140-141. 9/11 TRIBUTE

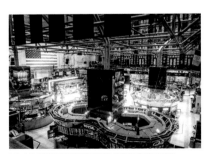

142-143. INSIDE THE NEW YORK STOCK EXCHANGE,
WALL STREET

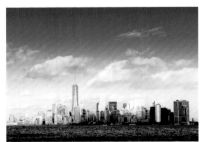

144-145. MANHATTAN

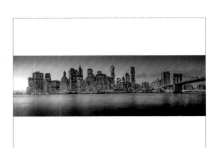

146-147. MANHATTAN ISLAND

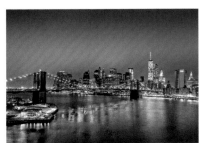

148-149. VIEW FROM THE MANHATTAN BRIDGE

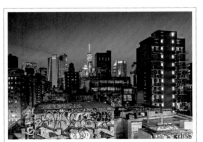

150-151. GRAFFITY AND BUILDINGS

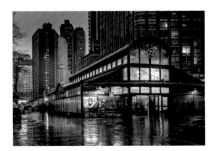

152-153. SUBWAY ON THE UPPER WEST SIDE

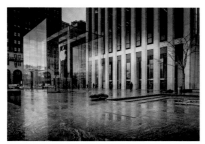

154-155. APPLE STORE, FIFTH AVENUE

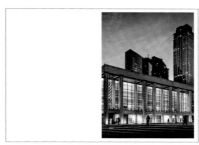

157. NEW YORK CITY BALLET

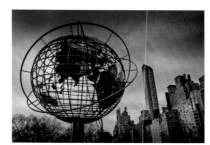

158-159. COLUMBUS CIRCLE

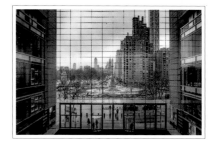

160-161. TIME WARNER CENTER AND COLUMBUS CIRCLE

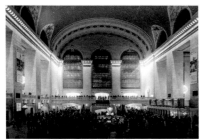

162-163. NEW YORK CENTRAL STATION

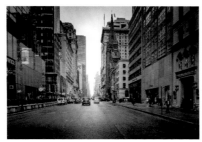

164-165. FIFTH AVENUE

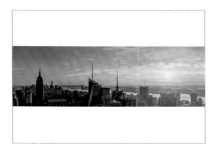

166-167. PANORAMA OF MANHATTAN

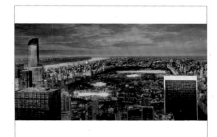

168-169. CENTRAL PARK UNDER SNOW

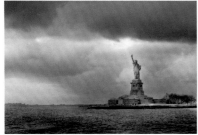

170-171. THE STATUE OF LIBERTY AND THE STORM

IMPRINT

© 2015 teNeues Media GmbH + Co. KG, Kempen
Photographs © 2015 Serge Ramelli. All rights reserved.

Introduction by Harold Hinsinger
Translations by WeSwitch Languages, Zoe Cécilia Brasier and
Romina Russo Lais (English),
Ursula Held, VerlagsService Dr. Ulrich Mihr (German)
Design by Romy Choueiri
Editorial coordination by Inga Wortmann, teNeues Media
Production by Dieter Haberzettl, teNeues Media
Color separation by ORT Medienverbund Krefeld

Published by teNeues Publishing Group

teNeues Media GmbH + Co. KG
Am Selder 37, 47906 Kempen, Germany
Phone: +49-(0)2152-916-0
Fax: +49-(0)2152-916-111
e-mail: books@teneues.com

Press department: Andrea Rehn
Phone: +49-(0)2152-916-202
e-mail: arehn@teneues.com

teNeues Publishing Company
7 West 18th Street, New York, NY 10011, USA
Phone: +1-212-627-9090
Fax: +1-212-627-9511

teNeues Publishing UK Ltd.
12 Ferndene Road, London SE24 0AQ, UK
Phone: +44-(0)20-3542-8997

teNeues France S.A.R.L.
39, rue des Billets, 18250 Henrichemont, France
Phone: +33-(0)2-4826-9348
Fax: +33-(0)1-7072-3482

www.teneues.com

ISBN 978-3-8327-3253-0

Library of Congress Number: 2014958821
Printed in Italy

Bibliographic information published by the Deutsche Nationalbibliothek.
The Deutsche Nationalbibliothek lists this publication in the Deutsche
Nationalbibliografie; detailed bibliographic data are available in the Internet at
http://dnb.d-nb.de.

teNeues Publishing Group
Kempen
Berlin
London
Munich
New York
Paris

teNeues

© 2015 YellowKorner Éditions. Tous droits réservés.

DIRECTION ÉDITORIALE
Alexandre de Metz
Paul-Antoine Briat

DIRECTION GÉNÉRALE
Frédéric Ennabli

RESPONSABLE ÉDITORIAL & FABRICATION
Alexandre Zimmowitch
assisté de Manon Vanesse

PHOTOGRAPHIES
© 2015 Serge Ramelli. Tous droits réservés.

INTRODUCTION
Harold Hinsinger

RÉALISATION
Conception graphique et mise en page : Romy Choueiri
Supervision du texte : Eve Sivadjian

ISBN 978-3-8327-3253-0
Dépôt légal avril 2015

YellowKorner
éditions

84, rue Beaubourg
75003 Paris-FR
contact@yellowkorner.com
Téléphone : +33-(0)1-49-96-50-20

Rendez-vous sur le site internet www.yellowkorner.com, rubrique « Livres »
pour découvrir les ouvrages des Éditions YellowKorner ; consultez également
la rubrique « Galeries » pour découvrir à travers le monde nos galeries
de photographies d'art en éditions limitées et numérotées
et inscrivez-vous à la newsletter.

YELLOWKORNER
PHOTOGRAPHY · LIMITED EDITION

75 GALERIES À TRAVERS LE MONDE :
PHOTOGRAPHIES D'ART EN ÉDITIONS LIMITÉES ET NUMÉROTÉES.

PARIS · LONDRES · NEW YORK · LOS ANGELES · SYDNEY · HONG KONG · SÉOUL

MIX
Paper from responsible sources
Papier aus verantwortungsvollen Quellen
FSC® C107556